Nature Exposed

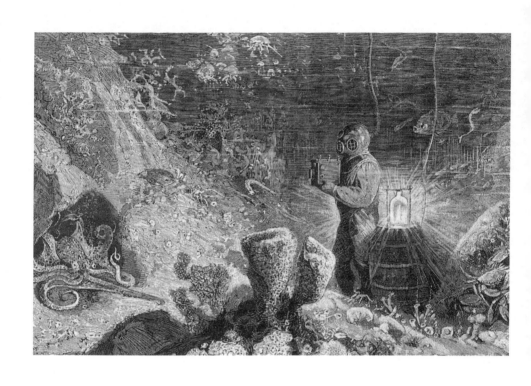

Nature Exposed

Photography as Eyewitness in Victorian Science

Jennifer Tucker

The Johns Hopkins University Press
Baltimore

© 2005 The Johns Hopkins University Press
All rights reserved. Published 2005
Printed in the United States of America on acid-free paper

Johns Hopkins Paperback edition, 2013
9 8 7 6 5 4 3 2 1

The Johns Hopkins University Press
2715 North Charles Street
Baltimore, Maryland 21218-4363
www.press.jhu.edu

The Library of Congress has cataloged the hardcover edition of this book as follows:

Tucker, Jennifer, 1965–
 Nature exposed : photography as eyewitness in Victorian science / Jennifer Tucker.
 p. cm.
 Includes bibliographical references and index.
 ISBN 0-8018-7991-4 (hardcover : alk. paper)
 1. Photography—Scientific applications—History—19th century. 2. Evidence—History—19th century.
I. Title.
 TR692.T83 2005
 509'.039—dc22 2004023568

A catalog record for this book is available from the British Library.

ISBN-13: 978-1-4214-1093-7
ISBN-10: 1-4214-1093-1

FRONTISPIECE Early underwater photography—taking a picture of an octopus in a cave. From Science Illustrée (1894), 53. Mary Evans Picture Library.

Special discounts are available for bulk purchases of this book. For more information, please contact Special Sales at 410-516-6936 or specialsales@press.jhu.edu.

The Johns Hopkins University Press uses environmentally friendly book materials, including recycled text paper that is composed of at least 30 percent post-consumer waste, whenever possible.

Contents

Acknowledgments

This book would not have been possible without the help of many people. It is a pleasure to thank them.

I am grateful to Jane Maienschein for putting me on the path to the study of visual representations in science. The book began in conversations around the seminar table in the History and Philosophy of Science Department of Cambridge University. I was fortunate to be in a graduate program with Iwan Morus, Alison Winter, Emma Spary, Michael Bravo, Richard Staley, Adrian Johns, Rob Iliffe, Arne Hesschenbroek, and other students who became my friends and teachers and made Cambridge a wonderfully collegial and stimulating place to study the history of science. Many of us were privileged to have Simon Schaffer as an advisor. His enthusiasm for my work, his perceptive criticisms, and his breathtaking insights into the problems it addressed, as well as the model of his own scholarship, mean more to me than he could know. Jim Bennett's scholarship, his counsel, and his knowledge of the history of scientific instruments inspired my work. Nick Jardine, Ann Secord, and James Secord stimulated my thinking about the history of natural history and the popular culture of science.

An Owen Fellowship made it possible for me to begin writing a dissertation on this book's topic in the graduate program of the History of Science, Medicine, and Technology Department of the Johns Hopkins University. I am deeply grateful to my graduate advisors, Robert Smith and Judith Walkowitz, who were generous in their support and their criticism, encouraging and insistent in just the right measure. Their advice and perceptive criticism sharpened my work at every stage, and they inspired me with the models of their research, teaching, and mentorship. My thanks to Mary Fissell, Leslie Reagan, Anni Dugdale, and Pamela Long for their friendship, support, and insights into the history of science and medicine. I was fortunate to be in graduate school with Nadja Durbach, Judd Stitziel, Dylan Penningroth, Lara Kriegel, Jennifer Summit, Sharon Marcus, Sandra MacPherson, Mark Canuel, Natalie Brender, Simon Firth, Annie Thrower, Bhavani Balasubramanian, David Roberts, and

other students whose friendship and colleagueship made Hopkins an exciting place to be. I thank Sylvia Brownrigg for providing me with lodgings and friendship during a year of dissertation research in London in 1994.

I was fortunate to receive the support of several private foundations and research centers to complete this book, including fellowships from the National Science Foundation, the National Endowment for the Humanities, the Social Science Research Council, and the Smithsonian Institution. A postdoctoral fellowship at the California Institute of Technology from 1996 to 1998 allowed me to begin revising the dissertation into a book. I am grateful to Miriam Feldblum, William Deverell, Alison Winter, Kevin Gilmartin, Daniel and Bettyann Kevles, Cathy Jurca, Adrian Johns, Andrew Milne, Michelle Brattain, Cheryl Koos, Clark Davis, Phillip Goffe, Kate McGinn, Sharon Block, Dave Newman, Amy Meyers, Jennifer Watts, Dian Kriz, David Igler, and other friends and colleagues who I met at Caltech and the Huntington Library for their support, encouragement, and inspiring examples of research and teaching.

The assistance of numerous librarians and archivists was essential, and I thank Peter D. Hingley of the Royal Astronomical Society; David Davison of Birr Castle; Gwyneth Campling of the British Museum of Natural History; Joseph Struble of the George Eastman House; Linda Briscoe Meyers of the Hansom Research Center at the University of Texas-Austin; Anne Barrett and Catherine Harpham of Imperial College, London; Audrey Hall of the Lady Lever Art Gallery, Liverpool; Gina Douglas of the Linnean Society; Antoinette Beiser of the Lowell Observatory Archives, Flagstaff, Arizona; Mark Vivian of the Mary Evans Picture Library; Christine Woollett of the Royal Society; Peter Johnson of the Society for Psychical Research, London; Kenneth James and Pat McClean of the Ulster Museum, Belfast; Melissa Gold Fournier, Martha Buck, and Lisa Ford of the Yale Center for British Art, New Haven; Ellen Thompson of the Missouri Historical Society, Photographs Collection; Steve Jebson of the Royal Meteorological Society; Todd Maine of the History of Medicine Library, Yale University; Brian Liddy of the National Museum of Photography, Film, and Television; Pamela Roberts of the Royal Photographic Society Historical Collection; and David Thompson of the Science and Society Picture Library, London.

Several people generously shared sources and research leads, including Elizabeth Green-Mussellman, Helen Rozwadowski, Elizabeth Edwards, Timothy Barringer, James Ryan, Laura Wexler, Bernard Lightman, Rusty Shteir, Barbara Gates, and Larry Schaaf. Amy Meyers profoundly influenced the way I thought about the history of the visual culture of science and generously facilitated and sharpened my work. I am grateful to Jennifer Watts for her insights into the

cultures and techniques of amateur photography, and to Douglas Nickel for his comments and for the model of his work on early photography.

One of my greatest debts is to my students at Caltech and Wesleyan who shared their reflections and insights and who provided a continual source of intellectual energy and curiosity. The History Department of Wesleyan University gave me the freedom of a year's leave of absence in which to finish the manuscript. I am grateful to my Wesleyan colleagues in the History Department, the Women's Studies Program, and the Science in Society Program for their support of and comments on this project. In particular, I thank Stewart Gillmor, Joseph Rouse, Christina Crosby, Bruce Masters, Patricia Hill, Gary Shaw, and Ann-Lou Shapiro for their insightful criticisms, corrections, and suggestions. Suzy Taraba and William McCarthy helped identify important visual and print materials for this project in Special Collections and Archives and the Davison Art Center. For their support and good counsel during the final stages of this project, I thank Henry Abelove and my colleagues at the Center for Humanities, including Stephen Spector, Jeffrey Schiff, Allison Polsky, Jeffory Clymer, and Peter Hoyt.

It has been a genuine pleasure to work on the production of this book with the staff at Johns Hopkins University Press. I thank my editor, Robert J. Brugger, for supporting this project and his assistant, Amy Zezula, for her help in shepherding the book into press. Special thanks to Jeffrey Escoffier, Julia Perkins, Julia Ridley Smith, and Kim Johnson for their valuable criticisms, suggestions, and editorial advice. It has been a pleasure working with Megan Mangum on the book design. For assistance with preparing photographs for reproduction, I owe special thanks to photographer John Wareham of Wesleyan.

I am grateful to my parents Roger and Pat, and my siblings Guy and Amanda, for their love and support, and for their wit, intellectual curiosity, and spirit of adventure. Special thanks to my grandmother Winston Harrell Tucker and my aunt Elinor Lutch for their love, encouragement, and practical support. I also honor the memory of my grandmother Floyce Pamelia Kelley and my grandfather Clyde Tucker, who did not live to see this book.

Numerous friends provided practical and moral support, perspective, and good humor. Special thanks to Natalie Brender, Crystal Feimster, Dani Botsman, Nancy Godleski, Nancy Kuhl, Richard Deming, Doug Manson, Paul Bertoni, Sharon Block, Dave Newman, Louise Brown, Paul Horgan, Martha Buck, Renee Clift, Lori Gruen, Algernon Austin, Lauren Paquette, Freddye Hill, Mary Hu, Joan Scribner, Renee Romano, and Genesis Baez.

Finally, I dedicate this book to my new daughter, Josi, who is the greatest of gifts.

Nature Exposed

Introduction

Ever since its invention in the 1830s, many have seen photography as a medium of truth and unassailable accuracy. Photographs have been used by scientists to map the planets, by police to identify criminals, and by magazine editors to document events around the world. Photographs are able to represent phenomena that are invisible or difficult to see with the naked eye, whether bacteria, a bolt of lightning, the landscape of Mars, or spirits of the dead, and thus can have the status of scientific data. Today, more than a century and a half after their debut, photographic images are shown as authoritative evidence in nearly every political campaign, from contests over abortion rights to those over war. Faith in the representational power of photography remains strong despite recent advances in digital technology that allow for the facile fabrication of almost any image imaginable.

How did photographs acquire their authority as evidence in the first place, and how has photographic evidence been collected, organized, and institutionalized ever since? As the historian of art and photography John Tagg pointed out years ago, understanding the complex dynamics of the history of photographic evidence is crucial in today's visual society. Tagg argued that the coupling of evidence and photography in the second half of the nineteenth century was bound up with the emergence of new practices of observation and record keeping that were central to the development of disciplinary institutions, including the police, prisons, asylums, hospitals, departments of public health, schools, and even the modern factory system itself.[1] What photography critic Roland Barthes called "evidential force," Tagg said, is a "complex historical outcome and is exercised by photographs only within certain institutional practices and within particular historical relations." The very idea of what constitutes evidence has a history that implies "definite techniques and procedures, concrete institutions, and specific social relations—that is, relations of power." It is into this more extensive field that we must insert the history of photographic evidence. To underscore the need to accept critically the assumption of

trust in photographs, he asked people to consider: "Under what conditions would a photograph of the Loch Ness monster (of which there are many) be acceptable?"[2]

We still lack the history of photographic evidence that would help us answer this fascinating question, particularly for photographs of the natural world, which themselves are situated within the disciplinary institutions of science. As Tagg noted, whether photographs are believed depends in part on what the representations reveal. Although historians accept the need to consider questions of photographic evidence across different cultural realms, surprisingly little attention has been paid to the microhistory of social processes involved in the manufacture of photographs as evidence across different levels of cultural production, from scientific atlases to tabloid magazines. This is especially true for photographs that were disputed in their time. Tagg's own study, for example, while urging theorists and historians to consider the local reception of photographic evidence, dealt only in passing with photographs that were contested by contemporaries.

There are many reasons historians continue to treat discussion about the evidentiary paradigms of individual photographs as unimportant or unnecessary. As Martin Rudwick noted in his 1976 article, "The Emergence of a Visual Language of Geology," historians of science have long favored written texts over pictures as sources of knowledge about past scientific theory and practice.[3] Other factors are practical and economic. It is often quite difficult to track the production and reception of individual images, particularly those that have not been canonized as exemplary evidentiary photographs. In addition, photographs that have already been reproduced are generally much cheaper to reproduce from archives than those for which new prints must be ordered. This contributes to the canonization in historical literature of a relatively small sample of the large number of surviving nineteenth-century scientific photographs.

Surely the biggest reason historians have not paid more attention to how photographic evidence was established is the strong assumption that photography's authority was unchallengeable in the nineteenth century. As one journalist has put it, even the most outrageous photographic "lies"—such as "blatantly faked 'spirit' photographs"—were "taken at face value" during that period.[4] Since at least World War II, the idea of the universality of nineteenth-century faith in photography has been canonized by influential writings. William Ivins Jr., one of the foremost early historians of photography and a leading figure in its recognition as a significant social force, wrote in an often-quoted 1953 book that "the nineteenth century began by believing that what

was reasonable was true and it wound up by believing that what it saw a photograph of was true—from the finish of a horse race to the nebulae in the sky."[5] A little more than fifty years later, much current scholarship on nineteenth-century history assumes that it is the truth value of photography, not its limitations and unreliability as evidence, that needs to be explained. The notable exception to this is spirit photography. No book-length academic study has yet appeared, but with few exceptions in current scholarship, spirit photography most often interests historians as support for the theory that nineteenth-century people had an "unshaking belief" in the medium.

In the twenty-first century, an age that is increasingly flooded by visual arguments and evidence, it is more important than ever to understand how photography became elevated to the status of evidence, to unearth the history of the social frameworks that were developed for handling and presenting photographs as empirical proof, and to accept counterevidence that indicates nineteenth-century skepticism about photography as a neutral mirror of reality. Drawing on a wide range of primary visual sources and critical theories, this book provides the first book-length historical analysis of how photography was used in science from 1839 to the beginning of the twentieth century. The evidentiary paradigms that underpinned scientific photography's functions as evidence have been less studied than in other forms of photography, such as social reform photography (despite that scientific photographs were hailed as the pinnacles of evidentiary forms of photographic representation). Moreover, scientific photography strongly expressed a powerful underlying paradox of photography in the nineteenth century: the paradox between the philosophical ideal of "mechanical objectivity," or automatism, and the realities of photographic evidence in practice, where, as this study shows, issues of skill, gender, class, and taste continually undermined that claim.

As Peter Galison and Lorraine Daston explain in their important and influential essay, "The Image of Objectivity," published more than ten years ago, the ideal of the mechanical objectivity of photography as an empirical form of pictorial representation seemed consistent with nineteenth-century aspirations to a "wordless" science. Machines such as the camera, they write, offered scientists "freedom from will—from the willful interventions that had come to be seen as the dangerous aspects of subjectivity." Wary of human intervention between nature and representation, nineteenth-century scientists "turned to mechanically produced images to eliminate suspect mediation." They enlisted photographs "and a host of other devices in a near-fanatical effort to create atlases—the bibles of the observational sciences—documenting birds, fossils, human bodies, elementary particles, and flowers in images that were certified

free of human interference."[6] This powerful belief in the idea of photography as automatic and mechanical in the nineteenth century is reflected in the terms that its inventors coined to describe the new process: "sun's pictures," images "impressed by nature's hand" or "pencil." Whereas earlier pictures were made or "willed into existence," photographs were "'obtained' or 'taken,'" like natural specimens found in the wilderness.[7]

But photography—even when its end product was dispassionate, objective science—was a labor-intensive process, and photographs were the result of labor that was divided by gender and stratified by class. How did photographs come to matter to what could count as knowledge in the rich tradition that we know as science? How did science-in-the-making become part of negotiating the continually vexed boundaries of scientific photography? As close examination of nineteenth-century commentary on photographs of scientific phenomena reveals, social concepts of skill, judgment, and human agency informed what counted as objective and subjective in scientific photography even in the culture of persuasion about mechanical objectivity that denied their critical influence. In many cases, people who argued for the mechanical objectivity of photography failed to persuade viewers about the primary evidence value of individual photographs. By the same token, critics of individual photographs often appealed to the universality of photographic truth, even as they disagreed over specific pictorial interpretations. The ubiquity of such debates in the nineteenth century signals the need to combine the study of the ideal of mechanical objectivity in photography with analysis of the actual processes through which people mobilized and used photographic evidence.

Here I take a new look at the role of photography in Victorian science, focusing on the discussions that the topic of photographic evidence generated. Although nineteenth-century faith in photography was powerful, the idea that people over a hundred years ago accepted photographs at face value is exaggerated and misleading. Indeed, nineteenth-century viewers frequently asked many of the same questions that are asked about photographs today. Many recognized that photography is mediated at various points during the process. As in Victorian science, where many people contested authority, the study of scientific photography highlights the frequent contrast between the ideals and practices of photographic evidence.

This book sketches a number of important changes and developments in how photographic evidence was used in British science across various disciplines through a series of case studies. It highlights how such changes contributed to shifting scientific and popular understandings of the ontology of the photo-

graphic image, or the question: what is a photograph? Nineteenth-century Britain was an international capital of science and arguably the center of the world's largest extended community of photographic amateurs and professionals. The study of scientific photographs in Britain provides a chance to look at a specific national response to an international phenomenon. Unlike their continental counterparts, the British generally adopted a laissez-faire, market approach to ideas in photography, one that generated a volatile and intense discussion about its reception.[8]

Although much has been written about the history of photography in Britain, the history of the experience of looking at scientific photographs and deciding on their worth as empirical forms of pictorial representation has been little studied. This study of British science and photography considers such factors as how images were mediated and argued over, how critics argued against them, and how photographs gained and lost authority as evidence as they traveled across different domains of manufacture and use. This approach, which is being pioneered by scholars such as Elizabeth Edwards, Deborah Poole, and James Ryan, neatly converges with issues of current concern to scholars investigating nonvisual texts in the history of science.[9] Whereas earlier literature in the history of science stressed transformations of theory, authors of recent studies have analyzed the changing practices and communities in order to explain why certain theories emerged in the form that they did at particular times and places. A focus on photography in Victorian science therefore provides a unique opportunity to assess in a new context the issues of the historical relation between theory and practice, the reception of new scientific instruments, and the politics of observation across both fields of study.

Scientists were closely involved with defining the meaning of photographic observation from the very beginning. The French physicist and astronomer François Arago gave the first public account of the invention of photography in 1839, and John Herschel, the British astronomer, was the first to apply the term *photography* to the new technique.[10] Around the middle of the nineteenth century, astronomy was revolutionized by the development of two branches of physics—spectroscopy and photometry—which produced the new science of astrophysics. Victorian astrophysics led to a host of important discoveries of the chemical composition, physical structure, temperature, radial velocity, rotation, and magnetism of the sun and stars. Photography enabled the development of astrophysics and quantum theory, and provided a new means for analyzing the composition of comets and nebulae and for detecting interstellar matter in the exploration of the structure of the galaxy. By the turn of the twentieth century, photography used in conjunction with telescopes helped astronomy overcome

major obstacles to its progress, including the sheer number of stars and the faintness of the light received from them.

Since photography first appeared in the days when science was generally described as "natural philosophy," and because many of its most important applications were in the sciences, its meanings inevitably were tied to public opinions about science, including its politics. Everything people stated about the truth of scientific photographs, or the lack thereof, was therefore colored by who made the statements and the rhetoric of science that was available to them.

Despite growing praise for photography as a scientific tool, the empirical truth claims of photography, like those of science, sometimes were questioned.[11] Victorian attitudes to photography were much more complex than they initially seem. Contests over photography demonstrate the character of Victorian science; they also throw into relief the social contours impressed on technology by the social order that produced and sustained it. Throughout the nineteenth century, people debated truth claims based on photographs and, in the process, established the criteria by which a photograph could be accepted as scientific evidence. These debates erupted in laboratories, observatories, and scientific meetings as well as at world's fairs and in courtrooms, illustrated periodicals, and spiritualist séances. Contests over photographs centered on the authority of science as an agent of civilization and imperialism, and as an arbiter in social debates ranging from the "Woman Question" to the social utility of evolutionary theories. These controversies were frequently mediated by the popular press, which debated such questions as whether women could make rational interpretations of photographs and whether photographs of "canals" on Mars indicated otherwise unseen socialist political and social forms of organization.[12]

Central to discussions about how photographic evidence was established was that the processes of scientific investigation and the debates over those investigations were highly public. As scientific photography evolved as a visual genre, the debates around its manufacture and use tapped into and transformed the conditions that governed the recognition of science in the first place. Many of the forms now widely associated with modern science and professionalism emerged in the late nineteenth century, such as laboratory culture, national initiatives in scientific education, and mass scientific culture. Photographs of scientific phenomena, such as bacteria and clouds, mediated public understandings of these wider institutional changes, as images were collected, displayed, and eventually disseminated in correspondence, atlases, exhibitions, newspapers, and magazines. The period from 1839 to 1914 carried tremendous excite-

ment and anxiety about scientific discoveries in England, especially discoveries of the properties of invisible natural forces. New ways of communication developed, such as mass-circulation newspapers, which linked people across the reach of the British Empire. Scientific knowledge increasingly became professionalized and democratized; scientific, legal, and journalistic politics evolved to address a wide range of issues from the exclusiveness of scientific orthodoxy to the need for expert photographic witnesses.

Debates about how the authority of photographic evidence was established revealed deeper concerns about the cultural boundaries of science: about where, for example, the lines were to be drawn between scientific knowledge and popular science. What defined many scientific photographs as a genre was not merely their subject matter (e.g., lightning, clouds, microscopic objects, planets) or even their production at the threshold of human vision. Instead, what made them scientific photographs in the eyes of officials was often based on such considerations as how they were made and by whom and where they were exhibited, as is still the case today.

Nineteenth-century Britain is often remembered as a place and time where scientific naturalism and photographic naturalism became conflated in the presentation of observable fact, a point that has long been recognized in writing about photography, the body and visibility, and surveillance and control.[13] An important international center for the manufacture and interpretation of scientific photographs, Britain was a setting for the elaboration of arguments promoting the ideal of mechanical objectivity of photography, and for a series of important challenges to that ideal in practice.

The study of the reproduction of scientific photographs illustrates how multiple scientific and reading publics were constructed through photographic display. Like law, journalism, and travel writing, scientific activity is based on the witnessing and reporting of matters of fact. As Steven Shapin and Simon Schaffer have shown, scientists constructed texts, such as photographically illustrated scientific atlases, to multiply and secure assent from "virtual witnesses," that is, readers who became witnesses of experimental scenes by means of the production in their minds of images realized in the laboratory. The power of new scientific instruments such as the camera, the microscope, and the telescope resided in their power to enhance perception and constitute new perceptual objects. Through virtual witnessing the multiplication of witnesses is, in principle, unlimited; therefore, the technology of image replication, Shapin and Schaffer declare, is "the most powerful technology for constituting matters of fact." As in criminal law, the experimental foundations of the natural sciences had to be confirmed by the testimony of eyewitnesses, and witnessing was to

be a collective act. In experimental practice, one way of securing the multiplication of witnesses was to perform experiments in a social space, such as the Assembly Rooms of the Royal Society. Another was to facilitate the replication of experimentally produced phenomena, thereby multiplying the number of experimentalists and experimental facts. "Far more important than the performance of experiments before direct witnesses or the facilitating of their replication" was "virtual witnessing," defined as the "production in a *reader's* mind of such an image of an experimental scene as obviates the necessity for either direct witness or replication."[14]

Most of the general public rarely saw scientific photographs outside of popular exhibitions and book and newspaper culture in the nineteenth century. Even early trade journals for specialists such as the *Photographic News* rarely included photographic reproductions. Until the end of the century, when magazines and newspapers began to reproduce scientific photographs for the first time, most lay people and even scientists saw them only in private or public albums, at exhibitions, or at popular science lectures and demonstrations. This fact not only suggests the need for cautious skepticism in the face of bold pronouncements that everyone believed scientific photographs but also requires us to look carefully at where people saw them.[15]

Although their public circulation was smaller than that of other types of photographs (portraits, for example), scientific pictures had a disproportionate hold on people's concept of what photography was. It is therefore vital that this study looks beyond the standard atlases and signature images toward the different forums in which scientific photographs did circulate. They included private albums, scientific society exhibitions, scientific atlases, and photographically illustrated magazines. Each of these sites for display and interpretation was associated with distinct and emerging cultures of photographic manufacture and interpretation in nineteenth-century science.

The 1880s and 1890s were the premier age of the illustrated press and an increasingly diverse range of visual communicative media. The possibility of reproducing photographs in newspapers and magazines promised to revolutionize science because it seemingly opened the archives of photography for all to see. Scientists turned to the illustrated press to democratize scientific photography, to increase public support of science, and to promote their wider cultural agenda of cultivating a more scientific electorate that recognized and responded to their authority. Many depicted the dissemination of scientific photographs into the public sphere as a missionary venture taking light into darkest corners.[16]

Photography also helped move the issue of observation mediated by sci-

entific instruments to the center of arguments about "Englishness" and the cultural superiority of British civilization. The British impulse to record, collect, and classify scientific phenomena by means of photography was stamped by ideologies of empire even when the subject matter was stars and comets rather than colonized people. Photography in Victorian astronomy, biology, meteorology, geology, and natural history circulated within scientific communities that, like institutions of anthropology and public health, depended on imperial support and networks of exchange. Many Victorians argued that science and photography demonstrated the superiority of British civilization. London scientific institutes became the seat of the production of photographic knowledge in the sciences partly because London was the center of the British Empire. At the same time, however, this study shows that increasing access to photographs did not inevitably strengthen their credibility, either in the scientific community or in the culture at large. For a variety of reasons, the illustrated press proved to be a problematic means for ensuring distant but direct witnesses.

To locate scientific photography in the context of developments in Victorian science and visual culture, a new approach is required. As Douglas R. Nickel has remarked, we must examine epistemological issues, belief systems as well as material objects.[17] Elizabeth Edwards has argued that the study of photographic representation in science must also draw on available material sources and other evidence about how scientific photographs traveled and were discussed across diverse intellectual and cultural domains in Britain. As Edwards points out, "Despite, or perhaps because of, the ubiquity of photography by the late nineteenth century, there is relatively little commentary on it, on specific images or practices, when compared with the huge body of material" in collections and archives.[18] Existing historical analyses that draw on scientific archives often focus on a few well-known photographs that became emblematic of scientific discovery in certain disciplines or fields: so-called "signature" images, such as Eadweard Muybridge's running horses and Wilhelm Conrad Röntgen's X-ray of his wife's hand.[19] However, as with earlier histories, which often focused on pioneers to the exclusion of workers in ordinary science, the stress on canonical photographs like these published in official scientific atlases risks eclipsing less-known photographic studies in "normal" science, or the routine practices that define ordinary scientific work.[20]

Entering the landscape of visual representation in science raises the problem of how to interpret it. Over twenty-five years ago, Martin Rudwick illustrated the promise of visual representation by exploring the artistic practices and styles found among different groups, such as cartographers, naturalists,

travelers, and geologists. Since then a flurry of publications on visual representation in science has appeared, many of them from sociologists seeking to understand how the hidden aspects of scientific practice enter into the construction of scientific knowledge. Although the large body of literature now available may indicate that historians of science have shed what Rudwick called an "intellectually arrogant assumption that visual modes of communication are either a sop to the less intelligent or a way of pandering to a generation soaked in television," Gregg Mitman has noted that the recent trend in studies of visual representation in science suggests that the "profession is still far from comfortable in disassociating itself from elite, scientific culture."[21]

The tendency to focus almost exclusively on elite, scientific culture is particularly notable in writings on the history of scientific photography. Despite the access that large numbers of people had to photography from the very beginning, both as producers and consumers, most of the existing scholarship, with few exceptions, has examined photographs that appeared in atlases for scientific elites. Notably absent in much of the recent work on scientific photography and mechanical objectivity are analyses of photographs as mediators between scientific and popular culture, and between science and other aspects of photographic culture, such as commercial photography. How did the practice of scientific photography become defined in the wider context of interactions and debates across elite and popular culture? How were the boundaries drawn around scientific photography and its subfields? To answer questions like these requires attention to the multiplicity of meanings that photographs convey to different audiences, and the complex ways in which scientific knowledge based on photographs is appropriated, resisted, and transformed by different groups. Feminist scholars of visual representation have been particularly active in this regard; their work and the questions behind it inform this study. By examining the social asymmetries that structured people's access to, and definitions of, scientific photography, I hope to contribute to the larger body of scholarship on gender, visual culture, and science pioneered by Lisa Cartwright, Donna Haraway, Ludmilla Jordanova, Sally Kohlstedt, Katharine Park, and many others.[22]

To recover the histories that scientific photographs encode, this study draws on methodologies that are not often employed together. These include British intellectual and cultural history, histories of scientific disciplines and practices, visual culture studies, science studies, and women's history. To locate scientific photographs used for evidentiary purposes in the specific historical contexts in which they were made and circulated, I surveyed discussions about photographic evidence in a wide range of primary published and unpublished docu-

ments: newspapers and magazines, laboratory notebooks, articles in scientific and medical journals, photographic trade journals, practical drawing and photography manuals, written correspondence of professional and amateur scientists and photographers, spiritualist journals, works of popular science, and scientific atlases. These sources contain crucial and hitherto overlooked information about how the genre of scientific photography was created and defended.[23] At the same time, this book pays attention to how the authority of photography as evidence was established and critiqued across different scientific disciplines and venues. Rather than focusing on a single discipline or case study as is commonly done in the history of science, it maps out a different approach to the topic of photographic evidence by tracing the contests over scientific practice in photography across a range of disciplines and exchange networks, and across different modes of observation, from the field to the observatory to the laboratory.

The objects discussed here are just a small sample selected from thousands of photographs and prints in British scientific and medical archives. Most of the images in this book are relatively unknown today, though they were deemed valuable and important in the nineteenth century. Indeed, at one time photographic images of stars and lightning traveled across the boundaries of official and popular scientific institutions and helped define the British public's image of science and scientific observation. In the following pages, I explore how the evidentiary paradigms for photography changed in Great Britain from 1850, when the culture of photography was just beginning to expand to include diverse practitioners, to the early 1900s, when photography in the sciences often, though not always, was restricted to specialists trained in a scientific discipline. I also look at other visual materials, for to understand the photographs and their significance it is necessary to recall the forms with which they competed and to which they were compared, including wood engravings, lithographs, and paintings.

In what areas of British science did photographs begin to displace other methods of evidence and illustration? Through what processes did photographic evidence become authoritative in the resolution of disputes about natural phenomena? In what instances in scientific culture was the realism of photography contested or denied, and what was the basis for those rejections? What social patterns are evident in the way that photographs were used to arbitrate debates over matters of fact in science?

This series of case studies about scientific photographs highlights some of the different ways in which photographs were mobilized as evidence in Victorian Britain, and develops an argument through specific examples about some

of the wider historical and social trends that characterized the use of the medium in science. What we see in chapter 1 is that through the 1850s and 1860s, issues of skill, gender, class, and taste already were starting to eat away at the idea of photography as an unmediated process. Drawing on a crucial and often overlooked source, the *Photographic News,* the chapter examines how photographic culture was recast in these years of social clash between an older tradition of genteel photographers and new working-class and itinerant practitioners who threatened their hegemony over the future direction of photography. In this context, the argument that photography gave Nature the power to reproduce herself—and therefore that the human factor was irrelevant—was eroded again and again by the reality that who made photographs clearly mattered. As middle-class photographic operators, including scientists, struggled to police the profession, their efforts to rationalize photography and science revealed social factors that operated to distinguish their photographs from others. Building on recent excellent studies of William Henry Fox Talbot's circle and integrating them into my research on the mid-nineteenth century, the chapter also shows how middle-class and elite photographers during the 1850s and 1860s developed a legitimating grammar for their work partly by pointing to scientific photographs as exemplary productions.

Chapters 2 and 3 take this argument further, showing how the authority of photographs made by amateurs was supported by the wider discussion about photographic evidence. Although metropolitan class and gender tensions at midcentury generated public discussions about evidence and raised suspicions about who could be trusted to make reliable photographs, there was no clear-cut doubt about the mechanical objectivity of photography. As is shown in the case of spirit photography, discussed in chapter 2, many people tried to draw on those claims about mechanical objectivity to reinforce their contention that spirit photographs, or—broadly speaking, photographs of ghosts—were direct representations of an otherwise unseen reality. This controversy meanwhile made the issues of trust in photographic production visible to a wider Victorian public than ever before and focused new attention on the qualifications of people, both technically and morally, to make and to judge genuinely authentic photographs. As it turned out, there were no easy grounds for rejecting the possibility of photographing invisible spiritual forms. Scientists who usually argued that the mechanical objectivity of photographs meant that it did not matter who made them found themselves arguing, on the contrary, that who made them mattered a great deal. Since spiritualists who believed in the plausibility of spirit photographs used men of science to elevate the status of the medium, scientists inevitably were drawn into public discussions whether they liked it or not.

In the first tumultuous years of the transformation of photography into a commercial and scientific art, interest focused especially on who made photographs; by the time new scientific societies began forming and collecting photographs, increasing attention was paid to how photography was done and how it functioned in the scientific community. Chapter 3 takes a fresh look at some of the often taken-for-granted mechanisms that meteorologists used to systematize the collection of photographs. Looking at meteorologists' instructions to other photographers about how to make an image that scientists could use for evidence reveals the contradictions between the ideal of mechanical objectivity that meteorologists drew on to discredit painters of the weather and the ideas of photographic skill and virtuosity to which they simultaneously appealed. As with spirit photography, meteorological photography was grounded in the idea that the medium stood to benefit from the democratization and expansion of amateur scientific networks. The case of meteorological photography is also interesting because people ended up acknowledging its legitimacy as objective evidence and its continuity with meteorology as a scientific discipline, even though the social processes embedded in meteorological photography were, in most important respects, no different from those in spirit photography.

Whereas chapters 2 and 3 are concerned with how authority was demonstrated in the amateur world of nature and spirit photography, where practitioners more or less had great autonomy, the last two chapters explore the shifts in the professional scientist's use of photography by the end of the century. Chapter 4 looks at the role of science and scientific institutions (and the different levels of production and reception) in creating the authority of photography as scientific evidence of bacteria. Photographs of bacteria excited the greatest scientific and popular interest in late-Victorian England, where public health measures and germ theory were major topics. This chapter gives an account of the professional debates over photographing bacteria and analyzes a prime example of its popularization. Belief in photographs of bacteria was facilitated by mediating arguments about scientific observations more generally, including those made by means of scientific instruments, such as the microscope and telescope. Focusing on images such as bacteria photographs that mediated between science and popular culture, this chapter illustrates how multiple scientific and reading publics were constructed through photographic display, from the international sphere of scientific collaboration to illustrated mass magazines that claimed science as an intrinsic element of "Englishness" and national patriotism. This chapter shows how newspapers and magazines provided a competing arena for scientific ideas and photographs, and how the repro-

duction of certain photographs in the press often pushed popular understandings of public science beyond the limits that many scientific men imagined.

As chapter 5 demonstrates, scientists often disagreed over the interpretation of images, and increasing access to photographs did not always strengthen their credibility. The chapter draws on the case of planetary photography and especially that of Mars to emphasize the shift in scientific photography toward systematic collecting as well as the move to patrol the networks in which photographs circulated. This chapter explores some new contexts for interpreting the role of the illustrated press in the establishment of the authority of photographs at the end of the century. It also highlights similarities between the rhetorical arguments advanced against the evidence furnished by photographs of Mars and those made in the earlier context by genteel critics of itinerant and spirit photography, both of which discredited photographers for lack of skill and honesty.

As the epistemological contexts of photography have changed and evolved, so have understandings of the medium. Studying the history of scientific photography in different guises, across shifting domains of elite science and popular culture, raises fascinating new questions about the social field in which photographic evidence is inserted today. It heightens appreciation of the myriad uses of photography as evidence and the role of institutions in defining photographic knowledge. Finally, and perhaps most important for this study, it allows us to move beyond the uncritical acceptance of binaries of photographic truth and falsity in science, one that associates human agency only with photographic deception rather than with the manufacture of photographic truths.

This book traces a period in history when formal rules and tacit guidelines regarding the admission, exclusion, and interpretation of photographic evidence originated in scientific and legal settings, establishing assumptions about and providing precedents for the use of photographic testimony today. As Berenice Abbott remarked over fifty years ago, photography is "a new way of making pictures and a new way of seeing. Indeed, the vision of the twentieth century may be said to have been created by photography. Our familiar awareness of the visual world has been evolved for us not alone by the eye but by the camera, used for myriad purposes. The very character of the medium, its dualistic science-art aspects, is the index of its contemporaneity. It took the modern period, based on science, to develop an art from scientific sources."[24]

The labor and rhetorical arguments that people invested in establishing photography's authority as scientific evidence in the early days of camera work

resulted in a new vision of the world that has become synonymous with modern culture. The final chapter returns to the medium of photography and what we learn about it through this history, and discusses this study's implications for contemporary understandings of photographic evidence.

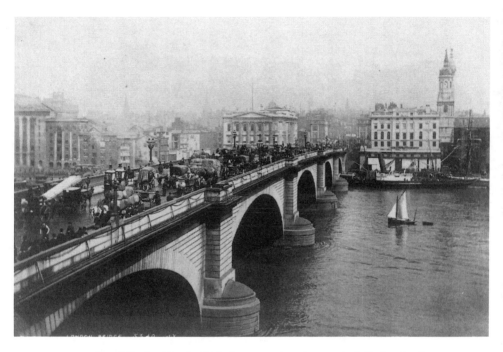

FIG. 1.1. James Valentine, "London Bridge," ca. 1870-1880. 1983-12-117 (335), Davison Art Center, Wesleyan University.

Chapter 1

Constructing Science and Brotherhood in Photographic Culture

Photography, by the end of the nineteenth century, was a well-established method for documenting different aspects of the city: its streets, people, and monuments. A photograph taken by Scottish photographer James Valentine between 1870 and 1880 shows London Bridge teeming with people and commerce (Fig. 1.1). The capital city of London was the scene of rapid innovations in the sciences and the visual arts, of vigorous experimentation in ways to bring these together, and of reflection on the meaning of art and science. The rise of photography as a new form of evidence in the sciences over the course of the century occurred in the context of wider reflections on the nature and interrelationship of scientific authority and observation. However, scientific observation was not a monolithic category but a term associated with cultural practices ranging from observing comets through a telescope to painting a landscape to making daily thermometer readings. To understand how photography became established as a new form of visual documentation in science, it is necessary to take a fresh look at what different Victorians meant by scientific practice and how these understandings shaped perceptions of photography as a new tool for discovery.

The Promise of Photography

A medallion designed by the Irish medallist William Woodhouse for the Photographic Society of Ireland's award for the "Best Paper Negative," given to Lady Mary Rosse in 1859, shows a classical female figure taking a picture with a modern tripod camera (Fig. 1.2).[1] The scene is remarkable for its representation of a woman behind a camera at a time when men outnumbered women in the practice of photography, and for its suggestion that the camera itself was a subject of mystery. The figure is shown seated, facing the viewer, one hand holding a laurel wreath in her lap, the other drawing the cloth away from the camera lens. She is preparing to expose a plate, the tools associated with photography—distilling equipment, a dust brush, plateholder, water vase, and lens box—at her feet.

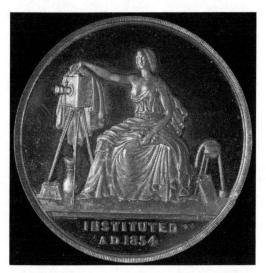

FIG. 1.2. William Woodhouse, "Truth" personified as a woman, ca. 1859. Silver medallion awarded to Lady Mary Rosse by the Photographic Society of Ireland for "Best Paper Negative." Birr Castle, Dublin. Rosse was the first recipient of the honor.

The figure's gesture—unveiling the camera to expose a plate—is a fitting one for Victorian photography, which was a new wonder of the age. Photography's inventors were masters of curiosity and illusion: Louis Jacques Mandé Daguerre, who invented the daguerreotype in Paris, was a theatrical scene painter, and William Henry Fox Talbot, the creator of the calotype process in England, was a gentleman collector of natural wonders and artificial curiosities. These two men raised the curtain on photography during the 1830s, an age of fascination with techniques of illusion and feats of mechanical achievement. On Lake Como—the Italian lake where, years earlier, Mary Shelley had invented the figure of Frankenstein—Talbot in 1833 conceived the idea for something that also took on a life of its own: the idea for a technique to make permanent chemical images of nature. Talbot finally succeeded at creating a process for making "sun pictures" at his home in Lacock Abbey, near the golden spa town of Bath, England, during the "brilliant summer" of 1835 but kept it a secret until 1839, when the public announcement that Daguerre was making such images propelled him into a race for priority of invention.

Early photographers were involved in a partnership with nature, and at the same time they were artists familiar with traditions of picture making. Working with a medium that called into question so much in art and representation, photographers often attended to the special conditions obtaining in their medium. In his photographically illustrated book *The Pencil of Nature* (1844), Talbot imagined an audience with varying interests like his own, genteel amateurs interested in travel, family history, decorative art, botany, and architecture. In reflecting on the distracting questions that his photographs raised, he showed how much he relished their incidentals and dwelled on their mystery and fascinating irrelevancy.[2] For example, a photograph of a Parisian street re-

vealed much tangential information. This, for many, was the pleasure of photography and the source of its documentary power: things that the observer did not see at the time might be discovered later in a photograph. However, the presence of incidentals also revealed that the instrument was only partially under the operator's control. From the beginning, Talbot raised an issue that would resurface over the course of the nineteenth century. What was the relationship between the operator's intentions and the disinterested eye of the camera? How could photographers lay claim to being artists (or scientists)?

The pictures in Talbot's book invite questions, such as what do the elements of the scene represent, and what did the photographer wish to convey? Talbot famously announced in his book that the "mute testimony of the picture" would achieve the level of legal evidence in a case against a criminal, though he also, significantly, averred that "what the judge and jury might say to it" was difficult to know.[3] From the very beginning, people recognized that photography presupposed an active and inquiring audience. What people saw in photographs, meanwhile, was shaped not merely by the photographer's intentions but by their own way of seeing the subject represented.[4]

The story of nineteenth-century scientific photography is ultimately inextricable from the story of the people who manufactured, circulated, displayed, and argued over scientific photographs. Implicit in Talbot's early work, as Ian Jeffrey remarks, is "the question of how a picture might be made out of a photograph."[5] Talbot's "The Open Door," plate 6 in *The Pencil of Nature,* shows a broom, lantern, and harness before a dark entryway. This picture, one of the most widely known and reproduced of Talbot's arrangements, does not tell a complete story. Rather, it includes details and elements that signify and suggest meanings that guide and restrict interpretation. Similarly, scientific photography, which lacks many of the narrative details and elements of other photographic genres, carries associations and meanings through the presence and absence of details recognized by people trained to see them. Interpreting from a range of possible meanings of such pictures, in turn, requires an audience interested in deciphering what the story of scientific photographs was.

To understand what makers and audiences saw in early photographs requires investigating their cultural and intellectual backgrounds and the forces shaping how they saw pictures. The men and women who pioneered photography in the 1840s were genteel amateurs in the broadest sense of the word. This was partly because the expense of equipment and supplies prohibited most people from participating in the formative years. Photography thus developed in the informal, convivial networks that assembled around the empirical study and drawing of the natural world in genteel circles.

The word *science* came into common usage only in the 1830s, natural phi-

losophy being the common designation before. As Douglas Nickel explains, Talbot's photographic process was introduced at a moment in which ideas about empiricism and the inductive method fit comfortably with a foundational metaphysics that understood the Book of Nature as a repository for marvels, secrets, and "natural magic."[6] Talbot's first public announcement, delivered to the Royal Society in London on January 31, 1839, reflected his interest in the invention of photography as an idea as well as a practice. Proposing that the invention of the technique alone illustrated the soundness of the inductive method, whether or not it proved useful in practice, Talbot revealed that he wanted to be associated with a kind of science: pure research through the Baconian system.[7] He wrote that photography offered "proof of the value of the inductive methods of modern science." At the same time, his understanding of science and the nature of reality incorporated an intellectual tradition that offered up marvels, spells, emblems, and symbols. "The most transitory of things, a shadow, the proverbial emblem of all that is fleeting and momentary, may be fettered by the spells of our 'natural magic,' and may be fixed for ever in the position which it seemed only destined for a single instant to occupy."[8]

Two things are of particular interest: first, figures associated with photography, such as Talbot, promoted the invention of photography as an idea with elements of a cosmology and belief system that brought them into being. Significantly, many of the figures involved in the story of photography participated in the creation of its multiple meanings, whether or not they actually practiced it. Second, invocations of modern science helped invent the idea of photography, as well as the practice. From the very beginning, beliefs about science informed the history of photography. For the remainder of the century, however, different opinions on what counted as "modern science" revealed fractures in that seemingly unproblematic designation.[9]

The creation of new photographic exchange clubs, which began to form in earnest in the late 1840s, reflected a wider trend toward organization around scientific interests in the nineteenth century. New societies were springing up all around the British Isles, from the Geological Society (1807), the Astronomical Society (1820), the Zoological Society (1826), the Meteorological Society (1836), to the Chemical Society (1841). Members of these societies typically had the money and leisure to pursue a variety of self-improving activities with enthusiasm, ease, and confidence. Photographic societies were founded by devotees who were shifting their focus from how to get a picture to what subjects to represent. Like their peers in related societies, to which they also often belonged, photographic society members discussed and debated the meaning of scientific practice and observation.

As photography entered the material landscape of British life, it projected

cultural values about science onto the new medium and the field of seeing. Almost immediately after the invention of the daguerreotype and the calotype, amateur scientists and photographers began to use photographic processes to give visual expression to familiar objects—shells, flowers, insects, ruins, and rocks—that dotted the English countryside. Photographs, like artificial and natural curiosities, were to be collected, gathered together, catalogued, viewed, and displayed.[10] Early photographs combined the early-modern scientific tradition with the Victorian love of things and evoked the sensibility of a rising middle-class culture of consumption. This curiosity about seeing objects took a number of forms, including a table set up near the National Gallery with a stereoscope, slides, and a microscope. Passersby paid a penny for the pleasure of new views. As one journalist put it, this was a method for "illustrating science for the million."[11] Natural philosophers compiled photographs so avidly that, as the Victorian natural philosopher David Brewster once observed, collecting photographs became, like so many other early nineteenth-century pursuits, a "monomania."[12] As Carol Armstrong astutely remarks, to photograph was to "collect directly from nature."[13]

Advances in photography were linked with the creation of communities and viewing audiences that were modeled on botanical exchange. Early photographers' interests centered on the study of nature and its forms. Like objects displayed in curiosity cabinets and early-modern still-life paintings, early calotypes of natural subjects offer precise visual details; like trompe l'oeil paintings, they also implicitly allude to the optical techniques of microscopy.[14] Botanical specimens such as flowers and leaves provided the subject matter for many of Talbot's calotype experiments. The persistence of still-life forms is evident in his fascination with material objects, such as ribbons, lace, a basket beside a tree, a cherub and urn, garden implements, Horatia's harp, figurines on a shelf, and a ladder.[15] Furthermore, the physical placement of objects in Talbot's photographs borrowed from the traditions of natural history, even when he was not representing a botanical subject. The arrangement of hats in Talbot's salt print from a calotype negative "The Milliner's Window" (ca. 1842), like Daguerre's daguerreotype, "Arrangement of Fossil Shells" (1837–39), mirrors the display of objects in seventeenth- and eighteenth-century natural history drawings (Fig. 1.3).

Like botany and natural history, photography's promise was inextricably tied to the creation of communities and viewing audiences. In March 1839, Talbot sent examples to William Hooker, Britain's leading botanist, proposing that they collaborate on a volume about native plants, illustrated with photogenic drawings.[16] Hooker rejected the idea, saying that "Your beautiful *Campanula hederacea* was very pretty as to general effect—but it did not express the swelling of the flower, nor the calyx, nor the veins of the leaves distinctly." Botanists main-

FIG. 1.3. William Henry Fox Talbot, "The Milliner's Window," ca. 1842. Salted paper print from a calotype negative. National Museum of Photography, Film & Television/ Science & Society Picture Library.

tained dry plant specimens for study purposes and exchange within the small community of botanists in England and abroad.[17] As Nickel points out, photography promised to render plant samples reproducible and thus available for exchange.[18]

In 1847, the Calotype Society included well-known scientists and inventors, such as the chemist Robert Hunt and Scott Archer, the inventor of the collodion process in 1851, as well as male and eventually a few female members of the social elite.[19] One gentleman amateur who attended the first Calotype Society meeting described it this way: "We have attended a meeting of a society composed of a dozen gentlemen amateurs associated together for the purpose of pursuing their experiments in this art-science (we scarcely know the word fittest completely to designate it); who carry on their operations at different times and places—some residing in the country—but keep up a constant communication with each other, detailing their several improvements and discoveries, and interchanging the repetitions of such sun-pictures as each may have produced."[20] By the 1850s, the elite and middle-class social base of photography was expanding. In 1853, the Royal Photographic Society was founded, borrowing from the model of the Calotype Society and its French counterpart, founded in 1851. Members might also belong to the Royal Society, the Linnaean Society, the Society of Antiquaries, or the Royal Academy.

The Great Exhibition of 1851 spurred the growth of photography by showing what could be done. Held at the Crystal Palace in London, it was the world's first international photographic competition, with submissions from England, France, Australia, and North America.[21] Never before had so rich a collection of photographic images been assembled in one place from so many parts of the world. At a time when many people did not see scientific photographs and when there were few models to be imitated, events such as the Great Exhibition of 1851 offered unprecedented access to important examples of contem-

porary photographs, particularly those of scientific phenomena such as astronomical photographs and photomicrographs. Spectators thrilled to see various optical entertainments and exact representations of places and subjects that satisfied the philosophical and the curious.[22] Mechanical displays and exhibitions of pictures, objects, and living creatures catered to a restless demand for novelty and innovation. Scientific entertainments excited popular interest in pictorial naturalism with settings whose fidelity to nature was heightened by imitations of changing lights, sounds, and visual effects. The Great Exhibition tapped into a spirit of improvement reinforced by the introduction of Archer's collodion process and the relaxation of Talbot's patent.

The balloon, the camera, the telescope, and the microscope were tools that allowed access to a new world of wonders. For Victorians, rendering visible the unseen with scientific instruments was a matter of conquering new territories in a spirit of adventure and disciplining the social order. Technologies of vision were used to alter social power through new mechanisms of surveillance and domestic social controls. They also served as touchstones for debates about modern science and its symbols.[23] Discussions of nationalism and technological confidence in England at a time of imperial expansion elevated science to center stage and gave scientists a public platform from which to generate more interest in their work.

Thus, the camera emerged into society at a moment when how to make proper data with a scientific instrument was becoming a topic of great concern.[24] Scientists associated with the exhibition, whether as judges, photographers, or viewers, were eager to extend their public influence. Many of them were active in teaching people how to make rigorous observations of nature that would be of service to science: an aim that unified scientists across a variety of emergent disciplines. The meteorologist and astronomer James Glaisher, for example, who was an exhibition judge and an eminent photographer himself, was by the 1850s teaching amateurs how to make meteorological observations using scientific methods. Glaisher led a wider effort to propagandize scientific observation, a campaign in which scientists differentiated between scientific experiences and merely looking.[25] Engraved illustrations and photographs of men of science making observations reflect the variety of visual media contexts in which the connection between science and Victorian precision was encouraged, as well as their wide popular appeal (Fig. 1.4). Photographs and lithographs showing Glaisher seated in a balloon in a portrait studio with meteorological instruments (ca. 1865) were as much public icons of scientific observation practices as the lithographs that accompanied his scientific travel narratives, which appealed to the appetite for topographical, scientific news from remote regions in an age fascinated by discovery and exploration (Fig. 1.5).

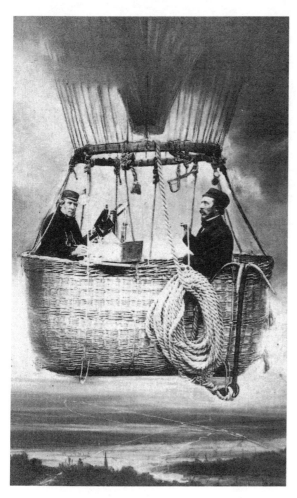

FIG. 1.4. James Glaisher and Henry Coxwell, seated with meteorological instruments in a balloon, studio portrait photograph, ca. 1863. RAS MS Glaisher 6, Royal Astronomical Society.

As the judges at the Great Exhibition deliberated on the qualities of good and poor work, and suggested where they thought the best future for photography lay, they powerfully influenced ideas about photographic taste and the role of scientific perception in shaping it. The judges, including James Glaisher and other men of science, stated in their official report: "We may be permitted to record some degree of disappointment at the absence of specimens of the application of photography to any departments of representation, other than those such as please the eye or administer to personal feelings." As regarded its "application to an infinity of useful and instructive purposes," the judges declared, "we have literally nothing!" "Rapid as have been the discoveries connected with Photography, and great as are the improvements it has received since the invention of M. Daguerre, there is yet much to be done to enable it to rank amongst the sciences of the age." Photography was "yet in its infancy." Overall, they held that there were few photographs that were useful or scientifically instructive.[26]

The judges' disappointment at the lack of "useful" photographs influenced the future development of scientific photography. They urged photographers to apply their medium to the study of useful science. For example, they recommended the study of prismatic spectra, and they singled out Bostonian J. A. Whipple's daguerreotypes of the moon for signal praise, saying they represented the dawning of "a new era in astronomical representation." They also encouraged the photographic delineation of tropical scenery, representations of microscopic organisms, and photographs of animals and plants as appropriate studies.[27]

After the exhibition, onlookers commented on the new direction it had given photography and watched for signs of the future. The Great Exhibition and the smaller ones that followed provided an important context for shaping the future of photography. In particular, it arguably played a role in effecting what Grace Seiberling perceptively describes as a "shift in emphasis from the medium itself to its uses for particular purposes—which seems in keeping with the modern definition of photography," a shift that "distinguished the amateurs and professionals of 1860 from those of a decade earlier."[28] Perhaps in response to the publicity that it generated for new subjects in photography, interest in photography's uses for science expanded. The public platform that the Great Exhibition gave to scientists to articulate how they thought photography could be useful is of crucial significance in this connection.

After 1851, photographers and scientists increasingly emphasized the spe-

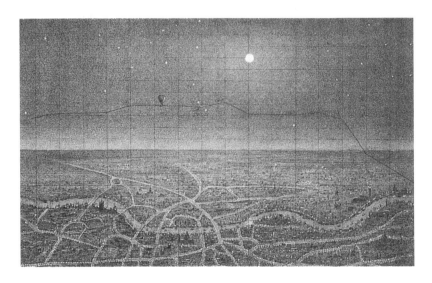

FIG. 1.5. "Path of the Balloon over London at Night, Oct. 2, 1865." Lithograph in J. Glaisher, C. Flammarion, W. de Fonvielle, and G. Tissandier, *Travels in the Air*, ed. J. Glaisher (London: Richard Bentley Press, 1871), 80.

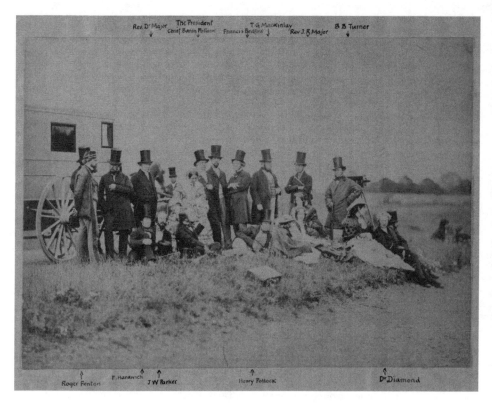

FIG. 1.6. Roger Fenton, "Summer Meeting of the Photographic Club at Hampton Court," July 1856. Albumen print of collodion negative. Royal Photographic Society Collection at the National Museum of Photography, Film, and Television.

cific uses to which photography could be put in scientific and medical research. Two years after the Great Exhibition, a group of energetic amateurs created the Royal Photographic Society, shown here at Hampton Court in 1856 (Fig. 1.6). The society provided a social structure for what had long been a part of amateur activity in different fields of inquiry: the amassing of collections and the exchange of specimens. It formalized earlier contacts among friends and helped consolidate a social hegemony around photography. In 1856 the society founded a Photographic Exchange Club, a social organization "to promote friendly feeling amongst the members of the Photographic Society."[29] After the Photographic Society was founded, more amateurs participated in photographic exchanges. Amateurs believed that everyone from the holiday fern hunter to scientists like Charles Darwin could be considered a naturalist. In 1864 *Quarterly Review* noted: "There is an inner photographic world in which photography is pursued with an earnestness which far transcends mere professional zeal, and has something in it of the enthusiasm of the devotee."[30]

Naturalist photographers, mostly in the south of England, enlarged their photographic collections much as they accumulated their treasures of botanical specimens. The Exchange Club included mostly men and a few women, all drawn chiefly from the landed classes and those who aspired to their ranks. Significantly, the new system for the exchange of photographic positives—which had roots in traditions of material exchange in botany—provided a structure for what had long been a part of amateur activity in different fields of inquiry: "the amassing of collections and the exchange of specimens."[31] A 1853 "Notice to Members" advised that "most valuable results would also be reaped from a system of exchange of positives, by applying the art to Architectural and Archaeological subjects; they would derive from it advantages similar to those which naturalists now experience from the interchange of local natural productions, and it is scarcely too much to say, that when once adopted exchange of photographs will become as indispensable to antiquaries as the exchange of plants is to botanists."[32] Count de Montizon displayed a large collection of photographs of live animals, while botanist and astronomer John Dillwyn Llewelyn showed his photographs of animals and plants, along with a collection of stuffed birds and mammals, seaweeds, rare plants, and painted watercolors—illustrating the wider material context in which early photography functioned. Society members' photographic work continued to emphasize subjects from nature and natural history through the 1860s.

Amateur photographs not only incorporated game; they were like hunting trophies. Representing game was a traditional means of showing wealth and displaying social status, for shooting was—in theory—restricted by law and traditionally the province of the elites. Hugh Diamond, who frequently used dead game in his compositions, compared photography to fly-fishing: "as the fly-fisher in the dull winter months prepares his flies ready for the approaching spring, so may the photographer in the dull weather which now prevails, with much advantage prepare his stock of iodized paper ready for the approach of fine weather."[33] The metaphor of domination and conquest of nature was crucial to scientific photography as it developed.

On the one hand, they were experimenting on the photographic process itself. John Spiller, a chemist, was notable for his experiments with new processes and for his early application of photography to lunar investigation. This photograph is a rare example of one of his experiments, involving an emulsion of nitrate of magnesia, which he made with William Crookes during the 1850s (Fig. 1.7). Experiments like these suggested how scientific investigations helped improve the technology.

At the same time, photographers experimented with new subject matter in natural history, astronomy, and other natural sciences. The visual record that

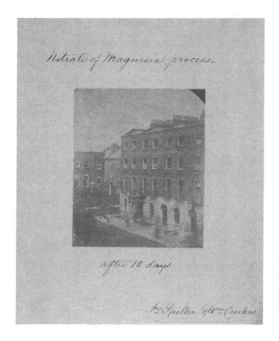

Nitrate of Magnesia process

after 10 days.

J. Spiller & W. Crookes

FIG. 1.7. John Spiller and William Crookes, "Nitrate of Magnesia process after 10 days," ca. 1854. Royal Photographic Society Collection at the National Museum of Photography, Film, and Television.

members left in their amateur photographic exchange albums from the 1850s and 1860s shows their range of scientific interests, from astronomy to botany to zoology and meteorology. These photographs, made by members in the 1860s, show a stereo pair of a cabbage and a close-up of a fly (Figs. 1.8–1.9). Alfred Rosling made what he called small cloud "portraits," which were then exhibited during the 1850s to great critical acclaim.[34] The son of a surgeon with the East India Company, Hugh Diamond was another member of the Royal Photographic Society. Soon after Talbot's announcement in April 1839, Diamond wrote in his diary that he "bought some Photogenic Paper" and "made a first attempt at Photogenic Drawing," a print of lace.[35] Over the next few years, Diamond applied photography to his studies of mental insanity, though, like other early practitioners, he did not seriously take up photography until it became less expensive in the late 1840s.[36] In 1848, he was appointed superintendent of the women mental patients in the Surrey county asylum. Diamond circulated his portraits of the insane to exhibitions, other physicians, friends, and, in some cases, to the patients themselves; as he later explained, Diamond used the photographs in his interactions with clients, searching their faces for reactions to the images. For these pictures, Diamond employed the conventions of medical portraiture, such as the use of frontal and side views. He kept in his album mostly photographs of women and girls, the population he supervised. Anticipating later displays in scientific settings, his albums were used for medical purposes as well as for the promotion of photography. After Diamond was

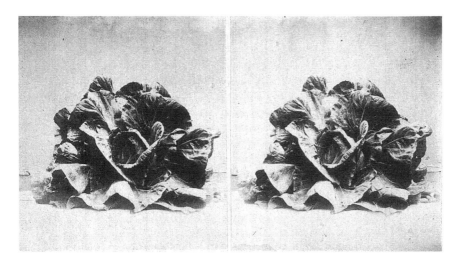

FIG. 1.8. Anonymous, "A cabbage," ca. 1860s. Stereo pair. Amateur Photographic Association Album, No. 22407. Royal Photographic Society Collection at the National Museum of Photography, Film, and Television.

appointed the secretary of the Royal Photographic Society in 1853, his medical photographs circulated among photographers beyond the medical community.

Photography allowed some middle- and upper-class women options for artistic and scientific expression that they might not otherwise have had in the late nineteenth century, when most scientific organizations closed their doors to women. Nevertheless, through husbands and other family members and friends, women had contact with men of science and their photography. Many women were drawn to photography through natural history, another practice in which they collected natural objects to make pictures.

The promotion of botany as a legitimate female pursuit also created paths

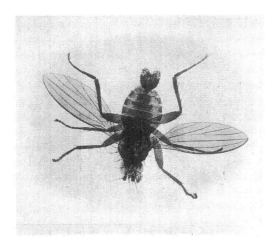

FIG. 1.9. Anonymous, "Fly," ca. 1860s. Amateur Photographic Association Album, No. 22439. Royal Photographic Society Collection at the National Museum of Photography, Film, and Television.

in photography for a few middle-class and elite women.[37] Flowers were thought to be an especially suitable subject for women, and amateur instruction manuals helped develop the botanical approach.[38] Anna Atkins, like many early women photographers, grew up in a scientific household, the daughter of John Children, the keeper of the Department of Natural History and Modern Curiosities. Skilled from an early age, she began illustrating botanical projects as early as 1823, when she did a series of drawings for her father's translation of Lamarck's *Genera of Shells.* Between 1843 and 1854, Atkins executed photographs of algae specimens and compiled them for her *Photographs of British Algae,* which she issued in twelve serial parts. Her presentation albums consist of two and three volumes, with up to 400 plates among them, and contain brilliant, cobalt blue photograms. These were made by laying plant specimens directly on paper treated with a light-sensitive cyanide solution. The individuality of each specimen is seen in the distinctive wrinkles and irregularities of the plant members that she photographed. Atkins related the members to an ordering system, giving their Latin names beneath each specimen. She arranged some of them individually on plates; for others, she arranged multiple specimens, from top to bottom of the plate, much like the conventional arrangement of natural history specimens.

During the early 1850s, Cecilia Glaisher, who, like Atkins, was a botanical artist, inaugurated her photographic study of British ferns. She was married to the nationally renowned scientist James Glaisher, who was for a time the president of the Royal Photographic Society and the editor of its official publication, the *British Journal of Photography.* From 1853 to 1856, Cecilia Glaisher compiled her album *The British Ferns represented in a Series of Photographs from Nature by Mrs. Glaisher from specimens selected by Mr. Newman.* The privately published album includes ten plates of photographs, each containing the specific botanical name given in Sir James E. Smith's *English Flora,* Charles C. Babington's *Manual of British Botany,* and Edward Newman's *History of British Ferns.* As Glaisher wrote in the preface, "the Process of Photography is admirably adapted to making faithful copies of Botanical Specimens, more especially to illustrating the graceful and beautiful class of Ferns: it possesses the advantage over all others hitherto employed of displaying, with incomparable exactness, the most minute chracteristics: producing absolute *fac-similes* of the objects, perfect both in artistic effect and structural details."[39] Glaisher's artistry is evident in the way she arranged the plants physically on the page; note that all the fern specimens are artfully arranged on plates, conserving space, with their leaves displayed (Fig. 1.10).

Women involved in the Exchange Club included Lady Caroline Nevill and her sister, Lady Augusta Mostyn, who depicted picturesque and antiquarian

FIG. 1.10. Cecelia Glaisher, "Bree's Fern." In *The British Ferns represented in a series of Photographs from Nature by Mrs. Glaisher from specimens selected by Mr. Newman,* c. 1853–1856. Linnean Society.

subjects in the 1850s and 1860s. Mary Emma Lynn Ipswich was also a member of the Royal Photographic Society.[40] Yet women who expressed their artistic and scientific visions through photography often had difficulty having their work accepted by the scientific establishment. This would become increasingly true as those working within scientific institutions played a greater role in elaborating the evidentiary significance of photography. Increasingly after the 1850s, scientific institutions closed their doors to women and restricted their roles as makers and spectators of scientific knowledge.

Initially, the choice of photographic process seems to have played a larger part in defining what constituted a scientific photographic work than the sub-

ject matter, as was the case later. As Lady Elizabeth Eastlake judged in 1857, collodion was a great technical achievement but was limited from an aesthetic point of view because it did not easily allow for more general effects.[41] Those who considered photography as an art medium tended to use calotypes, which offered more texture and breadth of effect, while those who thought of photography as a scientific means of recording tended to support collodion, which presented more detail, sharpness, and stronger contrasts of surface. Shadbolt, who was interested in the scientific uses of photography, welcomed changes that permitted sharper definition. The gradual acceptance of collodion within the Royal Photographic Society during the 1850s required an adjustment of attitudes, whereby members who used calotypes were seen as engaging with artistic enterprises, and those working with collodion were not.[42]

At the same time, photographers during the 1850s and after experimented with their arrangements, using models and schemes learned partly from each other and partly through looking at reproductions of others' works. Photographers such as Julia Margaret Cameron and Oscar Rejlander began using the medium for art, creating forms that experts often criticized for transgressing against prevalent understandings of photographic naturalism.[43]

The Pre-Raphaelite penchant for detailed realism and moral subjects evidently was taken up in photographic circles relatively early. Members of the Royal Photographic Society were discussing Pre-Raphaelitism in the late 1840s, before the brotherhood of artists gained widespread public notice.[44] Early Photographic Society members took an active interest in contemporary theories of art, and, reflecting their broad amateur interests and social and economic status, many were art patrons and collectors. The prosperity of early Victorian Britain produced an expansion in the art market and the rise of a competitive marketplace for artists and aesthetic styles. The Pre-Raphaelites, including John Everett Millais, his fellow student William Holman Hunt, and Dante Gabriel Rossetti, began showing their works in 1848. By 1852, the year of their famous Summer Exhibition, they had attracted the serious critical interest of John Ruskin, whom they deeply admired, and brought out a journal, *The Germ,* which called for artists to depict "things of today" and which publicized their existence as a "Brotherhood" of artists. Pre-Raphaelite artists developed a style whose hallmarks were bright color, naturalistic detail, and intensity of feeling. Ruskin influenced and, ultimately, defended Pre-Raphaelite art. His own watercolor studies were not finished works of art. He saw them rather as explorations arising from his study of botany and geology and his interest in natural processes such as the growth of plants and the formation of rocks.[45] His studies record minerals, mosses, leaves, clouds, or details of architectural ornament—objects seen closely, as if through a micoscope.[46]

George Shadbolt, a president of the Royal Microscopical Society and a founding member of the Royal Photographic Society who is said to have produced one of the first microphotographs, advocated the "sharp" school of photography.[47] As a microscopist, Shadbolt appreciated the Pre-Raphaelite brotherhood's stress on observation, precision, and detail. Of the division within the Society between "artistic" photographers led by Sir William Newton and the "sharp school" led by a vocal majority of other practitioners, Shadbolt remarked: "An artist [of the Modern School] comes to gain information in the practice of photography subsidiary to his art; whereas the scientific man cares very little for art; he wishes to supersede, as far as his purposes are concerned, art altogether. The scientific man does not accept art for art, but art for science; he does not like to have the representation of a natural object made so perfectly beautiful that no one will recognize it." He further explained that the hostility between two groups within the society—the "Modern" school and the Pre-Raphaelites—was "a little angry": there was a "very strong party feeling."[48]

However, even as amateurs and scientists exchanged and collected their pictures and awarded each other prizes, a major force of change was about to disrupt the "image world" that Photographic Society members were beginning to realize.[49] To observers in the early 1850s, it became clear that photography would not long remain the exclusive domain of a handful of cultured amateurs.[50] A rising class of commercial practitioners spelled, to many amateurs at least, the end of photography's associations with elegance of person, manners, and good birth, and the beginning of an uncertain social order.[51] One historian writes that during the 1850s, when photography was being shaped and given a new direction, the "shared interests and common assumptions" of amateurs gave them "a kind of unity" but that their differences and "changes in the medium and its uses" ensured that they "could not continue photographing as amateurs in the broadest sense of the word." By the mid-1860s, the number of amateurs had grown dramatically, and nearly all of the pioneers, "except those who had turned professional, had stopped photographing."[52]

Rising Metropolitan Class and Gender Tensions in Photography

The meaning of photographic evidence changed with the rise of commercial photography, which introduced new social factors and led to a heated debate over how to define the meaning of skill when photographers working in official scientific contexts and those working in commercial studios both claimed to use scientific practices. By the late 1850s, people from many social backgrounds identified themselves as photographers in an increasingly commercial and class-diverse photographic landscape. Photography was never a profession in the true sense of the term, since entry to it was virtually uncontrolled and

there were no agreed-upon standards. Relatively homogeneous in the 1840s, photography by the late 1850s was becoming a heterogeneous practice and, in the process, a source of both pride and considerable controversy.

The relaxation of William Henry Fox Talbot's patent on photography in 1851, around the time of the Great Exhibition held in London, opened up possibilities for hundreds of new practitioners to enter the field of photography, most of them from outside the genteel circles in which it had originated. Photography did not even appear as a profession in the 1841 census, and by 1851, there were only twelve photographers listed. Yet by 1861, the number of persons who called themselves photographers reached at least 2,534. Of these, around thirty-five were crowded into Regent Street alone. The following year, at the international exhibition of photography held in London, newspapers reported that "scarcely a favourable spot for the practice of the art is left untenanted" in the city.[53] One photographic firm in London consumed, on average, the whites of 2,000 eggs daily in the manufacture of albumenized paper for photographic printing, amounting to 600,000 eggs annually—estimated as a tenth of the total number of eggs consumed in the country.[54] A London photographer boasted in 1863 that "within little more than the last decade of years [photography] has grown from an amusement of the educated, or the occupation of a small number of professional Daguerreotypists, in a few metropolitan cities, into an important branch of the industry of the world."[55]

In part because of these new practitioners, photography was becoming cheaper and more widely available. After 1860, when J. E. Mayall of London published his picture of the royal family, millions of *cartes de visite* were sold in England alone. A *carte de visite* was a popular size of mounted photograph introduced in the 1850s. Measuring about four inches by two and a half inches, cartes remained popular until the early twentieth century. The advent of the *carte de visite* changed commercial photography and affected the belief in the camera's capacity to record truth. Many people attested to the superior accuracy of *cartes de visite* to depict likenesses, reinforcing claims that photography was a superior method of representation. For the first time the public began to see that a plain photographic paper portrait could be delicate and pleasing, while unpleasant coarseness could be eliminated by the minuteness of the proportions with which everything in the picture was rendered.[56] Though many thought that large lenses were essential for superior likenesses, *cartes de visite* did not necessarily require such expensive lenses, and large studios and many practitioners catered to the new craze for portraits.[57]

The industrialization and spread of photography fostered the association between it and democratization. Cartes made photographs cheap and available to a wider mass public in two main forms, portraits and stereos. *Cartes de visite*

were comparatively cheap at 1 to 1.6 shillings. In the new studios, photographers could take several small negatives on a single glass plate and develop them all in one operation. Prints were fixed on stiff cards with protective varnish. M. A. Belloc in "The Future of Photography" (1858) expressed the wider democratizing view of portrait photography when he declared: "Do not believe that this art, which embraces so many things, which supposes so much general knowledge, tact, and experience, requires on that account exceptional men." Photography was not confined to "the exalted spheres of science, always inaccessible to the great majority of minds." On the contrary, he predicted, in a few years, "most families will reckon among its members at least one operator."[58]

Crucially, the democratization of the photographic image through portraiture offered a powerful basis for claims by scientists that photography would democratize science and technology. One of the best results of photography, another practitioner said, in a statement linking photography and civilization, was that "the doors of knowledge and pleasure are widely thrown open to the masses"[59]—from the "educated lady" to the "humble cottage dweller."[60] In "Photographic Art a Blessing to the World—*Cartes de Visite,*" an anonymous contemporary exclaimed that by the "miracle" of photography, portraits could be made with a "rapidity and ease that places them within reach of all classes of the community."[61] One photographer called it "God's free sunshine." As he remarked, "No longer can the favoured few monopolize the elevating and ennobling influences ever exerted by true art; as well might they attempt to buy and sell God's free sunshine, for through the instrumentality of photography is to spring up a love and knowledge of art that will find its way to the homes of all, even the humblest in the land."[62]

While many praised the salutary effects of inexpensive photography that made *cartes de visite* available to the masses, many of the same people, especially established studio and amateur photographers, complained that the influx of newcomers deskilled photographic practice and debased the new art.[63] Despite the civilizing and educational potential of photography, some feared what they perceived as its degeneracy as it became a commercial medium outside of scientific circles. Photographers grew more numerous during the mid-Victorian years, and, significantly, they had less and less in common with one another. As with other occupations, the rise of casual labor in photography in London during the 1850s created anxieties among a handful of rising elite metropolitan practitioners, who feared such labor's incursions on their nascent hegemony over the practices and definitions of photography. Despite widespread praise for its use as a new scientific tool, many scientists, photographers, and even consumers at midcentury began to view photography as a morally problematic practice.

From an elite perspective, the problem with new technologies like photography was twofold: one, photography was becoming the purview of "unskilled" itinerants, and two, photographs were harnessed to low, popular taste and "cheap" consumption.[64] Although historians have paid more attention to the struggle *within* elite circles over the questionable status of photography as a fine art, these issues, which crossed elite and popular lines, dominated contemporary practitioners' discussions of photography. As art historian Lynda Nead acutely observes, the mid-Victorian metropolis was an "indulgent host" to new forms of visual and literary culture. For critics "nostalgic for a slower and more containable world of high art," Nead writes, the commercial street culture of the 1850s and 1860s was an "assault on the senses."[65]

"Cheap" photography brought the "whole art" under "reproach," complained one photographer.[66] "Cheapness is the bane of the photographer," moaned F. R. Window, the operator of a leading metropolitan studio. "It has done more to produce failure and disgust in this beautiful art, I believe, than all other causes combined." Window held that photographers were "most frequently not in a position to decide for themselves upon the positive goodness, or otherwise, of their apparatus and chemicals . . . Many photographers are not sufficiently mechanicians to decide upon the workmanship of their apparatus, and to such, a brilliant coat of French polish will hide bad work." With the rising availability of affordable and ready-made photographic materials in opticians' shops, the artisanship associated with early photography was declining. "Still fewer photographers are familiar enough with chemical manipulations to be able to decide upon the purity of the chemicals which they buy." Even "respectable" dealers sold "worthless" articles, sometimes because they were practically unacquainted with their use; manufacturers delivered adulterated specimens under the name of pure salts, and vendors tried to undersell their competitors with cheap wares.[67] A flood of "inferior" photos engendered widespread discussion among aspiring elite photographers about how to stem the apparent tide of deception and "bad taste" in photographs. Possibly there were also concerns about scientific photography in relation to obscenity laws. The sensational case of Henry Evans, trapped by plainclothes policemen for making "obscene" photographs, which Evans claimed were actually made for an ethnological society, struck many as illustrating the need for clearer differentiation of moral categories of photography.[68]

To differentiate between moral categories of photography, public commentary on photographers and photography in England began to evoke the language of binary moral extremes, such as "witness" and "impostor." Integral to discussions about the morality of photography was the related concern with proper practices of production, a concern that extended even to apparently in-

nocuous subjects, such as studio portraiture. An entry in Henry Mayhew's *London Labour and the London Poor* (1849–52), a collection of testimonies from street traders, reveals how a self-described "photographic man" from Lambeth, a poor neighborhood in south London, made a living. This man, formerly a banjo player, took the photographs in a "kind of garden" behind his lodgings. He and his wife, a boot-binder, bought the apparatus in Oxford Street for five pounds, five shillings. London was a center for industries using chemical processes, many of them located in south London, which explained how he "got an idea of chemicals." "I used to take a blanket off the bed, and used to tack it on a clotheshorse, and my mate used to hold it, if the wind was high, whilst I took the portrait." He reported initial difficulties, such as learning how to vary the exposure times with changing daylight. "I didn't know any thing about photography then, not a mite . . . I never knew anything about taking portraits then, though they showed me when I bought the apparatus . . . We are obliged to resort to all sort of dodges to make sixpenny portraits pay . . . I had a customer before I had even tried it, so I tried it on him, and I gave him a black picture (for I didn't know how to make the portrait, and it was all black when I took the glass out), and told him it would come out bright as it dried, and he went away quite delighted." If photographs came out black, he sold customers a "brightening" solution.[69]

As one contemporary remarked, a "whole army of professional photographers" had "sprung into existence, working with very various skill, and in very different social positions."[70] It was "disgraceful," one photographer declared, that "an art so beautiful, so popular, and so facile as photography" should have been so "quickly inundated, and surrounded, and well nigh strangled by a mob of 'needy villains,' whose only qualifications for obtaining a livelihood in any form consist in the completest incapacity, added to the most unscrupulous indolence."[71] Photography, which had been so quickly harnessed to a discourse of beauty, truth, and clarity, now seemingly was threatened by moral debasement.[72] The new trade journals were replete with complaints from photographers who struggled to keep prices high and to elevate the status of their medium and themselves. It was significant that it was photographers as well as consumers who experienced the crisis, for much of the commentary reflects their point of view.

In a particularly vitriolic attack on cheap work, a Victorian professional photographer in 1861 condemned the new photographer as a "so-called" "focuser, or whatever he may call himself," in the "dog-hole he terms a 'studio,'" who "executes vile libels on humanity which he misnames portraits; who enhances the original price; who bullies women and terrifies boys and girls into buying expensive frames, or having the blear-eyed patches he has drawn from

the camera coloured; and who, in default of finding dupes, or on being remonstrated with, resorts to such 'manipulatory' processes as striking, kicking, and half throttling his sitters." This attack on lower-class studio photographers targeted those accompanied by "door men," whose job, he said, was to "prowl up and down before the portal of the unwholesome temple of black art, to thrust villainous portraits into the faces of the passers by; to make use of filthy and ribald talk to the giddy girls who stop to stare at the framed display of portraits; to exchange blackguard repartee with the 'door men' of some neighbouring and rival studio; and, if need be, to assist their employers in ejecting, pummeling, and otherwise maltreating troublesome customers." He denounced these photographers as "human skunks," "ruffians," blackguards," "knaves," "cads," "photographic nuisances," and the "scum . . . of humanity."[73] This picture, which appeared in *Punch* in May 1857, illustrates a brawl outside a studio as two photographers compete for a lady's patronage. It highlights the degree to which fighting photographers had become part of the public imagination (Fig. 1.11).

Although professional photographers especially criticized "knaves" and the unskilled, they also blamed the rise of photographic deceptions on the feminization of photographic consumption. As recent scholarship documents, the number of women as photographic makers and, particularly, consumers started

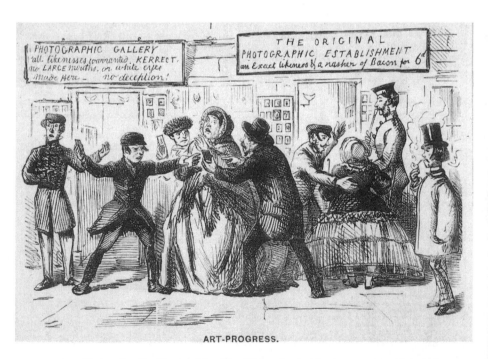

FIG. 1.11. Rival studios: "Art-Progress. 'Now, Mum! Take orf yer'ead for sixpence, or yer 'ole body for a shillin' "!" John Leech for *Punch* (May 2, 1857), 174.

to rise in the 1850s and 1860s, as photography entered the middle-class mainstream.[74] An engraving by an unnamed artist (ca. 1883) shows a lady and her male visitor looking through a photographic album (Fig. 1.12). Middle-class English women were widely blamed by male operators for what they saw as the rise of "bad taste" in photography. "They are thought," said one photographer, "especially by women, 'pretty,' and 'interesting;' and the gross improbability of their composition goes for nothing." This photographer blamed Belgian artists, in particular, for preying on the ignorance and lack of artistic knowledge of English women (for example, with faked memorial photographs of the royal family after the prince consort's death), though another expert pointed out that the alleged "faked" photographs were, in fact, studies from life.[75] Although none of these photographers evidently taught women how the process actually worked, nevertheless they blamed women, particularly the "young-lady portion of the public," for stimulating the desire for pictures such as "silly 'Christenings,' sentimental 'Weddings,' and namby-pamby 'Broken Vows.'"[76] An anonymous reviewer of the Fifth Annual Photographic Exhibition in London in May 1858 regretted the recent decline: "To see that noble instrument prostituted as it is by those sentimental 'Weddings,' 'Christenings,' 'Crinoline' and 'Ghosts', is enough to disgust anyone of refined taste."[77]

The linking of itinerant photographers and female consumers with cheapness, bad taste, and lack of technical knowledge provided the context for the identity of scientific photography in later years. Photographers anxious about the social and economic status of their medium during the 1850s and 1860s associated sound practice with scientifically educated "brothers." Thus gender and class were established as significant in demarcating between sound and unsound photographic practices for the rest of the century, profoundly shaping the new field of scientific photography as a predominantly middle-class, masculine domain. One response was to "rescue" photography by unifying male photographers in the spirit of fraternity. This return to what I am calling "photographic masculinity," which hardened sexual boundaries that may have started to blur in the 1850s as women began to participate more, also (as is seen later) entailed a turn to scientific photography as exemplary labor.

The ruckus over photography in London during the 1850s and 1860s was a far cry from what the judges of the Great Exhibition of 1851 had hoped for when they praised photography's future, and it resulted in calls for professional photography schools. Many practitioners experienced photography's growing heterogeneity as a weakening force, which made it more difficult to maintain the spirit of association in a metropolitan city such as London. "It is a pity there is not sufficient esprit de corps to induce the members of a society generally to meet and by their presence maintain the feeling of association which should at-

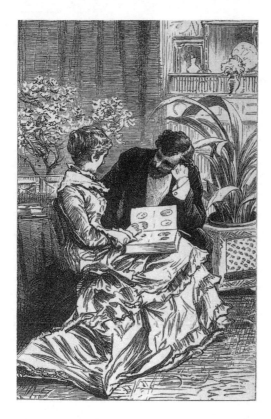

FIG. 1.12. A lady and her visitor look through the family's 'photographic album.' Engraving by an unnamed artist, ca. 1883. Mary Evans Picture Library.

tend such arrangements," one admitted.[78] As London-based photographer Jabez Hughes suggested, although photography had become "thoroughly established as a business," the practitioners were so numerous that it had "not become so consolidated as to have an *esprit de corps*."[79]

At the root of the challenge were differences in class, social background, and training. Professionals often lamented that photography was the "only science or art without a school."[80] As one remarked, "It is one of the singular facts in the history of photography that whilst thousands of persons are at this moment practicing it, with a greater or less amount of skill and success, as their sole reliance for an income, there is scarcely one to be found who has received any special education or training for its practice, or served any apprenticeship to it as a profession." It was not just that the prices were reduced too low but that, according to one disgruntled photographer, "as one of a class which should be composed of men of education and refinement, there is no broad sign to the public eye to distinguish them from men who are an abomination to the profession"—such men as "showmen" and "bullies" who had "perforce turned photographers."[81] Lack of professional status meant that fees varied extremely. As

one photographer explained, photography, unlike other trades, lacked formal organization and therefore what constituted a fair price for quality work was decided in the market.[82]

A variety of issues divided the nascent photographic community at mid-century, from the commercialization of photography and the impact of new metropolitan class divisions within the photographic community, to the growth of female photographic consumption, which some critics linked to the loss of photography's claims to rationality and taste. Against this background, London photographers developed a legitimating language of science to produce a coherent middle-class discourse around the photographic medium. Thereafter, the direction of scientific photography was shaped by politics within the separate fields of science and photography.

Defining Skills and Standards

As a newly professionalized class of scientists began to assert hegemony and domination over areas of study previously controlled by gentlemanly amateurs, the class dynamics of science were also changing.[83] Attention to skills and qualifications intensified and began to displace the more explicit imperatives of an elite social background. Unlike in other sciences, photography's strong and growing connection to commercial culture meant that a core of scientists could not as easily regulate and control entry to the practice, but they tried. In the absence of professional schools, those who sought to raise photography's status in the public's estimation ultimately did as scientists had done before them: they established new bonds of community and scientific standards. Photographic journals, particularly the popular *Photographic News,* became crucial for criticism, education, and community bonding around fraternal ideals. The new leaders saw themselves as replacing a mode of practice that rewarded wealth and social connections with one that acknowledged skill and hard work.

From the late 1850s on, a new hegemony in photography arose, controlled by middle-class practitioners. Many of these new leaders were professional scientists seeking to reform photography by usurping the power of elites and cultivating a moral ethic of work and self-improvement. Illustrations show them as laboratory workers, as in this 1862 advertisement for a darkroom tent (Fig. 1.13). These scientists and other photographers, amateur and commercial, banded together to create a new kind of community via the special-interest press.

Journals containing information of interest to photographers are a crucial and hitherto overlooked source chronicling the formation of photographic community beginning in the late 1850s. Of these, the most important photographic weekly in Britain from the perspective of community formation was

FIG. 1.13. Newspaper advertisement for Edward's darkroom tent, 1862. An illustration of camera work as laboratory science.

arguably the London-based *Photographic News,* founded in 1858. Under William Crookes's direction, the trade journal centralized efforts to raise the social status of photography in Britain through education and the creation and enforcement of community standards, many of them upheld by the market.[84] Crookes was a widely respected chemist who had a remarkable research career and became one of Victorian England's most venerated statesmen of science. At this time, scientists were only just starting to form disciplinary institutions in many fields, such as meteorology and astrophysics. Like others, Crookes had high hopes that photography could become a science like any other.

Crookes's career was typical of nineteenth-century British chemists who worked outside academic institutions.[85] The son of a tailor and one of twenty-two siblings, he was not born into an elite social world like Talbot and the rest. Rather, he gained access to science through entry in 1848 to the Royal College of Chemistry on Oxford Street. Within a year he earned a scholarship that released him from the obligation to pay fees. After coming to the attention of Michael Faraday at the Royal Institution, he was introduced to other physicists and eventually his interests turned away from organic chemistry toward chemical physics, then exemplified by the optical problems of photography and, later, spectroscopy. During his career, his interest in physics was linked with his involvement in spiritualism and spirit photography, which many saw as a stain upon his reputation. With Faraday, Crookes shared a brilliant experimental and

lecturing ability and a commitment to the popularization of scientific knowl-edge, and he was an honored leader of British science until his death in 1919.[86]

Faraday's friend Charles Wheatstone found Crookes his first job as a short-term research assistant in the meteorology department at the Radcliffe Astro-nomical Observatory in Oxford, where he used his photographic skills. Within a year, he left Oxford to teach chemistry in the north of England, where he fur-thered his connections with photography by editing the *Liverpool Photographic Journal* from November 1856 until March 1857, when he became editor of the *Journal of the London Photographic Society.* His skills and rising reputation as a photographer won him grants from the Royal Society and from the Depart-ment of Science and Art in 1856, and drew him back to London, where he worked as a freelance consultant, using a home laboratory, and as an editor of photographic and scientific journals.[87] In 1858, when the *Photographic News* was founded, he was just twenty-six and had completed four years of scientific ap-prenticeship. Crookes remained editor for roughly three years until he was suc-ceeded by George Wharton Simpson, an equally well-regarded scientist who, like Crookes, had a background in chemistry. Unlike many scientists in elite organizations such as the Royal Society, neither of them had a horror of trade.[88]

In the first issue of the *Photographic News,* Crookes's intention to use the newspaper to generate what one photographer termed "photographic intelli-gence" was realized in articles ranging from the uses and abuses of photography to descriptions of chemical processes to photography in law courts to reviews of exhibitions and reports of assaults in studios.[89] It was natural for photogra-phers to turn to the press as a means of creating a new community. This was an age of rising journal publication, and many special-interest groups organized through the printed medium. By 1860 in England alone there were already two weekly magazines devoted to photography, as well as monthly and fortnightly serials and a few photographic annuals. Within its first three months, the *Pho-tographic News* became the largest journal of its kind in Great Britain. Unlike its competitors, such as the *British Journal of Photography*—the official organ of the Royal Photographic Society—the *Photographic News* addressed a wide demographic base about issues of community and adherence to a common stan-dard. Its weekly publication was widely seen as appropriate for the modern age, a time—as one Edinburgh reader put it—"far too advanced for the slow place of monthly journals."[90] The journal offered a site for the exchange of recipes, techniques, and suggestions for raising the status of photography in England. Within just a couple of years, readers numbered in the tens of thousands, with a circulation not only in England but in India and every other English colony, as well as over the greater part of the continent, where it was widely quoted as an authority on photographic matters.[91]

Editors and many subscribers to the *Photographic News* criticized the Royal Photographic Society for its perceived lack of commitment to scientific openness and liberality of ideas. The editors began the new journal as a reaction to the society's refusal to consider for prizes any photographs that had been previously displayed in exhibitions or shop windows. The society's leaders also annoyed some of its members by vehemently criticizing the publication of the minutes of their meetings in journals other than their own. While some members supported this action as a way to ensure the continued hegemony of amateur photographers, others held that it was harmful to the development of photography as an open and democratic science because it excluded the voices of commercial photographers.

In the first issue of the journal, one reader who identified himself as "A Photographer Who Seeks the Extension of His Art" questioned the Royal Photographic Society's claim to be a scientific institution in light of its decision to exclude from exhibition and review works by commercial photographers, and to castigate the *Photographic News* for publishing its minutes. The resolution to reject previously exhibited photographs, he wrote, was so "utterly un-English, so completely repugnant to all our habits and sympathies, and approaches so much more closely to the measures adopted on the other side of the channel, that I am more than half inclined to believe that the Council in question is but the London representation of some great parent *Société Photographique* in Paris, with Louis Napoleon for its president." Here was "a company of scientific men, claiming an indefeasible right to scientific discoveries," yet "unwilling that any improvement should be published . . . Here are photographers— . . . a name which signifies delineators by *light*—anxious that everybody should remain in the *dark,* unless they receive their modicum of light through the literary lantern of the London Photographic Society." This reader strongly urged the publishers and editors of the *Photographic News* to reform photography by publishing news wherever it could be found, even in specialist societies. Photographers should "*strive* to make a market of their proceedings," he declared, but "not with the narrow-minded sordidness of a trading clique."[92]

Its promoters claimed that the *Photographic News* was more scientific than its specialist amateur competitors, despite its connection with profit-making professionals. How would photography become a science? The answer, according to the *Photographic News* during the heyday of its influence between 1858 and 1890, was to build on a foundation of "experimenters." They promoted photographers, from whatever field, with a "scientific turn of mind." This attribution was based less on a formal acquaintance with science, however, than on the practitioner's personal qualities. A "real photographer" made his own plates. The best were also "hard-working." "Every photographer endeavours to pro-

duce the best picture he can, hence the thousands upon thousands of attempts which are daily and hourly being made in order to improve on past successes."[93]

Throughout the mid-nineteenth century, the processes of capitalist development combined to undermine the craft organization of production. Many in the culture of photography, however, were nostalgic for an older, artisanal identity that was grounded in centralized photographic societies rather than in the social relations of the craft workshop. In promoting a culture of collectivity across photographic societies and commercial photography, the editors of the *Photographic News* promulgated a new image of what could be termed a *social artisan,* indicating a figure defined not by his relation to property but by his relation to skill and to the social institutions through which skill was acquired and put to use. In the case of photography, this social institution was the photographic press. One of the main aims of the *Photographic News* as it entered the 1860s was to repair the imperfections that stained photography's moral and scientific reputation before its status as evidence could be secured. A shared desire for reform united photographers from different backgrounds who otherwise had little in common.

The editors did not discriminate against commercial photographers in making their appeal to amateurs. Rather, they encouraged social collectivity based on skills, a commitment to hard work, and the values of honor and open-handedness among gentlemen photographers, whether amateurs or professionals. The editors recognized that the field of photography was expanding, its base diversifying. However, they saw its new heterogeneity, its very breadth of appeal, as a potential source of strength rather than a weakness. The associational life of an interest group was crucial to its ability to mobilize. In a spectacular feat of incorporation, the *Photographic News* made its appeal to professionals and amateurs alike, using masculinity as a key unifying ingredient. The editors announced that "the 'PHOTOGRAPHIC NEWS,' as the recognized organ of photography, will be the guide and instructor of the beginner, and the medium of communication and interchange of ideas between more advanced students, and the record of all improvements and discoveries which may take place in the art, or in the allied sciences of optics and chemistry."[94] The editor continued: "The wealthy amateur and the professional photographer, the man of science, and the working operator, there freely impart their treasures of theory and fact, to aid the progress of the art in the cultivation of which they are enthusiasts . . . There is a spirit of communism among photographers, which is altogether opposed to the restrictive and protective operation of patent laws. Photographers as a body are pre-eminently free-traders . . . Improvements and discoveries made by individuals are thus constantly becoming the common property of photographers at large."[95]

The key to the remarkable success of the *Photographic News* was its leaders' recognition that the new "imagined" community of these photographers had an economic base, and their shrewd manipulation of the appeal of fraternalism. Photographers across a variety of increasingly segmented practices were nonetheless united in their effort to raise the public status of photography, whether that meant lobbying the Postmaster-General to clarify the regulations for mailing photographs through the post or defending the need for provisional patents.[96] The editors recognized that the ranks of photographers were recruited from individuals with different interests and backgrounds. As one editor explained, those who approached photography from an art background viewed it as a "vehicle for artistic expression," others with "scientific training" leaned to the "optical and chemical aspect," others viewed the affair as "merely mechanical," and still others—"a considerable number," in fact—"look on it only as a means of getting bread and cheese."[97] Noting that they all had a stake in raising photography's reputation, the editors urged unity and reform, and thenceforth they pooled their efforts. In 1873, photographers showed up en masse in a London courtroom to hear a judge decide a case of nonpayment for an alleged poor likeness.[98] They also policed one another informally, publishing reports of assaults in studios and evidence of dishonest trade. They did so in a new spirit of collectivity: "Because black sheep have occasionally been detected, there are some people who think themselves justified in referring to the whole flock as tainted."[99]

The model of parlor science was the social basis of the magazine's opening issues, in which the editors expressed their aim to promote the "pleasant interchange of thought between our friends." The editor of the *Photographic News* considered himself a sort of host at a rather large dinner party. This implied convivial, cooperative, social, gracious, openhanded, friendly, and bountiful behavior, not mean-spirited rivalry. Crookes explained pointedly, "As becomes a host, we have rather busied ourselves in providing the fare, than in monopolizing the conversation." "We do not present ourselves as the especial organ of any society, but we hope by serving their interests, and recording their progress, to sustain the position, not simply of the organ of all societies, but of photographers at large."[100]

As they did with amateurs, Crookes and other writers gave professionals practical and artistic instruction. One photographer confessed: "I know of no profession where the demands on varied knowledge are so great."[101] Photographers were especially encouraged to study the composition of strong lines and the effects of light and shade in master paintings. "There is hardly any process so well calculated to improve the minds and to educate the eye of photographers as that of spending a few hours' careful study on the gems of the Royal

Academy." There, a photographer could "see many things to do and not to do."[102] In keeping with its middle-class commitment to self-improvement, the *Photographic News* stressed that photographers could acquire artistic taste. One had to understand not only the technical process itself but also the artistic traditions of history painting and landscape art. The magazine often printed crude reproductions of engravings of well-known paintings and advised readers to carry a portfolio of these engravings with them for study. "The subject below, by Velasquez, is a good illustration of the manner of treating a very simple and natural group of figures with vertical lines," Lake Price advised in an 1860 article. "No opportunity should be omitted," he added, of "familiarizing the eye" with the "excellencies" of the paintings of Rembrandt, whose execution of light and shade made them "almost startling in their truthfulness to nature."[103] "In photography, the arrangement, position, lighting, all demand artistic culture before the process of photography is commenced."[104]

According to the magazine, a "good operator" in the studio must do more than simply take a "sharp, clean, well-modelled negative." He must also be "shrewd," especially in gauging his sitters' moral character.[105] The theory of "alienism," that people revealed their inner souls by unwitting gestures, was a central element in the art of portrait photography. For the photographer—like the Victorian artist—was an anthropologist.[106] R. Disderi, the inventor of *cartes de visite,* attested that the "truest reproductions" did not consist in the "exact reproduction of the proportions, the features, and the attire," but instead, in their depiction of the sitter's "moral character," expression, and disposition. The photographer alone could make a good portrait, for it was he who composed it, "conceiving an appropriate representation, choosing the particular attitude or expression, as well as the distance, light, and accessories." Disderi gave as an example a young soldier who had distinguished himself and acquired rights to command beyond his years. "The aspect of the picture is clearly indicated: life, passion, and energy must here be expressed. The open air, plenty of light, no mysterious half tones, the body firmly posed, the gesture frank, without anything vague or uncertain" would be the "proper mode of treatment" of this subject.[107]

Issues of the *Photographic News* also functioned as etiquette manuals for photographers. They contained articles that advised professionals how to introduce their photographs to the public.[108] In "The Ethics and Etiquette of Scientific Discussion" (1861), one editor implored commercial photographers to eliminate acrimony and bitterness from their exchange of ideas. Stressing the need for difference from the tone of the Royal Photographic Society, a famous scene of turf wars, he urged against the tendency for photographic science to be pursued with a "waspish acerbity of temper." Many scientists in photography,

he complained, showed "inconsiderateness" and "sheer oblivion" to other people's feelings—not to mention "ignorance combined with a naturally snarling temper." These had a "most repressive influence on the freedom of debate." The "habit of pouncing upon, and 'putting down' every accidental *non sequitur* or doubtful statement, except where important interests are at stake, is a most dangerous one in any individual, and often serves to keep silent others who . . . might make important contributions." It rested with photographic societies and journals, he considered, "to teach and enforce courtesy, by suppressing rudeness and personality in the meetings of the one, and excluding it from the pages of the other."[109]

Few issues raised the concern about community standards more than pornography, a debate that rivaled spirit photography for threatening unity among photographers. Although the editors of the *Photographic News* were aware that many of its subscribers were pornographers, they sought to enroll and reform rather than distance them. Crookes noted that the magazine "circulates among that class who produce . . . indecent" slides. "We are not squeamish," he continued. "We do not feel called upon to clamour for a general investure of such figures with togas and fig-leaves; we are not shocked at the sight of a Cupid without pantaloons—not hypercritically fastidious about the pose of a Venus or a Hercules; but to see a too life-like representation of courtezanship [*sic*] transferred in all its faithful hideousness to picture tablets by photoactinism—a very microscosm of impurity—this is one of the things we cannot look upon without disgust. To our apprehension no sort of pictorial offence is so utterly bad and abominable as is perpetrated by these too faithfully rendered stereoscopic pollutions."[110] He therefore called on "all who deserve the name of photographers" to stop the practice. They "will at once see"—unless their "sense of decency is too far vitiated"—that they "are bringing upon our favourite art a scandal which it is highly desirable to have removed at once." With statements like these, editors of the *Photographic News* sought to make the weekly a watchdog for public morals and raise the social status of photography in the process.

Public commentary on photographs' lack of credibility tapped into a wider social discourse on respectable masculinity. Angus McLaren has shown how Victorian men deemed by middle-class society as untrustworthy were differentiated as "cads," "bounders," and "rotters."[111] The "ideal" photographer was distinguished from the "scientific experimentalist," too busy testing contrivances to earn a successful living; the "brusque operator" who "never changed his clothes" or talked to his customers; and the "swell" who wore a loose robe and red Moroccan slippers, aping the "eccentricities of genius" to impress his patrons.[112] Adding to the crisis of trust was that the darkroom was a chamber of

secrets. Photographic operators were called "photographic pests" or "nuisances" and were often portrayed in the popular media as dangerously sexual men who preyed on innocent lady customers.[113] The photographic press began to distinguish the "respectable" establishments from the photographic "dens": a reference to the ignominy of fashionable, secret, and mysteriously Eastern opium dens.[114] A Mr. Kurtz, a photographer on Broadway in New York City, was, according to the London-based *Photographic News,* a "model photographer" because he was a "skilful" manager of light, had "artistic feeling," and—most important—"has no secrets"—he was "willing to communicate all he knows to others" and "ever willing to receive instruction."[115]

Photographic masculinity, as I call it, became a unifying appeal to class-diverse practitioners. As Leonore Davidoff and Catherine Hall have argued in *Family Fortunes,* their influential study of gender, class, and the making of the middle class in early Victorian England, middle-class men's claims for new forms of manliness found one of their most powerful expressions in formal associations.[116] Many photographers called for robust reforms through the evocation of photographic masculinity and appeal to gentlemanly conduct. Most important, many believed, photography required "a gentleman in mind and manner . . . he cannot be a trickster, a *sharp* man, or what in medical parlance could be called a 'quack.'"[117]

Although women and assistants practiced photography and served as crucial forms of economic support, they also functioned as an "Other" against which a distinctively masculine, professional, or amateur scientific subjectivity could be inflected.[118] On the one hand, the *Photographic News* encouraged photography as an activity for middle-class women and advocated the employment of poor women in printing establishments. In its pages, the Reverend S. Miller promoted photography as a "female accomplishment" for young ladies, one that promised "something real" and provided "more pleasure and admiration" than works by brush and pencil. He was teaching his daughters and sons the art as a form of "rational amusement" that made the home "sweeter and more attractive."[119] At a meeting of the London Photographic Society, a Mr. Skaife was said to have exhibited a "portable laboratory" with a miniature camera for use by ladies, including governesses, in the drawing room. This laboratory would allow "ladies to photograph their babies or other subjects" without the trouble of setting up a separate darkroom. All the operations could be performed inside the cabinet with one hand, "by the sense of touch only"—without "soiling fingers, dresses, or carpet."[120]

On the other hand, as Jeanne Moutoussamy-Ashe points out, photography was only a democratic medium to the extent that those who used the process were free to express themselves.[121] Despite the rhetoric of the democratization

of photography and science, for women and many men, the intersecting forces of professionalization made it increasingly difficult over the nineteenth century to reproduce photographs as works of science. The men and women who took up photography in England encountered severe limits and asymmetries. This was especially true in science, where even middle- and upper-class white men and women who had the privilege of using photography for self-image making often lacked the authority and training to make photographs that institutions accepted as semblances of scientific knowledge. Professionalization worked differently in science and photography, but in both it functioned as a strategy for keeping out women and certain classes of men, particularly those seen as rejecting or lacking the potential to participate as full citizens in a scientific age.[122]

The fraternal social organization persisted in the mid-nineteenth century, especially among artisans; the cultural hopes pinned on photography were seen by many to hinge on its incorporation into a new fraternal order.[123] As sociologist Mary Ann Clawson points out in her study of fraternalism in England, France, and the United States, the social metaphor of brotherhood, most clearly visible in the popular culture of early modern Europe, exerted a persistent appeal in the mid-nineteenth century, forming the basis for guilds, workers' organizations, political societies, and social groups.[124]

The mutuality that developed among editors and subscribers was maintained within a context of collective identity that emphasized fraternity. Photographers who sought to rescue the "respectable" social status of the medium from the moral pits of sloppy practice and poor taste into which some thought it had fallen did so in part by evoking the social bonds and authority of rational manhood. To resolve the perceived crisis of credibility in photography, leading photographers declared that they must lay aside their differences of social status and temperament and be united as "gentlemen" and "brothers." As one photographer explained in the *Photographic News* in 1862, "It is impossible to speak of the devotees" of photography *except* "as a fraternity, with the strongest bond of a common interest and sympathy." He declared that every year photography gained "earnest recruits" that aided its "perfection," adding, "Such men are needed."[125] Brotherhood, photographers believed, would hold the trade together. A photographer explained in 1860 that "men of the most diverse lives, habits, and stations are united, so that whoever enters their ranks finds himself in a kind of republic, where it needs but to be a photographer to be a brother."[126] Another declared that "men of all tastes, habits, and stations, seemed smitten as with a mania, but which (unlike older manias, such as the Dutch tulip rage) did not die out in a short time, but has rather gone on increasing. Never was a taste so catholic as that which has united in the bonds of brotherhood the disciples of this new iconolatry."[127] Promoters of photography pushed

masculinity as a solution to the crisis in photography. They recommended that amateur photographers look to men of science for inspiration and examples of worthy work, and praised men of science for making socially valuable photographs.

After the relaxation of Talbot's patent in 1851, commercial practitioners debated their rights to intellectual property in photography, prompting many to think twice before they shared a secret formula. However, the *Photographic News* strongly advocated the sharing of secrets and recipes. Photography, even more than other occupations and hobbies, was thought to need openness and sharing of information, for the phenomenal growth of the medium itself was widely attributed to the "united efforts of many minds." In an article titled "Photographic Secrets" (1866), the author wrote that even the "humblest operator, by carefully watching and recording his observations, has contributed to the advancement alike of theory and practice." One writer thought that, while in certain cases patents were desirable, most techniques ought to be openly shared, for "no one ever really profited by the maintenance of a secret in photography . . . The most successful men know that secret dodges would avail them little: they rely for success upon the right application of the common stock of knowledge, personal skill, and constant care; upon, in short, the use of their brains." Another declared that "photography owes almost everything to this constant and unreserved inter-communication of ideas."[128] However, as one reader suggested, secrets were acceptable if they were kept by "good men," consisting in some special process that "required time and money to work out." In such cases, he said, the retention of a secret was "quite justifiable."[129]

The physical interiors of darkrooms were thought to reveal important and otherwise hard-to-access information about the moral characters of their operators, such as their willingness to share technical knowledge. Descriptions of them functioned to open up the darkroom, publicize the secrets, and appeal to a sense of scientific openness that was at the same time political. Editors of the *Photographic News* declared that the studio itself revealed the character of its owner.[130] Darkrooms were essentially chemical laboratories, and—to distinguish them from "dens"—it was important that they be kept clean and well-ordered.

Unlike the studio, where sitters and their family members, servants, and friends watched the photographer's operations, the developing room was dark and spatially segregated from the patrons. Associated with esoteric practices, darkrooms (like opium dens and other secret chemical places) invited intrigue and suspicion. The dark mystery of the noxious developing room contrasted with the brightness of the sitting area. Generally stifling, filled with poisonous chemical vapors, and dank with mold from the water, darkrooms could be scenes of tragedy and horror, and it was not unusual to read in London newspapers and magazines at this time that photographers or their family members

had committed suicide by drinking cyanide.[131] If a trick was going to occur, it likely would happen in the darkroom.

In "Visits to Noteworthy Studios," a regular feature, the magazine asked readers to follow them into the places where negatives by famous persons were produced and triumphs won.[132] The ideal "respectable" photographer was moderate: he read the *Photographic News* but did not "go to excesses." His establishment was clean and spacious; all the appointments and furniture were in "perfect order." While investing money in his equipment, he made improvements and repairs himself when it saved money. He was conversational—reading the newspaper each morning so he was never at a loss to entertain his sitters while they posed.[133]

Editors of the *Photographic News* also sought to improve the medium's reputation in part by making technical improvements. The technical problems were apparent to all who practiced, whether in the photographic studio or the astronomical observatory. The various potential sources of errors and artifacts in photography made it obvious that the camera itself was a prime object of investigation.

How Science Helps Photography

As more and more people purchased portraits of themselves, public scrutiny focused intensively on the detection of imperfect photographic works. Those associated with the *Photographic News* recognized that addressing the technical limitations of the new medium was crucial to establishing its authority as evidence. Magazine advice on portraits is crucial for understanding how a scientific culture around photography evolved, for it was part of the process through which profit-making photographers became assimilated within a social collective of rational, constantly self-improving experimenters. Because the problems with photography have so frequently been eclipsed in the literature by discussions of its presumed representational advantages over drawing, it is necessary to recall the many technical limitations of photography at midcentury.

According to the *Photographic News,* photography was afflicted with numerous "abominations": smears, marks, "ghosts," comets, "rockets," irregular spots, haloes, and fogs. "There are but few operators who have not been annoyed with the formation of all sorts of markings . . . [or] fiends . . . on the negative film at some period of their practice," Professor Towler reassured readers in his 1865 paper "Specks, Flashes of Lightning, Islands, Lakes, Etc. on the Negative Film During Development." To complicate matters, such problems had more than one source. One was the irregular concentration of the nitrate of silver while drying. Another common problem was faulty development. Photographers met with marks in "all manner of shapes"—shapes like "flashes of light-

ning, lakes, ponds, concentric circular spaces"—where the light could not possibly reach, even with clean plates. They inferred that the decomposition of the developer, by its mixture with free nitrate of silver and organic matter, produced a metallic film that was broken. Other causes for the same phenomena included the use of an old silver bath where an accumulation of organic matter might produce the same kind of reduction.[134] Ultimately, "some photographers doubtless avoid the above mentioned evils more than others, but, as a rule, they do not know why."[135]

Making prints permanent was one of the major problems and a matter of great importance, since permanence was tied to the future of photography's commercial success. "If photographs are to fade almost as quickly as they have been produced, I am sadly afraid that photography as a business will be at a discount," declared John Stuart in a paper presented to the Glasgow Photographic Society in 1867.[136] One theory connected faded prints with the method of washing proofs. If a proof was taken from the printing frame and immersed without washing in a fresh solution of hyposulphite of soda, four different substances encountered one another: nitrate of silver, white unchanged chloride of silver, the subchloride of soda (of which it was supposed that the image consisted), and hyposulphite of soda. The result of their coming together was that the subchloride (although insoluble in hypo) was altered, its chlorine eliminated, and the image formed of metallic silver.

The usual time to fix (in the late 1860s) was about ten minutes. If a dozen sheets were put in and taken out one at a time, however, problems arose; also, if not constantly agitated, the soda would be weakened. All the silver should be removed before toning—and removed with clean water. Prints sometimes were destroyed by being mounted onto board that had absorbed hyposulphite of soda, which would make the paper rotten. Indeed, photographers complained about the quality of paper available to them for mounting prints.[137]

Photographs with spots were a source of great consternation. Irregular spots on the collodion film could be caused by over-iodization of the collodion and by iodization by potassium salts. Potassium salts were prone to quick drying and created a hard film. Excess of silver did not run down evenly and therefore produced irregular spots on drying. This problem could not happen so easily on a soft film, which held moisture long enough to keep the nitrate of silver on the film from crystallization for some time. Spots could also be caused by a bath containing more than forty-three to forty-five grains of silver to the ounce of water. Photographers were advised not to remove the plates from the bath before the film was well formed.[138]

Blurring was a common problem that, while it intrigued pictorial photographers with its potential to create new aesthetics, distressed the majority of am-

ateur and commercial operators. There were many scientific theories about blurring in circulation. A meeting of the North London Photographic Society was devoted to this subject to clarify the differences between three kinds of abnormal deposit that produced either irregularity of form or of light and shade. Halation, nubation, and blurring had distinct causes but were associated, and therefore people confused them.

Halation (the formation of apparent "haloes") was a phenomenon consisting of a line of light surrounding dark objects, which many believed was due to chemical or physical causes. Some chemists thought that when the free nitrate and the developer came into contact with a part where light had acted, two things happened: one, the free nitrate belonging to that part was reduced, and two, the free nitrate from the dark part where it was not reduced was swept up and thrown down, forming on the edge of the lighter portion a line of increased density shown in the print as a line of light or a "fine halo round the dark parts." This was greater in some chemical conditions than in others, but this was not well decided; some thought it happened when the collodion possessed little bromide and the plate was slightly underexposed.[139]

Nubation, a name proposed by Shadbolt to describe unwanted fog effects, consisted of the encroachment of light on the darker portions of the picture, similar to a cloud. It was most frequently seen in interior pictures taken near a window, in landscapes where sky was seen through tree branches, and in portraits where black drapery surrounded white, such as a shirt breast. Nubation was common in wet collodion and calotype processes. There were many theories at the time, one holding that diffraction was the cause. The prevailing idea was that nubation resulted when the lens was pointed toward the light with dark, imperfectly illuminated objects cutting against that light. Experiments determined that a frequent cause of nubation—or fogging from reflected light—was actinic light passing through the plate and reflecting back again; however, others thought that reflection alone could not explain the phenomenon.[140]

Some people tended to mix up blurring and halation, but in the 1860s, photographers began to recognize blurring as a separate defect. As one explained, blurring was "that irregular or imperfect definition of fine lines, or encroachment of other light objects upon such lines as almost entirely obliterates them." This often happened with tree branches, the rigging of ships, and the rendering of fine lines of engravings copied by the tannin process. Though some thought it was an optical effect, others thought the cause was mainly chemical and physical, resulting perhaps from a tendency of the deposited silver to spread. This most frequently happened when the exposure had been long and the development rapid and energetic, rather than slow and gradual. There was therefore a greater tendency to blurring with iodized collodion, where the

reduction was generally more rapid. The presence of a bromide rendered the development more deliberate, and the tendency to lateral deposit lessened.[141]

Other defects had optical origins or were caused by adverse external agency, which could include atmospheric effects, faulty technique, or carelessness. Poor technique or lack of foresight was blamed for many apparent misadventures, as was failure to clean the plates after disappointments occurred. Photographers were encouraged to destroy their old glass, rather than risk so-called dirty pictures. Rubbing the plates, which many thought would make them cleaner, because it transferred perspiration from the hand to the plate via the cleaning cloth, actually made them more unclean.[142]

The most common sources of distortion included neglecting to adapt the depth of distance according to the structure of the lens. This distortion was influenced by the social class of the photographer because use of a large lens required a large studio or glass house, and many could not afford large studios.[143] Many photographers had introduced lenses of very short focus; so short, in fact, that they distorted the faces and figures in the images.[144] Some lenses were of such shallow focus that if the eyes were in focus, the nose would be blurred. This defect could be remedied by reducing the aperture of the lens—also called "stopping it down"—by which the depth of focus would be increased. However, this made a longer exposure necessary—and long exposures were inconvenient for both sitters and photographers: either the sitter moved, causing blurring, or "he assumes an aspect of unutterable gloom," which made the picture unpleasing. Another form of distortion produced an even more grotesque caricature. Every lens was constructed to cover a plate of a certain size. Sometimes photographers who could not afford large lenses used small ones for taking *cartes de visite* photographs. However, these smaller lenses were not made to cover easily the whole plate they employed. The result was that the sitter's feet were in the margin of hazy distortion at the edges of the image that marked the limit of the lens.[145] A larger, more expensive lens would solve this problem, but as the lens increased in size, so too a larger distance was needed between the photographer and the sitter, and therefore a larger studio, which most photographers could not afford.

Promoters of the *Photographic News* thought that in addition to addressing technical limits, science provided an example of a social base. The editors reinforced the culture of collectivity by promoting the viewing and exchange of photographs, a practice akin to that pursued by the Amateur Photographic Association and, later, by the British Association for the Advancement of Science and other scientific institutions. Rituals of exchange were collective experiences that created social relationships as they created meaning, and cast photographic exchange as a site for education and self-improvement.

Crookes and his successor G. Wharton Simpson supported organizing photographers into a "regular system of experimenters." Above all, Crookes and his associates implored professionals to participate in the scientific investigation of photography, meaning the selection of subjects and precise methods of practice. Crookes declared that even the photographic novice "can make any amount of experiments; and, with a little system, he can make experiments that will be of great service to the department; and the photographic journals are always ready to record the results of such labours." It was a "new world" in which "each practitioner is an experimentalist, working to multiply photography's force and efficacy."[146] From the accumulation of facts thus made, minds thoroughly educated in natural science would be enabled to make legitimate syntheses and simplify the art.

Crookes conceived his editorial role as that of an instructor.[147] Drawing on his background in chemistry, Crookes urged that "photography must be learned in the same way as any other art or science," that is, methodically. "A firm foundation must be first laid in the general principles upon which the science is based; and when these are well mastered, the pupil should commence with the easiest and simplest experiment, in order to assist the hand, eye, and judgment, in the proper understanding of the complex phenomena which will constantly be brought under the notice of the earnest scientific photographer." Crookes suggested certain projects as especially useful subjects for beginners. To a "young photographic tyro" who requested an "*intelligible* method of arranging the telescope and camera for taking heavenly bodies," Crookes suggested a "modus operandi in taking the pictures."[148]

> The telescope having been moved until the moon's image was in the center of the focussing glass, the water-mill was turned on, and the dark slide containing the sensitive collodion plate was substituted for the ground glass . . . When the motion was most perfectly neutralized, I uncovered the sensitive plate at a given signal and exposed it, counting the seconds by means of a loud ticking chronometer by my side. From the ease with which on my first attempt I could keep the cross wires in the finder fixed on one point of the moon by means of the tangent rods [held by his assistant, Mr. Hartnup, in each hand] I confidently believe that with the well-tutored hands and consummate skills which guided this noble instrument, the moon's image was as motionless on the collodion film as it could have been were it a terrestrial object.[149]

Practical lectures and demonstrations with a camera showed that successful photography depended on proper scientific practice. One correspondent wrote: "As I am desirous to learn the photographic art, I would be glad if you will tell me what instruments and chemicals I shall require, and what will be their cost (about)." The editor replied that the correspondent should not buy too much immediately: "Do not *on any account* begin with attempting por-

traiture by the collodion process, or you will never be a photographer; but commence with obtaining an insight into the laws and phenomena of the science by copying lace, leaves, ferns, etc. on paper by super-position, then proceed to the talbotype negative process, and *keep to it,* . . . until you are so thoroughly . . . competent to decide upon the merits of the waxed paper or any other paper process."[150] In "Table of Necessaries for Beginners in Photography," a contributor published the prices and quantities of chemicals with the novice in mind, and such advice as to use small (5″×4″) plates when starting out.[151] "A Simple Dark Room For Work Near Home" suggests the innovative spirit of its readers. "My plan has the advantage of being sufficiently practicable for use in the house or garden," and was comparatively cheaper than expensive darkrooms for outdoor work. The author recommended procuring a small box ("a large tea chest would answer admirably") and cutting out at the back or left side a space for a window, six inches by four.[152]

Many contributors recommended sights for photographic views. One letter, submitted by "Sarah C.M," recommended places near London where one could walk into the country from the suburban railway stations of Watford and Kent.[153] Like the leaders of the British Association, the editors directed photographers' labors. One article, for example, offered a set of instructions for photographers A–Z, each conducting a different experiment or studying a different phenomenon, with photographer Z deducing what they meant.[154]

The system of exchanging positives among amateurs and sending them to experts (who were called *scrutineers*) was developed by the *Photographic News* editors. "A free and spirited exchange system is one of the most pleasant stimulants to effort in photography, giving considerable additional zest to the production of fresh pictures."[155] According to the editors, no form of education was so valuable to the photographer as the opportunity of seeing excellent work. It was "only [in] a collective display that proper opportunity for comparison is afforded; and without comparison with others, no man can form a fair idea of his own relative excellence, and learn how much he still has to achieve."[156] Referees evaluated the prints according to several criteria including the quality of the photography, artistic merit, rarity of subject, and the amount of effort involved in securing them. Those members who sent their best results for consideration were urged not to be disappointed if their photographs were returned as unsuitable for exchange. Instead, they were encouraged to "take courage and continue sending until they attain sufficient excellence for acceptance."[157] They were not to place poor photographs in their "collection with the remark, 'It is pretty well for an amateur,'" but rather to say: "'This is a bad photograph—I must try again.'" Amateurs were to "compare their productions" with those of the "best professional photographers."[158]

The mid-Victorian "gospel of work" provided a framework for seeing success at making photographs as a model for social virtues in a modern society. During the mid-nineteenth century, the British debated how best to secure the moral order needed to achieve the kind of economic growth the country's industrial leaders demanded, and these debates inspired an outpouring of writings on the national and social character, a body of literature that appealed directly to working-class laborers, artisans, mechanics, and middle-class businessmen. The Leeds physician and social reformer Samuel Smiles, author of *Self-Help* (1859), *Thrift* (1875), and *Duty* (1887), was Britain's leading proponent of the "gospel of work" and an advocate of the "self-helping spirit" as a feature of English manly character.

His first book, *Self-Help: With Illustrations of Conduct and Perseverance,* was a remarkable success; 20,000 copies were sold in the first year, and 55,000 by 1864.[159] Addressing working-class laborers with a wider message for "men of business," Smiles articulated his dream of self-reliant men in a developing society. Smiles emphasized self-set standards of individual behavior as the means for achieving social improvement and national progress. Social improvement could only come about through individual deeds; accordingly, the performance of individual duty was the "glory of manly character." Smiles declared that his chief object was to stimulate youths to rely on their own efforts, not the patronage of others. Illustrious men sprang even from low social ranks through their "perseverance and application and energy." Smiles's heroes of self-help included field geologists such as William Smith, Hugh Miller, John Brown, and one "profound geologist, in the person of a baker," whom Sir Roderick Murchison had discovered in Scotland. Attention to detail and accurate note-taking were crucial: "The practice of writing down thoughts and facts for the purpose of holding them fast and preventing their escape into the dim region of forgetfulness, has been much resorted to by thoughtful and studious men." The creed of the humble observer shines through Smiles's writings. He insisted that the "intelligent eye of the careful observer" gave "apparently trivial phenomena their value," for "so trifling a matter as the sight of seaweed floating past his ship, enabled Columbus to quell the mutiny which arose amongst his sailors at not discovering land . . . There is nothing so small that should remain forgotten; and no fact, however trivial, but may prove useful in some way or other if carefully interpreted." The "repetition of little acts" built individual character and improved "the character of the nation." Accuracy of observation was the mark of a well-trained civic man: "Too little attention is paid to this highly important quality of accuracy," he declared, adding that an eminent man of science had confessed to him that "It is astonishing how few people I have met with in the course of my experience, who can *define a fact* accurately."[160]

Exchanges of individual prints among photographers with varying levels of expertise highlighted the hierarchies of skill involved and compelled a wider discussion on the problems, defects, and errors that ultimately focused on the photographer's work ethic. The system of exchange raised the question of what to do about failures. As one correspondent lamented, "Out of some hundreds of trials, I can only produce six possible negatives."[161] Photographers thought that viewing failures could be instructive and often considered them more valuable than prized successes. Just a few years earlier, in his book *On the Economy of Machinery and Manufactures* (1832), the inventor Charles Babbage had urged, "we shall find in the history of each article, of every fabric, a series of failures which have gradually led the way to excellence."[162] Extending that idea to photography, someone else explained, "It is these failures that we wish them to have: for, in the commencement of an experimental science, failures teach far more than success,—the latter, when accomplished, being simply success, but the former, when overcome, is *experience*."[163]

Some even proposed exhibiting failures. The photographer J. A. Cotton at a meeting of the South London Society sought to establish an "Album of Failures," to which members were invited to contribute specimens of "exceptional, unexpected, and unexplained results which occurred in their practice of photography" with all the circumstances of their production "carefully noted and detailed."[164] There was also a proposal to exchange rejected prints with "others as bad, which were also rejected."[165] For, "explanations of exceptional phenomena, based on known theories without regard to their possible fallacy, must often therefore lead to error. What is wanted, then, from individuals is a simple and unvarnished statement of facts in regard to their failures; or at least—for this is an important qualifying clause—*such of their failures as ought to have been successes*."[166]

Photography as a "Handmaid" to Science

The idea that science stood to gain as much as it contributed was firmly a part of photographic discourse from the very beginning. In an address titled "The Application of Photography to Scientific Pursuits," delivered in 1860 at a meeting of the South London Photographic Society, the geologist and photographer F. F. Statham urged that it was vital "to awaken public attention to the wide field of usefulness opened up" by photography.[167] For example, Roger Fenton's pictures of the Crimean campaign showed many people that photography could be valuable in military science for taking views of fortifications and chronicling the effects of attacks.[168] In "Photography and Medical Science," a contemporary praised photographs over sketches by "hurried travelers or half-skilled designers." In addition to the delineation of human skulls, he thought that the

photography of the heads of various nations and tribes would be "most inter-
esting" and considered London "the best" place to gather such a picture gallery.
"A selected collection of such portraits" of kings and queens of "Cannibal Is-
lands, Persian ministers, Siam princes," and, in Whitechapel, "Malays, New
Zealanders, Turks, Egyptians" demonstrated photography's potential as an in-
structional tool for a new imperial age.[169]

Science supplied illustrations of exemplary rational labor, as well as subject
matter. Men of science who worked with photographs appeared hardworking,
trustworthy, and civic-minded. The *Photographic News* encouraged amateur
photographers to imitate men of science who were photographic discoverers.
"Scientific technology may be mastered in a few hours, but a clear under-
standing of the ideas it is intended to convey can only be secured by a long
and laborious exercise of the mind."[170] To make a photograph, editors urged
repeatedly, meant performing a process that involved great skill and a highly
exacting technique. Photography required the eye and hand of judgment and
skill—what Victorian photographers called "the judging eye."[171] Far from being
a mere recorder, photography, as much as engraving, gave "room for the exer-
cise of individual genius."[172]

The journal extensively reported on the photographic experiences of men
of science. In 1865, the *Photographic News* gave an account of the astronomer
Samuel Fry's lunar photography experiments, in which Fry explained that the
light of the moon was so feeble that it would not produce an instantaneous pic-
ture but had to act for a long time even with the most sensitive collodion avail-
able at the time. Success involved knowledge of the "very best" chemicals, the
highest state of "cleanliness," and "perfect freedom from floating particles in the
bath, collodion, or developer, and all three so suited to one another, as to work
uniformly together." As any change in the relative position of the moon, the
telescope, and the negative would blur and destroy the image, it also was nec-
essary to have the telescope so mounted and moved that its axis continued to
point to the same portion of the moon during the entire exposure.[173] Readers
also learned that it took two years of hard labor before Lewis M. Rutherfurd
obtained in 1865 what contemporaries described as the most perfect photograph
of the moon ever taken. To bring the focus into the proper position to pro-
duce a perfect image of the actinic rays, he even removed the object glass from
the telescope and ground the lenses with his own hands, to adapt the lens to
the refrangibility of the actinic rays.[174]

The repercussions of unskillful practice in science also were widely remarked
in the *Photographic News*. After the failure of the English photographic expedi-
tion led by Major George Tennant to record the solar eclipse in India during the
mid-1860s, many Victorians learned of the flaws of photography and were told

of the need for skilled men. In a letter from India to the Royal Astronomer George Airy, an ashamed Tennant reported soon after the event that the expedition was a "failure": every plate had been underexposed and covered with spots. The journalist corrected him: it was not a "failure," it was a "disaster." It must have been a staff of men who "knew nothing of photography," or "we should not have heard of such puerile difficulties as spots from concentration of the silver solution," he exclaimed. The editorial staff of the *Photographic News* blamed the British government for sending inferior workers and compared the expedition unfavorably with a successful one by the Germans, led by *"experienced photographers."* By contrast, the Germans had tested the chemicals and collodion under different conditions and—like a "military drill"—even had tried preliminary exposures on location.[175]

Stories like these illustrate that men of science had to work at making their photographs appear trustworthy. Indeed, working at photography was precisely the point, for it differentiated the manly "operators" from the effeminate "swells." Ultimately, professionalization made it essential that entry to scientific photography depended on knowledge, including theories and practices particular to each field of study. The "time is coming," predicted one photographic journalist in 1859, "when the various branches of photography will have to be subdivided." Eventually, none could adopt it as a profession without studying also the subjects of that peculiar branch to which they intended to apply themselves—botany, zoology, archaeology, and the like.[176]

Partly as a result of photographers' efforts, medical and surgical societies recommended the establishment of new library collections of photographs as early as the mid-1860s. Samuel Highley, a fellow of the Geological Society, the Chemical Society, and the London Photographic Society, began to promote the use of magic lantern slides for mass scientific education and museum collections. This illustration shows a popular science demonstration in which two speakers illustrate their lecture with a magic lantern slide projection of an insect (Fig. 1.14). At an 1864 meeting of the British Association, Highley recommended the projection of transparent positive photographs of natural-history objects on a screen for the purpose of class instruction. To illustrate their value for scientific and medical teaching, he gave the examples of photographs of anatomical subjects that he had made ten years before at Bartholomew's Hospital, including specimens prepared by Mr. Luther Holdens and Hugh Diamond's photographs of the physiognomy of insanity.[177]

Photographs were potentially more valuable than sketches not because they were inherently more truthful but because with faster exposure times it was possible to follow the rapid changes of a disease with photography more easily than with time-consuming sketches.[178] With a large photographic lantern picture,

FIG. 1.14. Engraving of a popular science demonstration with a magic lantern projection.

Highley insisted, the lecturer could "fix the attention" of his class, whereas with "ordinary paper diagrams," the "eyes of idle students listlessly wander." [179] According to Highley, book knowledge was of little value to the student who would become a true naturalist. Rather than storing photographs away in boxes where they could not be seen, he urged that photographs should be made available for educational purposes in the open cases of museum displays. Mounted in frames backed with glass, they could even serve as appropriate borders to the windows of a scientific institution. [180] Photography would not replace practical experiment; the student must, if possible, see and handle the objects of his study. However, he explained, the "next best thing" to direct observation was photography. [181]

The years after 1870, as we see in more detail later, represented a boom era for photographic collections in scientific and medical institutions. Beginning in earnest in the 1870s, scientific and medical societies collected numerous photographs and stored them in paper and wooden boxes. The institutions that amassed large collections included the Royal Meteorological Society, the Royal Anthropological Society, the Royal Astronomical Society, and local hospitals, among many

others. In 1888, the meteorologist and photographer Arthur Clayden suggested that the "great thing" about the Meteorological Council's appeal for thunderstorm information was "the beginning of a collection of lightning photographs."[182] The wave of photographic exhibitions fostered new interest in photography among members of many organizations, such as James Glaisher and Arthur Clayden at the Royal Meteorological Society, and William H. Wesley at the Royal Astronomical Society who, as we will see, shaped the field of scientific photography.

By the mid-1870s, people widely agreed that photography benefited science as much as science benefited photographers. One *Photographic News* editor reported that photography helped science in two ways: through the "high office of investigation," and the "subservient one of simple record."[183] The language of class difference permeated the discourse of scientific photography. "High office" described revered photographic discoveries in science. They included photographs by named individuals, such as Robert Koch's photographs of bacteria in animal tissue, photographic research on the action of the pulse and heart by Drs. Ozanam and Lucs, and new spectrum photographs made by Henry Draper and William Abney.[184] They also included astronomer William Huggins's pictures of the spectra of the stars, Edward Whymper's Chimborazo pictures showing the uniform thickness of ice crust at a specific altitude, and Pierre-César Jules Janssen's pictures of the sun's orb, in which he investigated the sun's mass.[185] Many of these, such as photographs of bacteria and star clusters—phenomena beyond the threshold of unaided vision—were made with the new gelatin plates and circulated in books, newspapers, and magazines, using the new half-tone processes. "Subservient," or "low," investigations with photography included those made, for example, by the use of self-registering instruments.

By the early 1870s, photographers organized informally through the *Photographic News* had mostly succeeded in forging a new hegemony over definitions of the medium's meanings, displacing the control that an earlier genteel community had enjoyed. To a great extent, the leaders of the new community managed to elevate the status of photography. The reform of photography became linked to the unifying power of hard work, skill, fraternalism, and collectivity. Through meetings and the press, practices and protocols for making photographs that were socially useful were established. Conventions for exhibiting and viewing photographs were also put in place. As the direct result of interventions like these, even Victorians who were not photographers began recognizing that a skillful photographic operation involved many kinds of knowledge, including the choice and arrangement of equipment. Even if photography remained a mysterious process, they generally knew that failures, such as blurs and distortions, could be caused by such factors as a neglect to adapt the depth of focus of the lens and to the subject of the picture.

Two findings, in particular, emerge from studying the dynamics of the debate over photography's social status in the 1850s and 1860s that are important for understanding the history of scientific photography. The first is how this context made the materiality of photographic practice into an issue of public morality. Over the remainder of the nineteenth century, scientific associations increasingly assumed the role of defining what "scientific" photography meant. To the leaders of scientific institutions with specific disciplinary interests, encouraging photographers how to make proper data in their field was essential for the advancement of scientific knowledge. Henceforth, scientists in specific disciplines, rather than editors in the photographic community, led the way in defining the future direction of scientific photography. As they did so, they moved issues of moral scientific practice to the center of discussions of photographic truth in science.

Second, that it was in the wider context of the aggressive sales pitches and photographic dens, and not just in scientific institutions, that the discourse of mechanical objectivity evolved is significant for understanding the political and cultural influences on the early creation of scientific photography. As this chapter has shown, a discourse of photographic skepticism originated in metropolitan class and gender tensions to which reform-minded scientists and photographers responded by postulating new rational and "scientific" standards of practice. As they appealed to a collective ideal of fraternity that they hoped would unite photographers across social and class divisions, they created new categories of exclusion.

As the next chapter will show, social factors such as skill, taste, gender, judgment, and class continued to eat away at the idea of photography as an unmediated process throughout the nineteenth century. Even photographers engaged in the scientific practice of taking photographs had to struggle to make scientific authority for themselves and the objects they produced. Over the next several decades until at least the early years of the twentieth century, those who promoted photography as a tool for making scientifically significant pictures had to emphasize the skills and labors that they brought to the task. Furthermore, as more people gained access to the manufacture and reception of photographs, consensus on what constituted photographic evidence became harder than ever to control. The brotherhood of photography, like the community of men of science, ultimately produced an image of unity that could be difficult to preserve when controversies over individual photographs erupted, as they increasingly would.

Chapter 2

Testing the Unity of Science and Fraternity

From the late 1850s on, the press reported numerous cases of mistaken photographic identity, particularly in metropolitan cities. Although readers learned about many people who were arrested solely on the basis of a photograph, they also learned about mixed success with photographs as a test of identification. They discovered, for example, that a solicitor sued the sheriff of Surrey for false imprisonment after he was arrested on the basis of his likeness to a photograph of someone else, that even a photograph was insufficient to give certainty about the identity of a dead man found in Hackney, and that Lord Chief Justice Cockburn, who heard arguments about identity based on photographs, "has not a high opinion of the trustworthiness of photography."[1] In some cases, sitters who took photographers to court to demand the return of their money for disputed likenesses won judgments.[2]

Inside and outside the courtroom, photographers reminded consumers that portraits were not always exact likenesses. As one photographer stated in 1861, "It might be supposed that a portrait obtained by means of mechanical appliances would trace the features of the sitter literally, but such is not always the case, for many causes operate to deprive photographic portraits of that resemblance to the original, which, theoretically, they ought always to possess."[3] Another exclaimed, "A little reflection on the conditions of photographic portraiture will suggest the wonder rather that the photograph is so frequently a successful and satisfactory likeness, than that it occasionally fails."[4]

During the early 1870s the national coverage of the trial of the Tichborne claimant for perjury elevated the complexities surrounding photographic evidence into a wider public discourse on imposture and criminal deception. The Tichborne claimant case was regarded by many photographers in Britain as a disaster that put on trial not only the claimant but also respectable photography. At the center of this story was a man who claimed to be the lost son of a dying heiress near Guildford, south of London. He apparently had died at sea about twelve years earlier. The claimant answered Lady Tichborne's advertise-

ment for information about her son and explained that he had, in fact, survived a deadly shipwreck off the coast of South America before being rescued by sailors and moving to Australia. Although the claimant was physically very different from the young Roger Tichborne, being fat where the lost man had been thin, he nevertheless presented sufficient personal knowledge of the family and their circumstances to convince many people— and significantly, Lady Tichborne—that he truly was Roger Tichborne.[5]

It was the longest criminal trial in British history, lasting four years as witness after witness was called to testify for or against him. Photographs were central to the case, as a daguerreotype made of the young Tichborne before he died served as a major piece of physical evidence and identity. As the Tichborne case showed, although photographs were said to be readily comprehended, the reality was often far different. Witnesses ranging from jurors to judges to photographic experts frequently disagreed over what the photographs showed, and in the middle of the trial, a judge impugned the ethics of a photographer hired by the defense.[6] A photographer who observed the trial later commented that the status of photography was ironically never more uncertain than in the 1870s, the moment of its ascendancy as an epistemological practice of seeing. Capturing well the complexity of social perceptions of photographic evidence at the end of the trial, he declared: "There is a certain anomaly in the public estimation of photography which is worth noting." He continued: "No art is so frequently treated with contempt and contumely," yet "none more blindly and unreasoningly admired and trusted."[7] After the trial, the debate over the photographic evidence continued, with William Mathews, a physician who supported the claimant, publishing a comparison of photographs of the young Tichborne and the claimant in order to try to prove their identity (Fig. 2.1).

Although these challenges never cast serious doubt on photography's evidentiary value, they generated public awareness that there was a gap between the ideal of mechanical objectivity and the realities of photographic practice, where the operator's skill, judgment, and attentiveness to details were recognized as playing some role in obtaining good likenesses. Portraits and their kin, spirit photographs, illustrate nicely how nineteenth-century consumers shaped the meanings of photography, whether or not they knew how to take pictures or even had direct access to cameras.[8]

Victorian spirit photography was a subgenre in which "spirits" materialized on photographic plates, often as veiled figures and occasionally as geometric shapes, angels, or blurs. In the context of this wider discussion about photography as a new test for identity, because so many people claimed to immediately recognize their ancestors in the pictures, spirit photography presented a

FIG. 2.1. "The Tichborne Blended Photographs." In William S. Mathews, *Identity Demonstrated Geometrically with Phototype Illustrations* (Bristol: Wright and Company, 1876). Mathews wrote for the caption: "Close scrutiny of these blended Photographs, (truthful and authentic beyond all denial) must convince every intelligent person that they represent one and the same man—SIR ROGER TICHBORNE." Mathews believed that the diameter of an individual's eye remained the same over the course of an adult lifetime and used a geometric grid here to argue that the claimant's eyes were the same diameter as Roger Tichborne's and that therefore they were the same person.

problem to advocates of mechanical objectivity who denied its credibility. In the triumphal history of scientific photography, marked by firsts and technical advances leading to fundamental discoveries, spirit photography might seem like an embarrassing detour: the first photomicrograph (1839), the first photograph of lightning (1847), the first reported photograph of a genuine ghost (1861). Today, spirit photographs are generally not commemorated in books on historically valuable scientific photographs.[9] Beginning in 1839, however, scientists had justified their optimism in the future of photography by recommending its application to studies of phenomena at the threshold of vision, including accurate and easy recording of celestial bodies, measurement of their brightness, and spectral analysis of their light. To those who found such optimism excessive, enthusiasts like French astronomer François Arago replied with confidence that whenever observers applied a new instrument to the study of nature, they hoped for a host of discoveries, and that in such matters, it was on the unexpected that one could especially count.[10] If such invisible natural ob-

jects could appear in photographs, why not invisible supernatural phenomena? When was a spirit photograph a trick, and when a promising scientific discovery?

This chapter traces the origins and development of spirit photography in London in the 1870s and 1880s and analyzes how making spirit photographs became publicly scrutinized. The tremendous popularity of spirit photography owed much to the vogue for spiritualism. The modern Spiritualist movement began in the United States in 1848 when sisters Katherine and Margaret Fox, aged twelve and thirteen, claimed that the spirit of a dead peddler who had been murdered and apparently, or so it was said, buried in their house in upstate New York could communicate with them by rapping on the walls and furniture. Spiritualism arrived in Britain through the American medium Mrs. Hayden, who began to advertise her professional services in London in 1852. Her influence was felt immediately, and within a year séance circles had formed throughout the country. Spiritualists generally held that the spirit survives after the death of the body, continuing to evolve toward enlightenment, and that disembodied spirits could communicate with the living, usually through a human medium. Many believers argued that experimental séances provided scientific evidence for the spirit's survival after death, and they perceived science as fully compatible with spiritualist views. Spiritualism made the invisible visible, the impalpable palpable. Witnesses saw, heard, and felt the presence of spirits, and therefore manifestations could be tested empirically.

English Spiritualism flourished from the 1860s through the 1880s, and the movement continued through World War I and beyond.[11] For some, Spiritualism was an amusing parlor game; for others, it was a passion that sustained their lives. It was a way for the disenfranchised to gain access to social power—women and the English working classes were often mediums—and a way for the socially privileged to reinforce dominant racial attitudes: mediums frequently materialized as Native Americans, African Americans, Indians, Africans, and Arabs, furthering the idea of the exotic "Other" (Figs. 2.2–2.4).[12] Orientalism was a powerful force in late-Victorian visual arts, and the iconographic associations of Orientalist motifs and an exoticized East Asian or Middle Eastern landscape transposed to Mars can be seen in other Spiritualist illustrations from the period. In "News from Mars: Alleged Communications by a Martian 'Control,'" an article that appeared in the occult journal *Borderland* (1897), a spirit photograph depicted an alleged Martian, shown wearing a turban and holding a laurel branch, the symbol of an ancient republic (see Fig. 2.3).[13]

Building on previous studies of Victorian spiritualism and integrating them into my account of Victorian scientific photography, I look closely at an aspect of spirit photography that has received less attention, namely, the processes

PLATE VI. (Page 34.)
From Untouched Negative.

FIG. 2.2. Spirit photograph made by medium Sarah Power, seated, ca. 1890. Her domestic servant Eliza stands behind her. The "spirit" is the white blur above Power's head. Thomas Slaney Wilmot, *Twenty Photographs of the Risen Dead* (Birmingham: Midland Educational Co., 1894), plate VI, p. 34.

through which photographic evidence of the spiritual world was manufactured and received. London by the 1860s was a metropolis where thousands of people recognized the contingency of claims about photographic truth and were proud of their skills at detecting flaws and errors in photography. Many people recognized that failures of photography such as blurs and distortions could be caused by a variety of factors. When photographers revealed how illusions and deceptions were achieved in certain pictures, people wondered then—as they do now—how people living in a modern scientific culture could be so deceived. After looking closely at the arguments made for and against the merits of photographic evidence of spirits, the chapter explores how spirit photography moved to the center of social reformer and innovative journalist William T. Stead's project in the early 1890s to use the illustrated newspaper to cultivate a wider, responsible, and educated representative democracy—what historian Patrick Joyce has called the "manufacturing of the democratic."[14] Debates

FIG. 2.3. "Martian," spirit photograph from a spiritualist séance in London, ca. 1897. Reproduced in "News from Mars: Alleged Communications by a Martian 'Control,'" *Borderland* 4 (1897), 407. The laurel leaf carried by the "Martian" is the symbol of an ancient republic.

around the practices of amateur and commercial photography conditioned the reception of photographic evidence of spirits, and scientists and photographers forged ties across the lines of this debate. There were no easy grounds for rejecting the possibility of spirit photography without risking the appearance of being unscientific. The prevalent philosophy of scientific photography that was established by the late 1850s emphasized the need to experiment, to remain open to competing evidence, and to share work publicly. Therefore, a sufficient number of people thought that the honest production of just one spirit photograph justified its investigation. As an author in the London *Review* declared in 1861: "We will believe even the modern ghost if it can be fixed on paper," for the photograph was "liable to no delusions, has no brains to be diseased, and is exact in its testimony."[15]

FIG. 2.4. "No. 9—An Arab Chief." W. T. Stead is shown seated on the left. Reproduced in W. T. Stead, "Spirit Photography: A New Series of Psychic Pictures," *Borderland* 2 (October 1895): 320.

Photographic Trust

Spirit photography was at the nexus of a variety of nineteenth-century intellectual and practical traditions, including family and devotional photography, science and technology, commercial entertainments, and religion and spiritualism. Victorians were fascinated by new areas of research. Topics such as hypnosis, evolution, phrenology, deviance, spiritual phenomena, mesmerism, artificial life, and strange meteorological effects such as "thunderbolts" defied understanding and invited public speculation. Advertisements publicized the wonders of science and technology, and people from all social backgrounds marveled at remarkable displays of electricity and new telecommunication processes. Telegraphy, for example, drew huge crowds to exhibitions that dazzled the public with mysterious technologies of remote communication.

Amateur and commercial photographers alike experimented with the deliberate evocation of "ghosts" in the darkroom even before the first genuine examples of spirit photographs were alleged. The natural philosopher and physicist David Brewster sparked interest in the manufacture of ghost pictures with his recommendation in the *Stereoscope* in 1856 that "for the purpose of

amusement the photographer might carry us even into the realms of the su-
pernatural," by using photography "to give a spiritual appearance to one or
more of his figures."[16] In 1858, the first year of its publication, the *Photographic
News* instructed amateurs how to make ghosts "appear half invisible in the
stereoscopic pictures . . . in the shop windows."[17] Editor William Crookes,
who as we have seen was eager to demystify photography, told practitioners
how to make spirit photographs in their darkrooms. He averred that the chem-
ical and optical process was "very simple . . . Arrange the subject with the per-
son whose ghostly representative you wish to secure, in the desired place, ex-
pose the plate in the camera (a stereoscopic camera with twin lenses should be
used) for about half the requisite time; then carefully cover the lenses, remove
the 'ghost,' taking great care not to disturb anything else, either of the furni-
ture or drapery, and then uncover the lenses, and expose for the remainder of
the time."[18] Amateurs also experimented with the practice. A stereo photo-
graph titled "Apparition" (ca. 1862) by a member of the Amateur Photographic
Association shows a young girl frightened by a vapory specter, illustrating an
early popular connection between amateur photography and ghostly subjects
(Fig. 2.5).

The invention of collodion photography around 1851 allowed shorter ex-
posures and saved time by alleviating the need to pose a ghost for each sitter;
it also offered a wider variety of possible ghost actors, since negatives could be
obtained from one of a number of circulating portraits. Yet, as photographic
editor H. Dennis Taylor pointed out years later, opportunities for fraudulent

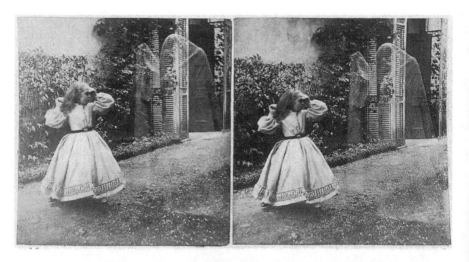

FIG. 2.5. John Revington, "The Apparition," ca. 1862. Stereo Pair. Amateur Photographic Association
Album, No. 22631. Royal Photographic Society Collection at the National Museum of Photography,
Film, and Television.

manipulation of the photograph were fewer with the wet-plate process than with the dry-plate process (in widespread use by the 1870s), a factor that contributed to the richness of the visual culture of spirit photography from the 1870s on.[19] In 1869, a Mr. Davie published a "Formula for Spirit Photographs" in the *Photographic News*. He explained how he used collodion and a method called "double printing." Davie recommended the preparation of plates for making two impressions. First, one ought to impress the plate with "some [celebrity] spirit"; next, one could photograph a sitter with the unclean plate.

> Select a very soft sample of glass, and make on it a negative of some spirit (say Benedict Arnold or Jefferson Davis, or any of our strong-minded women), and develop it with a weak solution of protosulfite of iron. Without washing, redevelop with bichloride of mercury until the high lights are as black as midnight; wash lightly, and flow the negative with a feeble solution of aqua fortis. Let this remain on the plate five minutes or more, then wash well and place the negative in strong sunlight to dry, to be left exposed to the light from six to ten hours. As soon as the plate is thoroughly dry, place a white paper behind it, so as to increase the strength of the light. Having got thus far, soak the film off in a feeble solution of concentrated lye. As soon as the film slides off, wash the glass under a stream of water, and stand it up to dry spontaneously. The plate is now ready for a second impression.[20]

Subsequently, he stated, "The ghost is etched in the glass, and all you have to do is to look until you see it; it may require a little imagination, but whether you see it or not, real or imaginary, the ghost is there, and will reappear when another negative or impression is made on the glass."[21] The report of a visitor to a photographic establishment in Brooklyn around 1869 provides a glimpse into this emerging new trade. Asked if he wanted a picture "with or without spirits," the customer was offered a wide range of "anything, from a grandmother to an infant, aunts, cousins, distant friends, in any style."[22]

From a technical and commercial novelty in the 1840s and 1850s, spirit photography evolved into a practice that invited serious scientific and philosophical interest beginning in the early 1860s. William Henry Mumler's own account *The Personal Experiences of William H. Mumler in Spirit-Photography* (1875) maintains the date of his first spirit photograph as a day in March 1861.[23] While making a self-portrait in the course of repairing a camera in Mrs. H. F. Stuart's Washington Street studio in Boston, he recalled, another human form appeared beside him in the photograph. Upon developing the plate, he began to see in the lower corner of the frame the faint image of a young girl sitting on a chair. She wore a short-sleeved, low-necked dress, and her image faded away beneath her waist. The chair could be seen through her body, as could a table on which her arm rested. The outline of the upper portion of her body was clearly defined, though "dim and shadowy." London papers reported that the photograph

"startled" Mumler, who instantly recognized the figure as a cousin, not materially present in the studio.[24] Another photograph made by Mumler around 1865 shows a young man seated in a chair, with a shadowy ghost figure standing behind him, reaching over his shoulder with what appears to be an anchor (Fig. 2.6). It was Mumler who provided the initial example, interpretation, and vocabulary for a phenomenon that captivated people for the rest of the century.

Mumler showed the picture to his friend, who laughed it off by explaining that the photographic plate had probably been exposed before and used unclean. The form was simply the result of a previous image on the plate. Mumler later claimed that he accepted this explanation because he lacked expertise in photography. Not long after, he was visited by a spiritualist friend. Mumler later stated that he wanted to "have a little fun, as I thought, at his expense," and he showed his friend the mysterious photograph and told him that he was alone when it was taken. The gentleman asked him to write that statement on the back of the image and sign it, which Mumler did. Curiously, he added the

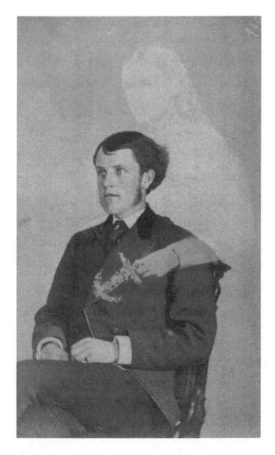

FIG. 2.6. William Henry Mumler, spirit photograph, ca. 1865. George Eastman House International Museum of Photography and Film.

inscription that he recognized the form as his cousin, who had died twelve years earlier. Mumler then gave his friend the photograph.[25]

Not long after, the New York spiritualist press announced that the first genuine spirit photograph had been taken. A description of the picture was given along with Mumler's statement. Mumler later claimed that he was "mortified" upon finding out about the article, especially when it was reprinted in Boston's spiritual journal *The Banner of Light,* with the address of the gallery where it had been taken. Mumler decided to visit the gallery to inform people about the misunderstanding. Upon arriving, he found the reception room full of people waiting to see him; everyone present desired a spirit photograph. Mumler refused and explained how his photographer friend had accounted for the image. However, one man, whom Mumler identified only as a scientist from Cambridge, "thoroughly acquainted with photography," insisted that Mumler's explanation was impossible because the latent-image theory—while valid for the daguerreotype process—was not so for the collodion wet-plate method.[26] Mumler agreed to take the scientist's picture, and after several failed attempts eventually succeeded in obtaining a spirit extra. Mumler was quoted later as saying that this experience "confirmed me in the belief that the power by which these forms are produced is beyond human control."[27]

By 1861, Mumler had worked for nearly twenty years as an engraver for the distinguished Boston jewelry firm of Bigelow Brothers and Kennard. In his autobiography, he claims that he was torn between his demanding jewelry-engraving business and this "wonderful phenomenon that needed investigation." Word of Mumler's success spread, and soon he was deluged with requests. Eventually he left his engraving job and began working full-time as a medium for taking spirit photographs. In this, he received assistance from his wife, Elizabeth, a spiritualist and local mesmeric healer who encouraged his first experiments. Elizabeth operated a spiritualist medical practice in an examination room that opened onto Mumler's studio, and she probably recruited many of his clients. Like many American female mediums, Elizabeth rose from humble beginnings to a higher social position and some measure of financial independence by exercising her healing powers. As a youth she earned a reputation as a natural clairvoyant for diagnosing and treating disease, and her mother was reputed to have been one of the best medical clairvoyants in the country. Her husband called Elizabeth "a perfect battery," adding that her powers were "magnetic" and that she exemplified "animal magnetism."[28]

Mumler's procedure of spirit photography was not substantially different from a portrait studio session. The person desiring a spirit photograph would pose as if for his or her own picture. The spirit "extra," as it was called, did not appear in Mumler's studio, but in the negative and the print made from it.

Mumler's spirit photography eventually attracted so much attention that he became the target of an undercover investigation that led to his being tried for fraud in a sensational 1869 trial in New York City. At the trial, where he was acquitted, several distinguished witnesses testified that they recognized their deceased ancestors in the portraits. Mumler and his lawyers concealed the fact that Elizabeth Mumler had acted as a medium, saying that she was the receptionist at the gallery, a common occupation for women married to commercial photographers. This was perhaps done to protect her from prosecution, as she also was threatened with indictment.[29]

By identifying the spirit as his cousin, Mumler redefined spirit photography more as a new way of visualizing the physical traces of heaven than as a subgenre of commercial photography. Increasingly after 1861, spirit "extras" were identified as recognizable deceased people, not simply as novel tricks.[30] Over time, the quality of Mumler's images became sharper, and the clarity of the likeness became the hallmark of success in spirit photography. One sitter from Maine who purchased a photograph from Mumler's studio wrote to the *Banner of Light*: "The likeness nearly overcame me, it was so plain. His collar and cravat are precisely as he used to wear them. It is as plain a picture to me as the one hanging in my room. We all see it alike, and I think any one who knew him *must see the likeness at once.*" Around the time of Mumler's trial an American judge exclaimed that it was "one thing to take a likeness of a dead person," but quite another to take a photograph containing a likeness of a person "of whom there is no photograph or likeness in existence!"[31] After all, if personal testimony by people who recognized alleged criminals in photographs was sufficient to convict fugitives they previously had not seen, how could skeptics rule out the ability to identify in photographs one's closest relatives, people one saw in life every day? Even ordinary portrait photography, as has been seen, often yielded disappointing results. So many portraits failed to please that sitters often took photographers to court.[32] Yet, here were dozens of sitters claiming to recognize instantly their deceased loved ones in spirit photographs.

A relatively new concept of heaven underpinned intellectual and cultural understandings of spiritualism and its associated visual practices, including spirit photography. As historians Colleen McDannell and Bernhard Lang have shown, a novel view of heaven surfaced in the eighteenth century with the writings of the Swedish visionary Emanuel Swedenborg, peaked in the nineteenth and twentieth centuries, and faded by the mid-twentieth. This perspective of heaven, which they term *modern,* has four characteristics. First, only a thin veil divides heaven from earth; "for the righteous, heavenly life begins immediately after death." Second, rather than viewing heaven as the structural opposite of life on earth, it is seen "as a continuation and fulfillment of material existence

. . . Delighting the senses, once perceived as a frivolous pastime, becomes a major aspect of eternal life." Third, although heaven continues to be described as a place of eternal rest, the saints are increasingly shown "engaged in activities, experiencing spiritual progress, and joyfully occupying themselves in a dynamic, motion-filled environment." Spiritual development is therefore endless. Finally, they suggest, "a focus on human love expressed in communal and familial concerns slowly replaces the primacy of divine love experienced in the beatific vision."[33]

Works of art from the eighteenth through the early twentieth centuries expressed these themes, showing social relationships and especially heterosexual love as fundamental to heavenly life (Figs. 2.7–2.8). Spirit photography must be seen, therefore, as part of a continuum with other contemporary visual representations of afterlife. However, there were other distinctive aspects of pho-

FIG. 2.7. William Blake, "Robert Blair's The Grave, A Poem. London, 1808. pl. 12: 'The meeting of a Family in Heaven.'" Engraving. Yale Center for British Art, Paul Mellon Collection.

FIG. 2.8. "They whom you call dead are alive amongst you, living as they lived on Earth only more really, ministering to you with undiminished love." Dorothea St. John George, watercolor, reproduced in "The Problem of Death," *Bibby's Annual* (1918): 43–44. The painting shows life in Heaven as visually similar to life on earth—only blurrier.

tography's special relationship to spiritualism. Both were concerned with invisible natural forces that scientists found hard to explain. An American physician and photographic chemist, Dr. Child, announced that the "best and oldest photographic artists in Boston" were "unanimous" that they did not know how Mumler's spirit photographs were produced. Child informed readers that he was aware of the modes by which the photographs might have been simulated, one of which was to place another negative in contact with the sensitive plate, already containing a latent image of an actual sitter, and allow the light of a lamp to pass through the negative. He claimed that he had seen a spirit photograph so produced, but the fake was distinguishable from the "genuine" spirit photograph by having a "very marked yellow tint, the *result of the artificial light of the lamp!*" Mumler invited Child to "bring [his] own glass" and test the phenomena: "to examine the camera, its tubes, and lenses; his chemicals; to see him apply the collodion to the glass, and immerse it in the silver bath; to see him take it out of the bath and put it in the shield, then in the camera, and then to go with him into the dark closet . . . and see him take the glass from the shield, which is a little dark box, then pour on an iron preparation, wash it under a stream of water, and then hold it to the little lamp."[34]

Mumler by his actions established the precedent for examining spirit photography in situ. Child testified at the trial that he "carefully observed all the above operations in detail," and attested that he saw a "picture of a mortal and a spirit on it." William Guay, an American practical photographer with ten years experience, agreed that it was difficult to know how Mumler did it. In 1863

Guay reported to the *Banner of Light* that he "went through the whole operation of selecting, cleaning, preparing, coating, silvering, and putting into the shield, the glass upon which Mr. M. proposed that a spirit form and mine should be imparted, never taking off my eyes and not allowing Mr. M. to touch the glass until it had gone through the whole of the operation. The result was, that there came upon the glass a picture of myself and, to my utter astonishment—having previously examined and scrutinized every crack and corner, plate-holder, camera, box, tube, the inside of the bath, etc.—*another portrait.*" "Those who are so carefully making their investigations are not ignorant of the manner in which the well-known stereoscopic ghosts are produced," stated Dr. H. R. Gardner, addressing the Boston Spiritual Conference. "The pictures themselves" furnished "evidence" that their "gauze-like appearance . . . has not been imitated."[35]

Others thought the spirit photographs had been "cooked." Dr. Woodward, an American physician and photographer, explained in the British press how he thought Mumler had made the spirit photographs. Mumler, he reasoned, had selected a plate of glass containing considerable alkali and placed it in a solution of caustic potassa for a few hours. Then he had cleaned the plate with water and rottenstone, selected an adhesive collodion, and taken a negative in the ordinary way on the plate "of some one whom you wish to appear as a ghost." In finishing, he had dried it thoroughly, using heat, and omitted varnishing. He then removed the negative picture by scouring it with rottenstone and water; when the plate was apparently perfectly clean, he stored it for future use after marking the side on which the picture was taken. Finally, he took a picture in the ordinary way on the side thus prepared, and the last image was distinct, while the former appeared as a ghost. The theory was that the kind of glass he selected was etched very slightly by the potassa solution, so that in making the first picture (ghost), the coating of collodion and iodide of silver, after drying, adhered with such tenacity to the granular surface of the plate that no ordinary amount of scouring would completely remove the silver compound, "although the plate appears to be perfectly clean and transparent."[36]

Both then and now spirit photography polarized viewing audiences. Even among Anglo-American practitioners of mesmerism, phrenology, and spiritualism, many people denied its credibility. In the September 1863 *American Phrenological Journal,* a phrenologist entertained the idea that spirits of the departed could appear on a sensitive plate but ultimately concluded that Mumler's photographs were not evidence of this kind. Only "weak" people, he asserted—the example he gave was of a grieving mother—were easily "deluded" by spirit photographs, saying that the "poor mother" takes a "rounded something, like a foggy dumpling," for her infant.[37]

British photographers quickly learned of Mumler's photographs but had to wait to see the originals. As in America, the topic frustrated British photographic experts, many of whom frankly admitted they did not know how it was done.[38] Whatever their opinion, most photographers appear to have sensed that spirit photography was an unprecedented and significant crucible in which their medium would be tested and shown to be either an elevated tool of discovery or a low one of imposture.

For many British photographers, Mumler was an unskilled artist attempting to make money by duping the public and, in the process, lowering the photographic profession in the public eye. Soon after Mumler's announcement, the *Photographic News* apologized to its readers for "occupying their attention" with a matter that they styled a "pitiable delusion originating in shameful fraud or mischievous trickery . . . Our business is not, however, with the general claims of what is termed 'Spiritualism,' but with a phase of it in which our own art is prostituted to purposes of imposture, and which we feel called upon to lay fully before our readers, if not to denounce." The "faith of photographers" had been "challenged on new grounds." One British practitioner complained that photographs of ghosts were "abortions" and a "pitiable delusion." He expressed the wider fear that photography was "brought into disrepute by being made subservient to such an impudent trick."[39]

Questions of "tricks" and secret formulas threatened the fragile sense of community that many photographers were trying strenuously to forge. Quite aside from spirit photography, photographers were increasingly concerned about their own capacity to be duped by pictures even outside the context of spiritualism. In 1869, reviewing a recent photographic exhibition, one photographer complained that photographers "appeared generally to be imbued with a wholesome fear of 'tricks' by which they might be seduced into admiring as a wonderful natural effect anything which was the result of a manipulatory dodge on the part of the photographer." He proposed that "the fear of deception in many cases had "paralyzed the perception and warped the judgment."[40]

Many photographers were dismayed when spirit photographers claimed (as they often did) that they had no idea how their images happened. This was especially frustrating at a time when photographers were uniting around the imperative of rationalizing the photographic darkroom and making its hidden secrets visible. As one photographer explained: since a "dark-room is indispensable in photography, and as in the case of spirit-photographs, there appears to be a necessity for the photographer to have the plate in his possession in some such room, for the purpose of magnetizing it previous to its being placed in the camera, a suspicion naturally arises that this offers an opportunity for playing a trick."[41] One photographer was so outraged that he compared Mumler's spirit

photography to commercial sex; as he put it, "our own art is prostituted to purposes of imposture." The writer of a January 1863 *Photographic News* article about spirit photographs sarcastically summoned "Joe Smith, Mormon prophet" to help discredit the "barefaced impostors."[42]

The debate carried into scientific and popular-science culture. The *Photographic News* editors initially gave the announcement about Mumler's photographs a chilly reception, a result that might reflect the editorial leadership of Crooke's successor G. Wharton Simpson, who (unlike Crookes) was unsympathetic to spirit photography.[43] In light of the journal's strong emphasis on the need for sharing secrets, it especially irked the staff that the spirit photographs were not available to the public for free inspection. Photographers wanted to see the physical evidence. Hearing that the British-based *Spiritualist Magazine* had purchased some of Mumler's photographs and advertised them for sale, Simpson blasted what he saw as the magazine's hypocrisy: seeking "material cash" while promising "spiritual truth." Remarking on the unseemly commercial character of the exchange, one *Photographic News* writer complained that spirit photographs were "sold in *sealed packets,* like some other matters of more than questionable character."[44] The reference here was to pornography, which connected spirit photography with the photographic underworld that editors sought to reform and censor.

The journal's stated purpose was to expose "all that transpires in the photographic world, whether it be useful or ridiculous," even if it meant reimbursing correspondents for posting them prints.[45] Commensurate with this intent, a *Photographic News* editor who bought three of Mumler's photographs from an American magazine described them. "The first picture contains a portrait of Mumler, the 'medium and photographer,' standing with his hand on a chair." The next showed the "spirit" of a young woman, "attired in the ordinary costume of the material world as worn in the nineteenth century and sitting in the conventional position, with one arm on the table holding a book and the other laid across a lap, as doubtless Mr. Mumler is in the habit of posing young ladies." Mumler had printed a note on the back of the photograph identifying the spirit as a woman who had been recognized by her relatives. The correspondent reported: "In the printed description at the back it is stated [that] 'in the chair sits a half-defined female form,' and that 'this was at once recognized as a deceased relative.'"[46]

The printed description did not sate the public's hunger to see Mumler's spirit photographs. Rather, the article sparked as much public interest in the scandal as was given later to the sensational trial of Oscar Wilde.[47] Just as scientific discoveries could hinge on a single, opportune photograph, many believed that just one honestly produced spirit photograph justified the enterprise.

Because of photography's evidentiary weight, a London photographer and spiritualist pointed out that "a spirit-photograph cannot be argued out of sight; it must take the first place as evidence."[48] Another contemporary queried who was to say that spiritual beings could not be photographed, if they existed? For "who will deny the possibility of photographing the angels who appeared unto Abraham, partook of food, and conversed with him for a considerable time? . . . Spirit photographs may seem absurd now but so did scientific discoveries ridiculed in other ages."[49] As one British photographer declared, "If the spiritual phenomenon is a reality—and as a reasonable man I cannot reject the evidence in its favour—why should the announcement that spirit photographs had been obtained come upon us as a 'good joke', or even excite our astonishment?"[50] Science for years had claimed to build a foundation of knowledge on the seventeenth-century natural philosopher Francis Bacon's injunction to accumulate observations, even those that seemed insignificant or unbelievable at first. Another photographer implored: "Let us be Baconian, even to our ghosts," and signed his letter: "I am not a Spiritualist, but ONE WHO WAITS FOR FACTS."[51]

Photographic experts who helped lay the initial foundation for public faith in democratic possibilities in photography now faced the difficulty of convincing others that spirit photographs made by amateur and professional photographers, including scientists, were illegitimate. Judge Edmonds, a former New York Supreme Court justice and state senator, and himself a spiritualist, testified that while not prepared to "express a definite opinion" in the matter, he was convinced that "the camera can take the photograph of a spirit" and that it was better to "wait and see" than to falsely accuse a spirit photographer of fraud. Explaining why he spent money on spirit photography, one contemporary in Britain stated that "this question is *the* question of our time, and I would rather spend money on it than anything beside."[52]

Many British photographers, like their American counterparts, simply thought that Mumler was a poor or careless experimenter and that his photographs belonged in the category of unskilled practice rather than fraud. Upon viewing the photographs, one photographer reported that they were the result of old, poorly cleaned plates which might have been produced by "accident, and afterwards presented as a joke." Another pointed out that Mumler's own physical descriptions of spirit photography—and of such terms as "cloudy vapours," "white undefined masses," "blurs," etc.—resembled how one spoke about fogs and stains in failed photographic plates. That the image of the ghost was often of a different size than the sitter also raised questions about the photographer's skill regarding the focus. Remarks like these, which faulted Mumler's skills rather than his honesty, were part of a wider effort to reform photography by elevating its practice. As one photographer put it: "The half-

defined female form is simply and palpably, to the eye of any experienced photographer, the smudgy trace of a former image on an imperfectly cleaned plate." Two of them, in particular, bore the marks of a problem that had plagued "almost every photographer of any practice."[53]

Others took a darker view of Mumler's honesty and credibility.[54] The same photographer who thought Mumler was sometimes careless also argued that Mumler had crossed the line between trickery and fraud in one picture in particular. Referring to a photograph of Luther Parks with the spiritual form of his deceased nephew, he declared that it bore evidence of "intentional imposture." He referred not to Mumler's practice, which he had not witnessed, but instead to how the figure looked: "It is robed in flowing white drapery, with something like a nimbus, or it may be a fancy night-cap above its head." In its "general position and aspect," the "conventional and time-honoured ghost" reminded him too much of allegorical paintings of Victory crowning heroes. Moreover, the ghosts were "too indistinct in feature to identify," and "although representing persons dead for half a century, they appear attired in the mode of today." Therefore, they presented "internal evidence" of their "mundane source, stronger than all the testimony as to their spiritual origin."[55]

American photographers began reporting in the late 1860s that the pictures by Mumler and his rising cadre of imitators were being made by modes ever more difficult to detect, and British photographers scrambled to resolve the mystery. Editors at the *Photographic News* supposed that, after a plate was exposed, a transparency of another portrait was placed at the back of the plate and given a momentary exposure. Some photographers thought that Mumler's ghosts could be replicated by a lens introduced into the camera, by the imposition of a positive plate on the negative, and by the transmission of light through it in the bath. They thought this explained why Mumler so confidently combated the "dirty glass with an old impression explanation" with offers to produce them on new glass that the investigator himself could obtain and give, marked, to the photographer. Convinced that a friend had been deceived, one correspondent showed his friend "how a fraud could be done, by putting a transparency on the exposed plate before development, and exposing it for a few seconds."[56]

The spiritualist press also paid close attention to how photographic journals covered spirit photography. Like photographers, spiritualists in England were divided over the veracity of the photographs, even, initially, without seeing them. Although the *Spiritualist Magazine* expressed hostility to spirit photography, it also contained articles that gave it credence and that distinguished between "real" and "sham" spirit photographs. Once, stung by criticism of spirit photographs, a writer for the *Spiritualist Magazine* challenged skeptics at the

Photographic News to try the experiment themselves: to produce likenesses of deceased sitters whom they had not known in life, and without the collusion of the living sitters, in the presence of "honest and experienced investigators." The *Photographic News* staff often refused. One writer hotly replied in 1863 that "when the editor of the *Spiritual Magazine* [*sic*] will furnish us with sitters, and investigators who will be willing to accept patches of white paper without a trace of feature . . . as 'strong likenesses,' . . . we shall unhesitatingly produce any quantity of such likenesses."[57]

The Photographic Studio as a Scene of Spiritual Revelation

It was almost ten years after Mumler's announcement in the United States that most people in London saw what the "real" spirit photographs actually looked like, or participated in their manufacture. As it turned out, they looked a lot like those manufactured and sold as commercial amusements.

The first genuine spirit photograph in England was announced by the celebrated medium and publicist for spirit photography, Georgiana Houghton (1814–1884). Born in Las Palmas in the Canary Islands, where her father was a merchant, Houghton spent most of her life in London. Never married, Houghton trained as an artist and established herself as a painter but gave up her art in 1851 upon the death of her youngest sister Zilla. In 1859, she heard from a cousin of the possibility of communicating with the dead and began attending séances at a neighbor's house in order to connect once again with her sister. A fervent Christian, Houghton soon became a medium herself. First she practiced "table tipping," and then began transcribing messages through a device known as a planchette. In 1861 she learned of a Mrs. Wilkinson's automatic drawings and was inspired to take up automatic drawing herself. Houghton initially used pencils and then switched to watercolors and was amazed by the results, declaring the method to be "completely different from any I had ever seen, producing a transparency of effect that is quite marvelous . . . while at the same time possessing a richness and brilliancy which filled me with more delight as each drawing was done." At this point she realized that she had found her "life's work," and her artistic career was rejuvenated by her new technique and her ability to communicate with spirits. Houghton continued to produce automatic watercolors for another ten years until hampered by the financial difficulties brought on by the death of her parents, who had been her providers. She reportedly exhibited over 150 spirit drawings at the New British Gallery in London's Old Bond Street in 1871.[58] Houghton's brothers refused to help her on account of her involvement with Spiritualism and because (they alleged) she spent all her savings in exhibiting her work, so Houghton raised money by switching to a more lucrative profession—serving as the medium for the photogra-

pher Frederick A. Hudson. She summoned spirits, he photographed them, and they charged for the results. Houghton is a prime example of a medium, interpreter, entrepreneur, and publicist. She also illustrates how people shaped the cultural idea of photography, even when they did not practice it themselves. She eventually published a book about her experiments, *Chronicles of the Photographs of Spiritual Beings and Phenomena Invisible to the Naked Eye* (1882) (Fig. 2.9).

Historian Robert Cox has suggested that spirit photography represented a conservative trend within American Spiritualism because "in nearly every case in which a female spirit is positively identified by a sitter, the spirit is specifically situated within a domestic context, as wives, mothers or children of the living." It is, he writes, "as if the 'bonds of womanhood' have transcended the grave and the affective ties that unite a woman with her husband or child remain intact despite the biological inevitability of death." Cox is right to point out that spirit photography worked in many (although not all) cases to natu-

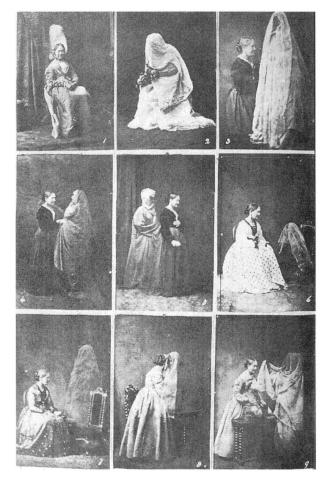

FIG. 2.9. Spirit photographs by Hudson and Houghton, ca. 1873. *Cartes de visites.* Plate 1 in Georgiana Houghton, *Chronicles of the Photographs of Spiritual Beings* (London: E. W. Allen, 1882).

ralize the ideologies of separate spheres, including domesticity and female spir-
ituality, especially on a symbolic level. As women's historians have pointed out
in other contexts, however, the ideology of domesticity did not always restrict
women's ability to wield spiritual authority, as Cox claims.[59] Women figured as
more than simply "spirits," and their involvement with spirit photography
helped expand the scope of spiritualism beyond the home and into the com-
mercial public sphere.

From the beginning, women played a key role as makers and consumers of
spirit photographs. Mediums were crucial to Spiritualism, and in late-Victo-
rian England, many mediums were women, for women were widely seen as the
more "sensitive" sex. Whether or not they sat in the studio, female mediums
played a crucial and often overlooked role in promoting spirit photography by
suggesting that sitters have their photographs taken. More middle-class women
at this time were picking up photography as a hobby and, to a lesser extent, as
a means for professional employment. The spirit photographer Sarah Power
(about whom more is said later) learned photography as a hobby from a com-
mercial operator who was also a spiritualist. Well into the early twentieth cen-
tury, the community rituals surrounding women's roles in spirit photography
shared much with their roles in spiritualist activities, such as spiritualist painting
(Fig. 2.10).

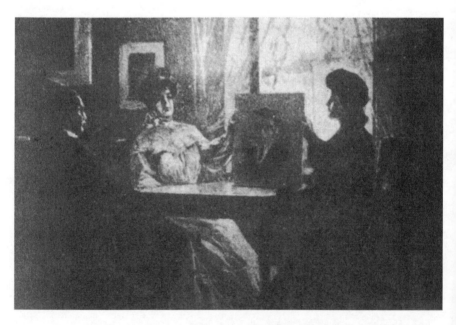

FIG. 2.10. Illustration of a spiritualist séance, illustrating the matter of sitting for a spirit portrait painting,
ca. 1894. Two mediums (possibly the Bangs sisters of Chicago) hold a canvas before a male sitter, seated
left. In James Coates, *Photographing the Invisible* (London: L. N. Fowler, 1911), 293.

Women of all classes also had an intimate and practical relationship to death that grounded their interest in spirit photography. More than most men, women sat with the sick and dying, prepared their bodies for burial, and wrote condolence letters to the grieving. Men were expected to control their feelings more, and women often sought emotional solace from female relatives and friends. Those who were economically dependent on male relatives were particularly vulnerable when a husband, father, or brother died, and leaned on other relatives not only for comfort but also for financial support. Spirit photography acquired meaning in these social networks of consolation, in which women frequently came together to grieve and to imagine what their futures would be like after a loved one's death.

About ten years after Mumler changed from being a jeweler's engraver to a spirit photographer, Houghton made the transition from spirit flower painter to publicist for spirit photographers. In 1872, she announced the startling news that the first genuine spirit photograph had been produced in London. In a letter to the spiritualist press, she wrote: "It may be rather early to announce the new *fact* while in its embryonic state." Yet, she declared, "being a *fact,* you will be glad to learn that a spirit photograph has really been obtained here in London, and I trust that all the details may be interesting to you and your readers."[60]

Houghton's story took the form of an eyewitness account. As she later explained, one day she went to Hudson's studio with her friends and neighbors the Guppys, prominent London spiritualist mediums, who had already begun one trial of photographic experiments with Hudson. "I went on Thursday last, March 7th, to Mrs. Guppy's, and in the course of the afternoon, Mr. Guppy shewed me three photographs, and told me that the spirit who usually converses audibly with them had given particular instructions as to the needful arrangements to be made, which they had carried out at the photographic studio of Mr. Hudson."[61] Mrs. Guppy had entered a dark cabinet behind Mr. Guppy. Mr. Guppy, while sitting for his photograph, felt a wreath of flowers placed on his head. In this first picture, a large veiled figure appeared beside Mr. Guppy.[62]

The publicity that Houghton generated about Hudson's photographs created tremendous interest in actually seeing them. William Harrison, the editor of a major London spiritualist magazine, confirmed Houghton's findings. He published testimonies that reinforced claims about the evidentiary status of spirit photographs much as scientific testimonies generally did. He reported that "Mr. B. Pycock, of Brook's Hotel, 33, Surrey-street, Strand, had obtained a clear picture, with features and the whole face so distinct as to be beyond doubt, of a lady some years 'deceased,' standing by his side." Similarly, a Mr. E. Russell, of the Post Office, Kingston-on-Thames, had procured a "clear likeness of one known to him; the falling drapery is caught by his knees and feet,

and so hangs in folds about himself that it could not have been produced by double printing."[63] Meanwhile, several London practitioners wrote to the photographic papers, maintaining that their visits to Hudson converted them to belief in the plausibility of spirit photographs.[64]

The practical procedures of spirit photography usually required the participation of the medium, whose involvement varied from person to person. Houghton generally stood close to the wall, about halfway between the sitter and the camera. "I told Mr. Hudson that after he had uncapped the lens, he was to wait for me to say, 'Now', before covering it again"; the spirits "judge best how long an exposure is needful." Large, and expensive, plates were deemed critical to the experiments, which their critics would argue was implied in the deception. Houghton defended Hudson's practice, saying that if he acted on the "stingy suggestions" of sitters and used smaller plates, "many of the spirits would be lost altogether." For, she explained, the spirits "cannot always approach close to the sitter, nor is it possible to know beforehand on which side of him it could appear, therefore if a space were left in readiness, it might be on the wrong side."[65]

Houghton explained that many experiments might be required before a successful spirit photograph was obtained. She elaborated on this in a published theory in which she argued that spiritual mediumship was crucial but also "insecure," for the power of mediums could pass away at any moment. Her theory of spirit photography mediumship, like nineteenth-century theories of economic systems, was powerfully informed by scientific concepts of the conservation of energy. According to Houghton, spirit power was gathered as a "reserve force"—to be used "in combination" with the power "*naturally* issuing forth" from the medium and the sitter. Her theory coalesced with Victorian scientific interests in the physics of fluids. The "reserve force" theory explained many things, including why a full figure was not always manifested, as when daggers were held by unseen hands. She thought that spirits generally showed "wise economy" in using the reserve force, only using what was "absolutely needed." When arms and hands (only) appeared in a print, for example, this suggested that spirits were simply conserving their emanations or that "atmospheric impediments" (earthly or spiritual) necessitated a greater expenditure of reserve force. The spirits were careful not to withdraw too much from the medium's "vital powers." Houghton's reserve force was often called on because of Hudson's own weakness. She thought this explained why Mumler became "exhausted after taking three or four negatives in a day . . . perhaps his spirit friends may not be quite so careful, and may go on drawing on him while he is at work." Sometimes, the emanations from the mediums and the sitters might not "harmonise and amalgamate," in which case, "no good photograph can be

the result." Houghton recalled being visited by "spirit friends" who were busy "gathering the emanations from me for these photographs in the same manner that they were accustomed to do in preparation for my séances."[66]

Houghton's theory of spirit photography also was informed by an awareness of Victorian portrait studio practice. Houghton impressed on sitters that they must try to be in a "perfectly healthy state of mind and body" at their sittings, "so that their atmosphere may be thoroughly receptive of the spirit-presence." Once she even criticized a sitter for coming to the session "fagged," or tired, after staying up late at a séance the previous night, reflecting contemporary advice from photographers to consumers.[67] Victorian photographers complained that failures in portraits were frequently caused by the difficulties involved in making sitters comfortable and relaxed. As one photographer explained, the sitter was placed in conditions "all new and strange," and the manipulations and anticipation created "self-consciousness and anxiety which fill the mind at the critical moment." The result was often a "constrained and unnatural expression."[68] Writings on how to achieve that all-important criterion of "likeness" in portraiture emphasized the need for a "quiet and natural" session and restraint from theatricality on the part of the sitter.[69]

Houghton, too, believed that a relaxed environment was most conducive to a natural photograph, one that brought out the best likeness of the ghost. She wrote that "the more quiet and passive and patient the circle, the better the result in that as in other forms of mediumship." She therefore harshly criticized the presence of cynics and skeptics, holding that their negative energy interfered with the success of the experiments.[70]

Sitters at photographic séances often did not immediately recognize their deceased friends and relatives in the portraits—a problem that, as discussed in chapter 1, plagued portrait photography more generally. Spiritualists, including Houghton, sometimes blamed the fact that the sitters' own mediumistic skills were only partially developed. According to Houghton, it helped if everyone participating concentrated their thoughts on obtaining a particular likeness, as with the photograph of the dead mother of a young child. "People express and feel great disappointment when they do not see the face ardently hoped for on the photographer's plate," she explained. If those persons just realized the "very great difficulty experienced in preparing the sitter for this work," they would try to be patient.[71]

As Mary Cowling has shown, Victorian history and scene painters were judged on their ability to depict class position and moral character using contemporary physiognomic visual codes.[72] The study of physiognomy and emotions was regarded by photographers on both sides of the Atlantic as a central aspect of their practice, another context in which skill was regarded as impor-

tant in the production of truthful interpretations of photographs.[73] Houghton, who was familiar with the application of physiognomy to art, declared that she herself had great skill at recognizing persons in photographs, even when she had not known them in life. "I have been as closely trained in the study of faces during the last year that my eye has been thoroughly educated," she declared. Shortly after Houghton began her experiments, around the same time as the Tichborne claimant trial, Francis Galton began experimenting with composite photography in an attempt to reveal hidden truths about people. Houghton's suggestion that manipulations of technique were central to physical investigations of otherwise hidden or "occult" resemblances between individuals, families, and groups was therefore, in many ways, in vogue.[74]

Spirit photography was a kind of funeral rite, and the preparation of dead bodies involved their draping. Drapery was also used widely by commercial studio photographers to confer theatricality and dramatic effect. The texture of the drapery was deemed especially important in interpretation of spirit photographs. The "dead inertness" of drapery seen in a photograph of a live sitter was often contrasted with the vitality of drapery on spirits, reflecting the view that the transparency of the drapery provided a physical register of the spirit's vitality after death. Houghton described the drapery on a spirit in one picture as "beautifully transparent"; it "flows very gracefully." In another picture, a ghost's draperies were described as "exceedingly various, ranging from a most gauze-like transparency to rich satin-like folds, as in the robe worn by my Aunt Helen."[75]

In spirit photography, practitioners competed for patronage and prestige. Even as she insisted they were genuine, Houghton was often critical of the quality of others' spirit images. Of Mr. Reeves's photographs, she wrote: "They have not the material texture or appearance of those produced by Mr. Hudson, but more nearly resemble the spirit-forms of Mr. Mumler's photographs, which are, however, of a greyer colour and more defined in outline."[76]

Spiritualists often confessed publicly that they themselves did not believe *all* spirit photographs were genuine. Houghton announced on many occasions that "counter-feit spirit photographs" were made in various quarters; in fact, she publicly exposed them. Nor did she deny that some failures were chemical or optical; like many photographers at the time, she blamed "untoward influences at work" in the bath for problems such as decomposed pictures. Most of the photographs would only have "the slightest interest" for any one as pictures; however, for her, they were "valuable as marvellous evidence of spirit powers." Yet like ordinary experiments, "each manifestation is a step towards that which is yet to come . . . If only a single genuine spirit-photograph is obtained, it carries with it the whole principle of Spiritualism, and proves that spirit-photog-

raphy is possible, just as a single instance of spiritual apparition, well established, overturns the whole fabric of materialism."[77]

Hudson and Houghton made an unusual pair in the studio. In her notebook, Houghton noted that mediumship in Hudson's glasshouse had to be exercised "under peculiar difficulties, so that the case is very different to that of mediums comfortably seated in warm rooms to obtain other phases of manifestation." Hudson's studio was modest, its side and roof lights curtained with old and stained curtains. At one end was a background painted in oils, standing about two feet from the wall. At the other end was the operating room, lit with yellow light. The bath was a common porcelain type without a lid. The apparatus was an 8″× 10″ bellows camera, drawn in to suit a portrait lens with a back focus of about six inches.[78]

At odds with Hudson's shy and cautious persona, Houghton's own nature was assertive and robust. One observer noted that Hudson used to be so nervous that several times in the most critical moment the glass "slipped from his trembling fingers," and "whatever might have been upon it" was "utterly lost." Houghton herself was often aggrieved with Hudson. Once when taking a plate from the slide, Hudson had let it slip from his fingers into the tank, leaving the film with an exposure of Houghton's deceased father so damaged that she declared it "a failure." To relieve Hudson of his nervousness, spirit photography sessions often became "purely curative," wrote Houghton.[79] As we saw with the testimony of the photographic man in Mayhew's *London Labour and the London Poor* in chapter 1, many thought the camera was mesmeric. The relation was more than metaphorical.[80] Eliminating Hudson's nervousness by mesmerism was key to the success of his experiments. Once, when criticism left Hudson "flurried and out of sorts," she comforted him by mesmerism "as well as I could." Often at these times she would mesmerize him by burning frankincense before sittings. Once she went to a chemist's and chose gum olibanum to clear away "unholy influences." The bronze Javanese incense-burner she used to cure him can be seen in some of the surviving photographs. Houghton's work in healing Hudson was part of the wider interrelationship she saw between spirit photography and health: "While I am acting as photographic medium, I am placed in especial rapport with my sitter, and may thus be enabled to impart healing influences."[81]

Houghton's self-representation as a heroic investigator and professional healer built on and transformed prevalent images of male scientists, such as James Glaisher, John Tyndall, and Edward Whymper, who published popular narratives in the 1860s and 1870s about their risks and adversities in the service of science and public health, and who similarly relied on the help of people from a lower social class.[82] As Houghton stated, "in these earlier stages of spirit

photography, much of the work must be experimental." At a time when middle-class women were warned not to go to the photographer's studio alone, Houghton carried out experiments with Hudson for over four years, from roughly 1872 to 1876. She paid more than 250 visits to Mr. Hudson's studio, sometimes by herself and other times with paying sitters. For her own private studies, she wrote: "there is no other person when I have my own sittings, we have the glass-house to ourselves, where no intruders are admitted." The glasshouse was often dark, covered with leaves and snow. Heavy rains often flooded it. Weather was always an adverse external agency. "The long continuance of unfavourable weather has been strongly against the progress of this peculiar phase of mediumship, as it is of course detrimental to phenomenal manifestation as well as to the material work, which we all know needs good atmospheric conditions, therefore we can not be surprised that the pictures should often be failures as specimens of photographic art," though "none the less valuable" with reference to "the cause of Spiritualism." When the studio flooded, Hudson had to dig hard to make drains and trenches to carry away the water; and they also had to carry chairs and all the camera equipment into the house. Once they tried the experiments in her own home but found the situation cumbersome. The "dark closet" was in the "lowest depths," so that "Mr. Hudson and I had to toil up and down a long amount of stairs for each plate." A gust of wind through Mr. Hudson's garden studio once threw the background screen against her during a sitting. "Spirit-photography has to be carried on by standing about, perhaps for hours, in a cold, damp glass-house, with all sorts of atmospheric impediments to contend against, as well as fatigue of body and nervous anxiety." Some problems were technical, including broken negatives, which were on thin glass. Often the challenges were of a supernatural nature. Curious phenomena often startled them, such as chairs moving, palm branches falling into a sitter's lap, and hair combs being withdrawn by spirit hands. Houghton reported that "there were many other difficulties" that "it would be impossible to detail." These included "pinpricks and sharp arrows" and "wheels within wheels." In all of these situations, Houghton stressed her willingness to endure discomfort for the sake of knowledge. When a screen blew against her and pinned her with its weight, she was thankful that Hudson did not see the accident and rush to her rescue, for "in his flurry he would have rushed over to me" and "spoiled the picture."[83]

Rather than being simply oppressed by the scientists who came to investigate her practice, she courted their interest and participation as a way to expand the market for the photographs, from which she derived an income (as she had done from her spiritualist flower paintings). Houghton's experiences bear out the remark, made many years later, that when women made photographs, es-

pecially when they were not "detected" in the act, they "experience[d] a sense of power which borders on the supernatural."[84] Although she transgressed the usual gender norms by undertaking scientific investigation of the immaterial world with a camera, Houghton was less like a scientist in claiming supernatural powers over the machine. She considered herself a creative director of the spirit photography experiments. While some photographers, such as John Beattie, denied the importance of the medium, Houghton, like most spirit photographers, held that a spiritual medium, or "sensitive," was crucial to the enterprise—as or more crucial than a sensitive photographic emulsion. Unlike those who vested the camera with supernatural powers, Houghton herself claimed special spiritual powers over the machine. Houghton often interpreted photographs with a Bible before her. Once, when she was having difficulty interpreting the meaning of "one curious stereograph," her eyes fell on a verse from Psalm 107: "O that men would . . . *declare* the wonders that He doeth for the children of men!" Immediately she looked at the photograph and noticed something she had missed before: a spirit-form, possibly of an angel, for at the back of the ghostly figure there seemed to be a wing.[85]

Far from being a solitary investigator, Houghton was at the center of a large social network. Like her flower-painting circle, this community was structured around the requirements of economic entrepreneurship and religious devotion. For a single independent woman like Houghton, the ties she forged with other women were vital sources of support. The practices in which she and her friends engaged were religious, but like many other religious practices, they had deep social and economic significance. Houghton rejoiced in the "great outpouring of spiritual gifts in these days, especially to women, of whom there was to be a linked chain—as if to work with one another." The spiritual union of women acquired visual expression in Houghton's photographs, such as this one, of Houghton with two friends, joined by hands and an apparitional blur (Fig. 2.11). Another photograph showed Houghton and a female spirit standing face to face, "her right hand is within mine, while with the left she gathers the drapery under her chin." There was "something" passed around her left shoulder, "almost like an arm." After examining it closely, her friend Mrs. Tebb declared, "It is a ray of coloured light, flowing from her to you; they are shewing it to me," adding: "It is the link binding you to each other." A time was coming when "that link will be perceptible to all of us," and thus they should "*know* with whom we may beneficially hold communion" and who they ought "not to have anything to do with."[86]

The use of light as a link often entered the spiritualists' ritual language. Houghton discussed one photograph showing a ray of light flowing from her to her beloved deceased sister, Zilla. Again, as her maid Charlotte said of the

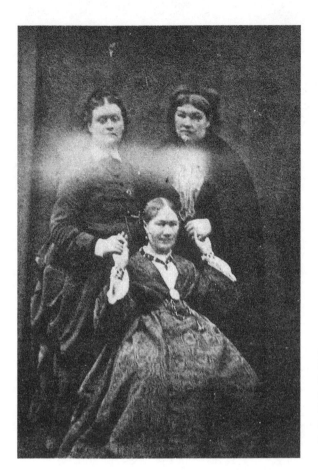

FIG. 2.11. Georgiana Houghton with friends, joined by a "blur" which she interpreted as a symbol of the union of their friendship. Plate 4.28, Georgiana Houghton, *Chronicles of the Photographs of Spiritual Beings* (London: E. W. Allen, 1882).

light in this photograph, "it is the link binding you to each other." Houghton yearned for the day when the "links binding them" would be "visible and perceptible." Another photograph shows Houghton standing with her deceased aunt Helen behind her (Fig. 2.12). As Houghton reported in her book, her aunt was the "first to give me any promise with reference to the work to which I have been called. " It was she who gave Houghton the money to fund her spirit drawings exhibition. Spirit photographs often revealed what people already knew. Her maid Charlotte, whom Houghton believed to have mediumistic powers, said, "She seems as if she were propping you up." Added Houghton, Helen "certainly may be said to have *pecuniarily* propped me up ever since Mamma's death."[87]

Houghton's commentary on the photography séances reads like a diary of social occasions, many of which occurred outside the studio proper: "Mrs. Tebb was here on March 28th, and we talked over many of the photographs, which were spread out on the little table before her."[88] Spirit photography opened a whole world of remote communication to Houghton and her friends. They

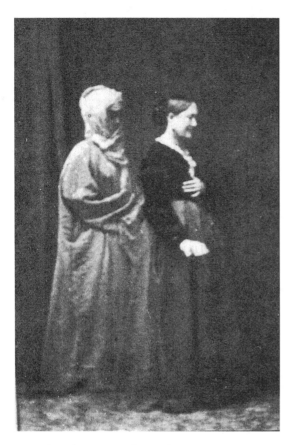

FIG. 2.12. Houghton (left) with a relative. She interpreted this photograph as a sign of the support she received from women kin. Plate 1.5 in Georgiana Houghton, *Chronicles of the Photographs of Spiritual Beings* (London: E. W. Allen, 1882).

manifested great pride in the photographs, which possessed value as artistic specimens and as moral, empirical proofs of heaven. Houghton interpreted one as a communication from the spirit of Salome, the mother of James and John in the New Testament. Biblical personages represented in the photographs also included John the Baptist (Fig. 2.13). Another frequent spiritual visitor to Hudson's studio was Joan of Arc, the French saint and visionary.

Houghton and her friends extracted moral and aesthetic lessons from photographs. Houghton urged that by means of photography, spiritual lessons could "reach the heart through the eye" and make the impression "permanent." One image of a female sitter with a female spirit "clad in tattered garments" suggested to her a sexual admonition; the sitter was indicted by the spirit's white robe having become "a filthy rag." She found another photograph conveying an "awful lesson." In it was a spirit "without any covering" except a cloth around his loins. "Unseen teachers" told her that while upon earth he lived for himself alone, "weaving himself no garments for eternity by clothing the naked." Now, after death, he was "naked and earth-bound."[89] Given the wide publicity of the photographs, sitters could be forgiven for anxiousness about who

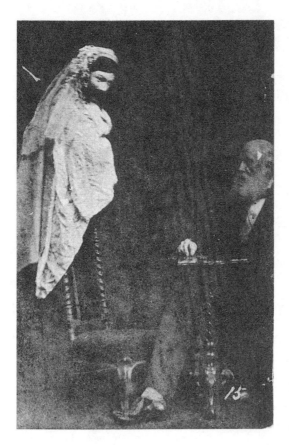

FIG. 2.13. "John the Baptist," ca. 1873. Plate 2.15 in Georgiana Houghton, *Chronicles of the Photographs of Spiritual Beings* (London: E. W. Allen, 1882).

would see them and how they would be interpreted. Perhaps to relieve their concern, Houghton reported that she had once partially covered the face of one sitter shown with a spirit wearing a dirty rag, suggesting sinfulness, to avoid giving offense to the patron. Ever financially savvy, she did not eliminate his face entirely, just in case he wanted copies.

Spirit photographs might be difficult to explain, but for Houghton and others, that did not therefore make them untrue. Nor did Houghton and her friends think such pictures were particularly "good" specimens of photography. On the contrary, they often suggested, the badness of the art reinforced their credibility; after all, why would anyone publicize photographs that looked so obviously fabricated? In a letter to a visitor, Mrs. Brown of Belfast, Houghton explained, "These last spirit-photographs, though bad as works of art, have done more to convince my friends of their genuineness than all they ever saw before." Although they were "photographic failures," she wrote, they were "wonderful" spirit photographs.[90]

Houghton often expressed unhappiness at the deleterious effects of scientific investigations on the quality of the pictures. After one test in which a "sci-

entific gentleman" recommended a test that involved taping Houghton in a grid so that she "stood as it were in a kind of prison," she complained, "Of course as a picture it will be very unsightly, with the double array of crossing lines from the scratched glass and the tapes." She also mentioned the difficulty it involved. "I may here venture to suggest, that scientific men are very exacting, and have no kind of compunction as to the labour and fatigue that their fancies may entail." Yet she and Hudson expressed their willingness to comply with any conditions, "however incongruous they might seem." She added, "All this preparation in a glass-house, on an intensely hot day in July, was decidedly a trial to Mr. Hudson and myself (neither of us young) . . . Reaching up with chairs and stools to pin those tapes to the upper part of the screen; measuring, marking, etc., so as to make them equidistant; hammering nails where we could manage them; and trying various contrivances to make the arrangements perfect; were none of them occupations to leave us in the calm, placid state that mediumship demands."[91]

A London optical and philosophical instrument maker named Thomas Slater investigated Hudson in May 1872, shortly after the publication of Houghton's announcement, and reported "I am certain Mr. Hudson played no tricks on this occasion." A "fine female figure, draped in white" had appeared on the plate, "her hand resting on my head . . . The drapery nearly covers the whole of my body, leaving only the side of the head and one hand visible." He carefully observed Hudson and his operations: "I saw the slide drawn up, and, when sitting, saw the cap or cover of the camera removed, and, after the usual exposure, replaced on the lens." He accompanied Hudson into the darkroom and watched him pour the developing solution onto the plate. Slater was ever vigilant: "I witnessed the whole process from beginning to end."[92]

These experiences shaped Houghton's practice and motivated her to exert more control over the experimental conditions. "Katie King," a female spirit in communication with Hudson, advised him that "Miss Houghton's negatives" were "to be held sacred, not to be shewn to any one, but kept apart from all other negatives, nor were the proofs to be seen without Miss Houghton's permission." Houghton took the destruction of one photograph, which Hudson accidentally ruined, as a warning to exclude sitters from the dark room; a sign that Hudson "by his nervous anxiety had indeed 'disturbed the manifestation' by wishing to shew it."[93]

To establish the veracity of spirit photography, Houghton and her peers used visual arguments, not just practical demonstrations of their honest methods. Houghton stressed the spirits' "modest attitude" as proof of their existence. Compared with "mortal" sitters, she declared, spirit extras "usually look much more natural and unconstrained than when sitting for their own likenesses."

One picture of a friend's sister-spirit "charmed" Houghton with its "simple, unassuming, modest attitude": "As being in its nature an evidence of their genuineness, even were there no other proofs, for we well know that the universal attribute of photographs in general is the Ego that they all exhibit." By contrast to vain humans, the spirits' "thoughts" were not focused on improving their appearance. Instead, they were "engrossed with the desire of again beholding a lost loved one." For this reason, she said, "*self* is for the moment entirely set aside, much to their own embellishment."[94]

As with any portrait photograph, clients had differing expectations about what they would get. One critic of Mumler's photographs had complained that his spirits were too "modern" and "conventional" to be plausible ghosts.[95] Houghton admitted: "Some persons may be disappointed in the photographs themselves, because they do not come up to their *imagination* of spirits." Nonetheless, even if they did not always gratify sitters' speculations about how spirits ought to appear, they were meaningful. According to Houghton and her circle, they at any rate "prove that spirits are not shapeless airy nothings, but have bodies really as substantial as our own."[96] She contended that people did not necessarily become angels overnight. Reflecting awareness of the current evolutionary theories, an interest intensified by the publication of Charles Darwin's *The Descent of Man* in 1871, spiritualists held that spirits evolved in the afterlife as they had on earth.[97] Houghton also maintained that photographs of spirits often yielded more successful likenesses than regular portraits. As this example suggests, it was not just the physical object but the quality of the image that confirmed the evidentiary value of spirits.

The Spread of Spirit Photography in London after Hudson and Houghton

Houghton's experiments introduced spirit photography as a common practice in British scientific, photographic, and spiritualist circles, as well as among ordinary sitters. Soon, a variety of people were experimenting with spirit photography in other places including commercial studios and in private parlors. The introduction of dry plates during the 1880s, the invention of celluloid roll film, and the development of the handheld camera changed and expanded the burgeoning amateur mass market that was making photography accessible to thousands. These innovations made the camera a practical, simple, and easily handled device for amateurs and professionals. Technological advances from 1880 to 1910 had definitive and far-reaching implications for spirit photography, its audiences, and the culture of display. The amateur movement established some of the principal conditions for spirit photography's widening appeal as a democratic practice. In 1888, George Eastman set out a new philosophy

of amateur photography in an advertisement for the Kodak camera that he had designed and produced. The commercialization of handheld ("detective") cameras in the 1880s opened up new possibilities for amateur photographers to test the authenticity of spirit photographs, either by attempting it themselves or by "marking" commercial plates prior to sittings to eliminate the possibility for operators to cheat. (These experimenters set the precedent for the famous Cottingley fairy photographs investigated by Sir Arthur Conan Doyle in the 1920s.)

The experiences of Sarah Power, a Birmingham amateur also known as "Thomas Slaney Wilmot," showed how spirit photography, like photography more generally—and women who transgressed gender norms—were both admired and condemned. Power (shown seated in Fig. 2.2, with her uniformed maid, whom Power recognized only by her first name, Eliza) held that psychic photography and clairvoyance were proof of the invisible soul resurrected after death. Power's spirit photography grew out of her work as a Sunday school teacher, and she expressed interest in building a "Scientific Religion." According to a tract she pseudonymously published in 1894, *Twenty Photographs of the Risen Dead*, Power at the age of forty had become engaged to a young male student who then committed suicide when his parents frustrated his plans to abandon business for religion and marry her. He "communed" with her in spirit, suggesting she go to a local photographer to have her portrait taken and that he would appear visible on the same plate. When local professional photographers refused her entreaties to participate in the experiment, he advised her from beyond the grave to take up photography and "experiment herself."[98]

In her initial search for a teacher, Power was greeted with hostility and suspicion, "some thinking she was in the first stages of incipient lunacy, and others, that it must be *wicked* to try to photograph *that which cannot be seen by the human eye*." One day a "strange voice" (she assumed it was Jesus) gave her the name and address of a photographer who promised to teach her. The man lived in an unfamiliar part of town in a house with no sign to indicate that he was a photographer; nevertheless, he agreed to give her lessons at her house and refused payment for his services because "an angel of light" had advised him to help her.[99]

Despite public opposition from members of the Christian Evidence Society and the press, Power learned to take spirit photographs at home, and several of her photographs appeared in *Twenty Photographs*. "Wilmot" explained in the book, which he dedicated to the spiritualist Countess of Caithness, that women had special natural powers in spiritualism, thus equipping them for new public roles. "Wilmot" declared that many women had "outgrown the domestic and sex proclivities, and look upon the world as their special object of care, therefore they become writers, teachers of original and advanced knowledge, platform speak-

ers, and other officers in public or semi-public life." He contended that most photographers who experienced "foggy plates" never tried to ascertain "the cause of the fog." He suggested that instead of "breaking up" plates "for fear that the fact should get about" that there were "unseen operators" at work trying to "prove to their loved ones that they are risen," photographers should preserve plates with local photographic societies and consult customers as to whether a "fact should be made public" should a spirit form appear.[100]

Power built on and extended the theory that people, like many inanimate objects in nature, were surrounded by an aura or "atmosphere of their own. . ." Comparatively few people had a "luminous aura," which explained why so few photographers of spirits were clearly defined.[101] Power believed that only people gifted with clairvoyance could make successful psychic photographs. This was because only they could see the spirits being photographed; only they were "gifted with the natural qualities"—that is, the "necessary luminous aura which renders the surrounding atmosphere transparent to the heavens and the sensitive plate at the same time." Power, explaining why spirits had not registered on a plate, said that the lady sitter was photographed following a bitter argument with a skeptical visitor, which had withdrawn the psychic light. Optimal conditions were "mental repose, a calm unworried atmosphere, and isolation from all opposition." Power's theory was that spirits occupied the space between atoms: "Those who are able mentally to travel thus far from the physical plane of effects to the psychic plane of causes will be prepared to see the possibility of registering by means of the camera the active intelligent entities which Spiritual Science terms Ministering Spirits, Guardian Angels, etc., that is, when the operators have sufficient luminosity of soul to supply that actinic power which the material instruments at present lack; it will also explain why the same operators succeed at one time and fail at others in photographing the Unseen, for the soul of man is not equally clear at all times."[102]

Just a few years after Houghton's pioneering photographs, there were as many different styles of spirit photographs as there were practitioners. Some were figurative; others were geometric, including flames, stars, and cones. There were even, some suggested, different national styles. Many remarked that the French spirit photographer M. Buguet made more "artistic" pictures than English spiritualists. Even in the realm of spirit photography, it seemed, the French were more artistic; in that sense, one declared, he was like a "missionary" to them.[103] M. Buguet arrived in London around 1874, about the same time that Hudson and Houghton began losing business.[104] Strategically, unlike Hudson, whose studio was in North London, Buguet opened a studio on Baker Street, right in the heart of spiritualist London. It was also the home of fictional detective Sherlock Holmes, created by the writer and spiritualist Sir Arthur Conan

Doyle, who many decades later took a famous interest in the Cottlingley children 's "fairy photographs."[105] Contemporary reports describe Buguet as a "gentlemanly-looking man," a compliment that observers often qualified by cautioning that appearances could be "deceptive." Buguet was credited with disturbing the "spirito-photographic quiescence of the metropolis" when he arrived in the city.[106] His success during his short stay there shows that Houghton and Hudson's declining economic fortunes around the same time cannot be easily interpreted as representing a more general waning interest in spirit photography.

The sheer variety of spirit photographs compelled discussions among spiritualists about how the genre would be defined. Even when made by the same practitioner, no two spirit photographs were exactly alike.[107] The "most remarkable circumstance about them," exclaimed Houghton, was their "great variety." For "no two of the pictures resembl[ed] one another, either in pose or drapery."[108] Many Victorians thought that spirit photographs were difficult to categorize and that, in fact, their rich variety was probably part of their appeal. As there had been with photography itself in 1839, there was great difficulty reaching consensus on what to call this category of images.[109]

Among those who were sympathetic to spirit photographs—and therefore who tended to view them as representing variety, not homogeneity—the attempt to classify them provided a common link to other modes of scientific work. People had referred variously to "spirit" and "psychic-force photographs," or "spiritual photographs" or "psychic portraits." By 1911, the spiritualist and historian of spirit photography, James Coates, divided them into several categories: portraits of psychical entities not seen by normal vision; pictures of objects not seen or thought of by the sitter, the medium, or the photographic operator; pictures that looked like they were copied from statues, paintings, or drawings; pictures of wraiths and doubles of persons still in the body; and portraits on plates that developers failed to bring into view but that could be seen and described by clairvoyants and mediums when in a trance.[110]

Images of Indian and African servants increasingly appearing in spirit photographs. Sarah Power's plate 13, for example, shows a "black man with a white beard" and a star atop his head, whom those at the session immediately recognized as a guardian spirit. Nineteen spiritualists attested that "no coloured man was present." Power claimed that Africans, Hindus, and "Red Indians" were more easily photographed than Christian English people because she held the romantic notion that they had a "natural religion." According to Power, they were "better fitted for the office of Spirit Control" than people brought up under the "narrow and aggressive religious policy" adopted by so-called modern "Christian races."[111]

By the 1890s, there was rising concern among spiritualists about copyright law, intellectual property rights, and photographs. Spiritualists were cautioned against gazing too long at the Grand Master paintings at London's new private and public art galleries for fear that they might unwittingly violate new copyright regulations if the same painting appeared later on a photographic plate at a séance.[112]

At odds with the idea that spirit photographs were becoming more varied was that studio production of spirit photographs proliferated and their conventions, to some, verged on cliché. "Only the other day," one person reported around 1892, "I was told of a young lady who . . . sat as an ordinary sitter, suspecting nothing. The plate came out blurred all over; photographer surprised, and on point of casting plate aside, when sitter begs to see it, and further begs to have it printed off. Result—photo blurred all over, sitter unrecognizable; when subjected to high magnifyer [sic], milky way of blue reveals innumerable faces, but all the same face! Recognised by young lady at once as face of dead lover." Spirit identifications of dead friends, lovers, relatives and, increasingly, nonrelatives (celebrities, guardian spirits, and saints) had by this time become a mass cultural phenomenon. Identifications were "tiresomely common" yet "bewilderingly well evidenced."[113]

Among spiritualists, however, the term spirit photography represented different cultural practices and competing schools of thought about how they were made, defying tendencies today to categorize them as homogeneous. Spiritualists widely held that the sheer variety seen in spirit photographs produced in England was caused by different styles of mediumship and by the "higher or lower degrees of the invisible friends at work." To the "physical philosophers," as they were often called, spirit photography revealed a mode of action confirming the subtle nature of force and the unity of force. To Christian philosophers and spiritualists, they confirmed the reality of the existence of heaven and the immortality of the soul. Others viewed the practice in relation to modern discoveries in electricity and magnetism. Some spiritualists claimed, for instance, that luminous substances seen by mediums—or "sensitives"—arose from magnets and crystals. When condensed by powerful chemical forces, the positive energy thrown off from them struck the prepared photographic plate like a strong solar light. This force was then taken up by intelligent invisible beings and molded into shapes, like "clay in the hands of an artist."[114]

By the 1880s spirit photography was stigmatized in many medical, legal, and social circles. As "Wilmot," Power complained that she, a "lady experimentalist," had been rebuked by Birmingham religious groups who "hired halls and paid men to publicly condemn her and her researches as diabolical." She eventually sought protection and solace by the seaside, where she was given money

and support from Hensleigh Wedgwood, a fifteen-year veteran of psychic photography.[115] "Wilmot" scolded a London newspaper writer who had criticized Power, saying he "negatived any effect her researches may have had upon minds prepared to receive" the "truth," perhaps, he added slyly, because the "guilty" were fearful that the spirits would "avenge them" beyond the grave. Only those "on the alert to commit legal frauds" were eager to attribute fraud to others, he suggested. "An honourable man believes every one truthful and honest until he proves otherwise. On the contrary, the rogue treats every man as a rogue until he proves him to be true, and even then, is wary." By contrast, he commended the *Practical Photographer* editor who traveled one hundred miles to visit Lady Marie Caithness and took away thirty-six of her photographs for further examination. This editor had praised her, saying it was unlikely she would perpetuate a fraud for years: "As to the suggestion that she, herself, is a charlatan, we can only point out that she has nothing to gain—but all to lose—by following her psychic investigations."[116]

Masculinization of Spirit Photography

Over time, arguments about spirit photography gradually moved from the pages of the spiritualist and photographic press to the center of discussions about what it meant to be a full participant in a scientific age, and who could be included. Scientists and photographers who desired to extend their public influence could hardly avoid participating in the debate, particularly those statesmen of science who had committed themselves to claims about the wondrous worlds that technology could reveal in the future. Photographic and spiritualist magazines provided a framework for men, in particular, to publish current theories about the manufacture of spirit photography. In the spirit of exchange and open scientific communication, the *Photographic News* published many competing theories about spirit photography and through this channel gave men a public voice. At the same time, and as with other scientific sensations before and after, some worried that their involvement in such public controversies might compromise their credibility and even dignity as scientists.

The practice of spirit photography, while remaining open to women, became increasingly masculinized in England from the late 1870s through the 1890s, as more men became manufacturers, investigators (skeptical and sympathetic), and even mediums. In addition to Mr. Hudson, there was Mr. John Beattie, a retired photographer from Clifton who became convinced by the U.S. experiments and began holding a circle with usually exclusively male members, including a medium, Mr. Butland, two other "gentlemen," and a photographer, Mr. Josty.[117] Other experimenters included Mr. Russell and Mr. Champernowne of Kingston-on-Thames; Mr. Slater, optician, of Euston Road; and

William Hope. Reeves and Parkes of York Road, King's Cross produced an album of fifty-one spirit photographs. In London there were John Jones of Enmore Park and Mr. J. Traill Taylor, editor of the *British Journal of Photography.* Some of these men held that female mediumship was unnecessary for making spirit photographs and began using male mediums.[118]

Spirit photography tested the bonds of fraternal unity in the distinct but related fields of science and photography. Commercial photography fueled anxieties about tricks in the darkroom and raised concerns that spirit photography was unscientific if nothing else because, according to some, its practitioners were generally tight-lipped about the practice. Judgments on photographic practice involved assessments of character and these in turn inflected concepts of gender and class. One man who visited Hudson at his studio reported that he had no phrenological organs associated with the "knave" or mental "defective" but noted that his organs of "self-esteem, firmness, and the instinct of persistence" were "all defective." He was, the visitor concluded, "a man you would not take for a deceiver, yet one you might suppose would be easily led." Hudson's daughter, he stated, was "good-mannered, unassuming, and intelligent"; in other words, she was too transparent to effectively deceive.[119]

The Society for Psychical Research (SPR), founded in 1882, provided a measure of organizational and intellectual support for people who sought to test the legitimacy of spirit photography. The SPR grew out of the many spiritualist societies that had come and gone in Britain since the 1850s.[120] Although fascinated by the possibilities of psychic phenomena, its members remained aloof from what they saw as the religious enthusiasm of many spiritualists and declared that they, by contrast, were scientifically impartial. Its members included some of the leading intellectuals of the day, their intention being to "attract some of the best minds which had hitherto held aloof from the pursuit" of psychical knowledge.[121] Within the group, members disagreed about the laws of nature and the supernatural. What gave the SPR its distinctive appeal was not merely its social and intellectual cachet but its intention to follow scientific procedures. They devoted much time to investigating and debunking spiritualist mediums. When approaching scientific tests of spirit photography, however, they generally relied on measurements, grids, and scrutiny of equipment rather than phrenological readings.

Members frequently tested spirit photography in studios and parlors, and they left behind a treasure trove of writings about the tacit, or esoteric, skills associated with photography, which praise for the practice's automatism frequently obscured. An observer at a parlor séance in the West End of London made a drawing showing the placement of the camera and a sitter (Fig. 2.14).[122]

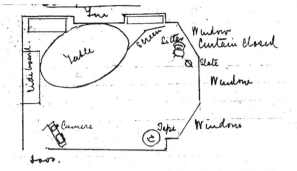

FIG. 2.14. Notes from a scientific investigation of a parlor photography séance, showing the placement of camera and sitter, December 20, 1894. "Colonel Taylor's Notes of Sittings with David Duguid." Duguid MS, Society for Psychical Research Papers, Cambridge University Library Syndicate. Reproduced with kind permission from the Society for Psychical Research, London.

In its careful attention to technical details and times of exposures, this notebook description of spirit photography more closely resembles the scientific narratives of seventeenth-century natural philosophers than the first newspaper reports about Mumler's photographs, which often established an emotional relationship to the audience.

Not all tests of photography were conducted in the darkroom, however. Scientists outside the SPR also scrutinized spirit photographs. In 1874, the biologist Thomas H. Huxley received a letter, with three photographs enclosed, from Hensleigh Wedgwood, Darwin's brother-in-law and an avid believer in spirits. Wedgwood had tried only weeks earlier to interest Huxley in spiritualism by dragging him to a séance with the medium Charles Wilcox. Huxley was one of Victorian England's most visible public scientists, and his opinion on spirit photography was widely sought.

Now Wedgwood offered the three photographs as proof. "I venture to offer to your notice a photograph or two that it seems to me impossible to explain on the theory of a fraudulent concoction," he began. Each showed one or two spirits draped in white fabric hovering over a respectable gentleman, shown seated and wearing a top hat (Fig. 2.15). The pictures were made in a "bare pho-

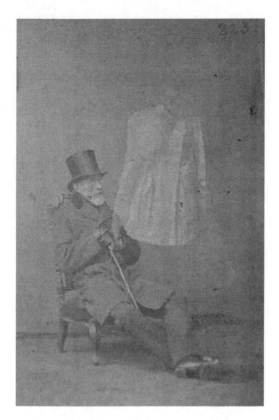

FIG. 2.15. Spirit photo sent to
T. H. Huxley for examination.
T. H. Huxley Papers, General Letters,
Vol. 28 (Imperial College Archives,
London), TI-WE. This is one of three
photographs (221–223).

tographing shed" with "nothing but the bare-covered walls and a chair or two
. . . My seat was close up against the wall and it was impossible that I should
not have seen if there had been any one there . . . [He] went into the dark room
with the photographer" and "saw him take the glass out of the camera when
there was nothing visible upon it . . . for I carefully looked . . . In order to put the
matter to proof I took my daughter, Mrs. Farrier with me, a practical photogra-
pher, and a woman of sense and observation, and every stage of the process was
carried on under her eyes." She saw the glass cleaned, the collodion poured on,
and "never quitted the photographer for a moment. " She herself sat for the por-
trait with a "marked glass." "In one of the photographs you see that the drap-
ery of the figure partially covers me": the figure itself stood "right before my
eyes." "How could this thing be concocted?" Something unusual had happened:
"Immediately afterwards the figure you see on the photo E came out simulta-
neously with my own, and you will see that here also a lappet of the drapery
overhangs me." He could plainly see that a possible answer was that the figure
was the remains of "some former photograph," only washed off, so that its im-
pression remained on the film of collodion. But was there "any evidence what-

ever" that such an impression would remain visible under the superimposed collodion used for the preparation of a second plate, or that the figure would appear as distinctly as the image of the sitter? He intended to "take possession of the negatives" to show others that only one film of collodion was on the plate.[123]

Huxley thought the spirit photographs clearly indicated that the photographer had perpetrated a fraud, and he explained in a letter how he thought the trick was performed.[124] It was quite clear to him that the figure was "situated somewhere between you and the collodion plate in which the negative was taken . . . The whole upper dress of the figure is about half as white as your own face." Consequently, if the spirit lay between him and the camera, he stated, it "must have reflected half as much light as your face." Therefore it must have "intercepted that amount of light, and if it lay between you and the light which fell upon your face, it must have been perfectly visible on a well defined dark object . . . Your evidence proves that no such dark object existed." Mrs. Farrier's evidence proved to him that there was nothing on the collodion plate when it was put into the camera. He concluded that the photographer had surreptitiously introduced into the camera a collodion positive of the "ghost" and that this lay immediately in front of the collodion plate that his daughter saw prepared during the time that the photograph was being taken. If Wedgwood did not want the negatives, Huxley added, he would like them for his own private collection as "pièces justification."[125] Private and public collections of photographs, as discussed in chapter 5, could serve a variety of purposes. Here, a private collection functioned as a way for Huxley to refute spirit photography to his acquaintances, in this case, using scientific arguments derived from optics.

Spirit photography also attracted dogged public defenders, including some of science's most respected leaders. William Crookes, a founder and editor of the *Photographic News,* remained open to the idea, as did J. Traill Taylor, the venerated photographic chemist and editor of the *British Journal of Photography.*[126] Crookes's experiments in psychical research are described in his book *Researches into the Phenomena of Spiritualism* (1874). In his presidential address to the British Association at the turn of the century, Crookes linked his interest in spiritualism and his interest in the fourth dimension with the work that culminated later in his invention of the cathode-ray tube, used in X-ray research. Crookes was not unaware of other ways of producing spirit photographs; he was one of the world's experts on unclean plates, having introduced widely used formulas for cleaning glass based on a mixture of salt and water, rottenstone, and Tripoli that promised to make dirty plates a "thing of the past."[127]

Another man of science who publicly lent his support to the spirit photography phenomenon was Alfred Russell Wallace.[128] By the 1870s, when Houghton began making her experiments, Wallace was a widely respected sci-

entific explorer and traveler, the co-discoverer with Charles Darwin of the theory of natural selection, and the author of numerous works, including *Palm Trees of the Amazon* (1853) and *The Geographical Distribution of Animals* (1876). From 1870 to 1872, he was president of the Entomological Society of London and, in 1876, president of the Biology Section of the British Association for the Advancement of Science. Introduced to mesmerism in the 1850s, he became a public spokesman for spiritualism, publishing "The Scientific Aspect of the Supernatural" (1866), followed by "A Defense of Modern Spiritualism" (1874), and *On Miracles and Modern Spiritualism* (1875).

Spiritualism appealed to Wallace as offering the potential for discoveries more amazing than those he made in the forests of South America. For roughly fifty years, Wallace tried to reconcile his vision of science, his conviction about natural law, his own theory of evolution, and his belief in spiritualism. He believed that Darwinian theory supported a belief in the spiritual nature of humankind. After his first sitting with Hudson and Guppy around 1872, he later recalled, "the first glance showed me that the third plate contained an unmistakable portrait of my mother." It was "not such a likeness as a portrait taken during life, but a somewhat pensive, idealised likeness—*yet still to me an unmistakable likeness* . . . I at once saw a remarkable special feature of my mother's natural face, an unusually projecting lower lip and jaw . . . A photograph taken twenty-two years before shows this peculiarity very strongly."[129]

The public criticism that spiritualists such as Houghton, Crookes, and Wallace faced during the 1880s and 1890s was a manifestation of wider social criticism of photographic consumers' ability to distinguish between good work and imposture, and of the rising medical belief in spiritualism as symptomatic of a diseased mind. The masculinization of spirit photography was part of a larger dynamic whereby the interpretive and technical skills of its consumers, many of whom were women, were made the subject of public critique. Alex Owen and Judith Walkowitz have described the struggle during the 1870s and 1880s of spiritualists who vigorously opposed physicians seeking to portray spiritualism as evidence of a pathological condition. The latter half of the nineteenth century was an era of rising tensions around the "Woman Question" and a backlash against many women's assertive claims to expanded power and rights. Many women were threatened by husbands, other family members, and doctors with incarceration in mental hospitals because of their belief in spiritualism, a system in which women traditionally had acquired power. As Owen points out, the ensuing struggle circulated implicitly around the key issue of the construction of normalcy and, by extension, normative womanhood.[130] Also implicit, though with less consequence for the primary actors, was the issue of normative scientific manhood.

Sarah Power's tale, as "Wilmot" reported it, shares many elements with the late-Victorian anxieties generated by "platform women" and sexual danger that Owen and Walkowitz describe. Because Power dared to "openly state" her experiences in a scientific way, the Christian Evidence Society and the media "denounced" her as a "haunted lady." In 1888, she escaped to the seaside where, according to an article in the *British Journal of Photography,* she received money from an anonymous patron, later revealed as Hensleigh Wedgwood.[131] Harassed for weeks, she eventually had to apply to Scotland Yard for protection.[132]

By the 1880s and 1890s, women were thought to be superior mediums, though the increasing medicalization and pathologization of female deviance meant that women involved with spiritualism risked stigma and even hospitalization. Many doubted "the powers of recognition of many Spiritualists." According to one *Photographic News* writer, "credulous persons" were mistaking the development of imperfectly received images of a former picture "as a spiritual manifestation." Many observers like him thought that spirit photography reflected poorly on people's ability to interpret photographs correctly, a skill that some deemed essential to the denizens of a modern scientific nation. In 1869, one skeptic asked (as would others later in the case of alleged popular superstitions, such as thunderbolts), "Is it not surprising that in a land where education is supposed to be universal, and, as alleged by its admirers, of the most perfect kind, such a clumsy imposture should receive a moment's credence?"[133]

Those who shied away from testimony probably feared that embracing the claims associated with spirit photography would implicate them in the advancement of the tenets of spiritualism—would stain their reputation or imply a critical stance toward science.[134] Skeptics labeled those involved with spirit photography frauds, impostors, and idlers "carried away by the light of an idea."[135] Although not as vulnerable to harassment as women spiritualists were, it is striking that men who professed interest in spirit photography were seen as unmanned by their credulity. It is not surprising therefore that Andrew Glendinning and other spiritualists responded by stressing the manliness of disclosing their faith in spirit photographs despite hostile critics. Many pointed out that practitioners had "nothing to gain—but all to lose" by openly pursuing psychic investigations.[136] Thus, by the late 1880s, spirit photography was an arena of knowledge production that was still vastly popular but also increasingly stigmatized, and one that male experts in the Society for Psychical Research themselves often policed harshly for that reason. Even the public-spirited Houghton confessed, "I thought that others might deem me visionary if I mentioned it, so I kept my information to myself."[137]

Photographers who declared their openness to the possibility of spirit photographs promoted the spirit of scientific exchange that Crookes and the *Pho-*

tographic News encouraged. Public defenders of spirit photography did not relinquish their hold on the connection between scientific integrity, masculinity, and spirit photography. As Sarah Power using the voice of "Wilmot" explained, practitioners who publicly revealed spirit photographs were more scientific than skeptical photographers because they acknowledged and confronted anomalies in their laboratories for which they had no ready scientific explanation. When professional photographers obtained anomalous results that they could not explain, he declared, many of them broke up plates "for fear that the fact should get about and damage their connection." However, an "honest man has nothing to fear in the recital of truthful facts . . . [but] "should face them out, and follow them up, until he thoroughly understands them."[138]

Ideologies of gender and trust worked differently for men and women involved with spirit photography, but together they kept the issues of skill, judgment, and interpretation in front of multiple publics, including photographers, spiritualists, scientists, and, significantly, groups of ordinary people. Many people discussed the idea of photography, whether or not they actually took pictures themselves. Despite the common impression that interest in spirit photography declined after the heyday of experiments around Hudson and Houghton in the early 1870s, by 1890, there was a dynamic public culture with thousands of people inquisitive, capable, and willing to give their opinions about a spirit photograph. It was against this backdrop that the Liberal journalist William T. Stead launched a project to promote a liberal vision of democratic access through reproductions of spirit photographs in the newspaper.

Spiritualism and the Photographically Illustrated Press

For many people, criticizing spirit photographs signified participation in the enlightened world of modern science. By this time, such photography was firmly connected through the efforts of Houghton and others with the democratization of seeing. Houghton published spirit photographs, calling them "evidence on a sensitive plate" that carried "a weight of evidence as to the substantiality of spirit beings" far superior to other testimonies. Her writings linked spirit photography with the ideologies of democratization. As she put it, although spiritual phenomena appeared in the "*written* records of almost all mediums," they rarely were known "beyond their own immediate circle." Yet by the "multiplying power of printing from negatives," the evidence was "in the hands of all Spiritualists."[139]

Mechanical reproduction of photographs might have lessened the "aura" of original art, but it was a chief method for expanding witnesses. Although the widespread use of photographs in newspapers did not occur until early in the twentieth century, newspapers nevertheless played an important role in how

the idea of photography was constructed. The rise of the photographically il-
lustrated press during the 1880s and 1890s gradually expanded the culture of
visual witnessing in new ways, and the appearance of photographs of scientific
subjects in illustrated newspapers and magazines was part of a more general
trend.[140] The possibility of reproducing photographs in newspapers more
cheaply had a revolutionary appeal because it seemingly opened up the archives
of photography for all to see.

The rise of the illustrated press after 1840 was one of the most remarkable
phases of newspaper history in Great Britain. Broadsheets and newspapers of
course had played crucial roles in the creation of traditions of viewing images
long before photographs were reproduced in them. From the seventeenth cen-
tury on, events such as the Great Plague, the fire of London, and marine bat-
tles with the Dutch provided rich opportunities for the pencil of the special
artist. Newspaper illustration became widespread during the eighteenth cen-
tury as naval and military officers became valued correspondents, and a per-
spective view of Fort Fouras, from an eyewitness aboard a British ship, in *Owen's
Weekly Chronicle* (1758) was among the first attempts in a newspaper to give a
pictorial representation of a specific place in connection with the news. The
Grub Street Journal was one of the first papers to use the expensive process of
copperplate engraving for printing illustrations, while the *Daily Post,* published
from 1740, used woodcuts to illustrate current events.[141]

Like the London shows before them, illustrated newspapers sold scientific
entertainment. They marketed the spectacle of science for many to see. Some
of the correspondents to the *Illustrated London News* were Britain's leading sci-
entists, such as the Scottish astronomer Charles Piazzi Smyth, an accomplished
engraver who sent illustrations to the art department.[142] Mason Jackson, the
first art editor of the *Illustrated London News,* reflected that for ten years be-
fore that journal was founded he had noticed the growing inclination of the
people for illustrated news in the pages of the *Observer* and the *Weekly Chron-
icle.* The *Observer,* founded in 1791, was the prominent illustrated newspaper in
the early nineteenth century. Using copper engravings printed on letterpress
pages, the *Observer* published pictures of the House of Lords preparing for the
trial of the popular Queen Caroline in 1820, of King George's coronation in a
special issue in 1821, of a celebrated murder case in 1823, and the death of the
Duke of York.[143]

Crime, politics, and scandal were popular themes with the illustrated
papers. The *Weekly Chronicle,* first issued in 1836, started with the idea of illus-
trating the news of the day as one of its principal features. Its first edition con-
tained an engraving of a new grand balloon above Vauxhall gardens from a
drawing made by a gentleman who ascended expressly for the paper. Early on,

however, the *Weekly Chronicle* selected the criminal records as favorite subjects for woodcut illustration. From the first examination of the murderer before the magistrates to his final exit in the Old Bailey, the artists of the paper were "on the alert, pencil in hand." These pictures were sensational, even shocking: sketches of a murder scene with the head of the murdered woman preserved, the body of a dead balloon aeronaut laid out for a jury to inspect, pictures from a riot.[144]

The publication of the *Illustrated London News* from 1842 was part of a wider marketing bid by its editors for more middle- to upper-class readers, and a determination to influence middle-class concepts of taste. The first regular illustrated newspaper that combined art and news, its first issue included thirty-two woodcuts on sixteen pages, and its price was six pence. Although ostensibly the drawings were based on direct observation, it is notable that the first engraving published in the newspaper—a picture of a fire in Hamburg—was based on an image at the British Museum. The editors of the newspaper, which reached a circulation of 66,000 by the end of its first year, targeted a "respectable" middle-class audience, one that, during the Great Exhibition of 1851 found the imagery of peaceful display more enchanting than images of revolution.[145]

A rival newspaper editor, Charles Knight, founder of the *Penny Magazine,* described his first encounter with the working practices of the *Illustrated London News*: "In 1842, having occasion to be in attendance at the Central Criminal Court, my curiosity was excited by an unusual spectacle—that of an artist, seated amongst the civic dignitaries on the bench, diligently employed in sketching two Lascars, on their trial for a criminal offence." After learning that the *Illustrated London News* had been announced for publication on the Saturday of the week, he wondered how artists and journalists could "so work concurrently that the news and the appropriate illustrations should both be so fresh?" How "could such things be managed with any approach to fidelity of representation unless all the essential characteristics of a newspaper were sacrificed in the attempt to render it pictorial?"[146]

The expansion of the illustrated press linked visual reproductions with ideals of the democratization of scientific and artistic taste.[147] Jackson declared that visual images in newspapers "speak a universal language, which requires no teaching to comprehend." The beginning of mass photographic journalism in turn-of-the-century scientific visual culture was widely regarded as a sign of a speeded-up society: a new information order that connected people across vast spaces in an age of empire.[148] By the 1890s, dozens of new illustrated magazines appeared in London, including *Cassells* (1897), *Harmsworth* (1898), *Pall Mall* (1893), *Pearson's* (1896), *Royal* (1898), *Strand* (1891), *Wide World* (1898), *Windsor*

(1895), *Pictorial World* (1874–92), and the *Picture Magazine* (1893–96). Editors of photographically illustrated periodicals were particularly interested in tapping into public interest in the sensational news of science. Specialized journals (sport, drama, country life, and popular science) usually paid photographers very well, and, as with the technical journals, their requirements often included special knowledge of the subject.

The editors of *Photogram* urged that a photograph, like any other market commodity, "must be offered to the right market, and it must be offered at the right time."[149] Magazines, during the 1890s in particular, regularly began including photographic reproductions, many of which had scientific interest. In the *Strand,* "A Day with an East End Photographer" included illustrations of racial "types" revealed by the camera, promising to give readers a "very fair idea of the evolution of the foreign immigrant." "Weather Watchers and Their Work" gave a heroic account of scientists working with self-registering instruments and photography at Kew Observatory. The *Strand* also published remarkable lightning photographs made by A. H. Binden, a prominent meteorologist, creating an audience beyond the Royal Meteorological Society for scientific photographs of lightning.[150]

Picture Magazine, the *Strand* companion comprised entirely of pictures, was another source of scientific photographs and commentary. As the editor explained, "The pictures will be selected from the best publications of all countries (special arrangements having been made with the holders of copyrights)" and would provide a "unique review of the world's illustrations," in the fields of fine art, humor, celebrities, "strange and striking places," trick photographs, scientific recreations, and pictures for children. After the discovery of X-ray photography in 1895, photographs in *Picture Magazine* were chosen to illustrate an article on "the possibilities of the Roentgen method." *To-Morrow,* edited by J. T. Green, was a futuristic monthly review devoted to speculation about technology and included articles about the latest techniques of anthropometry and photography. An 1896 article on the influence of science on future society evoked a special interest in the new photography of the invisible, stating that it was "achieving fresh triumphs every day in the assistance it renders in the analysis of movements of bodies so rapid as to be beyond the capabilities of unaided human vision."[151]

Standing out as a popularizer of scientific news was *Pearson's Magazine,* a sixpence family-oriented periodical addressed primarily to middle-class readers. Like other contemporary popular periodicals, it was patriotic, militaristic, and devoted to royalty. First published in 1896, *Pearson's* dealt with many military, animal, and scientific themes in a context of adventure. Favorite topics included colonial wars, photography of the invisible, microbes, Mars, ghost sto-

ries, and scientific marvels. From 1896 through the end of the century, *Pearson's* published, for example, "Animals as Criminals"; "A Photograph of the Invisible"; "Life on Board a Battle-Ship during the Maneuvers," with photographs; "The Newest Marvel of Science," an article on the scientific discovery of "Martian Canals"; a biography of the French astronomer Camille Flammarion; and H. G. Wells's famous story of Martian invasion, "War of the Worlds." Its articles also linked photography and scientific discovery in nature and the criminal underworld, such as in "Criminals, How They Are Identified," by Tighe Hopkins, with photographs taken at Wormwood Scrubs by W. H. Grove; "Methods of Photography by Electricity," about Worthington's splashes; and "Photographing Flying Bullets," with six pictures of bullets in motion that visually linked scientific phenomena with a military theme.[152]

As early as the 1880s, there was in newspaper journalism, as in electoral politics generally, increasing anxiety about the "disharmony" of voices represented by the papers.[153] In his famous *Nineteenth Century* article "Up to Easter" (May 1887), in which he opposed Irish Home Rule, cultural critic Matthew Arnold blasted the New Journalism as "feather-brained." He testily argued that no "reasonable man, who thinks fairly and seriously," could doubt that to constitute Ireland was a dangerous act. He trivialized support for Irish Home Rule as coming from "the new voters, the democracy, as people are fond of calling them . . . They have many merits, but among them is not that of being, in general, reasonable persons who think fairly and seriously." He compared the new democracy to the new style of popular politics in journalist William T. Stead's *Pall Mall Gazette:*

> We have had opportunities of observing a new journalism which a clever and energetic man has lately invented. It has much to recommend it; it is full of ability, novelty, variety, sensation, sympathy, generous instincts; its one great fault is that it is *feather-brained.* It throws out assertions at a venture because it wishes them to be true; does not correct either them or itself, if they are false; and to get at the state of things as they truly are seems to feel no concern whatever. Well, the democracy, with abundance of life, movement, sympathy, good instincts, is disposed to be, like this journalism, feather-brained.[154]

Critics agreed that the New Journalism embodied in the *Pall Mall Gazette,* the *Star, Review of Reviews,* the *Daily Mail,* and the *Daily Chronicle* was more than a new approach to politics; it involved questions of style. Evelyn March Phillips, herself a "New Journalist," described the form: "By the New Journalism, I take it, we mean that easy personal style, that trick of bright colloquial language, that wealth of intimate and picturesque detail, and that determination to arrest, amuse, or startle, which has transformed our Press during the last fifteen years."[155]

Objections like Arnold's effectively feminized the press at a time when women were writing for the papers in larger numbers and starting to be trained as "New Women" journalists. As Tania Modleski and others have argued, mass culture has often been associated with the feminine because—in stereotype— it is sentimentalized, "merely consumed," and is seen as requiring less intellect. Stead rejected the notion that mass culture was "feather-brained," arguing instead that mass circulated papers represented a new class and mixed-sex form of public assembly where people could meet on common ground, even (perhaps especially) when they met to differ. The liberal editor, he stated, was the "uncrowned king" of an "educated democracy" and a member of the "priesthood of Comte."[156]

Victorian science and its methods of fact collection are central to understanding Stead's vision of the newspaper as an arbiter of public opinion. How to gather reliable data was uppermost in his mind when he wrote "The Future of Journalism" for the *Contemporary Review* in 1886. Like scientific observers, journalists were expected to ascertain at first hand the facts of their subjects. Stead proposed gathering public opinions (as amateur science often did) through a network of corresponding associates, including major generals and journalistic travellers.[157]

Best known today as the editor of the *Pall Mall Gazette,* Stead was a famous literary and political figure in Victorian England. Stead's contribution to the radical-democratic edge of Liberal politics transformed the newspaper into a forum of critical opinion for an expanded public that would include working people and women traditionally excluded from what Jürgen Habermas has described as the classical bourgeois public sphere. Stead was confident that the papers could change society. "I have seen Cabinets upset, Ministers driven into retirement, laws repealed, great social reforms initiated, Bills transformed, estimates remodelled, programmes modified, Acts passed, generals nominated, governors appointed, armies sent hither and thither, war proclaimed and war averted, by the agency of newspapers." In "Government by Journalism," published in the *Contemporary Review,* Stead declared that the press was "the eye and the ear and the tongue of the people." It was the "visible speech if not the voice of democracy. It is the phonograph of the world." Unlike MPs, editors' "direct and living contact with the people is the source of their strength. The House of Commons, elected once in six years, may easily cease to be in touch with the people." He defended sensational writing as economically unavoidable and socially important: "The editor . . . must interest, or he ceases to be read," and journalism "must be a mirror reflecting all the ever-varying phases of life in the locality," even those that Parliament members might view as beneath their interest.[158]

The professed intentions of the New Journalism were contained in Stead's high-minded pronouncement that it was "the duty of the press to interpret the knowledge of the few to the understanding of the many," an ambition that had as its ostensible aim the widening of the intellectual franchise for political ends. Stead's vision of democracy was founded on an ideal of scientific investigative culture—an entire nation of rational, constantly experimenting truth-seekers who voted. Stead claimed to provide a form of communication that would anticipate a revolutionary future because its approach was personal: it spoke to readers and gave them a chance to reply. In England, as in Europe more generally, a radical-democratic Liberal strategy in the years before the foundation of the Labour Party was to bring together at least the moderate representatives of labor who favored reforms. These included the union of all democrats, republicans, and anticlericals against mobilized enemies of these causes. This approach had a good chance of success in late-nineteenth-century Europe, especially in England, where Liberal leaders sought to reassure and capture the labor vote and where a moderate or reformist wing had emerged in all the socialist mass movements, even among most Marxist parties.[159]

By addressing and constructing a national newspaper-reading public, as Judith Walkowitz has shown, Stead's New Journalism expanded and consolidated the social boundaries of the public sphere. Stead was a great advocate of women's work and suffrage (although he also wanted to lead the women). In 1889 he opened the *Pall Mall Gazette* to socialist and radical critiques of police repression of striking workers. As editor, Stead used media scandals to try to create a single moral majority out of an expanded heterogeneous public. Sensational stories—the Ripper murders in 1888, false reports of "respectable" women mistaken for prostitutes—were "catalyzing events" that forced a range of constituencies to take sides and assert their presence in a heterogeneous public sphere. In 1885, Stead led a newspaper campaign to eliminate child prostitution in which he set about demonstrating the need to raise the age of consent for young girls by purchasing one himself—a feat of daring investigative reportage for which he ended up in jail. The "Maiden Tribute," as this story came to be called, was taken up by different constituencies and revised for diverse political purposes above and beyond that with which it is typically associated, that is, passage of the Criminal Law Amendment Act of 1885.[160]

Around 1890 Stead began laying plans for a new journal, *Borderland,* which like his earlier journalistic ventures linked newspapers, democracy, and scientific fact collection. Like P. T. Barnum's appeal to audiences that they guess for themselves how tricks were done, Stead's inclusion of photographs reflected his view that pictures imparted to the newspaper a more accessible and personal

style appropriate to a modern democracy.[161] Spirit photography and other oc-
cult phenomena discussed in *Borderland* carried the whiff of charlatanry and ir-
rationality—hardly political virtues. Few topics, however, could have suited his
venture better. Stead's *Borderland* opened a wider debate about photographic
evidence and the qualifications for making and interpreting it that tapped into
current interests in national politics. As it did so, mass media changed how spirit
photographs were viewed. Stead believed that the "borderland" was a place not
only where the line between life and death was blurry but also where contests
over science and religion were fought. The metaphor of the borderland was a
liminal space where spiritualism and materialism, ghosts and science coexisted.
He founded *Borderland* in 1893, as part of his journalistic enterprise to demon-
strate the role of the newspaper and its editor in a modern political democ-
racy. He began by soliciting the opinions of eminent Victorians for their views
on the relationship of occultism, religion, and science. The purpose of *Border-
land*, Stead explained at its founding, was to advance communication between
scientific experts trained in psychology and the "great mass of ordinary people"
who saw apparitions but were not trained to record them. *Borderland* was an
attempt, on the one hand, "to democratize the study of the spook; on the other,
it [was] an attempt to instruct those who see spooks as to the nature of evidence
and the importance of making immediate record after careful observation of
the facts." This work would "enable the man of science to construct, from the
multitude of recorded observations, some working hypotheses" about the forces
of nature and the invisible world.[162]

Stead's commitment to the practice of New Journalism shaped his occult
project in three important ways. First, it shaped his ideal of reader participa-
tion. He encouraged a proliferation of meaning by reporting readers' conflict-
ing perspectives. Second, through his own first-person narratives, he established
a personal relationship to this general readership. Third, from the letters he re-
ceived from clerical and scientific correspondents, Stead concluded that neither
the church nor scientific institutions were capable of providing leadership and
guidance toward democracy because their members were elitists who regarded
the newly enfranchised masses as superstitious or idle. Stead fused notions of
science and democracy, art and investigation.

Stead's interviewing of all sorts of people and his opening up of the corre-
spondence columns to ordinary readers was a journalistic breakthrough.
Through newspapers, scientists would be drawn into the spiritual world of hu-
mankind, and humankind would learn enough about science to make them
worthy of the vote. In "What Think Ye of the Study of Borderland?" which ap-
peared in the first issue of *Borderland* in 1894, Stead expressed his hope that

the journal would mark what he called a new epoch in the investigation of unknown forces. Through photography and his journal, he hoped to do for the "great public" what the Society for Psychical Research had done for a "select few." In one sense, he stated, the subject of the occult stood in no need of democratization, for "the common people have preserved an invincible belief in the reality of the phenomena commonly called supernatural." Although belief in the occult was "almost universal," however, it was only quite recently that "any attempt has been made to deal with the problem scientifically." Though he did not make an explicit connection with Crookes's project in the *Photographic News,* Stead similarly sought to democratize photography and restore a spirit of open investigation: "What we wish to do in BORDERLAND is to be a medium of communication between the scientific expert versed in all the secrets of psychology, who will bring his trained intelligence and his scientific methods to bear upon all recorded phenomena, and the great mass of ordinary people, among whom these phenomena are constantly occurring but which, at present, are neither noted carefully nor recorded accurately."[163]

To investigate spiritual phenomena scientifically, he stated, it was necessary to combat skeptics' prejudice against people who believed in the possibility of occult phenomena. The Archbishop of Canterbury, in a letter to a woman later published in *Borderland,* offered his opinion that spiritual "phenomena [were] of a class which appears mostly in uncivilized states of society" and were "exhibited in persons of little elevation of intellect." People who believed in them had "apparently no tendency to improve or make use of the reflection or reasoning faculties, any more than the spiritual side of our nature, but aim at simply depositing isolated facts, often of a trivial nature (and often the reverse of facts), within the cognizance of the subjects of the phenomena." The Bishop of London thought investigators were probably "self-deluded" and "tempted to consciously delude others"; consequently, he thought that the dangers attending it were great. Words like "charlatanism," "willful or unconscious imposture," "unverified stories," and "vague surmises" surfaced in the commentaries of many contributors who responded to Stead's poll.[164]

Others, like the Dean of Lincoln, believed that inquiry into the veracity of psychical phenomena was legitimate but thought the Psychical Society was solely qualified to do it. Frederic W. H. Myers, who shared this opinion, thought it would only be useful if investigators depended on strict rules of evidence from correspondents. Max Dessoir, whom Stead described as "a Brahmin of the Brahmins," thought Stead would "cultivate a dangerous amateurism," saying, "The forthcoming magazine, BORDERLAND, will have the effect of popularising a species of investigation hitherto undertaken only in private circles." Dessoir thought scientific knowledge "in most cases gains absolutely nothing by the co-

operation of persons of varying education . . . no good result can be obtained from such heterogeneous material."[165]

Undeterred, Stead declared that the "first essential is to establish a mode of communication between investigators of all kinds, so that we may have the field scientifically mapped out." He proposed to establish a series of circles of students. These students would enroll and register on payment of ten shillings to cover subscription. He asked readers to send to the secretary the name of the study to which they wished to devote attention; the secretary would record and store them for reference. Members would communicate with each other and with the secretary, who would advise as to the best books to study. "By this means it is possible that BORDERLAND may become a veritable College of the Occult Sciences." *Borderland,* then, was a practical illustration of the popularization of psychical research, "bringing to the study of these obscure phenomena the religious enthusiasm born of a great hope, wedded to the scientific spirit which accepts nothing on trust, which recognizes no authority but that of truth, and which subjects every assertion to the searching interrogation of the methods of experimental research."[166]

The problem, according to Stead, was that the "borderland" had not been studied in the close, systematic, and sustained way that the physical sciences demanded. In the study of scientific phenomena in a democratic society, Stead declared, the problem became how to assimilate the views of the "miscellaneous scattering of observers planted here, there, and everywhere . . . If mankind had investigated steam and electricity in the haphazard, intermittent way that it has investigated the spiritual world, we should still be traveling in stage coaches, and the telegraph and the telephone would have been scouted by all our wise men as the fantastic imaginings of a disordered brain." Stead hoped that his journal would serve as the vehicle for transforming a heterogeneous body of English people into a mixed-class, modern public comprised of rational and diligent truth-seekers. His ideal came close to Ruskin's utopian view of meteorological observers. [167]

Stead opened his journal to current arguments about life on Mars, pictures of thoughts, automatic handwriting, clairvoyance, astrology, palmistry, crystal gazing, and hypnotism. As he had done in previous undertakings, he also made extensive use of pictorial illustrations, including spirit photographs, and publicized women's work in that field. For example, he brought Sarah Power's photographs to the attention of general readers in 1894, the same year that the book based on them was published. Drawing on a style of Victorian reporting that focused on interpretation of the appearance of spirit forms as an index of their truth, he offered visual evidence of her spirit photographs, including comparisons that identified some differences he noticed between them.

Spirit-Photo.	*Carte de visite.*
1. Spirit is standing.	Mrs. Neal is sitting.
2. Clad in white, loose robe.	In tight-fitting dress.
3. One hand is outstretched.	Both hands are on her lap.
4. Wears a white cap-frilled.	A dress cap on, full over . . . ears.
5. Wears embroidered . . . robe.	A plain dark bodice.
6. The angle and size of the face are different in both.	
7. The curls have dropped . . . are straggling.	The curls are neat and in order.[168]

He also publicized spirit photographs that attracted extraordinary attention. Although figures of women as dutiful daughters and occult mothers persisted until the end of the century, other spirit images exemplify the anxious social relations that marked the new emphasis on women's independence. A photograph made sometime during the early 1890s and published in Andrew Glendinning, ed., *The Veil Lifted: Modern Developments of Spirit Photography* (1894) with the caption, "Photograph of a Psychic Lady," shows an unidentified woman who appears in front of a surprised-looking male sitter (Fig. 2.16). Discussions of this photograph in *The Veil Lifted, Borderland,* and the *British Journal of Photography* revealed that even after their earthly death, women's behavior was policed by men. "Psychic Lady" is larger than the male sitter, and her features are more pronounced. J. Traill Taylor complained that she "mo-

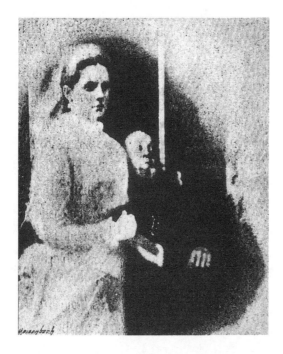

FIG. 2.16. "Photograph of a Psychic Lady," ca. 1892. Spirit photograph made at a séance by J. Traill Taylor. In Andrew Glendinning, ed. *The Veil Lifted: Modern Developments in Spirit Photography* (London: Whittaker and Co., 1894), 29.

nopolised the major portion of the plate, quite obliterating the material sitters."[169] Taylor also speculated that the spirit form was proportionally larger than the sitter because the photographer had used a portrait lens of short focus. This photograph precipitated vehement debates among spiritualists and photographers in *Borderland* over whether the image was an original or a copy— and whether the spirit was dutiful or "behaving badly." Debates over spirit photographs such as "Psychic Lady" and others therefore mirrored more hostile discussions in 1890s London about the relationship between art and life and the novel visibility of the assertive "New Woman."[170]

The *Borderland* debate over the "Cyprian Priestess Mystery" exemplified Stead's journalistic approach because it was organized around a series of highly public inquiries. Subsequently, the "Cyprian Priestess" photograph was widely reproduced as a print and through the newspaper. This "Grecian priestess" (or, as Stead put it, "the printed likeness of her problematical person") caused a "war in the press" after it was discovered that the face was practically identical with the face of a female figure in a German painting titled "Night."[171]

The history of the picture again involved Andrew Glendinning, who claimed to have seen the materialized priestess at séances held in Scotland with the medium David Duguid. Glendinning became so enamored of her that he reproduced the photograph as the frontispiece of his book *The Veil Lifted*. To Glendinning and other *Borderland* correspondents, the picture represented a "priestess of Venus in the isle of Cyprus during her earth-life." These correspondents believed that her photograph captured a high ideal of feminine beauty and spirituality (Fig. 2.17). Duguid was quoted as saying that hers was "a most exquisite face," a visage "full of each charm and grace that make up the womanly character." The photograph that Stead reproduced is a sentimentalized Victorian interpretation of the Madonna, a medieval/Renaissance motif in Christian iconography. The picture shows a classical figure with her hair and part of her forehead hidden by a white veil falling in loose folds along her face.[172]

In the first volume of his new magazine, Stead asked correspondents to furnish their opinions about the photograph's origins. The question turned on whether or not the psychic picture was an original or a fraud. To settle the dispute, Stead insisted on determining "the *history* of the picture."[173] The discussion that resulted provides a glimpse of the multiple, competing interpretations that surrounded individual images.

Since Duguid was silent about his methods, Stead's correspondents speculated on how the picture was made. People suggested that it was a direct impression of a spirit on the photographic plate, a fake (or the materialized double of Duguid himself), the product of fixing fleeing figures passing in the astral region, a copy of a painting reproduced by spirits, or thought forms taking the

FIG. 2.17. "Cyprian Priestess," floating over the head of Andrew Glendinning, ca.1890. Spirit photograph exposed by David Duguid. In James Coates, *Photographing the Invisible* (London: L. N. Fowler, 1911), 68.

likeness of a priestess. As for Stead, he thought "it more likely to be a 'fraud' than a thought-picture," but he remarked (as he had in the case of the "Maiden Tribute") that the theories should rest until "all the circumstances in reference to the history are *known.*" Meanwhile, Duguid's silence about how the picture was made prompted Stead to pressure Glendinning to answer inquiries. Although Duguid's defenders retorted that he had neither the inclination nor capacity to write letters about it, referring to his working-class background, his critics were not satisfied. Issues of misplaced trust and bad faith were raised, as Stead stated that Mr. Duguid's conduct in the matter suggested "sinister indifference" rather than "simple-mindedness."[174]

Other correspondents denied that the spirit extra was real. Isabel de Steiger, a member of the Theosophical Society who lived in Edinburgh, stated that she had seen an identical print in a friend's parlor and offered to travel to London to show experts that it had been faked. "The photo in my friend's house is from the real picture," she wrote to Stead. "I do not say that the alleged spirit-photograph was not one, but I do say that like all such 'spiritual' productions, falsehood is at the bottom of them." Steiger brought to London written testimony from a Scottish solicitor, Brodie Innes, who testified that he had purchased the photograph at a print shop on Fleet Street in London in 1873 or 1874. "They were certainly not sold as spirit photographs, nor did the shopman look on

them as such," he wrote. "The shopman told me he got them from a traveler of a German house, and that they were photographs from German pictures by a well-known artist." Others responded, too. James Anderson, a spiritualist medium from Glasgow who was friendly with Duguid, urged that it was in the interest of truth, to have this matter cleared up, one way or other." He volunteered that he had photographs taken of the "Cyprian Priestess" five years before, in which the figure was "in a reclining or floating position across the top of the cards."[175]

The sexual morality of spirit "extras" was one of several axes on which the truth of the photograph was adjudicated. The "Cyprian Priestess" was shown in different poses, including one in which she was an "undraped syren," reclining and naked, rising out of vapor surrounded by Cupids (Fig. 2.18). Steiger found it " unworthy of the dignity of an immortal spirit, to be idling about in such a fashion, and then appear in a purposeless manner on the plate, with a face already well known in print shops!"[176] In fact, the spirit world offered competing visions of womanhood, and people marveled at how female extras pre-

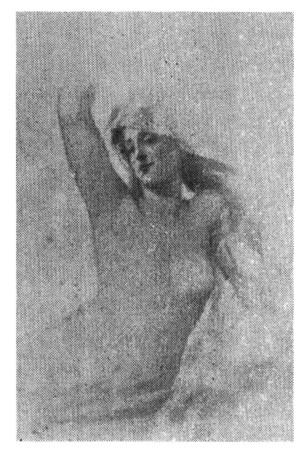

FIG. 2.18. "Cyprian Priestess," shown undraped and "idling." In W. T. Stead, "The 'Cyprian Priestess' Mystery," *Borderland* 2 (July 1895): 243.

dominated in spirit photographs.[177] For some investigators, such as the vener-
ated Taylor, the spirits of women were notable for their physical beauty. Some
were "comely . . . others not so."[178] Many such photographs showed a man's
dead wife's spirit standing with her head lying lightly on his, seeming to exem-
plify a bourgeois vision of domesticity.[179]

The debates over the "Cyprian Priestess" and similar photographs were
never resolved in the paper, but the point, perhaps, was not simply to settle
the question. More importantly, Stead used spirit photographs to demonstrate
a process through which social consensus could be made. In this context of the
often tensely negotiated association between democratization and science—an
association that newspaper editors shrewdly exploited—the public culture of
scientific photography appeared to widen, even though the boundaries around
professional science were becoming more tightly drawn.

Spirit photography became a battleground for a wider struggle over not
only the capabilities of photography but also what it meant to participate in a
modern, democratic society. Spirit photography was a social phenomenon
shaped by the larger forces behind the creation of new boundaries among am-
ateurs and professionals, the growing power of male professional scientific ex-
pertise as arbiter of scientific knowledge, the resulting displacement of women
from arenas where they previously had held sway, and the often competing
claims of natural religion and secular science. The controversy over spirit pho-
tography made the issues of trust in photographic production visible to a wider
Victorian public and focused attention as never before on the necessary quali-
fications to make authentic photographs. Many male scientific professionals
distanced themselves from women spiritualists and spirit photographers. At the
same time, there is ample evidence that scientific institutions used spirit pho-
tography as an "Other" against which to define a distinctively masculine, pro-
fessional or amateur scientific subjectivity.[180]

Spirit photography suggests two points of interest that are crucial for un-
derstanding the development of historical links between photography, science,
and the culture of display. First, photography was an ambiguous practice that
meant different things to different people. Whether or not they actually oper-
ated cameras, diverse people helped develop the idea of spirit photography.
Moreover, the whole idea of belief in the power of photography to mechani-
cally reproduce reality offered no easy way for skeptics to criticize the spiritu-
alists. Second, the asymmetries of gender and class that informed debates over
photographic truth and falsity in spiritualism were reflected in science more
generally. Spirit photography did not differ from other areas of scientific pho-
tography either in its evocation of gender and class considerations or in its ex-
tensive engagement of scientists with popular discourse and public formats.

As the next chapters show, scientists at the center of institutions that promoted photographs of more widely accepted phenomena had to prove their scientific worth in diverse public arenas. They evoked images of skill and sociability to support claims made with photographs. In doing so, who made photographs and how became central to the practice of scientific photography. Science, like photography, was not a monolithic term, and scientific photography encompassed a diverse range of cultural practices. The ideas and practices of scientific photography in turn were often positioned in opposition and in relation to other disciplinary practices, within science and vis-à-vis related fields, such as painting and art photography.

Chapter 3

Acquiring a Scientific Eye

Meteorological photography, one of the fastest growing and publicly visible areas of scientific photography during the second half of the nineteenth century, resembled spirit photography in its reliance on a network of skilled amateur and professional photographers. Developing at the nexus of landscape painting, drawing, and amateur nature photography, serious interest in meteorological photography began around 1850, the year that the Royal Meteorological Society (RMS) was founded and began organizing the work of hundreds of observers around the country. The society's visual materials are a crucial and hitherto almost untapped resource for learning how local, disciplinary, and institutional interests contributed to the ideas and practices shaping scientific photography.

From the 1850s through the 1890s, meteorologists wrestled with how to represent the weather in drawings, watercolors, and photographs. In some cases, they explicitly compared their productions with those of artists and, in so doing, redrew the disciplinary boundaries of art and science.[1] Although meteorologists after 1850 evoked landscape art as worthy of imitation, at the same time they projected it as an "Other" against which a distinctively professional, scientific subjectivity could be inflected. Their studies of clouds and lightning suggest how scientists borrowed from artists in terms of visual practices and ideologies, as well as how the language of naturalism shaped discourses and practices of scientific imaging, how the art-versus-science debate extended beyond the elite art world into everyday middle-class social realms, and how photography was developed through social and material practice.

Reforming Meteorological Representation

To understand the impact of meteorological photography, it is first necessary to move forward to the 1890s. In an address to the Royal Meteorological Society in 1895, the astronomer and meteorologist Richard Inwards blamed artists for the "weather fallacies" of Victorian society. Inwards regretted that "there are still people who are ready to believe that the saints' days rule the weather, that

the sun puts out the fire, that warm water freezes sooner than cold, or that a man is a prophet because he says so himself . . . In the long and patient pursuit which the attainment of all accurate knowledge exacts from man it may sometimes be instructive to turn one's gaze backward and contemplate the errors which have been corrected, the fallacies which have been demolished, and the superstitions which have been lived down." Meteorology had only with "difficulty" been "able to emerge from the mists and darkness of guesses and surmises such as have surrounded the transfer of any truth from the barbaric to the philosophic stage." Even so, there were many "weather fallacies," among them "artist's lightning."[2]

Inwards reminded his audience that a "weather fallacy, for which artists are responsible" was that "flashes of lightning take the form of long angular lines of a zigzag shape, and of which I show you an example, taken from a work on the subject."[3] He projected a comparison of "artist's lightning" with a photograph of lightning on a magic lantern screen. A photograph "taken direct from nature," he declared, shows that the artist had "very little understood the true form of the lightning flash, which consists of numbers of short curves joining each other, something like the course of a river depicted on a map, or in some degree like the outline of a clump of leafy trees seen against the sky." As far as he knew, there were "only two artists whose acute vision saw lightning in anything like its true form." One was J. M. W. Turner who, "long before the time of photography, scratched his lightning flashes with a penknife, making short curved dashes across the picture" (Fig. 3.1).[4] The other acute observer was the

FIG. 3.1. J. M. W. Turner, "The Bass Rock," ca. 1824. Watercolor. Reproduced with the kind permission of the trustees of the National Museums, Liverpool.

FIG. 3.2. James Nasmyth, lightning flashes, ca. 1855. Wood engraving. In Nasmyth, "On the Form of Lightning," *Report of the BAAS* 25 (1856): 14. "Artist's lightning" is shown as fig. 1, "true" lightning as figs. 2 and 3.

astronomer and engineer James Nasmyth, who "also saw the lightning in its true form, and duly noted the same, only to be confirmed years afterward, when it became easy to photograph the lightning flash itself" (Fig. 3.2).[5]

Nasmyth made the zigzag lightning into a matter of widespread scientific and public concern. In 1856, he published "On the Form of Lightning" in the *Report of the British Association for the Advancement of Science,* in which he insisted that "in no instance" among all the thunderstorms he had "most attentively watched," had he ever seen such forms of lightning as those represented in works of art. Nasmyth blamed artists for imitating the form of Jupiter's thunderbolt as sculpted by the ancient Greeks. Artists had classical training; thus it was not surprising that they studied ancient forms of nature. Yet lightning, retorted Nasmyth, had

a "true natural form . . . correctly represented" either by an "intensely crooked line," or a "forked or branched form" but not, significantly, by a zigzag. To make his point, Nasmyth drew and contrasted three sketches of lightning: one zigzag, one arc or streaking, and one arc with branches, ramified (see Fig. 3.2).[6]

Painters had long represented lightning in the form of a classical zigzag to communicate tension, danger, surprise, and divine vengeance, and during the eighteenth century, nature was frequently depicted using neoclassical visual vocabulary. The zigzag form appears as an ominous sign in William Hogarth's line engraving "A Rake's Progress, Plate IV: Goes to Court" (ca. 1735), and in Richard Wilson's "The Destruction of the Children of the Niobe" (ca. 1759–60). Exhibited by the Society of Artists in 1760, this painting was the key picture of Wilson's distinguished career and became one of the most popular engravings of the eighteenth century. By the early nineteenth century, classical zigzag lightning had become the established convention for depicting atmospheric electricity and was used by painters Francis Danby, John Martin, Luke Clennel, and Phillipe de Loutherbourg. The form is evident, for example, in the mezzotints and etchings (ca. 1827) made by Martin to illustrate Milton's *Paradise Lost,* in Loutherbourg's oil on canvas painting, "Landscape with Wagon in a Storm," displayed at the Royal Academy in 1809, and in Spooner's portrayal of King Lear (ca. 1761), after Benjamin Wilson (Fig. 3.3). As Dian Kriz points out in her study of nationaliz-

FIG. 3.3. Charles Spooner, after Benjamin Wilson, "Mr. Garrick in the Character of King Lear—'King Lear,' Act III, Scene V." Mezzotint, 10″× 14″, 1761. Yale Center for British Art, Paul Mellon Fund.

ing discourses in English landscape painting, Loutherbourg's painting was criticized. The scene was typically sublime—it shows a road accident in the mountains caused by horses taking fright at a thunderstorm—but its critics suggested that the painter lacked the sensibility needed to represent the English landscape.[7]

The high-art motif of lightning ultimately was translated into a popular sign as the zigzag lightning flash became conventionalized in sermons and popular morality tales. Gods holding thunderbolts in scenes of Olympia also were rendered in sculpture. One of the most widely circulated sources of zigzag lightning illustrations for popular audiences was Wilfred de Fonvielle's book, *Thunder and Lightning,* translated from French into English in 1869. At the same moment that meteorologists lamented its ubiquity, zigzag lightning was depicted in Fonvielle's scenes of danger and death: "Coast Guard Blinded by Lightning," "A Murderer Struck by Lightning," "Fish Killed by Lightning," "A Brigand Struck by Lightning," and a "Bell-Ringer Struck by Lightning" (Fig. 3.4).[8]

The issue of accurate representations of lightning galvanized scientists just as many British landscape painters began focusing on the need for more naturalistic detail in paintings. In this context, it is noteworthy how many scientific

FIG. 3.4. "Coast-Guard Blinded by Lightning." Wood engraving reproduced in Wilfred de Fonvielle, *Thunder and Lightning* (New York: Charles Scribner and Co., 1869), 219.

observers and artists traveled in the same social circles and in some cases, studied together, during the 1840s and 1850s. Nathaniel Green, an astronomer and friend of Nasmyth, studied alongside painters John Everett Millais and Dante Gabriel Rossetti, who, together with W. Holman Hunt and William Leighton, founded the Pre-Raphaelite movement to protest what they saw as low standards in British art. Green studied at the Royal Academy Schools in London in 1844. Becoming interested in astronomy in 1859, he built a telescope and became a keen lunar observer and an early member of the Selenographical Society, which met at the Royal Astronomical Society in Burlington House, Piccadilly, next door to the Royal Academy. Throughout his career as an astronomical observer, watercolorist of the planets, author of drawing books, and drawing tutor, Green exhibited his work not only at the Royal Academy and other galleries but also at the British Astronomical Association and the Royal Astronomical Society.[9]

Artists were struck by the apparent inaccuracy of paintings of lightning. Joseph Bartholomew Kidd of the Royal Scottish Academy wrote: "[J. M. W.] Turner is the only painter who seems to have seen lightning at all, his Stonehenge is proof of this." Kidd was probably referring to "View of Stonehenge," published as an engraving in 1829 for Turner's "England and Wales" series. "Wilson, Claud [*sic*], Martin and a hundred others have given us a sharp angled piece of metal in place of the quivering liquid fire painted by the finger of the Almighty" (see Fig. 3.1).[10]

Training the Eye and Hand

Drawing was a favorite Victorian amateur pastime, a "polite and useful art" for the middle classes.[11] Sketching landscapes was an accessible cultural accomplishment for the businessman who did not have the time or interest to take up the serious study of painting. (Talbot, as seen earlier, ultimately abandoned landscape drawing for experiments with photography because he considered himself a poor drawer.) Meteorologists' reliance on amateur artists for accurate drawings of weather phenomena suggests that visual activity in meteorology crossed several cultural domains and institutional contexts. The linking of the practice of the picturesque with amateurs provided an important context for the simultaneous development of a culture of meteorological representation.

Miscellaneous observations of unusual weather phenomena that could not be seen directly were long seen as valuable, if their credibility was verified. Europe's scientific institutions historically had relied on scattered observers in meteorology, auroral studies, geomagnetism, botany, and zoology to furnish data and material specimens for display and study. Concepts of skill and visual acuity permeated meteorological writings and discussions on drawing and photography for the duration of the nineteenth century. These in turn were con-

nected with ideas about national participation in science, science literacy and education, and politics within the field of meteorology.

The observation and depiction of atmospheric phenomena were pursued by European natural philosophers and landscape artists for hundreds of years before the invention of photography in 1839 and the foundation of the Royal Meteorological Society in 1850. These practices fit well with the building of empires in South America, India, Africa, and Asia. The establishment of successful agricultural settlements and economic relations of trade, for example, depended on accurate information about the natural history of places, including the physiology and tempers of the atmosphere. During the eighteenth century, the artists who accompanied Captain James Cook on his voyages to the South Pacific carried instructions from the Royal Society to return with drawings and watercolor sketches that recorded atmospheric views and meteorological phenomena seen around the world. As Bernard Smith explains in his study of Pacific art and exploration, "a compositional mode congenial to empirical naturalism was significantly advanced by the artists of Cook's voyages who had to front up as best they could to portraying—with scientists looking over their shoulders—the startling radiance of tropic seas, the drama of tropical weather, the half-light of Antarctic seas—situations that were new to them all." Meteorological observations were published in the *Philosophical Transactions* of the Royal Society, often with instructions on how to collect storm-related specimens, note sunspots, and describe aurorae.[12]

Growing interest during the late eighteenth century accompanied the rise of "Humboldtian science," defined by Susan F. Cannon as the accurate measured study of widespread but interconnected real phenomena such as geographical distribution, terrestrial magnetism, meteorology, hydrology, ocean currents, mountain chains, geological strata, and solar radiation. Thunderstorms and spectacular phenomena had always attracted attention, of course, but writers like Luke Howard and John Dalton in England and Friedrich Heinrich Alexander, Baron von Humboldt, in Germany during the early nineteenth century attempted to explain them in relation to other occurrences. The cloud studies of Luke Howard, John Constable, and Cornelius Varley manifest a clear interest in the precise registration of natural phenomena.[13]

In *Modern Painters,* published in several volumes between 1843 and 1860, art critic John Ruskin praised Turner for combining imagination and perception with close empirical observation of nature. In "The Truth of Skies," Ruskin urged that "the landscape painter must always have two great and distinct ends; the first, to induce in the spectator's mind the faithful conception of any natural objects whatsoever; the second, to guide the spectator's mind to those ob-

jects most worthy of its contemplation, and to inform him of the thoughts and feelings with which these were regarded by the artist himself."[14]

Ruskin's *Modern Painters* attempted to show that Turner's late style was truer to nature than any other landscape art had ever been. His wish to expound Turner's work in terms of a developing style was in tune with the general inclination of nineteenth-century writers to see painting as a series of visual discoveries, an approach that has dominated art criticism to this day.[15] Born in 1775 in Covent Garden to a barber and wigmaker, Turner (d. 1851) was one of England's greatest painters. Critics praised his subtle rendering of light and color and his "feeling for the infinity of nature."[16] In the first years of his professional career, he made rapid advances in his use of watercolor. After first visiting North Wales in 1789, he began experimenting with new color systems to create extraordinary landscapes. By the turn of the century he was painting in oils outdoors. His pieces, which were widely exhibited at the Royal Academy and the British Institution, show his preoccupation with effects of moonlight and firelight, geological and meteorological forms, and topographical knowledge. Turner's power to combine the observation of nature with the power to stimulate the feelings and imagination of viewers is seen in his *Views in Sussex, Consisting of the Most Interesting Landscape and Marine Scenery in the Rape of Hastings* (1820).[17]

British landscape painters after Turner were led into a sustained and often exhilarating examination of the nature of perception and representation. As a *Monthly Magazine* writer explained in a review of the Royal Academy exhibition in the summer of 1810, the "progress of the British school" of art required that artists be "beyond competition in landscape."[18] Artists set the stage for scientists to insert themselves into the national debate over how the British landscape and skies ought to be represented pictorially. To discredit what they regarded as false representations of lightning and to educate the public about its accurate representation, scientists mounted competing exhibitions of scientific representations of meteorological phenomena. International expositions already drew massive audiences in the nineteenth century, and their exhibits transmitted a new visual culture to an eager public. In attacking "weather fallacies," meteorologists displayed their methods for seeing phenomena scientifically. The demonstration of scientific practice was an essential way to train observers and to distinguish meteorology from ordinary weather watching.

The possibility of forging vast networks among distant meteorological observers expanded as developments like telegraphy, the railroad, and Greenwich standard time created new communities, real and imagined. Five years after

George Airy moved to the Royal Observatory at Greenwich as the Royal Astronomer, he appointed James Glaisher as superintendent of the Magnetic and Meteorological Department. At Greenwich, Glaisher superintended Britain's first system of precise, simultaneous observations by volunteers in different parts of the country for the preparation of meteorological reports in the *Daily News* and the registrar-general's returns of births, marriages, and deaths.[19] Most of these volunteers already were entrusted with managing disciplinary institutions; significantly, the list of names and occupations includes clergy, medical men, prison managers, and railroad station managers.[20] Glaisher's networks mirrored, in a scientific setting, those used by the architects of imperialism to create and manage the vast bureaucracy of the British empire. At roughly the same time, the British Association for the Advancement of Science (BAAS), founded in 1831, developed schemes to advance meteorology, a new science that depended on the cooperation of many observers, some with little or no specialist training.

The London Meteorological Society collapsed in 1843, after members disagreed over whether "astro-meteorology," a cosmology uniting astrology and meteorology, was a scientific subject that they should pursue.[21] After the establishment of the Royal Meteorological Society in 1850, meteorologists renewed their efforts to make the study of weather more rational and systematic. Members began organizing the discipline in earnest, intent upon eliminating weather superstitions as well as proving their science's social worth. Many of the leaders were active in photographic circles and promoted scientific photographers. They included James Glaisher, David Brewster, and William Whewell, who played important roles in defining the underlying concepts, practical uses, and techniques of photography. Their contacts proved significant for the growing closeness of science and photography in the field of meteorology.

They collaborated to foster meteorological correspondence through expanded networks, created journals and a specialist publication, made observations and maps, and worked with instrument makers to standardize meteorological instruments. The society actively recruited empirical contributions from distant observers to build a collection of data about atmospheric occurrences. They also worked strenuously to elevate the social status of meteorological science in the public eye. With the founding of the RMS came new opportunities to realize John Ruskin's dream of creating an extended community of meteorological observers. In 1838, Ruskin had urged that the future of meteorology as a scientific discipline depended upon successful efforts to synchronize the empirical contributions of a cadre of meteorological observers. He predicted that a central network would revolutionize meteorology by providing a framework in which individuals might "think, observe, and act simultaneously,"

though "separated . . . by distances, the greatness" of which the very "utility" of the observations depended.[22] In turn, the RMS raised in an especially public way the issue of observation, drawing, and photography as activities that required special skill. That the new science continued to interest the masses as well as elites was reflected in the popular meteorological and general newspaper press, and in the large response to Victorian meteorological societies' appeal for assistance in recording and photographing phenomena around the country, the British Empire, and the world.

Along with scientists, landscape artists helped popularize the notion that literate, middle-class people were capable of making aesthetic judgments and realizing those judgments in the form of sketching and drawing. As Kriz suggests, the picturesque was a term associated with diverse cultural practices, ranging from landscape gardening and the appreciation of old masters, to domestic touring and amateur sketching.[23] The chief popularizer of the picturesque from roughly 1790 to 1820, the Reverend William Gilpin, encouraged the idea that the art of sketching landscapes was ideally suited for the bourgeois amateur and should not be exclusively the province of professional artists. For Gilpin, the picturesque mode implied variety and contrast, massing and effects of light and shade, suggestion rather than detail.

British landscape painters and their critics generally held not only that different national climates required different aesthetics but also that certain skies were not appropriate for certain landscapes. Joseph Pott suggested that a truly English school of landscape painting could be produced if domestic artists would concentrate on the skies of England rather than the views of continental master artists. William Gilpin compared the "obscurity" of English skies with the clarity of Italian ones. As Kriz writes, "Ironically at the same time that many domestic artists and writers were disavowing the link between climate and national culture, others involved in the promotion of English landscape painting found it in their interests to emphasize the artistic potential and distinctiveness of English climate and topography."[24]

Concerns about picturing an appropriate sky also surfaced in amateur photography. In a short 1861 *Photographic News* essay, the author wrote: "Nor can it be said with truth that there is less beauty in an English than an Italian sky, since each will be found to suit best with the general complexion of its respective scenery." The most important thing was to cultivate a "habit of constantly observing the works of creation as they really exist, rather than as they are set down in treatises or practical specimens of masters." He believed that because English artists could sketch nature at home, there was no serious need for them to study on the continent. What had all this to do with photography? His reply

spoke volumes about the nationalist perspective that informed much amateur practice. Saying that few British photographic readers would prefer a tour through France or Italy than "the land of their birth," he reasoned that if the "public requires foreign views, there are surely enough of foreign artists to supply them."[25]

As nineteenth-century meteorologists struggled to establish the field's authority, they encouraged meteorological observation as a daily practice and as a component of a moral, well-lived, and disciplined life that benefited the nation. In the wider context of discussion about who was qualified to make and interpret scientific photographs, contests over the authority of photographs tapped into wider cultural debates over popular beliefs and scientific practices, data and interpretation, and who was qualified to participate in a rational age.

One of the first studies undertaken by the RMS was to determine the most frequently observed colors and forms of lightning. In 1857, G. J. Symons, meteorologist and RMS secretary, began a national study of storm-related phenomena. Witnesses were asked to document the date, time of day, color, form, and approximate distance of lightning that they happened to see. They then sent their reports to the society, where researchers compiled and analyzed the findings.

Members of the RMS requested and received hundreds of weather communications documented with a range of materials, including letters, sketches and photographs, and physical objects removed from sites of storm damage. Using this documentation, meteorologists amassed facts, assembled arguments, and communicated with their colleagues. The term *virtual witnessing,* coined by Steven Shapin and Simon Schaffer, is helpful here. It describes how Victorians came to use visual resources such as letters, drawings, and eventually photographs to produce "an image of the experimental scene in a reader's mind," thereby obviating the necessity for direct witness or replication.[26]

As they communicated their experiences of weather to others, Victorians drew on a wide range of available descriptive resources to instill images of lightning in the minds of those who had not seen it themselves. The weather was the subject of widespread observation and scrutiny, and the livelihoods of many people, such as farmers and fishermen, depended on it. Almanacs of weather lore were widely read, yet even so, popular beliefs about weather phenomena varied. Civil servants watching a storm from a verandah, for example, noticed different things than did shepherds whose lives and livelihoods were potentially endangered.

At a time of intense scientific interest in the natural causes and diverse forms of observable phenomena, lightning generated tremendous confusion, anxiety, and curiosity among various groups, from naval captains, farmers, and preachers to natural philosophers, painters, and novelists. Lightning flashes were among Victorian England's most sensational sightings. Many men and women

in the second half of the century found much to comment about in the way that lightning, like ghosts, apparently caused objects to move around rooms, left strange marks and holes in their walls, and made animals behave in unpredictable ways. Lightning flashes, unlike many other phenomena that scientists observed, were dramatic and singular local events that took place in remote locations outside the laboratory setting. Lightning gave people cause for worry, and vehement discussion took place about which objects were most likely to be struck and why. Between 1852 and 1880, 546 people in England and Wales were reportedly killed by lightning, with the average annual numbers fluctuating unpredictably between three in 1863 and forty-six in 1872.[27] Numerous personal injuries were reported, some of which were documented in medical photographs, such as an image of a shepherd injured by lightning, found today in the holdings of both London Hospital and the Royal Meteorological Society.[28] There were also many reported cases of damage to livestock, churches, and houses, which created economic hardships.

As well as being a danger, lightning flashes also intrigued Victorians as a beautiful and dramatic form of visual entertainment. Among the legions of electric storm spectators were two women from Dorset who became awestruck by "charming" balls of "globular lightning" while cliff walking in the summer of 1897. They wrote to a friend in the RMS that "the balls were all aglow . . . with a soft, superb iridescence, rich and warm of hue . . . their charming colours heightening the extreme beauty of the scene . . . Their numbers were continually fluctuating; at times thousands of them . . . and then a few minutes afterwards the numbers would dwindle to perhaps as few as twenty."[29]

Finally, lightning invited natural inquiry and discussion as the perpetrator of bizarre and nonsensical effects. In 1883, the primary journal for English popular meteorological science, *Symons' Monthly Meteorological Magazine,* ran a series of articles on the "photographic effects" of lightning. One individual reported that a young child had been imprinted by the image of a tree: "A little girl was standing at a window, before which was a young maple tree. After a brilliant flash of lightning, a complete image of the tree was found imprinted on her body." The writer added that this was not the "first instance of the kind." Furthermore, sheep killed by lightning in Bath were discovered to have retained a beautiful image of the surrounding landscape on their skins. One witness recalled that the skins became part of a traveling exhibit, causing a "great local sensation" as residents recognized with fond memory the outlines of fields where they had played as youths. "I may add," he wrote, "that the small field and its surrounding wood were so familiar to me and my school-fellows, that when the skins were shown to us, we at once identified the local scenery represented."[30]

It turned out, Symons found, that two people literally saw the same flash of lightning differently. On a very fundamental level, people's experiences of lightning varied according to who they were and where they were located when lightning struck. Nasmyth's "On the Form of Lightning" (1856) had generated much excitement about lightning, and by the 1870s, the RMS was a treasure trove of visual materials, from photographs and physical specimens to drawings and watercolors. However, the society's national study of lightning forms posed difficult issues of skill, visual acuity, and discrepancies among observers, often referred to as the observer's "personal equation." The Meteorological Council found it difficult to create order out of the data that they collected from observers. For example, they confided later, while they wished to consider only "primary" colors (blue, white, red, and yellow), and "primary" forms (sheet and forked), they faced instead a wide array of descriptions that in no way conformed to the desired standard categories. There was, for example, the case of two flashes seen by a Manchester correspondent: "one vivid reddish yellow, and one vivid purplish pink." Others reported red sheet, blue curved, whitish, "not forked," rose, zigzag flashes, and "pale lilac, sheet" lightning. Among the various forms that individuals observed, to make matters more confusing, were "forked," "very forked," "not forked," "zigzag," "sheet," "curved," and "flame."[31]

Ultimately, Symons stated that he was "obliged either to reject or reduce many observations, so that the variation between individual observations might be eliminated." He wrote: "I have been obliged either to reject or reduce to some of the primary colours the terms employed by some of the observers, such as 'like a sulphur flame,' 'like a burning rope,' 'mauve,' etc." At the end of the published report, researchers included a table that registered the number of observations made on each of four standard colors and two standard forms of lightning. The council concluded that lightning was most often seen as blue (followed by red, white, and yellow), and that sheet lightning was observed twice as much as forked.[32] This is one way that the Meteorological Council proceeded to render their empirical descriptions into numerically based facts; that is, they standardized individual observations for statistical observation in order to achieve a more conventional scientific comparison.

"Unscientific" Ways of Seeing Nature

The politics of observing and representing lightning were framed by the politics of a newly emergent discipline. Ultimately, British meteorological studies generated not only new data about thunder and lightning but also immense public commentary on the weather-observing skills of the national population. Domestic landscape painting satisfied what Kriz describes as "the growing demand for representations inscribing the external 'truth' and the internal 'char-

acter' of English nature." British landscape painters worked intimately with the idea that the defining character of a place and its people resided in the most ephemeral parts of the landscape, such as the sky, a practice that Kriz links to the nationalist sentiment arising from the English counterrevolution and the French wars. These and other developments in the interrelated fields of philosophy, psychology, and aesthetics "offered artists, critics, and viewers a new framework for conceptualizing the relationship between the individual and the domestic landscape and for rethinking their own identity as members of a national community."[33]

In the view of several leading scientific observers in the RMS, including Symons, the lay populace saw the atmosphere in ways that the society often viewed as "unscientific." For example, meteorologists expressed the view, widespread today, that thunderbolts (often called *clinkers*) were ordinary material objects struck by lightning, such as iron pyrites, belemite fossils, fulgurites, cannonballs, bronze celt, and downed telegraph wires. However, many British observers claimed that thunderbolts actually fell from the sky and, significantly, that they had evidence. A photograph of a thunderbolt (ca. 1872) is found in an album from the HMS *Challenger* expedition, now on deposit at the British Museum of Natural History (Fig. 3.5). Two sailors are shown standing next to a thunderbolt displayed on a pedestal.

"I have been looking out for a real thunderbolt for over thirty years," Symons announced to the assembled members of the RMS on March 21, 1888.

FIG. 3.5. Thunderbolt on pedestal in the Cape Museum, with sailors standing by with measuring device, ca. 1874. Robert Higham, *Challenger* Photograph Collection, 1872–1876, No. 51. The Natural History Museum, London.

The society had invited Symons to present his findings from a series of skeptical investigations he had made into numerous testimonies from eyewitnesses claiming to possess physical evidence of thunderbolts. Symons began his report "The Non-Existence of Thunderbolts" by expressing incredulity that this belief in the "fall of material substances during thunderstorms" should still survive. These objects were "facts twisted into imaginary support of the theory . . . That the notion should still prevail with a population which may be said to be living in an age of electricity, and to be surrounded by telegraph, telephone, light, and bell wires, above our heads, below our feet, and running all through our houses, is passing strange." He obtained permission from the council to dissuade believers by presenting evidence both in favor and against the theory of thunderbolts.[34]

Symons began by offering the fellows a "true history" of "several (so-called)" bolts that he had encountered in the course of his scrupulous inquiries around the country. On July 2, 1866, a London daily newspaper, he said, had printed a letter from a Notting Hill resident who described a recent storm: "At a few minutes past seven a thunderbolt fell in the gutter opposite my house . . . and was smashed to pieces, one of which I have at the hour at which I write. Numbers of persons are still looking for the fragments." Symons had visited the letter writer, finding—to his surprise—the story "amply confirmed" by actual fragments of the attested phenomena. After investigating further, however, Symons had exposed a "trick so well-arranged," that it was "no wonder that the neighborhood had been deceived:" "Eventually I ascertained that one of the pupils of an analytical chemist had availed himself of his tutor's absence to fill a capsule with material calculated to burn vigorously, and explode in heavy rain, and, during the height of the storm, had thrown the burning mass into the gutter, so making an artificial thunderbolt."[35]

Symons cited similar accounts whose factual basis he had taken great pains to discredit. He had investigated thunderbolts found (among other places) in the kitchen grate of a house in Chelsea, struck by lightning on June 26, 1880; in a hole dug by a farmer in Cornwall, who reported seeing the "ground ploughed up in front of him by a vivid flash of lightning"; and on the city streets of Kilburn, London, an area heavily populated by Irish émigrés, where, according to the local newspaper, the "molten liquid had poured down from infuriated heavens," forming "clinkers" which ranged in size from a "walnut up to a man's hand." The staff at the *Kilburn Times,* after collecting nearly two bushels of clinkers, had placed them on public display and encouraged their inspection. According to Symons, the Kilburn "clinkers" had "most probably . . . been raked out of the steam fire-engine." However, there remained two "difficulties" that required explanation: "(1) How clinkers are formed in the sky?"

and "(2) Why they all fell in the street, and not one pierced a roof or broke a skylight?"[36]

Symons concluded by summarizing the evidence both for and against thunderbolts before urging the audience to assist him in eradicating this popular superstition. First, he presented the material evidence in favor of thunderbolts, including the previously mentioned iron pyrites and cannonballs that were, he said, "facts twisted." Next he spoke in favor of the evidence provided by the electric spark machine: "Our President has illustrated to you that a flash of lightning is nothing but a large electric spark, an equalization of potential between two unequally . . . electrified bodies." Having been persuaded himself by laboratory experiment, Symons declared: "For our credit as Englishmen we ought to drive the word 'thunderbolt' out of our dictionaries." The audience could help to discredit such testimonies by taking an active part in their circumstantiation: "And the greatest help of all will be, whenever one hears of a thunderbolt having fallen, not to content oneself with a shrug of the soldiers and an ejaculation as to popular ignorance, but to go to the spot, patiently examine the facts, and then explain publickly [sic] precisely what happened." He ended on an optimistic note: "Statements as to the existence of thunderbolts require only to be brought to the light of modern knowledge to be at once annihilated."[37]

Symons's plea for public assistance in his campaign against thunderbolts illustrates two important features of late-Victorian meteorological science: the field's dependence on the testimony of distant observers for its research data, and the sheer variety of media that its members deployed to disclose information about weather events. Yet Symons also made lightning investigation into a political campaign for wider scientific education, and, in the process, he distinguished between scientific and unscientific ways of looking.

Another lightning fallacy that meteorologists sought to destroy was the myth of zigzag lightning. By the 1880s, armed with their new knowledge and a new sense of their disciplinary expertise, meteorologists set out to combat artists' representation of lightning. Unlike most reviews of art exhibitions, meteorologists did not record the names of artists. Rather, they were only "concerned with the accurate representation of the sky, no matter by whom it is attempted." Their judgment was tinged with nationalism. In 1880, Symons and a meteorologist friend made a special trip to evaluate the depictions of weather in paintings exhibited at the Royal Academy of Art and the Palais des Champs-Elysées. In their report, the two meteorologists especially criticized the pervasive and false presence of that ubiquitous icon: "artist's lightning." Attesting to the powerful interrelationships of art and science at this time, the pair with thinly veiled sarcasm stated they did not think it "beyond our scope to critically consider 3,000 representations of atmospheric conditions." Among the British

paintings, they found "few or no such meteorological impossibilities" as were found in the French exhibition. Some seemed to them "very truthful," such as number 208, "Blushing Morn," which they judged "very good." There were "magnificent specimens" of different types of clouds. However, there were also many inaccuracies or poor renderings These included especially "too verdant" skies "nearly as a green as the field," some with an "unnatural coffee colour," and skies that were "too white." They parodied a painting identified only as number 999: "Make haste to save the hay, for rain will shortly come." They judged sarcastically: "We do not think that the labourers need hurry, for the signs of coming rain are not very obvious."[38]

As Inwards put it in his 1895 address, only Turner and Nasmyth had seen lightning in its true form before "it became easy to photograph the lightning flash itself."[39] Turner's paintings had become the standard against which later photographs would be measured and compared. From the point of view of many meteorologists, photographs confirmed the nonexistence of "zigzag" lightning as "artists" had depicted it.[40] In 1888, the *Quarterly Journal of the Royal Meteorological Society* published an early photographic classification of lightning, including a page showing four types of lightning forms recorded by photography (Fig. 3.6). Significantly, no zigzag lightning is shown. The first is "stream" lightning, pictured as a thin line of electricity running horizontally across the center of the plate. The second is "ramified" lightning, so-called because, unlike "stream" lightning, it exhibited tiny branches. The third is "meandering," represented by a line with whimsical curlicues and changing directions. Finally, there is "sinuous" lightning, shown as a cascade of thin, curving lines of electrical discharge.[41] By the end of the century, the blow photography dealt to "artistic" representations of lightning was seen as its major contribution to meteorology.

"Easy to Photograph the Lightning Itself"

Amateur photographers were looking out for extraordinary natural phenomena, including clouds and lightning, before scientists tapped them, but a scientific genre of meteorological photography emerged only gradually. The use of photography as a meteorological tool developed inconsistently with other aspects of industrialized labor. That is, the institutional use of photography with self-registering instruments preceded the large-scale use of photography by individual meteorologists (although eventually, of course, both were used simultaneously). Self-registering instruments were at the heart of Victorian meteorological practice and were the dominant mode of using photography in meteorology. The first known use of photography with a meteorological appa-

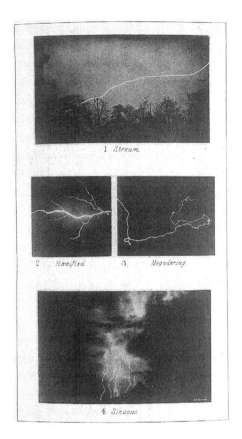

FIG. 3.6. Types of lightning, ca. 1887. Gelatin photographs. Ralph Abercromby, "On the Photographs of Lightning Flashes," *Quarterly Journal of the Royal Meteorological Society* 14 (1888): 232.

ratus occurred in Britain during the late 1830s, immediately after the invention of photography.[42] British instrument makers and meteorologists worked together during the 1840s and 1850s to devise new graphic devices: barographs, thermographs, pluviographs, earth current recorders, sunshine recorders, recording actinometers, magnetographs, electrographs, and even a photonephograph, or cloud camera. By 1890, most British observatories, as well as observatories in the British Empire and the continent, employed self-registering instruments. Data curves were generated into numbers, which were tabulated and sent to observatories and occasionally to newspapers as printed columns of figures.

The first known photograph of lightning was made in 1847, three years before the founding of the RMS, thousands of miles from London in the heartland of America. Trips west took people away from families and communities never to be seen again, and photographs filled a raw hunger for memories of family and loved ones. To attract customers, photographic shops in Missouri, as in London, did stiff competition with each other. Display windows bore wit-

ness to photographers' virtuosity and range. Like the first spirit photographs, the first lightning photograph was something of a novelty. The *Iowa Sentinel* reported "the success of Mr. T. M. Easterly of St. Louis" in securing a permanent record of the natural phenomenon. Easterly was a very skilled daguerreotypist who traveled and worked in the Midwest during the 1840s. After parting from a business partner named Webb during the spring of 1847, he set up a gallery in St. Louis, where he produced some of the earliest known camera-made pictures of Native Americans, particularly the Keokuks. While the original has disappeared, an 1880 cabinet card copy by Cramer, Gross, and Co. documents the photographer's skill in a process generally thought to preclude such instantaneous impressions (Fig. 3.7). An advertisement for the lightning photograph announces that it was displayed beside portrait likenesses of "prominent citizens, Indian chiefs, and Notorious Robbers and Murderers," a gallery of sensational frontier fantasies and fears. The photographer showed that he recognized that his remarkable technical achievement would interest scientists by doing something that was typical of scientific reports but unusual for photographs. Following the conventions of scientific observation and establishing his authorship, he wrote directly on the negative: "Daguerreotype of a Streak of Lightning taken June 18, 1847 at 9 o'clock," and he signed his name.[43]

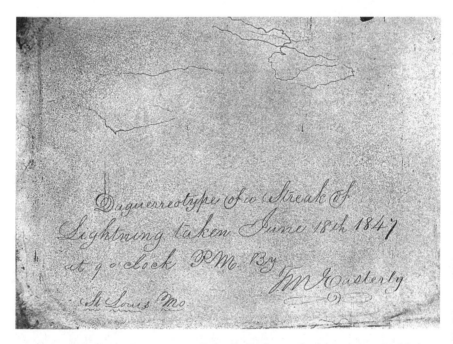

FIG. 3.7. Streak of lightning. "Daguerreotype of a Streak of Lightning taken June 18th 1847 at 9 o'clock P.M. By T. M. Easterly St. Louis Mo." Cabinet card photograph of daguerreotype by Cramer, Gross and Co., after Easterly, 1880. MHS Negative 17691. Missouri Historical Society, St. Louis.

From the 1880s on, photography became a powerful ally in the meteorologists' attempts to classify weather phenomena. Technological changes improved the sharpness and ease of photography of weather phenomena. A man from Lincoln boasted to the *Photographic News* in April 1869 that he had succeeded in photographing lightning during a storm with his ordinary Mawson's wet collodion and Dallmeyer's camera.[44] As gelatin dry plates replaced the earlier daguerreotype and wet collodion processes, it became possible to record lightning using much shorter exposure times. The introduction of dry plates, the invention of celluloid roll film, and the development of the handheld camera in the 1880s expanded the already burgeoning mass amateur market that was making photography accessible to thousands. The camera became a practical, relatively simple, and easily handled device for amateurs and professionals, a device that appealed to scientists in a field such as meteorology, which historically had depended on the assistance of amateur observers.

Despite these improvements, meteorological photography was hard to do. Inwards's claim that it was "easy" to photograph lightning is one of those rhetorical statements often invoked about photography's superiority over drawings that disguises the actual skills and techniques involved: labor that contemporary meteorological writings made visible. Victorians knew well that successful cloud photographs testified to the photographer's skill as well as to the meteorological eye that perceived extraordinary cloud moments. As one meteorologist explained, "The successful photographing of clouds is so entirely different from the ordinary run of photographic work that very few photographers succeed in producing even passing results."[45] Examples of excellent early cloud studies are shown here. The first is from the 1860s Amateur Photographic Exchange Album; the second from Scottish astronomer Charles Piazzi Smyth's album "Cloud-Forms" (Figs. 3.8–3.9).

FIG. 3.8. Anonymous, cloud study photograph, ca. 1862. Amateur Photographic Association Album, No. 22424. Royal Photographic Society Collection at the National Museum of Photography, Film, and Television.

FIG. 3.9. Charles Piazzi Smyth, "Cloud-Forms That Have Been in 1893–1894," Vol. 1, p. 99, photo no. 142, April 25, 1893. The text reads: "The infinite thin negatives of high, white, dry Spring-time clouds, though looking both bright and cheerful to the eye, on their base of exquisitely beautiful and most pronounced blue sky, but which refuses to be photographed except as more or less white, and nothing else." ©The Royal Society.

The amateur movement in photography and science established some of the principal conditions for meteorological photography's widening appeal as a democratic practice. In 1888, George Eastman set out a new philosophy of amateur photography in an advertisement for the Kodak camera that he had designed and produced. "The principle of the Kodak system," he announced, "is the separation of the work that any person whomsoever can do in making a photograph, from the work that only an expert can do . . . we furnish anybody, man woman or child, who has sufficient intelligence to point a box straight and press a button . . . with an instrument." Amateurs could get a perfect result if they gave up control over some of the steps: "You push the button, we do the rest." Although not every attempt to define knowledge drew the line between amateurs and experts where Eastman did—that is, at the pressing of the button—Kodak's famous slogan reflected the historical emergence of intervention by experts as the standard that defined specialization.[46]

The technological advances in photography had definitive and far-reaching implications for amateur involvement in meteorology. At roughly this time, photographic record-keeping increased, with some of the better-known documentary photographers, such as Roger Fenton and James Robertson, and the Americans Mathew Brady, Carleton Watkins, and Timothy O'Sullivan, recording physical landscapes of nature and war. Assisted by fellow readers of journals such as the *Photographic News,* amateur photographers were "looking out for

views."[47] Aided by the expansion of the national railroad system, photographers often walked to sites after alighting. They cultivated the habit of watching the weather, partly for practical reasons. The amount of humidity and sunshine and the potential for rain and clouds was crucial to the practice of the photographic art. However, they also observed nature because doing so fit with current theories of nature study, which stressed the virtues of direct observation over book knowledge. As the photographer J. H. Jones put it, "A habit of constantly observing the works of creation as they really exist, rather than as they are set down in treatises or practical specimens of masters, will teach him to vary his style, when he takes his subject from a different climate." Observing nature closely prevented obvious artistic "mistakes," such as "printing in" a cloudscape that obviously did not belong with a sun-drenched landscape. One man "much preferred" walking, since "the pedestrian has a better chance of meeting" with "wayside gems."[48]

A photographer who identified himself only as a London "mercantile slave," was one of many who wrote to the *Photographic News* requesting advice about the "best spots" for photography. "I am an enthusiast in the 'black art,'" he explained, but "my business vocations allow me little time to enjoy my favourite pursuit." He took every opportunity "of hastening into the country, with my camera and Fothergill's plates, and bringing back with me a few views" of the country scenery. Yet "from ignorance of the localities which I have from time to time visited," he often spent "half the day" simply "looking out for views." He wanted to know where he could "luxuriate in views of the picturesque, giving details of the best spots, etc, within a cheap and moderate distance from London."[49] Readers recommended sites for good pictures in and outside of London. The summer season, not surprisingly, was a favorite time for these "photographic rambles." Clubs even held their meetings out of doors during the summer recess so "they might be enabled to put into practice the knowledge which they had acquired in the Society." Women who participated in the outings may have struggled to be taken seriously by men in the group. The same spokesman added that these outdoor meetings among mostly male photographers would not only "advance the science of philosophy" but because "ladies" could come too, the "pleasure" would be enhanced.[50]

Amateurs therefore had skills at photographing nature out of doors well before the RMS began collecting images of meteorological phenomena for scientific use. As more people took up photography, they made discoveries in increasingly varied places, ranging from the laboratory and the observatory, to the portrait studio and the outdoors. Amateur photography grew in the 1880s and 1890s, and so many photographers were "out and about" that they provided a frequent source of amusement and graphic satire. *Punch* magazine in 1890, at

the height of the amateur photography boom, captured the invasions of pri-
vacy often associated with "detective" photography in an age when, as one said,
the camera seemed to thrust its "prying eye" into everything.[51] One picture re-
produced in *Punch* with the caption, "Amateur Photographic Pest," shows
scenes in which photographers pursue pictures against their subjects' will. In
the bottom right corner, the unwanted advance of a male suitor is mirrored by
the spying photographer who invades the couple's privacy. Although the dom-
inant photographers' presence in the sketch is male, there are a few "lady pho-
tographers": the older photographer with a "butterfly" net; a young girl; two
women with sunbonnets photographing a castle; another woman photographer
leading a pack of male photographers in hot pursuit of a "picturesque" folk
figure; and a much older woman with a bonnet seated in front of a tripod. In
the bottom left corner, a woman is surprised in the act of sketching by the
predatory approaches of male photographers with cameras. One man spies into
a house with his camera while another climbs onto the roof. The theme of cap-
turing elusive objects is worked out in an image of male and female photogra-
phers who run with tripods in hand, the cloths of their cameras flying behind
like butterfly nets. A "Photo-Balloon" soars in one corner; balloons, like cam-
eras, were a symbol of spying, as well as of discovery. A man with a gun lies in
wait behind a sign, "Photographers Beware!"

Few observers in the RMS thought that photographers knew how to make
scientific images just because they photographed nature. From 1870 to the early
1900s, meteorologists therefore worked hard to teach amateur nature photog-
raphers how to make pictures that were scientifically valuable. In so doing, they
documented an important aspect of scientific photography—its reliance on
concepts of skill, taste, and agency. A variety of cultural and intellectual forces
combined to promote meteorological photography as scientific work—forces
associated with developments in meteorology, attacks on sensation-producing
entertainments and calls for "rational" recreation, the forging of links between
geomagnetic and meteorological networks and astronomical observatories at
Kew and Greenwich, and the valuation of precision measurement. Just as dur-
ing the 1860s and 1870s James Glaisher was obliged to demonstrate that his sci-
entific balloon ascents with the aeronaut Henry Coxwell were scientific explo-
rations for meteorological purposes rather than stunts, meteorologists tried to
demonstrate that weather photographs were in the realm of science—not "mere
amusement" (see Fig. 1.4).[52]

To create a scientific genre of amateur nature photography, meteorologists
addressed in lectures and writings what scientific practice with a camera meant.
As Arthur Clayden put it, while nothing might seem easier than to organize "a
great army of observers," there was a "wide" difference "in getting others to act

on their own initiative, and in getting them to fulfill some definite appointed task." When observers missed opportunities for recording unusual storms and their aftermaths, "phenomenon after phenomenon passes unregistered," he complained.[53]

There were many technical limitations that hindered the creation of suitably scientific photographs of the atmosphere. Relatively long exposure times until the early 1870s made it difficult to photograph lightning. Meteorologist Frank Howard stated in an address to the South London Photographic Society that while technical developments had softened the often "violent contrast—black, intense shadows, and white, hard, high lights" in early photographs of lightning, many defects still had to be overcome. Cloud scenes also were difficult to make owing not only to solarization effects but also, some said, to the smoky metropolitan industrial atmospheres. Howard complained that "few pictures possessed any skies that were identifiable with respect to time of day." Most cloud photographs at the time lacked chiaroscuro—the fringes of illumination, rifts, modeling, and roundness that gave cloud images solidity, vapory form, and texture. As Charles Piazzi Smyth confessed in his private "Cloud-Forms" album in 1893, even with the use of dry plates "the infinite thin . . . high, white, dry spring-time cloud, though looking both bright and cheerful to the eye . . . refuses to be photographed except as more or less white, and nothing else." A number of articles in the *Photographic News* around this time addressed how to produce skies in photographic landscapes, including ways to eliminate the problem associated with "white skies," skies that lacked the appearance of texture and light contrasts because they were "burned out" in the process of exposing the darker landscape. Given these difficulties, they sometimes "pasted in" the same cloud negative for different photographic landscapes.[54]

Meteorologists taught amateur photographers how to observe weather phenomena so as to produce scientific data, emphasizing that the challenges of such photography usually had more to do with proper training than with advances in technology. Just as not all spirit photographs were regarded as scientifically legitimate, not all photographs of lightning and clouds were considered scientific. Although people had long attempted to photograph the sky, the newly specializing culture of mid-Victorian meteorology demanded that they be taught how to record scientific data. As with other types of meteorological observations, such as instrument readings in a balloon, simply having an instrument did not necessarily yield a result that met scientific requirements.

The amateur geological activities of Robert Welch shed light on how scientific photography made use of a practitioner's varied skills. Born in Strabane, County Tyrone, in 1859, Welch was Ireland's most prominent professional pho-

tographer at the turn of the twentieth century. Although Welch is unusual among professionals of the time because he did little portrait work, he is typical among amateurs in his interest in everything else, from landscapes to the photography of science and industry. Welch devoted hours to geological photography, often spending half an hour to get a photo of wildflowers on a windy cliff. To direct sunlight onto rocks, stalagmites, and stalactites shaded from the sun, he used a white sheet or newspaper, and sometimes exposures took up to twenty minutes.[55]

Beginning in 1888, Welch provided roughly half of all photographs supplied from Ireland to the Geological Section of the BAAS. Welch was listed as donating twenty-five prints and seven slides to the loan collection—one of the two highest individual contributions represented.[56] Unlike other contributors, Welch photographed in numerous counties, including Antrim, Donegal, Down, and Fermanagh.[57] Geologists praised Welch's photographs, singling them out for their excellence and scientific value. They also encouraged other photographers to be instructed by looking at his works. His views of the cliffs of Muckross were, one BAAS reviewer said, "an excellent study in joining, here, as sharply shown as in a text-book diagram."[58] The legends in BAAS albums advertised his skill. The label under "The Giants Fan" in one album, for example, reads: "This is a good bold picture to illustrate also the prevailing forms of columnar."[59] Of one picture of "the rumbling hole in the ravine, Glenariff, Co. Antrim," the BAAS remarked that it was a "triumph of the photographer's skill."[60]

Welch's contributions highlight the growing centrality of photograph collections within the BAAS and how photographs of nature mediated between scientific and popular culture. Welch marketed his photographs to commercial outlets, as well as scientists, for illustrated papers were paying big sums for pictures of special subjects.[61]

A scientific photograph was often distinguished by direct markings on the print. One of Welch's negatives has arrows scratched on it indicating two flint bands in situ in indurated chalk. Words on another negative indicate "boulder clay" and "chalk" layers at Whitehead Quarry, near Carrickfergus. The words "overlying basalt" and "intrusive trap dyke" are scratched onto this photograph of a dyke in the Whitewell quarries in Belfast (1892).[62] Another scientific marker was the presence of a device for indicating scale. Sometimes Welch used for this purpose common objects such as an anvil or a tobacco tin, other times, children or other visitors who watched him work (Fig. 3.10).

As with geological photographs, meteorologists instructed photographers on what constituted a scientifically valuable image. There were only two ways to get the kind of record that meteorologists wanted, declared Arthur Clayden,

FIG. 3.10. Geological photograph showing the use of a tobacco tin as a measuring tool, 1902. Robert Welch, from BAAS album W44/9. Reproduced with the kind permission of the Trustees of the National Museums and Galleries of Northern Ireland.

an RMS member who began instructing amateurs in how to take scientific pictures of lightning. Clayden explained that these involved "the multiplication of people who are both photographers and meteorologists," and "securing a number of local meteorologists who will undertake to try and get some photographing friend of theirs to take suitable views whenever opportunities come."[63] His remarks resonated with contemporary advice for amateurs. As one contributor wrote to the *Amateur Photographer* in 1887, general vigilance with a camera could prove useful in future court cases. He advised that "there are many occasions when a photographer ready at hand may, by means of a photograph taken on the spot, be the means of saving much litigation." Amateurs should "keep a sharp look out, and acquire the habit of keeping their instruments charged and ready for use in an emergency."[64] This imperative tapped into a wider social interest in the application of photography to military purposes.[65] At the same time, however, photographing meteorological phenomena was not simply a matter of pointing and shooting.

One of the main difficulties of lightning photography, of course, was focusing the camera on a chimney or tree before the appearance of lightning. As

one photographer explained, it was often "quite impossible to focus the camera on any object outside, it being quite dark, and there being no distant light in view."[66] Photographers resolved this problem by removing the camera from its stand, focusing it on a lighted candle placed at as great a distance from the camera as possible indoors, then shortening the focus to get as near as possible to the correct focus of the parallel rays.

Cloud photography required skill and judgment as well as special equipment, such as yellow color screens to reduce the intensity of the action of the blue and violet parts of the spectrum, a rectilinear lens, and a Nichol prism for the photography of thin, cirrus clouds. In developing negatives of clouds, great care had to be taken with the printing process, otherwise the blue of the sky appeared black and the delicate halftones in the higher lights were lost. To develop negatives of thin cirrus clouds, for example, it was necessary to use a highly restrained developer to bring out the contrast between clouds and the sky, even when color-sensitive plates and a yellow screen were used. Three methods were recommended for especially good scientific results: a slow plate and rapid lens, with short exposure; an ordinary plate and lens, with a sheet of pale yellow glass in front of the lens; and an ordinary plate and lens with a plane mirror of black glass in front of the lens at a surface angle of thirty-three degrees from the axis of the lens, so the image reflected in the mirror could be photographed.[67] Sometimes, meteorologists' instructions were paradoxical or contradictory: Frank Howard, who warned others to be careful and precise in making meteorological photographs also insisted that too much precision could start to blur into unwanted artistry. The "clean, neat manipulation" of photographs, he complained, often produced pictures of skies that lacked individuality and were "very like another."[68] Cloud photography required personal judgments especially on the timing of the exposure. Meteorologists insisted that individual skill was far more important to the success of cloud photographs than "can possibly be obtained by aiming at a mathematically correct exposure."[69]

William Marriott, meteorological photographer and publicist, stated that the RMS would be glad to receive copies of any lightning photographs, however unsuccessful, because "even apparently poor [pictures] often contain useful evidence." In practice, however, amateur nature photographers who wanted to contribute to scientific meteorology had to learn how to participate in the young community culture of meteorologists. As in the pioneering years of commercial photography, meteorological photography combined unity of interest with hierarchy in a noncontractual relationship. Fraternal orders offered to their prospective members a "ready-made sociability" and a form of entertainment that, according to Mary Ann Clawson, anticipated aspects of twentieth-century mass culture. Meteorologists functioned as fraternal agents, who recruited

volunteers from among their friends, many of them men in photographic and scientific societies. Birt Acres, an RMS fellow, agreed that meteorological photography was an inclusive, democratic, and fraternal activity, open to city dwellers as well as to more "fortunate confrères" who lived in the country.[70]

Marriott demonstrated the special techniques for taking scientifically valuable photographs of lightning in a presentation to a photographic club in London on July 10, 1889. Marriott issued instructions to the members to ensure that, in the event of a thunderstorm, they might be prepared to obtain some "really good photographs." Marriott guaranteed that if they followed his instructions, their photographs would possess scientific value. His recommendations included several hints for securing useful scientific testimony with a handheld camera. One should focus one's camera during the daytime to some distant object and make a mark on the camera, so that at night the apparatus could be quickly adjusted. A rapid rectilinear lens with full aperture should be used. The camera should be firmly screwed to the tripod stand. A portion of the landscape, roof, or chimney should be included on the plate in order to indicate measure and distance. The exact time of each flash, the interval in seconds between the lightning and the thunder, and the part of the compass in which the flash appeared, should all be carefully recorded. If circumstances permitted, two cameras should be used: one fixed on the tripod stand, and the other held in the hand.[71]

Significantly, meteorological photographers and their organizers used both the scientific language of mechanical objectivity (which eliminated the observer) and the pictorial language of the picturesque (which asserted the artist) to recruit participants. Meteorologists could not just assume that people would send in their photographs; they had to convince photographers to go to the trouble of sending their best examples. In an 1891 presentation to the RMS, Clayden predicted that photography would attract new recruits to the field because of meteorology's preexisting picturesque appeal. "Once arouse interest and weather charts, instrumental records, and the like will be studied by the light of that interest, instead of being put aside as dry and unintelligible."[72]

Clayden further testified to the importance of photographs from the point of view of meteorologists in another presentation, "Photographing Meteorological Phenomena," which he delivered at the RMS in July of 1898. "In the photograph we have everything from white to black, whereby the photograph is able to show detail which the eye can never hope to perceive," Clayden boasted. In addition to its value as an empirical record, photography attracted greater numbers to the study of meteorology by "presenting . . . the more picturesque and popular aspects of the science . . . It would be manifestly impossible to give anything like a full description of what has been done, and is being done at present, in the way of photographing meteorological phenomena in all

parts of the world . . . Some idea of the importance of the camera as a meteor-
ological instrument may easily be gained by counting how many of the papers
brought before this Society are more or less dependent upon photographic
methods."[73] The virtue of meteorology photography also lay partly in its easy
reproducibility for others to see, hence its value for promoting scientific mete-
orology. Clayden held that photographs gave a "clear exposition of argument
or fact" to specialists and lay people alike.[74]

In 1891, the BAAS Committee on Meteorological Photography issued sev-
eral hundred circulars to photographic and scientific societies requesting pho-
tographs of meteorological phenomena, including lightning, clouds, rainbows,
fog, ice, haloes, and so forth.[75] Many of the committee's leading members, such
as G. J. Symons, were members of the RMS, which three years earlier had simi-
larly requested photographs of meteorological phenomena from societies in the
United Kingdom and Europe.[76] Like the RMS and a similar committee on geo-
logical photographs, the Committee on Meteorological Photography requested
the help of amateur photographers especially. Clayden, who served as secretary,
drafted a letter, which stated: "We shall be glad to receive copies of any photo-
graphs illustrating meteorological phenomena, or their effects, but we should
especially welcome offers of future assistance in the shape of photographs taken
in accordance with simple instructions which will be supplied on application."[77]
They also included a form with blanks for the information they needed.

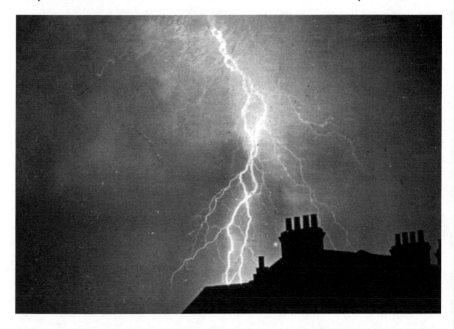

FIG. 3.11. Unattributed, photograph of lightning over a rooftop, ca. 1900. Lockyer Lantern Slide Collection,
Royal Meteorological Society Library. Reproduced with permission from the Royal Meteorological Society.

FIG. 3.12. T. N. Leslie, South Africa, photograph showing lightning and a lightning spectrum, probably made using a Thorpe grating, ca. 1900. Lockyer Lantern Slide Collection, Royal Meteorological Society Library. Reproduced with permission from the Royal Meteorological Society.

By the summer of 1891, the BAAS possessed 153 photographs of lightning, clouds, and other meteorological phenomena ranging from hail and fog to aurora boreali and rainbows. This total included ninety-three images of clouds, eleven of lightning, six of lightning damage, two of damage by hail, six of glacier structure, three of fog and its shadows, eight of hoarfrost, and two of snow crystals.[78] Several photographs of lightning included physical markers, such as a roof or a tree, which were often used to focus the camera (Fig. 3.11) Photographs such as this spectrum picture of lightning over water, and one of lightning striking the Eiffel Tower, gave visual expression to different types of atmospheric electricity (Figs. 3.12–3.13).

A distinguishing feature of meteorological photographs related to their scientific classification in taxonomies, a practice that can be traced back through the botanical books and zoos of the eighteenth century, to the medical atlases of the seventeenth century and earlier. Classification was a defining characteristic of Victorian science. Scientist Francis Galton, who founded eugenics in Britain and pioneered the classification of human "types" by means of composite photography, began by experimenting with composite photographs of weather types.[79] As in other classification endeavors, photographs in their rich variety defied simple categorization. In the case of anthropological photography, for example, as Elizabeth Edwards explains, "the formal presentation of objects arrayed within one frame both caused them to cohere within a taxonomic structure and gave them a comparative impulse through juxtaposition."[80]

Classifications of various meteorological forms also were not easy to achieve. As one scientist lamented, the "chaotic condition" of meteorological nomenclature made it "practically impossible to describe the minute differences of structure so admirably shown in the pictures in terms which would be gen-

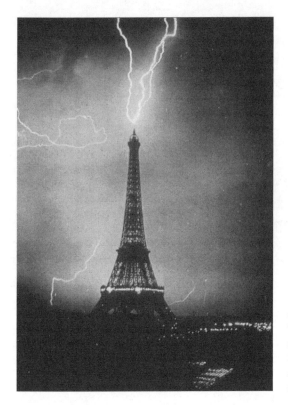

FIG. 3.13. Lightning striking the Eiffel Tower, Paris, ca. 1900. Lockyer Lantern Slide Collection, Royal Meteorological Society Library. Reproduced with permission from the Royal Meteorological Society.

erally intelligible."[81] Each photograph was given a number and registered into a specific "class" of meteorological phenomena. Many of these photographs were made into lantern slides for illustrating scientific and popular lectures; these survive today, often slightly broken, in their original lantern boxes. Observers completed a standard form stating whether the picture was taken by direct exposure, through yellow glass, by reflection from black glass, or by any other special device. The photographers provided detailed information, including the date, time of day, direction the camera was pointed, stop, exposure, and developer. If they used a special emulsion, they gave the committee its chemical formula.

At around this time, photographers generally were beginning to rely on a pictorial code in which the marker figure gazed at or rested among monuments; a device that not only signaled the sitters' relationship with their setting and the camera but also gave pointers to scale.[82] Field scientists making photographs also used pointers of scale, which they frequently referred to as unaesthetic. Meteorological observers making photographs for scientific purposes were asked to include in the prints some fixed object or, in the absence of these, they were to mark the north and the zenith for reference.[83] It is worth recalling here the measurement grids that scientists used when they tested Georgiana Houghton's

spirit photographs, of which she remarked that they ruined the beauty of the pictures. Many scientific photographs of lightning are designated as such because they include a tree or chimney to show the point of reference, much like the use of anvils, children, and tobacco tins to show scale in Welch's geological photographs. As one meteorologist explained while instructing nature photographers, "A photographer generally takes his views with an eye to pictorial effect . . . [He] did not often care to spoil his plate by inserting anything so ungainly as a yard measure."[84] By contrast, the scientific photographer knew that though they might detract from the image's beauty and unity, measurement markers signified a scientific meteorological picture.

Scientific efforts to classify lightning forms show the tensions involved in the attempt to reconcile the universalizing norms of scientific classification, on the one hand, and the varieties of phenomena that people visually experienced in nature, on the other. Among the research conclusions that the meteorological community eventually attached to lightning photography included demonstration of the reality of the "narrow ribbon structure." Second, photographs showed the existence of "visible multiple discharges." A third finding was that of the "compound nature" of many discharges, and a fourth was the long duration of these charges. Some of these findings, such as the first and second, were resolved only after long discussion, in which the reliability of the camera and the technical skill of the operator were called into question. In the case of lightning discharges, which the camera recorded as multiple flashes, meteorologists debated whether or not the flashes in a discharge truly followed the same path or merely indicated the movement of the camera.[85]

Photography was at the nexus of traditions in meteorology, between natural history and laboratory demonstration. By the end of the century, meteorologists regularly invoked laboratory recreations of lightning to support their arguments for the veracity of certain pictures. For example, Clayden stated in 1898 that he believed in the multiple discharge theory, saying that "something very like" it could "easily be obtained in the laboratory."[86] Photography was an intermediary step from the observation of nature in situ to the recreation of natural displays in artificial laboratories, as Peter Galison and Alexi Assmus have argued, but the techniques that meteorologists used to represent weather phenomena were used interchangeably throughout the nineteenth century, and the observer's skill and visual acuity in pictorial production and interpretation remained primary.[87] Through exhibitions and displays, meteorological photographs reified scientific photography as an active component of scientific observation. Exhibits demonstrated not only the subjects meteorologists wanted but also the practices on which scientists relied to obtain credible results. Meteorological photographers were not watched with suspicion like spirit pho-

tographers. Nevertheless, participants who wanted to make photographs valued by the scientific community had to demonstrate and justify their practices.

In 1894, the RMS mounted an exhibition of meteorological instruments and related photographs and drawings at the meeting rooms of the Institute of Civil Engineers in Westminster, where they displayed tools used by scientific observers of the weather. As a glance at its catalogue would make clear to contemporaries, the exhibition, titled "Clouds: Their Representation and Measurement," actually put the whole field of meteorology on display. For in addition to the usual instruments associated with the field (thermometers, marine instruments, anemometers, barometers, and traveler's instruments), the exhibit contained instruments for ascertaining the direction and height of clouds—cloud mirrors and slide rules—as well as sketches of lightning flashes. There were models illustrating the forms of clouds; many sketches and watercolor drawings of clouds, including sketches by the "late Mrs. Toynbee"; and sketches and photographs of frost fronds on a window, waterspouts, lightning, hailstones, storm damage, rainbow, a solar halo, and a man's hat damaged by hail.[88]

The history of photography's uses in meteorology illustrates that descriptions of photography as the fulfillment of an earlier mandate for objective images that eliminated human errors simplify the material and social practices associated with Victorian scientific photography. Skilled comparisons between photographs and drawings, the education of photographers, and the labor of making photographs public through exhibitions influenced the cultural values of meteorological photography. Because generating reliable knowledge depended on having a clear concept of witnessing and practice, photography in meteorology helped forge a connection between photography and the Victorian notion of scientific evidence.

Chapter 4

Photography of the Invisible

An 1882 *Photographic News* essay, "What Photography Does for Science," compared the proliferation of photography during the late 1870s and early 1880s to the hierarchies within the rising Victorian labor market for domestic service. Roughly forty years after its invention, the author wrote, the camera was no longer an "upper-servant" but rather a "maid of all work." After elaborating on photography's value in the self-registration of meteorological and other instruments, the author reported, however, that "when photography is used as means of investigation . . . more interest attaches to the subject, and within the past two years especially there have been some wonderful discoveries made through the medium of our art." Although he stressed the role of technology, the skill of the worker was also crucial. The taking of a scientific picture inevitably involved making aesthetic choices, judgments, and interventions. "Upper-servant" photography included new medical research on the action of the heart; discoveries in the chemical analysis of iron and steel by means of spectroscopic work; astronomical photographs of the spectrum, star spectra, and the sun's orb; the measurement of skull sections in anthropology; and pictures of the thickness of the ice crust at different altitudes. He was delighted "to find that the camera showed to the world something that previously had been invisible": bacteria. In his pioneering studies of bacteria, Robert Koch "found not only bacteria present in animal tissue, but he found, too, by taking pictures of the tiny organisms, that their shape and form varied with the nature of the disease by which the animal tissue had been attacked . . . As these organisms were not visible under the microscope, to photography alone is due their discovery."[1]

Whereas in meteorology scientists assembled images of phenomena seen by amateur photographers, many of them unspecialized in meteorology, the centralization of bacteriology in medical school laboratories meant that the photography of bacteria was practiced and interpreted by experts trained in the use of microscopical techniques. Microscopy imposed special problems of corroboration because it revealed to the eye completely unfamiliar images. As Gerard

L'E. Turner has shown, in the second half of the nineteenth century the microscope increased in scientific importance, creating a need for rapid and efficient means of communicating results, to which photography and new printing techniques were essential.[2]

The issues raised in the field of public health by the photographing of microscopic objects generated a fascinating and complex discussion about the different levels of seeing in Victorian science, and raises new questions for us to consider in thinking about scientific photography. Early photographs of bacteria caused a sensation in England from the mid-1870s to 1910. Some idea of this excitement can be gleaned from the many writings about them in scientific atlases, medical journals, newspapers, and magazines. The first part of this chapter offers a history of photography in bacteriology that suggests its importance in medical teaching and thus in the spread of laboratory knowledge about bacteria as research objects. The second part examines the relation of drawing to photography and, in particular, how drawings supplemented photography's limitations for showing and preserving scientific meanings of bacteria. Consideration of the visual imagery of bacteria that circulated in print, from the popular-science book to the scientific atlas to the periodical magazine, points to how different visual representations of bacteria carried ideological unity and coherence. The debate over bacteria photographs centered not simply on the truth or falsity of representation but also on whether photographs could be accurately paraphrased by drawings.

The Microbian Craze

The manufacture and subsequent evolution of the first photographs of bacteria excited interest in the possibilities inherent in the new science of photomicrography as well as in the new science of bacteriology. During the second half of the nineteenth century, many forms associated today with modern science emerged, from the creation of multiple scientific societies devoted to singular disciplines, to the rise of laboratories and the expansion of university-based instruction in the experimental sciences. From 1870 to 1914, British scientists gained public platforms and greater prestige as scientific observation became associated with the skills of political leadership. Men of science were widely seen as better leaders than military heroes, social reformers, and politicians. One contemporary declared, "In this new world, where . . . observation suffices to put us on the road to discovery, we never pause, but always advance."[3] As another observer put it, "Some day, when mankind has grown wiser, our descendants will smile at the folly which distinguished and decorated the so-called 'reformers' . . . [and] transfer their admiration and their honours together to the true revolutionists, the men of science." The "chemist, the mechanician, the geolo-

gist, the aeronaut, and the anatomist, and the archaeologist" were "the men whom history will take note of . . . not the jaunty [military] gentlemen in stars and ribbons."[4] Reformer and social critic Beatrice Webb later asked, "Who will deny that the men of science were the leading British intellectuals of that period; that it was they who stood out as men of genius with international reputations; that it was they who were routing the theologians, confounding the mystics, imposing their theories on philosophers, their inventions on capitalists, and their discoveries on medical men; whilst they were at the same time snubbing the artists, ignoring the poets, and even casting doubts on the capacity of politicians?"[5]

In the wider field of science, meanwhile, how people saw nature was rapidly changing. Photographs increasingly had specific uses for scientists. Meanwhile, new contexts of display, including photographically illustrated magazines, journals, and atlases, evoked new scientific kinds of expertise for multiple audiences. Bacteriology was, like photography, a relatively new science in the 1870s. By the 1870s a general anxiety about the nature of germs had shifted to a more disciplined medical discourse about bacteria. Long before the nineteenth century, people were acutely aware of living in a world that, as one Victorian said, "is teeming with life."[6] In particular, people speculated about the presence of living germs in the air and water and their possible connection to the transmission of disease. This was especially true in heavily populated urban areas such as London.

Around 1851, Arthur Hassall's drawings of microscopic life in drinking water alarmed London because they revealed depressing news about the insalubrious conditions of the city's drinking-water supply.[7] Over the course of the nineteenth century, the circulation of visual representations of microbes provoked a mixture of reactions, from pride in medical authorities intent on stopping the spread of deadly diseases, to considerable anxiety about the possibilities for contagion. The existence of microorganisms tapped into a broader cultural anxiety about the materialism of the living world and the nature of the relation between the living and nonliving world—a connection also found in spiritualism.

Although many saw repugnant matter in drinking water, there was little agreement about its effects, especially at first. As Deputy Inspector-General of Hospitals and Fleets and Assistant Professor of Naval Hygiene in the Army Medical School, J. D. MacDonald observed in *A Guide to the Microscopical Examination of Drinking Water* (1875), it was difficult "to link particular forms with special effects." He hoped the book's numerous tables and figures would "prove useful to young naturalists, who are beginning to investigate the world of waters, that wonderful world, in a single drop of which we may behold

varieties of form, almost as numerous as those upon the surface of the great globe itself."[8]

Even scientists were divided over the reality of these organisms invisible to the naked eye and how exactly they caused disease. Despite the credence that many public health officials and medical doctors gave to bacteria's existence, some research scientists and sanitarians in the field of water analysis still doubted the reality of disease-causing germs at the end of the century. The incorporation of bacteriology into their analyses was a long and complicated process. In the mid-1880s, the first phase was to count the colonies that grew on glass plates. The focus of research by the end of the decade was the conditions under which certain species could survive. The third phase, which peaked in the 1890s, used new determinative techniques to check waters for the presence of the microbe thought to cause typhoid. Bacteriology in all its phases, Christopher Hamlin convincingly argues, was looked to for resolution of the political disputes over water quality "which had for so long fed on the chemists' endless supply of uncertainty." As he shows, bacteriology offered plenty of uncertainties of its own.[9]

The growth of a disciplined discourse about bacteria was associated with the rise of fraternal laboratory study by a new class of scientific and medical professionals. In the late nineteenth century, leaders of teaching hospitals began to introduce into medical education compulsory coursework in bacteriology, emphasizing the need for specialized laboratory study. As German Sims Woodhead, one of Britain's most eminent bacteriologists, put it: "The professor of medicine who in days gone by was able to teach all that was known of medicine and surgery, has now in our schools been replaced by teachers . . . of individual and greatly specialised subjects." Bacteriology was associated mainly with doctors and public health workers. In turn, the rise of bacteriology in medical school teaching was closely connected with the expansion of the laboratory system of training, the symbol of modern, rigorous science in late-nineteenth-century medicine and public health. Workers in the field of microbe studies, a truly international science, were widely praised as among the most important servants of nation and empire.[10]

After 1870 there was increasing support for the view that many diseases were caused by the multiplication of microscopic parasites within the bodies of affected animals. Research on microbes excited many scientists because it promised to provide convincing evidence of the clinical importance of basic science. In the following two decades, biologists began to identify separate species of bacteria with the aid of the microscope, biochemical tests, and tests involving sera. They also began working out a theory of immunity.[11]

In part because many of the initial discoveries about bacteria were made on the continent, British scientists wanted them verified before they committed themselves to the controversial theory. In the 1860s, the work of Frenchman Louis Pasteur linked the presence of bacteria with the processes of putrefaction, which he demonstrated was a result of the presence of invisible living organisms. Yet there remained much confusion as to the nature of bacteria and how they should be classified. In England, as Hamlin shows, there were few converts to bacteria theory until the 1870s, although a number of people subscribed to the general idea that microbes caused disease, and microbes were studied in academic institutions, service laboratories, and commercial agencies. Keith Vernon uses the term "microbe-studies" to capture how microbes impinged on many lines of work and areas of expertise.[12]

One scientist who became committed to the bacteria theory early was Joseph Lister, who built up the technique of modern surgery in the 1870s and 1880s using carbolic acid to destroy living germs. In 1871, he established in London the Brown Institute, which by the 1880s was one of the few places where one could obtain educational training in the scientific investigation of bacteria. Lister made no major contributions to the study of bacteria, but he made practical innovations based on continental developments and helped popularize germ theory in Britain.[13] As a bacteriologist described them in 1889, bacteria represented a "great group of lowly plants, so small as to be quite invisible to the naked eye, and which until within a few years have been entirely unknown to man, which still linger in the primitive simplicity which we imagine to have belonged to the earth's earliest denizens."[14]

Pasteur's work on the microbial basis of fermentation and putrefaction and Lister's procedures for antisepsis were topics of international medical discussion about infection. Yet evidence on the role of specific microbes in specific diseases was lacking, and there was immense controversy in Europe over the parasitic nature of infectious diseases.[15] Critics of the role of microorganisms in infectious diseases included Rudolf Virchow in Berlin and Theodor Billroth in Vienna. Among its advocates were Edwin Klebs in Prague, Ferdinand Cohn in Breslau, and C. J. Davaine in France.

Prussian scientist Robert Koch is widely credited with converting skeptics to germ theory. Koch began working on anthrax as a model for infectious diseases in 1873. He had served briefly as a physician in the Franco-German War, which gave him experience in the practical treatment of wounds. During his experiments he found that bacteria formed "resting spores" that remained alive in the soil. He isolated bacteria in studies of anthrax in 1876 and made the first photographs of bacteria the following year. Ultimately, he became known as

one of the leading pioneers in the germ theory of disease, the development of new plate techniques for studying colonies, the isolation of the cholera bacterium, and the theory that healthy humans are the carriers of living pathogens.[16]

Bacteriologists such as Koch worked hard and with mixed success to convince people that harmful bacteria caused disease and, at least as important, that bacteriologists possessed the necessary expertise and tools to know which were good and which bad. Amid the excitement about discoveries of bacteria, there were many skeptics. Bacteria seemed fanciful to many Victorians partly because they were not visible to the naked eye. In 1886, Charles Tidy demanded that a bacterium be put on the table before he acknowledged its existence. As late as 1891, even Woodhead, a bacteriologist who hardly needed convincing, confessed that even to him theories about bacteria baffled the mind. Woodhead, the director of laboratories at the Royal College of Physicians and Surgeons and the first editor of the British *Journal of Pathology and Bacteriology,* an important source of bacteria photographs in the 1890s, remarked that such theories "appeared to be more like fairy tales than . . . the results of sober scientific invention and thought."[17] Bacteria generally were "so very small," said one bacteriologist, "that we can hardly form a conception of them except by comparison with some well known objects."[18] To add to the confusion, it was well known from practical experience that two viewers looking at the same specimen through a microscope might not see the same thing. Furthermore, in bacteriology, the British regarded themselves as importers of new knowledge rather than the international pioneers they had been in fields such as astronomy.

Physician Alexander Wilson declared in "Micro-Organisms in Disease: The Microbian Craze," published in *The Metaphysical Magazine* (1895)—a magazine to which many spiritualists subscribed—that the popular scientific notion of microorganisms was close to the Syrians' concept of "low" religious worship. The bacillus was an "offender described as being so small as to be entirely invisible, except perhaps with the aid of the microscope, and so universally diffused as to be encountered everywhere, but always imperceptible to the senses . . . Its apostles have brought to their christening-font a considerable number of germ-babies—a vibrio for disorders of the nostrils, a leptothrix for the teeth, a bacillus for diphtheria, a spirillum for tubercular disease, a cryptococcus for yellow fever, and so on," he exclaimed. He decried the hypocrisy of a situation in which "the many in medical circles who sneer at the concept of spiritual agency in the matter, so eagerly and zealously embrace the hypothesis of the bacterial origin of disease;" indeed, he argued, medical schools themselves had been "invaded."[19]

It was not that bacteria did not exist; Wilson held that a bacillus was a "little

trickster" found in other forms of disease. However, he countered that the organisms were the result (rather than the cause) of morbidity.

> Despite the zeal and even the fury with which the germ-theory in this its latest appearance has been promulgated, there are missing links between it and the unequivocal facts. Its strongest foundations are only assumed. The notion that the atmosphere is forever swimming with germs of bacteria and other microbial products, ready to rush into our wounds, into the living or every breathing thing, into our own water and kneading- troughs like the frogs of Egypt, and to enter the pores and through the stoppers of glass bottles, is purely a guess, without a solitary fact to sustain it, except such as are found in the interpretation wherein the guess is taken as established fact.[20]

Wilson regarded the harmlessness of the microbe as its "established fact," yet, he complained, the public held that it was as dangerous as a character in an "Arabian story."[21]

Many skeptics, including women, advocated for sanitary reforms over expensive medical searches for microbes. Mrs. Aubrey Richardson encouraged "ordinary means of health" such as fresh air, drainage, clean and safe dwellings, rest, and a good diet. "Many of our young doctors are fiddle-faddling about with a microscope and drops of blood, phlegm, and saliva, and fancying themselves little kings of science because they can see 'how many legs a caterpillar'— or rather a micro-organism—'has got.'" She accused the new breed of doctors of decadence, saying that "the luxury of observing isolated and petty disease-phenomena is one in which the medical practitioner or the active consulting-physician should rarely indulge," and she blasted the "humbug and nonsense of the whole microbe craze." Calling the germ theory "rash propagandum," she declared that it diverted attention from "ordinary means of health." One of a growing number of Victorian women critics of professional medical practices who took their campaign to the papers—thereby constructing for themselves political identities on a terrain different from that of the scientists—Richardson put bacteriological science in a league with "impulsive reformers" and "ecstatic religionists." She did not question that bacteria existed ("no one with the most elementary instruction questions the existence of bacteria"), but, like Wilson, she saw them as incidental to the disease.[22]

Photography as "Instructress"

Against the uncertainty about bacteria's very existence, photographic proof was connected with the development of bacteriological science. Koch's desire to communicate his work to other scientists motivated his pioneering photomicrographical studies. In 1873, he wrote to botanist Ferdinand Cohn, then the

director of the Institute of Plant Physiology in Breslau, the first such institute in the world. Like Koch, Cohn believed that there were numerous species of bacteria, and in his *Untersuchungen uber Bacterien* (1872), he defended the theory of bacteria as disease-causing agents.[23] After several attempts to meet, Koch received permission from Cohn in 1876 to visit and show him his experiments on the development stages of anthrax bacillus.[24]

While in Breslau, Koch visited the laboratory supply firm of J. H. Buchler to look at photomicrographic apparatus. He also made photomicrographs and drawings of bacilli endospores with Cohn and his colleague Julius Cohnheim, the director of the Institute of Pathology. As Thomas D. Brock states, much of Koch's work was "motivated by a desire to photograph bacteria through the microscope, as he realized that hand drawings were unsatisfactory for communicating the results of bacteriological investigation." Koch frequently criticized other scientists' drawings of bacteria when they failed to show the resting spores that he saw. Of drawings by A. Frisch, an assistant of a Viennese surgeon, Koch wrote to Cohn in 1876 that they "show chains of rods, but no filaments. I do not believe Frisch has really seen spores . . . Frisch's results contradict the results of my extensive studies so greatly that I must assume a confusion with other kinds of bacteria." Koch worked hard to obtain better photographic images. Believing that his microscope was a major limitation, Koch corresponded with the Wetzlar firm of Seibert and Krafft, one of the leading microscope builders of the day, about improving the microscope, an effort that contributed to the success of his first photomicrographs of bacteria.[25]

Today, too, it is possible to vary the focus of a microscope and obtain an image that shows detail in depth greater than is possible with a photographic image of the same phenomenon.[26] Photomicrography, as noted earlier, was crucial to the communication of scientific ideas in microscopy because it could fix the specimen so that viewers could be trained to see what was there. The specimen also could be reproduced easily for others to see. However, as microscopist and inventor of the dry-plate process, Richard Leach Maddox declared in 1867, despite its promise, "as yet, photomicrography can scarcely be said to be embraced by the arms of science; silently it has crept towards the fingers, but has not yet fairly shaken hands."[27]

Photographs were made by placing the object on the stage of the microscope, choosing a lens, and bringing the object into focus. To isolate chief points of observation, it was necessary to focus on the objects of special interest. Then the microscope was laid in a horizontal position with a lamp nearby to illuminate the specimen. Lighting the specimen was one of the arts of photomicrography. The object was best seen with oblique light, but photographers had to be careful lest the plate not be fully illuminated. When the illumination was

adjusted, the front of the camera was drawn up until the eyepiece of the microscope fit into a hole made for it. A black velvet hood helped make the connection between camera and microscope tight against the light. Next, the object was viewed on a screen, forming an indistinct image. The microscopist now could adjust the focus. Afterward, especially when high powers were used, the apparatus was generally left alone for a few minutes to allow for the expansion from the lamp's heat, which could destroy the results. It was very important for the microscope and lens to stay cool. When all was ready for an exposure, a black card was placed opposite the lens or below the stage to cut off the light. A dark slide was then inserted and the shutter drawn. During the exposure, the operator had to stay perfectly still because walking about would cause the apparatus to vibrate and ruin the sharpness of the picture. When the exposure was deemed sufficient, the card was replaced in front of the lens and the shutter pushed down.

A persistent problem for all who used the collodion and gelatin processes was the unrealistic response to light of different colors. Microscopists had to either compensate with delicate staining techniques or use blue filters to attenuate the shorter wavelengths. Experiments by H. W. Vogel in 1873 resulted in a more uniform response in collodion emulsion, and in 1884 J. M. Eder in Germany perfected orthochromatic plates of gelatin emulsion, color-corrected to strengthen the yellow-green region.[28] The first panchromatic emulsions, which successfully balanced all color tones in monochrome, were not achieved until the beginning of the twentieth century.

Koch viewed photomicrography as essential to bacteriology. Photography functioned as "a harmonizing mediator" among discordant microscopists and an "instructress" of novice observers. He also held that a photographic picture of a microscopic object was, in many circumstances, "much more valuable than the original preparation."[29] In 1882, Koch discovered a method for counterstaining preparations of tubercle bacilli with brown dye and photographing them with blue light. Further experiments convinced him that it would be possible using this method alone to distinguish tubercle bacilli from other kinds of bacteria. As Brock points out, Koch's paper on the tubercle bacillus, published in Britain in April 1882, prompted vigorous debates over the truth or falsity of his claims and methods. Some failed to find the bacilli and criticized Koch's empirical methods and competence, while others traveled to his laboratory to corroborate his observations.

Although he often praised photomicrography, Koch struggled with photographic techniques, and he evidently continued to rely on drawings for investigating bacteria. One of the biggest obstacles involved the lack of techniques that worked well with photomicrography for staining microscopic specimens.

Koch spent much time preparing drawings, photographs, tables, and models to illustrate his studies of tuberculosis.[30] Given the many different ways of representing bacteria, Koch labored to suggest how photography was differentiated from other modes of representation. He stated, "I think no one will blame me for only accepting with great reserve drawings of micro-organisms, the accuracy of which I cannot substantiate by examining the original preparation," he announced. However, when photography was applicable, it should be used. If anyone lacked the apparatus, skills, or desire to attempt photography of sections of bacteria, Koch offered to prepare the specimens so that others could photograph them or have them photographed. As with spirit and amateur lightning photographs, the impulse persisted to democratize seeing, even in a specialist laboratory setting that excluded most participants. Koch doubted that photographs would displace skilled drawings of minute organisms as objects of research and teaching, and expressed initial skepticism about the power of photographs of bacteria as evidence of what one sees through a microscope. Nevertheless, during the early 1880s he urged others to support their discoveries with the "convincing proof afforded by photographic illustrations" but insisted, "I do not mean to say that photographs should always replace drawings; that will never be the case, and in many cases a drawing alone is possible."[31]

At the time of his first visit to England, Koch was working hard to obtain good photomicrographs for his book, later published as *Untersuchungen uber die Aetiologie der Sundinfectionskrankheten* (1878). As he later explained in the preface, the difficulty was the lack of color sensitivity of his photographic emulsions. Seeing the bacteria, for example, depended upon observing color differences between the stained bacteria and the surrounding tissues. However, the emulsions then available were sensitive only to the blue region of the light spectrum. To render the bacteria visible for photography, therefore, Koch had to use a light filter made from eosin and collodion. Because this filter also reduced the intensity of the light that reached the specimen under the microscope, long exposures had to be made. The vibration of the apparatus during these exposures, in turn, caused the images to be fuzzy.[32]

Koch's eventual success in photographing bacteria largely resulted from his plate technique and his use of a new condenser and oil-immersion lenses. Koch confessed that the oil-immersion lens had "completely altered the pictures . . . In the same slides which had previously shown nothing, the smallest bacteria are now visible with such clarity and definition that they are very easy to see and to distinguish from other coloured objects . . . it is extremely easy to see pathogenic bacteria in tissues and to be able to distinguish them taxonomically. Whereas previously all we could see were micrococci and zoogloea [amorphous

clumps of bacteria], now we can see bacteria which can be differentiated by size and shape."[33]

In August 1876, Koch visited London to circulate his views and demonstrate his photomicrographs. There he met Charles Darwin and John Tyndall, who would play important roles in establishing Koch's scientific leadership there and in helping him demonstrate the evidence for his theories. Tyndall was a leading authority on germs, having recently read a paper to the Royal Society about the aerial presence of bacteria that resisted sterilization by boiling. In a famous address to the British Association for the Advancement of Science (BAAS) in Belfast in 1874, when he served as president, Tyndall declared, "Believing as I do in the continuity of nature, I cannot stop abruptly where our microscopes cease to be of use. Here the vision of the mind authoritatively supplements the vision of the eye."[34] Tyndall had learned of Koch's work from Cohn and eventually became one of Koch's strongest supporters in Britain, seeing the English translation of his work through publication.

Koch's photomicrographs circulated beyond his textbook because many scientists were eager to see the originals. After the book's publication, Koch sent his photomicrographs of bacteria to Lister, who in turn passed them on to W. Watson Cheyne, the assistant surgeon at King's College. Cheyne was excited about the photomicrographs and had Koch's work published in English as *Investigations into the Etiology of Traumatic Infective Diseases* (1880). Cheyne's translation includes five plates, each containing four or five drawings of bacteria made with the aid of a camera lucida and reproduced as two-color lithographs (Fig. 4.1). The drawings were, Cheyne assured readers, faithful likenesses of Koch's photographs:

> With regard to the plates which illustrate the text I am able to give the most satisfactory confirmatory evidence. Since the work was published Dr. Koch has succeeded in photographing his microscopic preparations, and he has forwarded a considerable number of the photographs to Professor Lister. These, which have unmistakenly been taken from sections of tissue, when examined by a pocket lens or projected on a screen, show plainly that the drawings are faithful representations of what has been seen. I have also lately received from Dr. Koch several of his stained sections, and those which I have been able to examine are equally satisfactory with the photographs.[35]

Koch added his own testimony, in which he explained why the book was not reproduced with photographs. "In a former paper [Cohn's *Beitrage zur Biologie d. Pflanzen*] on the examination and photographing of bacteria I expressed the wish that observers would photograph pathogenic bacteria, in order that their representations of them might be as true to nature as possible. I thus felt

FIG. 4.1. Typhoid fever. Section of the liver, showing the border of a mass of bacteria (a) which at b is broken up, and shows the individual bacilli, × 700. From a photograph by Robert Koch. Plate 5, fig. 16, *Recent Essays by Various Authors on Bacteria in Relation to Disease,* selected and edited by W. Watson Cheyne (London: New Sydenham Society, 1886).

bound to photograph the bacteria discovered in the animal tissues in traumatic infective diseases, and I have not spared trouble in the attempt." He explained, however, that to make the smallest ("and in fact, the most interesting") bacteria visible in animal tissues by staining them, the photographer had to deal with the same difficulties as were experienced in photographing colored tapestry. Although colored collodion had eliminated some problems, other difficulties remained. By the use of eosin-collodion and by filtering out portions of the spectrum of colored glasses, Koch had succeeded in obtaining photographs of bacteria that had been dyed with blue and red aniline dyes. Nevertheless, due to the long exposure and vibrations of the apparatus, photographs did "not have sharpness of outline sufficient to enable [them] to be of use as a substitute for a drawing or indeed even as evidence of what one sees."[36]

The Circulation of Bacteria as Laboratory Objects

The reception of photographs as evidence of bacteria coincided with new developments in medical laboratory teaching. An analogy can be made between institutions that taught people how to draw and paint, and the new medical institutions in which medical students were taught to see and draw bacteria. After 1750 a fresh interest in raising the intellectual stature of the visual arts led to the founding of a number of new academies throughout Europe, Mexico, and elsewhere. One of the most significant was the Royal Academy, established in London in 1768. Led by its first president, Joshua Reynolds, the academy maintained a school for young artists whom it hoped to teach in the style consistent with its academic beliefs and promoted strict rules of taste, reason, and beauty.

Just as art academics wrestled with whether artists drew more truthfully with a tutored or untrained eye, medical institutions debated a similar question. Even before the seventeenth century, compilations of visual illustrations had been integral to scientific and medical communication. Throughout the eighteenth and nineteenth centuries, women and men from middle-class and

elite social backgrounds learned drawing, and microscopic illustration was a popular pastime. Recall that Samuel Highley, in his lantern-slide lectures, popularized the spectacle of microscopic organisms, including animal and vegetable products such as infusoria, dead and decaying matter, and wormlike animals, also called "Annelidae." Amateur artists and medical people expressed hunger for raw images of nature to copy and draw. In 1874, P. H. Gosse's *Evenings at the Microscope,* which offered popular instruction for viewings and delineations, was criticized by serious microscopists for its lack of engravings.[37]

As print and drawing culture expanded, there was among medical people increasing interest in compiling scientific atlases of photographs of specimens from microscopical nature. In 1839, Talbot was one of the first people to make a successful permanent photomicrograph by means of a solar microscope that he had used in experiments from 1834. Several followed his lead, inspired also, perhaps, by the appeal by the official jury of the Great Exhibition to photographers to make scientifically useful photomicrographs. In 1853, the first photomicrographs in a British scientific journal were published in the *Transactions* of the Microscopical Society of London. These showed the spiracle and tracheae of the silkworm and the proboscis of the fly, prepared by J. Delves and Samuel Highley in 1852. Ten years after the Great Exhibition, William Henry Olley of Great Yarmouth published what is probably the first book of photomicrographs in England, *The Wonders of the Microscope Photographically Revealed,* published in parts and in book form in 1861.[38]

The important question then is not why did photographs displace drawings but rather in what cases were photographs or drawings preferred, and why? Writings on microscopy generated a wider discussion over whether it was better to learn how to see in textbooks or in nature. The promotion of photography for medical teaching accompanied a wider shift toward the use of microscopes, drawings, and photographs as aids to the study of pathology. Lionel Beale, professor of morbid anatomy at King's College, London, highlighted the need for visual illustrations. "Students of every branch of natural science must feel how very much more may be learned from objects and from drawings than from mere description." He added that this was "particularly the case in those departments of practical medicine in which the microscope is of real importance, as in the investigation of diseases of the kidney, chest, stomach, skin, etc."[39]

Beale used drawings from his laboratory, explaining that they were made "under my immediate superintendence, and, in some instances, by myself." Images traced on preparation paper were then transferred direct to lithographic stone or occasionally engraved within the pathology laboratory. According to Beale, beauty was less a factor in these figures than scientific accuracy. Echoing the earlier remarks of George Shadbolt to the Photographic Society, Beale

wrote: "The figures have no pretensions to be considered beautiful drawings, or to be looked upon as works of art, but it is hoped they will be found accurate, although somewhat rough, representations of nature, as the greatest pains have been taken to render them faithful copies." A student must not be "led into the error of giving a name to what he sees," merely because it appeared to resemble a structure "of which he has merely read a description, or of which he has only seen a bad drawing." He asserted that "practical observation alone enables any one to describe and interpret with confidence what he has seen under the microscope."[40] Histologist John Hall Edwards offered the opposite point of view, insisting that it was "next to impossible to recognize under the microscope some of the common objects" depicted in textbooks. This was "especially the case," he thought, with books of histology and pathology where even "the trained microscopist" encountered great difficulty in "appreciating slight differences in colour, when viewing objects under the high powers."[41]

Although leaders of the British medical profession disagreed about its pedagogical utility, photography rapidly gained a footing as part of routine practice in medical education in the 1880s and 1890s. The employment of photomicrographs of medical subjects in the lecture room was widespread by the 1890s, in Britain and abroad, with the French leading the way. Abbé Moigno was one of the first to demonstrate the value of photography in this connection, fitting his "Salles des Sciences" in Paris with a screen and oxy-hydrogen lamp for the purpose of showing subjects in a magnified form.[42] In Great Britain, photographs of objects viewed through the microscope were announced as an aid to medical students to supersede hand-drawn copies of the enlarged images. Many assumed that in some cases these would be more useful than the microscopic examination of actual tissues, unless the student was a practiced microscopist, in which studying the object was preferred.[43] In a *Lancet* article, "Use of Photography in Medical Teaching" (1893), the author commented on the rise of photography as a supplement to drawing in medical education and practice. "For many years the skill of the draughtsman was alone employed in the work, and we cannot even now by any other process attain to quite the same exactitude of expression." Recently physicians had "added to this another power in photography, of which we may say that if it lacks the clear precision and the facility in using color associated with the older method if offers instead other and important advantages."[44]

Of the advantage of photomicrographs over drawings for teaching purposes, British bacteriologist Edgar Crookshank argued that drawings were rarely "true to nature"; they were always prettier, with sharper lines and more attenuated shadows than the original. Sketches that improved on the representation of badly prepared colonies made them less truthful and therefore less

instructive, for a sharper line or darker shadow could give the figure a different meaning. Photography, by contrast, made improvements of the picture a "practical impossibility"; the shadows in the preparation formed the picture itself, and, therefore, Crookshank insisted, "any structure, form, or shape which may be represented, is actually what exists, and not what may have been evolved by unconscious bias in the mind of the observer." Photomicrographs were desirable for communicating with colleagues, he advised, noting that when one wished neither to part with the original nor to make many preparations to illustrate some object, several copies could be printed and circulated with remarks. Crookshank did not reject drawings; in fact, he stated that colored drawings were preferable to black-and-white photographs for recording double—or triple—stained preparations. If a colored drawing had to be reproduced by wood engraving, however, thereby losing the information that color conveyed, Crookshank urged that a photograph be made instead.[45]

Photographs were not universally accepted or even welcomed by scientists and doctors, however. In a September 1893 *Lancet* article, the author argued that while the camera was vital for recording external organs and that stereoscopic technique yielded realistic views of internal organs and certain disorders, photographs should complement rather than replace drawings. "It is a truism that after actual demonstration there is nothing so essential to reality in description as accurate pictorial representation." Only the "skill of the draughtsman" produced "exactitude of expression."[46] Reflecting the fact that drawings and photography prevailed in the investigation of bacteriology, the *Journal of Pathology and Bacteriology*, first published in 1892, included drawings made with the camera lucida, colored plates, and photographs, often on the same page. Photographs were reproduced with increasing frequency in the journal after 1896, but scientific contributors still felt the need to explain their special utility. Remarking about the imaging of the flagella of the tetanus bacillus, one physician explained that "careful photography has brought out details which the eye could only detect with difficulty, but which the sensitive plate has rendered very evident."[47]

Edgar Crookshank founded King's College's first bacteriological laboratory for human and veterinary pathology in 1885 and became Britain's foremost promoter of photographs of bacteria for use in medical teaching. As professor of bacteriology, Crookshank taught students, including public health officers, how to see subvisual microbes; therefore, he could well appreciate the perceptual problems involved. In his first year as an instructor, Crookshank published an illustrated manual for students, *An Introduction to Practical Bacteriology Based Upon the Methods of Koch* (1886), containing colored plates and wood engravings. So convinced was Crookshank that photography would advance bacteri-

ological science that he wrote *Photography of Bacteria* (1887), devoted solely to the topic of photographing microscopic organisms.[48] His photographs continued to be reproduced in books about bacteriology well into the early decades of the twentieth century. For example, his 1896 photographs appear in F. Lohnis, *Studies Upon the Life Cycles of Bacteria* (1921), a book that also contains photographs by Edward Klein from 1883, 1885, and 1894, suggesting that Klein also made use of photomicrographs.

Crookshank's *Photography of Bacteria* is remarkable among texts from an era when most books on photomicrography were written by technical specialists outside the medical field. As a bacteriologist writing for medical students, Crookshank's thoughts on photography's instructional uses reflect his disciplinary expertise. His was the first text devoted solely to the photography of bacteria, containing eighty-six images reproduced in autotype (Figs. 4.2–4.4). On the superiority of photographs over original preparations, Crookshank stressed their value in demonstration: "If I gave a microscopical preparation to a person in order to observe a particular part—for example, a lymphatic vessel containing bacteria—I could not in any way be certain that he would look at the right place, or even if he finds it, that he would properly focus and illuminate it." He discussed the photomicrography of "the tenants of the invisible world": the methods of staining and mounting specimens, the results of working with different powers, the arrangement of illumination and focus, the value of isochromatic plates, the operations of the camera shutter, and the need for delicacy of manipulation. Crookshank lauded photography as a pedagogical tool, "valuable alike for class demonstrations and for illustrating publications." It repro-

FIG. 4.2. Anthrax bacteria at different mags. (×400 and ×2500), stained with fuchsine. Plate VI in Edgar Crookshank, *Photography of Bacteria* (London: H. K. Lewis, 1887).

FIG. 4.3. Comma-bacilli, stained with fuchsine. Enlargement from a photographic negative (×2500). Plate XIII in Edgar Crookshank, *Photography of Bacteria* (London: H. K. Lewis, 1887).

duced the image for everyone to see under similar conditions—the same focus, magnification, and illumination. To throw light on points of controversy, he explained, one could place a finger on the photograph of the object, measure it with compasses, and compare it with photographs either of the same object or of another taken in the same manner.[49]

Photography, already part of scientists' campaign for more authority for bacteriology, increasingly dominated scientific and popular discussions on the merits of bacteriological science. One of the main ways that photomicrographs of bacteria circulated was through the new photographically illustrated scientific books and atlases for novice scientists and specialists. Timothy Richard Lewis's *The Microscopic Organisms Found in the Blood of Man and Animals* (1879) was one of the first books on bacteria ever to be illustrated with the assistance of photomicrographs. One reviewer, praising the book, declared: "The identity of the organisms which were found in the common rat of this coun-

FIG. 4.4. Bacillus figurans, stained with fuchsine (×50, ×200, ×450). Plate XVI in Edgar Crookshank, *Photography of Bacteria* (London: H. K. Lewis, 1887).

try was estimated much more readily from these photographs than from the wood engraving or the description in the letterpress."[50] Lewis, an army medical officer and assistant to the Sanitary Commission in India, dealt with organisms in the blood of rats in India. His book (published in Calcutta) contained several woodcuts made to represent photomicrographs, including one of bacteria magnified 700 times, and tracings of photomicrographs of bacilli from mouse blood. As he explained: "The 'spores,' therefore, are most remarkable organisms, seeing that they withstand influences which are destructive to every other form of vegetable or animal life. True 'invisible' germs are accredited with this marvelous power, but, as yet these 'spores' are the only *visible* bodies for which such persistent vitality has been claimed by eminent authorities."[51] He himself made several photomicrographs of spirillum for publication. However, being unable to make reproductions of the negatives in India "by any of the permanent photographic processes practiced in Europe" to meet the publisher's deadline, he had tracings made of some of the leading forms and had those reproduced as wood engravings (Fig. 4.5).

By the 1880s and 1890s, scientific atlases helped transform old conceptions of germs and create a professional scientific community. Through the interpretation of pictures, bacteriologists were trained to see bacteria the same way and, as in meteorology, to create a norm of seeing. As Lorraine Daston and Peter Galison have shown, atlases were the "bibles" of the observational sciences. They had a long tradition in the sciences, where they were used to train the eye to pick out certain kinds of objects as exemplary. The atlas would "drill the eye of the beginner and refresh the eye of the old hand." Daston and Galison show that by the late nineteenth century, atlases proliferated in number and kind,

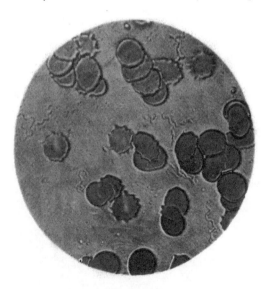

FIG. 4.5. Photomicrograph of bacteria, × 700 diam. Plate 3, FIG. 3 in Timothy Richards Lewis, *The Microscopic Organisms Found in the Blood of Man and Animals* (Calcutta: Office of the Superintendent of Government Printing, 1879). The caption reads: "Spirilla in the blood of fever patients at Bombay—one of two microphotographs of osmic acid preparations, mounted dry. Many of the red blood corpuscles are seen to present irregular margins in both figures." Historical Library, Yale Medical School.

purveying images of everything from spectra to embryos. They also became manifestos for a new brand of mechanical objectivity. The characteristic atlases of the mid-nineteenth century mark a transition between earlier volumes that sought to depict truthfully the typical subjects of nature, as apprehended by the skilled eye of the observer, and the later ones that sought truth in mechanical objectivity. Scientists' choice of which images "best represented 'what truly is,' they suggest, engaged atlas makers in ontological and aesthetic judgments that mechanical objectivity later forbade."[52]

In December 1893, the *British Medical Journal* announced that Carl Fraenkel and Richard Pfeiffer had published a new "excellent atlas of photographs of bacteria."[53] Some scientists, such as Crookshank and Koch, photographed their own preparations for publication, while some published photomicrographs taken by others or borrowed from other atlases with the permission of publishers. Crookshank recommended Gustav Hauser's *Uber Faulniss Bacterien und deren Bezichungen zur Septicamie* (1885) as containing photomicrographs of bacteria that were "the most beautiful results hitherto obtained."[54] Some atlases even included a short introduction to photography, as did Charles Slater and Edmund J. Spitta's *An Atlas of Bacteriology* (1898). According to a *Lancet* writer, the description that the Slater and Spitta atlas provided was "sufficiently detailed to indicate to anyone acquainted with the subject the conditions under which the negatives were produced."[55] George Newman, a demonstrator of bacteriology at King's College and author of *Bacteria, especially as they are related to the economy of nature, to industrial processes, and to the public health* (1899), commissioned photographs from expert microscopists Spitta and Andrew Pringle for his books.

Andrew Pringle was a member of the Royal Microscopical Society as well as an expert photographer whose images of bacteria and other microscopic phenomena, such as sperm, circulated in scientific atlases, textbooks, and prints. Though not a bacteriologist, he resolved a number of problems associated with photomicrography and published advice on how to do it, and thus he was widely admired by bacteriologists and other medical personnel. Pringle signed his name and the date on a photomicrograph of sperm (Fig. 4.6). He also mounted it in a rondo frame in the customary manner of portrait photographs. The physical object illustrates a public visual culture of photomicrography that evolved through signed examples of work and a mode of displaying scientific photographs that would continue into the twentieth century in the form of the poster session. A *Lancet* review of Pringle's book *Practical Photomicrography* (1894) announced that Pringle had resolved one of the major problems with bacteria and histological preparations by making sure that tissues not meant to be colored in the staining process were given "maximum decolourisation."

B. Termo. × 1500 · (Dowdeswell.)
(flagella.)

Andw Pringle
Photo . 14/8/90.

FIG. 4.6. Andrew Pringle, photomicro-
graph, ×1800 (1890). The Royal Micro-
scopical Society Collection at the History
of Science Museum, Oxford.

The reviewer also explained that "in nine cases out of ten the special tissues
are not sufficiently differentiated in the staining processes, and his two italicized
words, 'maximum decolourization,' of every tissue that is not to be coloured by
the special stain used, embody the most pointed and accurate direction that we
have yet come across."[56]

Edmund Spitta's *Photo-micrography* (1899) was one of many such books that
received critical acclaim from bacteriologists around this time. Others included
A. Cowley Malley's *Photo-micrography* (1885), I. H. Jennings's *How to Photo-
graph Microscopic Objects: or Lessons in Photo-Micrography for Beginners* (1886),
and F. W. Mills's *Photography Applied to the Microscope* (1891). Jennings even in-
cluded a chapter by the distinguished microscopist and physician, Richard
Leach Maddox, a Fellow of the Royal Microscopical Society, on preparing bac-
teria for photography. Maddox warned beginners that photomicrography was
a "difficult art" but promised that by its aid, scientific workers could "record
faithfully the results of difficult and delicate operations, or delineate the forms
of minute bodies, concerning whose true structure different observers may vary
in opinion."[57] Redefining the distinction between a specialist and an amateur
photographer to signify the difference between those trained and untrained, es-
pecially in science, he declared that photographers who took good landscape
photographs and portraits were not therefore "fit to be entrusted with negatives
of microscopic objects."[58] To make reliable photomicrographs, the operator had

to understand the nature of the object and this, he argued, could only be done by a microscopist. For advanced study in photo-micrography, he recommended the *Monthly Microscopical Journal,* the *Transactions of the Royal Microscopical Society,* and a chapter by Lionel Beale.

Reactions to Slater and Spitta's *An Atlas of Bacteriology* highlight how the same volume could generate different meanings and, in the process, raise issues of taste, aesthetics, and judgment, despite claims of mechanical objectivity. The atlas contained III original photomicrographs with accompanying text. The authors explained in the preface that bacteriology was "so recent a science that from its infancy it has been able to record by the aid of photography the forms and characters of the microorganisms discovered, and the pathological changes produced by them in the tissues." At an early date, they reminded readers, Koch had "insisted on the value of a photographic record as a convincing proof of the reality and accuracy of the descriptions." Such proof was no longer needed, they suggested, to convince people that bacteria existed, but even so, photography was "more and more" taking the place of diagrams or drawings. They complained that only one work, Fraenkel and Pfeiffer's *Atlas der Bakterienkunde,* systematically illustrated by a series of photographs the life history of a specific microorganism. That "excellent" book, however, was so expensive that it was beyond the means of ordinary students. Therefore, they provided "a series of photographs of preparations of micro-organisms and their cultures, such as are usually met with, and made by, the student in an ordinary course of practical Bacteriology." They insisted that it was not meant as a textbook and that the letterpress served merely "to link together and emphasise the teachings of the photographs." The photographs were taken from "fairly typical cultures" in the hope that, when compared with actual specimens, they would show students the extent and direction of variations.[59]

In February 1899, the *Lancet* praised the atlas for taking its images "directly from preparations made in the ordinary way in the laboratory of St. George's Hospital," although it criticized other medical texts illustrated with photographs for their "show" character. Atlas photographs might be accused of having "show" character if, for example, the viewer's eye was drawn to the virtuosity of the photographer rather than to the object itself or the skills of the bacteriologist. "Not infrequently, indeed, it would appear that the desire to instruct the reader has been lost sight of in the endeavour to show what excellent work may be done," the reviewer declared. Slater and Spitta's book avoided this problem. "The illustrations are from good average preparations and as such are more useful to the student than first-rate picked and special preparations ever could be." The student had to "get an idea of what an average preparation looks like"; if

he were only acquainted with "extraordinarily good examples," he would fail to make original observations and to pass his exams.[60]

Another writer with a different interpretation criticized the same atlas in *Guy's Hospital Gazette* the following month. "We doubt very much the utility of such a book," exclaimed this reviewer. The review faulted not only the cheapness of the reproductions and their distortions of the reality of the phenomena but also the very idea of relying on photographs for knowledge of bacteria. Of the poor quality of its reproductions, the critic stated: "The authors lay great stress on the cheapness, and with this we quite agree. Considering how well the photographs have been reproduced, and how excellently the book has been published, it is cheap." Doubting that it would become, as the authors had hoped, a laboratory handbook, an aid to the instructor, and a resource for the medical officer of health and consulting physician, the critic opined that "good as some of the photographs are, the authors might well have devoted their time and talents to something of more practical use." The critic failed to recognize some organisms in the photographs and, significantly, did not trust the image: "the few photographs of cultures which figure in the atlas did not remind us of the organisms named . . . No one would imagine, for instance, from fig. 44, that the streptococcus on gelatin was a delicate and small growth" (Fig. 4.7).[61]

This critic was not persuaded of the need for photographs. "The student learning bacteriology should be trained to observe for himself . . . All illustrations for the purpose of elucidation should be diagrammatic. On comparing a number of photographs together we found, as we expected, that many so nearly resembled one another that the student would become confused." The book was not appropriate for novices, nor was it useful for specialists. "The teacher who has to rely on a series of photographs cannot know much of his subject;

FIG. 4.7. B. Anthracis, section of kidney (Glomerulus), Gramand Picrocarmine, 1/6 apochromat, Projection Ocular 6 (×375). FIG. 23 in Charles Slater and Edmund J. Spitta, *An Atlas of Bacteriology* (London: Scientific Press, 1898).

and to the M. O. H. [Minister of Health] we cannot see of what use it could be. If he was competent to undertake the bacteriological work of his district, he would not need such an atlas; if he needed such a work, he would be incompetent."[62]

Edward Klein, a pioneer of English bacteriology while at the Lister Institute in the 1880s, was an especially outspoken critic of the use of photography to illustrate bacteria in medical textbooks of pathology. The author of several important works in the field of pathology, Klein wrote in the introduction to his *Micro-organisms and Disease* (1884) that the photography of microscopic specimens had yielded results "so unsatisfactory, that even Koch, who first introduced it, has abandoned it in lieu of accurate drawings made in the usual manner." Klein was a target of criticism from other bacteriologists such as Koch, Lewis, and Crookshank. Lewis disputed some of Klein's notions of spore germination, maintaining that since spores had been shown to be invulnerable to compressed oxygen and boiling, their invisible germs "still live, and under favorable circumstances, will reappear." Lewis also argued with Klein's interpretation of Koch's figures of bacilli as spherical, urging readers to consult Koch's "very valuable micro-photographs" in his 1877 paper where spores were "very decidedly of a long-oval form."[63]

In his review in *Nature* of Crookshank's *Photography of Bacteria* (1887), Klein reflected that "the time has not yet come when (photographs) can be said to have supplanted good and accurate drawings." He himself primarily used illustrations drawn and colored by an assistant, which were reproduced as woodcuts in the text.[64] He exclaimed, "It must certainly appear remarkable that in the numerous and important publications on Bacteria by Koch and his pupils since 1877 to the present time we do not find a single illustration reproduced by micro-photography. All their published illustrations are drawings."[65] (Koch did not stop making photographs, but many of his later publications do include only drawings.) Like other atlas-makers in the field of pathology and histology, Klein held that photomicrographic methods often yielded poorly delineated objects in a small field and allowed some bacteria to "escape reproduction." He concurred with critics who faulted illustrated atlases that included photographs less for science than for "show." Dr. George A. Piersol of Wurzberg discussed the respective merits of drawings and photographs in the *American Microscopical Journal,* saying that the value of the image depended on the judgment of the microscopist. The pencil (much "neglected") was better for magnifications under ordinary (200–350 diameters) conditions, while the camera was "serviceable" only for very low and very high powers. He added that photographs did not reproduce well in books.[66]

Going Public

Bacteriologists faced in particularly acute ways a dilemma that faced British science more generally. Even at this most public moment for laboratories, when experiment was on the rise and laboratory research became a new paradigm for knowledge, many Victorians thought of scientists as dangerously isolated individuals beyond the reach of social constraints, moralizing influences, and the civilizing effects of women. Late-nineteenth-century accounts of laboratory practices reveal deep social and moral ambivalence about the morality of the subjects of science (pathology, vaccination, bacteriology, and, most of all, vivisection) and about the degree to which many scientists appeared to dismiss public health practices, such as public sanitation. To encourage the public to place confidence in their expertise, bacteriologists had to do more than convince skeptical fellow scientists and train recruits. They also had to put their findings on public visual display.

During an era of widespread confusion about the reality and agency of bacteria, bacteriologists urged the public to place their confidence in laboratory investigations. That photographs did not show bacteria in action was a serious obstacle, particularly given scientists' need for national public and institutional support. Therefore, the illustrated press was used with the aim of brokering a positive message of scientists as a fraternal brotherhood. Documentation of military warfare in illustrated British newspapers and magazines provided scientists and their promoters with a broadened range of hierarchical relations and metaphors to suggest links between bacteriologists and heroic soldiers defending the Empire. The case of bacteriology shows that the scientific authority of photographs was made tangible not always by direct viewings of photographs but often by the evocation of racial ideologies and distinctions that were arguably more powerful than the presumed authority of photographic truth.

Many factors contributed to the rising cultural anxiety about scientists and the uses and abuses of experimental knowledge. The laboratory "revolution" in London may have excited public interest and national pride, but it also fueled class and gender antagonisms connected with the new power of the middle-class scientist. Middle-class scientists' usurping of aristocrats' privileging of classics and mathematics contributed to concern about the social implications of the laboratory, for example, as did the historical associations of the laboratory with practical training, proletarianization, and politically radical causes. For men and women of the working classes, meanwhile, there were more serious reasons to be alarmed by the rise of experimental science. People from poor communities had long feared doctors as enemies who preyed on their destitution for personal profit and success, especially after the passage of the 1832

Anatomy Act legalized dissection on the corpses of the poor.[67] The popular belief in 1888 that serial killer Jack the Ripper was a vivisecting London University surgeon who had extended his research from dogs to prostitutes, for example, occasioned widespread concern about the dangers of unrestrained research and male sexuality.[68]

Tales such as Richard Marsh's "The Beetle," Arthur Conan Doyle's "The Great Kleinplatz Experiment," Robert Louis Stevenson's *The Strange Case of Dr. Jekyll and Mr. Hyde,* Bram Stoker's *Dracula,* Wilkie Collins's *Heart and Science,* and H. G. Wells's *The Island of Dr. Moreau* reworked the concept (popularized by the new science of criminal anthropology) that mental genius was a neurological derangement often accompanied by moral insensibility.[69] *The Strange Case of Dr. Jekyll and Mr. Hyde* (1886) and *The Island of Dr. Moreau,* published ten years later, dramatized the potential dangers of knowledge as a privately pursued passion. Jekyll's experiments, though they filled him with "intellectual passion," also gave him "strange colourless delight."[70] Koch himself was widely known to subscribe to the view that the cries of vivisected animals helped habituate the student to the pain of a human patient.[71] As the feminist antivivisection reformer Frances Cobbe declared shortly after the Ripper murders: "Should it so fall out that the demon of Whitechapel prove really to be . . . a physiologist delirious with cruelty, and should the hounds be the means of his capture, poetic justice will be complete."[72] Public opposition to experimental procedures in physiology came from women and men across class lines. Even before things came to a head in the mid-1890s, the high mortality from ovariotomy occurring at the same time as the extension of laboratory methods to physiology confirmed people's worst suspicions that vivisection encouraged doctors to undertake cruel experiments on their patients.[73]

Bacteriologists had reason to be concerned about the negative images of experimental science that proliferated during the 1880s and 1890s. The failure to convince the Liberal and Tory governments to carry out the recommendations of the Devonshire Commission in the 1870s to raise support for scientific education drove home to scientists that they could no longer ignore the attitudes of the politicians and the political classes in striving for more state sponsorship. Believing that they were largely ignored by industry and the state, and only minimally incorporated into educational institutions, British scientists feared German competition. Various scientific leaders criticized the adequacy of a political system that, they said, paid little attention to the national duty of fostering science. To compound their problems further, antivivisectionists had succeeded in demonstrating that sustained political agitation modeled after other moral reform movements could achieve legal restrictions on professional scientific research.

All of these factors contributed to what Frank Turner has identified as a sudden, striking shift in the themes of late-nineteenth-century public science. Many scientists who previously had hoped to participate in public life found themselves unable to exert as much influence in the public arena in the mid-1870s. Despite the praise lavished on Victorian science, the last three decades of the nineteenth century were also years of anxieties about science and its cultural impact.[74]

Social fears about science often focused on laboratory experiment. From 1888 to 1910, London's major medical teaching schools gradually began adding courses and training in bacteriology. In London, small classes were already being held at the prestigious Brown Institute in the mid-1880s. Klein, lecturer on physiology and an outspoken defender of vivisection, taught bacteriology before moving to St. Bartholomew's Hospital in London in 1892 as a lecturer on general anatomy and physiology.[75] Systematic instruction in bacteriology began there in 1887, and instruction in medical bacteriology at King's College also began in the 1880s.[76]

Against this context in which public questions were raised about science's secretiveness, Edinburgh surgeon G. Sims Woodhead praised laboratories as a moral site for communication and friendly assistance, positive rivalry, and initiation into a "scientific brotherhood." The director of laboratories of the Royal College of Physicians and Surgeons, Woodhead was also an active participant in contemporary debates in sanitation science. In his popular writings on bacteria, he declared that, "Where men are working in the same laboratories, and are in daily communication with one another, . . . selfishness and secretiveness, the two special vices of original workers, are less warmly fostered."[77]

Earlier we saw that photographers appealed to an ideal of scientific masculinity to redress urban class and gender tensions that divided photographers during the early days when commercial photography seemed to many to threaten the status of their art. This ideal was characterized, among other things, by hard work, public spiritedness, and the desire to do scientific work. Now bacteriologists appealed to the fraternal idea of laboratory science to combat the impression that they were as secretive and dangerous as the phenomena they studied.

New audiences and displays at exhibitions and world's fairs ensured that scientific photography of bacteria was highly public and visible. People followed news of bacteria with the mixture of apprehension and thrill with which they followed news of criminals. Victorians referred to bacteria as "small offenders" that could be coerced into giving up the "secrets of their hidden life."[78] At the Royal Society *conversazioni*, which were initiated in 1872, visitors admired instant microphotographs of animalculae and insects, and photographs of microorganisms exhibited by Percy Frankland. Photographs were displayed alongside arranged demonstrations such as Klein's exhibit of specimens of microbes

shown under the microscope. On May 12, 1886, Crookshank showed pho-tomicrographs of bacteria, including thirty enlargements from negatives and photographs of anthrax-bacillus, hay-bacillus, tubercle-bacillus, as well as the famous "comma-bacillus of [Robert] Koch." "Living pictures in insect life," a series of lantern slides, were shown by Mr. Henry Burns to amuse guests.[79]

Ultimately, Victorian discussions about bacteria displaced the figure of the doctor/scientist with the shadowy, invisible objects of his obsessive interest. The language used to describe bacteria was similar to that used by police detectives and social reformers to suggest that the social body was corrupted invisibly from within. As Carlo Ginzburg has suggested, the late nineteenth century witnessed the assertion of a new "evidential paradigm," whereby knowledge was character-ized by the ability to construct from apparently insignificant clues and experimental data a complex reality that could not be experienced directly.[80] Dur-ing this period, deliberations in Britain over the complex meanings of photo-graphic representations surfaced in a range of places, including detective fiction, a genre characterized by the imaginary account of the detective who discovers the perpetrator of the crime based on evidence imperceptible to most people.

The campaign for more authority for bacteriologists included popular sci-ence writing in books and the mass media. Efforts to assure the public prompted other bacteriologists to evoke familiar objects and tropes, much as meteoro-logical observers had used familiar objects and comparisons to instill in the minds of meteorologists images of weather phenomena. In *Bacteria and Their Products* (1891), Woodhead explained that bacteria were "vegetable organisms" composed of protoplasm differentiated into round cells, of approximately 1/25,000 of an inch in diameter. They moved and grew at fast rates, and were classified into several types. Since the 1870s, bacteria had been identified as causal agents of diseases such as cholera, typhoid, tuberculosis, leprosy, anthrax, tetanus, and diphtheria. Bacteria could be found in air, earth, and water. Some were "pathogenic parasites," while others were known to have nonpathogenic properties. Unable to invade the tissues of living plants and animals, they usu-ally helped in the decomposition, for example, of garbage.[81] As Newman wrote in 1899, microorganisms "occur in our drinking-water, in our milk supply, in the air we breathe. They ripen cream, and flavour butter. They purify sewage, and remove waste organic products from the land. They are the active agents in a dozen industrial fermentations. They assist in the fixation of free nitro-gen, and they build unassimilable compounds, and they are both economical and industrial in the best biological sense of the terms."[82] Yet if bacteria were, as some said, society's "invisible friends," they were also potential "foes." In a violent age of imperialist expansion, the language of bacteria as invisible "friends and foes" had a rhetorical power.

At a time when colonized peoples were exhibited in England, stained bacteria and the tattooed bodies of "savages" were being conflated in popular scientific works, such as chemist and science popularizer Percy Frankland's *Our Secret Friends and Foes*. "Natives" were already being construed in newspaper illustrations and academic battle paintings as potential "friends" or "foes." In *Our Secret Friends and Foes,* which went through four editions by 1899, Frankland drew analogies between the painted bodies of "savages" and the colorful bodies of bacteria after they had been stained to make them more conspicuous in their surroundings. Frankland attributed advances in the knowledge of microorganisms to methods devised for accentuating their appearance. "Striking colours are employed by both the savage and the civilized man, or rather woman, to render themselves more conspicuous, in the latter case by clothing in coloured garments, whilst by the savage the process of brilliantly colouring the body itself is adopted."[83]

Scientists who promoted the field of bacteriology did not rely on popular science books alone. They also reached out to cultivate a favorable newspaper press to reach the public with their interpretations of the pictures. As it turned out, the newspaper press responded with different strategies. For reasons explored earlier, the photographic press proved extremely reliable in promoting the camera's centrality to the great discoveries in bacteriology. Photography of approved scientific objects was regarded as essential for awakening the public's awareness of the utility of photographic science and binding a larger community around a positive image of its scientific yield. As with many other photographic discoveries in science, the Victorian photographic press made the loudest announcements about the medium's important role in bacteriology, at least initially.[84]

Crucially, they opened the bacteriologists' "studio" to public view. In chapter 1, we saw that the photographic press published descriptions of darkrooms as part of a wider political strategy to make photography a public science and therefore reduce its associations with secrecy and mystery. As a result, these publications are an extremely useful source for finding descriptions of nineteenth-century photographic places of work. Although photographic journals rarely published photomicrographs, they did publicize bacteria photographs in other ways.

In "At Home With Professor Lister—Photographs of Bacteria," one of its many series on photographic interiors, the *Photographic News* promised to chronicle "one more successful investigation that has been brought to a successful issue by [the camera's] aid." A reporter visited Lister at the Brown Institute in order to see Koch's photomicrographs of bacteria. The article invoked the popular theme of photography of the invisible as a way to convey the importance of recent bacteriological researches: "We observe, by means of the micro-camera, objects unseen by the eye." Significantly, the author offered only

Lister's interpretation of the photomicrographs, although he acknowledged that "not all" surgeons "adopt his theory." Lister's theory was that diseases were caused by bacteria, which were so minute that "a lens of one-sixteenth or twentieth of an inch is necessary to examine them properly." Strangely, "the microscope, when appealed to, fails to bear out all Mr. Lister says." However, "a staunch friend has now turned up in most timely fashion, and this is the micro-camera . . . its evidence is likely to afford convincing proof of the soundness of Mr. Lister's theory and practice." The camera when used in conjunction with the microscope yielded fresh and truthful observations. "Look into the microscope, and you cannot see these bacteria in their bed of tissue; place them before a camera, and you secure a photograph of the tiny organisms forthwith . . . not only does the camera make a successful search, but it records permanently what it sees." Koch's photographs promised "to teach us more about bacteria and their terrible functions than any other scientific investigation" previously connected with "the tiny organisms."[85]

Other photographers also obliged, testifying to the significance of Koch's photographs in bacteriology. John Hall Edwards, the former assistant demonstrator of histology at Queen's College in Birmingham, testified in the *Photographic Quarterly* that photographs were superior to drawings as visual aids. It was "rare," he declared, to find a microscopist and artist in the same person. Moreover, he stated that most drawings were "little better than pretty pictures, drawn rather with the object of producing an artistic sketch, than a truthful representation of nature." By contrast, photography "plainly" showed differences, however "slight they might be." He concluded that even if the color of the objects were similar, if their refractive power differed, photography would "make a distinction between them when the eye may fail to do so."[86] Some of this scientific testimony suggests broader national rivalries. In May 1885, for example, Italian photographer Selimo Bottone, who published several remarkable photomicrographs in the *Photographic News,* argued that his images made with a quarter-inch French triplet lens were superior to "any English objective."[87]

In newspapers for general readerships, scientists had to negotiate the tensions associated with entering public culture without appearing to pander to mass popular taste. On the one hand, newspapers were reporting that bacteriology was merely the "latest fashion," and scientists felt compelled to publicly defend it.[88] On the other hand, scientists often were loath to be drawn into public controversy and debate, particularly in journalism where they had little control. In newspaper articles and popular science texts, scientists and artists conveyed an image of scientists whose authority derived from access to photographic equipment and special scientific skills. Photographs of bacteria did not show those things about which scientists and lay people disagreed most by the

1880s and 1890s, that is, whether or not, and how, bacteria caused disease. Even practitioners who agreed that bacteria existed and that they caused disease disagreed over whether or not photographs were valuable in showing this.

Journalists and scientists frequently turned to cartoons as ancillary guides to photographic interpretation. "The Army of the Interior," a collaborative effort between journalist Robert Machray, bacteriologist J. Arthur Browne, and illustrator David Wilson, reveals the cross-pollination of visual communicative practices across professional and popular science. Published in *Pearson's Magazine* in 1899, the article illustrates bacteriological science's dependence on newspapers and magazines to promulgate its interpretation of the photographs. The article is typical of the new popular periodicals between 1890 and 1914, when *Pearson's* frequently published articles that related science to the negotiation of social consensus on imperial expansion, social reform, and the ideology of national efficiency, which were also major themes of public science.

Pearson's was a patriotic magazine with a vested interest in promoting a favorable image of the army. Military scenes were a significant part of the visual history of Great Britain, forming nearly 40 percent of all illustrations in major British newspapers in an average year after 1875.[89] Within this group, colonial warfare was the most widely covered single subject in Britain's two major illustrated newspapers, the *Daily Graphic* and the *Illustrated London News*. Rival special artists who went to the front to cover colonial wars sent back news and illustrations of the campaigns being fought in outposts of the Empire, including the Zulu war, the invasion of Egypt, the Sudan expeditions of 1885 and 1896, and the Rhodesian revolt of the late 1890s. Occasionally, photographers accompanied colonial troops; during the Afghan War of 1878–82, for example, a British officer asked for a complete photographic unit from the Royal Engineers, but James Burke, a civilian photographer, agreed to accompany the force with his own equipment. Burke traveled with the soldiers as far as Gandamak before returning to Peshawar, where he sold copies of his photographs to defray his costs.[90] The photographer Roger Fenton was hired by an illustrated newspaper to take photos of soldiers during the Crimean War.

In contrast to earlier images of soldiers as rapacious and licentious, *Pearson's* tended to show them in a favorable light. An 1896 story evokes the kind of soldierly mutuality and fraternalism that "The Army of the Interior" associated with bacteria-eating leucocytes and bacteriologists. "One of the Bravest Deeds I Ever Saw" relates the last minutes of a captain who ran into a cave guarded by Zulus to rescue wounded fellow soldiers. "No one was seen in the passage, but the north side of the mountain above them was lined with Zulus with firearms." The captain and his party "all knew that though no Zulus were

in sight, yet their guns were covering the party, and, as all officers of experience are aware, the unseen is the most appalling form of danger."[91]

Co-author Machray had previously contributed other articles on military topics, including "The Bands of the British Army" (1896) and "The Army Medical Staff and Corps, and Their Work" (1897), illustrated with photographs by W. H. Homan. The story of "The Army of the Interior" highlights how scientists and journalists collaborated to try to show the same things that photographs showed, but with the confusing ambiguities removed. The story narrates a series of battles between leucocyte and bacteria "armies," portraying the body's fight against bacterial infection as an imperial war adventure. Three of the five illustrations depict the progress of war. The first sketch, "Going to the Attack," depicts the escalation of germ warfare as the leucocytes, after spying the enemy on the bank overlooking a stream of blood, move into battle. In the next scene, "The Captive Microbe," microbes advance into the lymph streams but eventually are subdued by leucocytes and their own poisons. Leucocytes surround the microbe, which is tied to a stake. In the lower left, readers are shown the processes of globulation and separation in "scientific" cartoons. This is followed by a "tremendous orgie" in which the soldiers cannibalize their opponents as well as their own "weaker brethren." The last scene is a moral tale of soldier unity; the captive microbe is bound and the "merry" soldiers gather round the campfire to digest their victory.

The challenge of reproducing photographs was even more difficult for the illustrated popular press than it had been for scientific atlases, which generally could afford excellent reproductions. "The Army of the Interior," which claimed to be based on an interpretation of photographs of bacteria made by the Russian pathologist Elie Metchnikoff, contained not photographs, but five pen-and-ink drawings, reproduced by line engraving, a commercial process that involved a metal relief plate produced by the photographic transfer of the drawing.

Close analysis suggests the centrality of the cartoons to defending the public legitimacy of bacteriological science. They were supposed to render a more intelligible version of what the photographs showed. The purpose of the illustrations, according to the authors, was to "elucidate and interpret the subject" for readers. As close-up depictions of incidents in an engagement, the pictures reflect a more general shift in Victorian painting away from the distant panorama typical of earlier battle scenes toward a close-up—typical also of microscopical photography. As we have seen, the cartoons illustrate the escalation of a war against bacteria from a "fray on the frontier" to a "regular campaign." The images rely not on the authority of photography per se but rather on the authority of racial, class, and gender stereotypes, circulating familiar representations

of soldier heroes, dark-skinned "natives," secret colonial wars, and foreign invasion to elucidate the unfamiliar topic of germ warfare for mass readerships.

Again, one of photography's main limitations was that while it showed what bacteria looked like, *it did not actually show germ warfare taking place.* The process by which photographs were rendered more intelligible by drawings was effectively mirrored in the cartoons themselves (Fig. 4.8). That is, the illustrations marked A–C consist of a central picture. Above each central picture in the top and bottom corners, two or more cutaways show "pure scientific diagrams" of the war of the body against bacteria invasion. According to the authors, these cutaways represent the meaning of Metchnikoff's photographs of bacteria, significantly, as bacteriologists interpreted them. The egg-shaped bodies represent red corpuscles, while the flower-shaped bodies represent white corpuscles moving across the wall of the vein. The authors wrote that these drawings-within-drawings were created to "paraphrase" the bodily process by means of a "free, easily intelligible" rendering.

Just as drawings and texts were used to elucidate bacteria photographs for medical students, cartoons were designed to supplement photography's limitations in popular writings on germ warfare. Drawings were an important way to get beyond the limitations of photographs and to associate them with particular meanings and interpretations. In the end, it leaves us with a question, still relevant today, about whether or not photographs could be, as the authors said, "paraphrased," and with what effect.

Victorians saw the world through what Mary Louise Pratt terms an "imperial eye" shaped by cultural forces of science and new technologies of vision.[92] Viewers of scientific illustrations in newspapers and popular science texts were

A.—Going to the attack.

FIG. 4.8. David Wilson, "Going to the Attack." Pen and ink sketch, in "The Army of the Interior," *Pearson's Magazine* (Jan.–June 1899): 264.

encouraged to see leucocytes as "soldier heroes." The soldiers in the cartoons in "The Army of the Interior," promulgated a heroic image of scientists as hardworking servants of the British Empire, building England's infrastructure at home and away. That the soldiers are presented as white suggests a visual link with England's own volunteer armies, composed mainly of white, working-class men. Volunteer soldiers were popularized by books such as Spencer Wilkinson's *The Volunteers and National Defense* (1896) and *Citizen Soldiers: Essays Towards the Improvement of the Volunteer Force* (1894).

In his study of the development of European racial stereotypes in the history of illustration, Jan Nederveen Pieterse reminds us that Europeans carried out their conquest of Africa with forces made up mainly of Africans. Yet the basic colonial image of the "native" was, as far as Africa was concerned, an enemy image, and the first episodes of colonialism were bloody battles. As Pieterse notes, "Virtues which earlier determined the image of the 'noble savage,' such as proud aggression, were now revalued to signify cruelty, beastliness."[93] Similarly, the *Pearson's* story describes a "wonderful army" (leucocytes and phagocytes) that battles "the enemy" (bacilli), which are depicted as "terrible, demon-like things." Machray begins with the popular claim that "science has many fairy tales." Yet "none, perhaps . . . [were] so marvellous and at the same time so vitally interesting, as the story of the way in which every human body is garrisoned and defended by an innumerable host of living, sentient, militant creatures—a great multitude of soldiers, to which we have given the title of "The Army of the Interior.""[94]

Just as Victorian newspapers depicted so-called hostile races as an undifferentiated mass, the images of "demon bacteria" in "The Army of the Interior" are depersonalized. The narrative explains that collectively the bacilli had but one "fixed idea," a monomaniacal impulse "to get possession of the human body upon which to work his wicked will, for he is its deadly and implacable foe, and delights to destroy it." Military metaphors of bodily processes are linked to visual illustrations of a white army's fight against a black bacterial "invasion."[95] While popular discourses about bacteria often were characterized by the presence of women who guarded private homes against bacterial invasion, here, men defend the shores of the British Isles against menacing bodies marked as foreign. That the bacteria on the title page appear in blackface with white eyes and mouths, strengthens the association that the writers and illustrator sought to establish between bacteria and "hostile" dark races in remote lands. The depiction of bacteria as minstrels with grinning mouths was a visual reference familiar to British readers. An earlier article by Machray for *Pearson's*, "The Army Medical Staff and Corps, and Their Work" (1897), reproduced a photograph of minstrels performing at the Netley Hospital Theater.[96]

In her study of the popular and scientific knowledge that shaped a diverse British public's perception of Africa, Annie E. Coombes notes that although endlessly reiterated racial stereotypes were disseminated through popular images of "things African," this was no simple reproduction of imperial ideology. Rather, there were a number of sometimes conflicting representations of Africa and of what it was to be African—representations that varied according to political, institutional, and disciplinary pressures. Throughout all the exhibitions of Africa from 1890 to 1913, however, she remarks that a common feature showed Africans locked in battle, "either with each other or against a white, usually British, defendant." She notes further that the persistent inclusion of the representation of the Zulus as fierce fighters worked in the colonial government's interest on an immediate but subtle level. "In most instances, the inevitability of conquest is evident to the audience through frequent references to the chaotic, unsystematic fighting of the opponents, as opposed to the military science displayed in the strategic devices deployed by the British forces." Illustrated articles documenting military campaigns aimed at "producing a diagrammatic statement of the African's inability to organise militarily, and, by implication, politically, despite the protracted and bloody campaigns that in fact took place and cost the British dearly."[97]

Winston Churchill's description of the 1898 Battle of Omdurman brought to a head a controversy between war correspondents and the army, and showed the Victorian public for the first time in printed photographs what mass slaughter looked like. Churchill described "natives" as a "mass" that "stabbed and hacked with savage pertinacity."[98] By contrast, the qualities associated by the *Pearson's* artist with the leucocytes—intelligence, versatility, heroism, and watchfulness—were desired qualities in a soldier.

Moreover, British reporting of imperial conflicts raised issues of national prestige as rivalries intensified within Europe. Invasion narratives mirrored the instability of Great Power diplomacy in the years before World War I. Imperial collisions in Thailand, Morocco, Nigeria, and Egypt threatened Britain's geopolitical economy, while alarms sounded at home about Britain's vulnerability to overnight attack from Germany by steamship. Such fears gave rise among other things to the establishment of a small volunteer force for the express purpose of repelling foreign invaders. Numbering over 100,000 members by the 1870s, the volunteer forces, recruited mainly from the working and clerical classes, were famous for their martial displays well into the early 1900s. The War Office encouraged the organization of volunteers to draw the urban middle classes into a patriotic commitment they did not feel for the regular army or the militia.

The invasion genre was developed first by concerned officers such as George Chesney, author of the prototypical story, "The Battle of Dorking" (1871) published in *Blackwood's Magazine.* By the 1890s amateurs less concerned with selling defense than with selling books took up the theme in popular fiction such as *How John Bull Lost London* and *The Capture of London,* published in the 1880s. In his essay, "Count Dracula and the Martians," R. J. Dingley has argued furthermore that the invasion story was a common source for Bram Stoker's *Dracula* and H. G. Wells's "War of the Worlds" (both 1897). In his book on the martial spirit in English popular literature at the end of the century, Cecil Eby defines "invasion narratives" as fictive pieces professing to describe a future war. More than sixty such pieces were published after 1871, most of which identified Germany as the aggressor. England was always on the defensive, trying to beat back bullies threatening her shores. These stories portrayed Britain in the language of Social Darwinism as an unfit "diseased organism."[99]

Cartoon illustrations of bacteriology in *Pearson's* and other popular magazines reinforced the more general message of scientists as a fraternal brotherhood. Both artisanal and military metaphors were used to make this corporatist appeal. Indeed, the military provided the fraternal world with a broadened range of hierarchical relations and metaphors. This was linked more generally to the gendering of bacteriology as a masculine, colonial science whose very existence was backed by military might. Artistic renderings of battle scenes between leucocytes and bacteria evoked associations with contemporary military art and British combat aimed at producing a diagrammatic statement of the British scientific community's ability to organize and protect the common good. At the same time, the fraternalism and universality of science was a social message that did not always persuade British publics, as the next chapter will show.

Chapter 5

Photographic Evidence and Mass Culture

For hundreds of years, astronomers and members of the lay public had speculated about the possibility of life on other planets. In May 1905, the "proof" appeared in the first successful photographs of Mars, made by amateur planetary astronomer and wealthy businessman Percival Lowell. Around the world, newspapers and magazines published reproductions of the photographs with accompanying descriptions of the "canals." Visual artists imagined how Martians looked. Through images of Mars in the popular press, the reading public learned not only that artists' conceptions of individual Martians were markedly different but also that even those scientists who believed that life on Mars was possible did not agree on its exact properties.

This chapter discusses the connections among science, audiences, and the culture of photographic display, moving outward from an examination of how scientific photographs were displayed publicly between 1872 and 1900 at the Royal Society to how the popular illustrated press helped construct new publics and meanings for scientific photographs. Focusing in particular on the growth of photographic collecting and exhibiting at the Royal Astronomical Society (RAS) and the Royal Society from the 1880s through the early 1900s, it examines how scientists and others used scientific photographs as part of larger rhetorical arguments about who superintended science. The chapter develops several themes introduced earlier: the variety of institutions shaping concepts of taste and skill in scientific photography; the contributions of many people to the idea of scientific photographs, whether or not they actually manufactured them; and the persisting significance of scientific skill, judgment, and aesthetics in debates over the evidentiary value of mechanical reproductions. A fresh look at one of the premier public controversies over scientific photographs, the first pictures of Mars, highlights key aspects of scientific photography by the end of the century, including how many different people weighed in on photographic evidence—and, in the process, science.

Worlds on Display

Funding for British scientific institutions and projects came from a combination of public and private sources, whereas on the continent centralized governments provided strong state support for the sciences. The Royal Society, founded in 1665, was under considerable pressure in the later nineteenth century to be perceived as a publicly minded institution. It was partly to broaden the audience for illustrations of the rapid progress of photography's uses in science that the Royal Society began holding annual *conversazioni* or soirees in the spring of 1872. At these events, exhibitions of photographs and other artifacts brought together the scientific community around the idea of public science at a time when the sciences were becoming more specialized and professional. Significantly, through the building and display of material photographic collections, members of scientific societies helped shape concepts of science, art, and taste in scientific photographs.

At a time when natural history museums were starting to banish unique objects from their collections in favor of typical artifacts, the Royal Society, through its annual *conversazioni,* placed important value on original, unique scientific images. Royal Society exhibits on meteorology, geology, and anthropology included sketches, photographs, and paintings that held as much value to scientists as famous artworks did to Victorian collectors and critics. Much like early photographic society meetings, *conversazioni* displayed the range of photographic work being done in the British scientific empire. Men and women who were invited to attend these soirees admired new technologies of visual entertainment deployed within an institutional setting where commercial ties to science and industry were noted and appreciated. The *conversazioni* continued the tradition associated with early nineteenth-century shows in London, where spectators encountered microscopic and telescopic views of worlds unseen by the naked eye. At these events, which were widely reported by the British press, objects having special scientific value or novel interest were displayed. These occasions therefore strengthened the association of individual photographs with scientific investigation of the natural world.

In 1872 more than 500 visitors attended the first soiree, which cost the society around fifty-six pounds, much of which went toward refreshments.[1] As at the Great Exhibition of 1851, objects were displayed along with names of their makers and exhibitors. Six rooms, filled with shrubs and flowers loaned by the Royal Horticultural Society and illuminated by oil lamps, were devoted to exhibitions of objects ranging from photographs and drawings to artifacts collected on geographical expeditions. Institutional sponsors included many with overlapping memberships and institutional ties with the Royal Society, includ-

ing Kew Observatory, Royal Geographical Society, the Royal Anthropological Institute, the Royal Meteorological Society, the RAS, the Berlin Photographic Company, and the Paris Observatory.

Spectators were awed by the electric eel and live animals from Burma and New Zealand exhibited by the Zoological Society, as well as specimens of invertebrates captured by the HMS *Challenger* expedition. Laboratory preparations by Robert Koch showed newly discovered bacilli in sealed tubes. From the Kew Museum came "articles made of leaves of Double Cocoa-Nut by French ladies in the Seychelles," articles made of paper prepared from barks of Japanese trees, fossil and coral collections, and coffee grown in Liberia. Scientific instruments included the spectroscope and micrometer, solar eyepieces, reflecting telescopes, and a trace computer, used for making deductions, invented by Francis Galton and exhibited by the Meteorological Office. G. J. Symons, from the Royal Meteorological Society, exhibited thermometers. Manufacturers such as William Ladd, in Regent Street, furnished displays of the latest philosophical instruments: telescopes, microscopes, hygrometers, barometers, and the like.[2]

Astronomy was one of the earliest traditional sciences to benefit from photography, as well as the first to witness photographs of subjects literally "beyond vision." Astronomical photography captivated the Victorian public's interest like few other areas of science.[3] As one observer boasted in an early issue of the *Photographic News,* England enjoyed special "pre- eminence" in celestial photography.[4] According to the British astronomer Andrew Common, photographs were starting to replace drawings: "We are approaching a time when photography will give us the means of recording in its own inimitable way the shape of a nebula and the relative brightness of the different parts in a better manner than the most careful hand-drawings."[5] Agnes Clerke, astronomer and science popularizer, agreed: "Photography may thereby be said to have definitely assumed the office of historiographer to the nebulae, since this one impression embodies a mass of facts hardly to be encompassed by months of labour with the pencil, and affords a record of shape and relative brightness in the various parts of the stupendous object it delineates, which must prove invaluable to the students of its future condition."[6]

At the *conversazioni,* people saw photographs of the solar spectra, exhibited by J. Norman Lockyer; large photographs of the sun, taken at Meudon Observatory; autotype enlargements of spectrum photographs, arranged according to Mendelejeff's system of the chemical properties of elements; and Common's famous photograph of the Nebula in Orion. Some of the astronomical images on display suggest a scientific amateur sensibility in the range of subjects and their composition. By all accounts, an extremely popular exhibit was the display of astronomer Warren De la Rue's photographs and photographic

processes. In 1852, De la Rue was among the first to make positive lunar photographs using collodion, and his works were widely sought after for the remainder of the century.

De la Rue frequently wrote about the relation between photography and drawing in astronomy, once declaring that a photographic picture of the moon was "more accurate" than a drawing. As he explained, a draughtsman could not draw the moon in a short time since "some portions of their pictures must be taken when the moon has turned itself a little out of its former position with regard to the earth."[7] Upon viewing De la Rue's large photograph of the moon hanging in the Royal Society, a visitor exclaimed that to see it was like traveling to the moon in person.[8] De la Rue's *Photographic News* account of his participation in the Himalayan expedition to Spain to photograph the solar eclipse in 1860 included detailed descriptions of the operations, exemplifying his commitment to sharing information among scientists.[9] In 1857, De la Rue tried to advance astronomical photography by resolving problems with the clockwork mechanism that was part of the telescope system. If a fixed telescope were used to photograph a star, because of the earth's rotation the star would course along the telescopic field in a line parallel to the earth's equator, resulting in an image of the star's path as a streak. Atmospheric disturbances caused the star to flicker, resulting in a path that was broken and distorted. These difficulties were resolved by mounting the telescope so as to follow the star's path and applying a smooth driving motion to the telescope. De la Rue's application of photography to lunar and other celestial phenomena eventually earned him a Royal Medal from the Royal Society in 1864.

De la Rue's commitment to improving photography for use in science endeared him to photographers, who often criticized scientists for using photographs for specialist investigations without either contributing in return or acknowledging the role of photographers in improving techniques. Astronomical photographs testified to the technical difficulties that needed to be overcome in creating such images. The difficulties of photographing comets were well known. The first photograph of Donati's comet, made in 1858, was so hard to obtain that one historian writes that only a "photographic man" could get it.[10] By the late 1880s, the photography of comets was becoming easier, but many problems remained.[11] As Jules Janssen declared in the *Annals of the Bureau of Longitude* in 1882, the photography of comets presented "difficulties scarcely conceivable to a person unfamiliar with these studies."[12] First, there was the problem of the "weak photographic power" of the tails, which emitted such pale light that it was difficult to capture them. Second, the comet's fast motion as it passed near the sun made it hard to register the impression of the comet's appendages, which were thin and faint. For these reasons, drawings of comets predominated well into the 1880s.[13]

Reinforcing the imperial theme, photographs displaying subjects of scientific interest also demonstrated the links that Richard Drayton has found in the appeal to science, imperial Britain, and the "improvement" of the world.[14] Photographs of Ceylon's vegetation were supplied by Kew director Joseph Hooker, a primary supporter of economic botany. Hooker also donated photographs of modern scientific sites, from the Naples Aquarium to the botanic gardens in the colonies. Anthropologists represented their work with "portraits of Natives" in Colorado by W. Blackmore; ethnographical photographs of Russians, Kalmucks, North American Indians, "Half-Breeds," and Central Africans, lent by the Anthropological Institute of London; and watercolor pictures of "mounted Arabs." The exhibition also included meteorological photographs made in places where British meteorological observers lived and traveled, from Iowa and Connecticut, to Paris, London, Brighton, Calcutta, and Natal. According to Ralph Abercromby, his forty-six photographs of clouds illustrated "very clearly the identity of cloud forms all over the world . . . from London to near Cape Horn—including one actually on the Equator; and the stratus from Sweden to New Zealand; while the mists in the Himalayas are indistinguishable in general character from those of Great Britain."[15] There were photographs of mud-springs in the Yellowstone region of the United States; Christian architecture in Ireland, exhibited by the Royal Geographic Society; diamond fields in South Africa, exhibited by Professor Tennant; Port Darwin and other sections of the country traversed by the Australian telegraph, lent by the Royal Geographic Society; scenes of China; Himalayan landscapes, exhibited by General Strachey, Fellow of the Royal Society; Chimborazo and other Andean scenes; and sketches illustrating an excavation in Troy.

Photographs from the HMS *Challenger* expedition displayed at the *conversazioni* illustrate especially well how the album format was used for official scientific documentation. The *Challenger* expedition from 1872 to 1876 was the largest government sponsored voyage for scientific purposes in the nineteenth century.[16] The scientific interests of the expeditionists ranged from landscape topography and astronomy to ethnology and economic botany. Although one of the trip's main purposes was to photograph the solar eclipse, amateur photographers on the expedition generally combined astronomical subjects with others of scientific interest. In Alfred Carpenter's album, for example, the solar eclipse photographs are pasted onto the same page as an ethnographic group portrait, in which a white British traveler sits among several indigenous inhabitants under a palm frond (Fig. 5.1).[17] The formal structure of this group portrait is similar to that of many other amateur photographs. It is an example of what Elizabeth Edwards calls a "photograph of encounter," in which the "natives" are shown in an organized group, usually wearing various exotic modes

FIG. 5.1. Scientist seated with local inhabitants during the *Challenger* voyage's Transit of Venus expedition, ca. 1872. Solar eclipse photos pasted below group portrait. HMS *Challenger* album, Ph 479; SH 369. The Picture Library, The Natural History Museum, London.

of attire. "Conventionally, in such photographs, the subjects are surrounded by British, or French, or German, or American sailors, or labour recruiters or curious tourists."[18] Also, they are framed by the technical mastery of the photographer. The formal arrangement and physical proximity of these photographs on the same page couches "native" people and physical phenomena as part of "Nature."

A reporter who attended the Royal Society's 1872 soiree especially praised "the magnificent series of photographs." Scientists regarded photography as essential for awakening the public's awareness of the utility of science, for publishing its results, and for binding a community around a positive image of science. But many practical photographers took a dimmer view of such exhibits. In "Photography at the Royal Society," a correspondent took members to task: "It is not often that photography occupies anything but a second place at the Royal Society, and our big-wigs are always quite ready to use it to help their investigations on other sciences; but they seldom bestow a thought upon making any improvements in photography itself . . . they are, as a rule, profoundly ignorant of anything about it, except the merely base mechanical part. What a godsend, these mechanical gelatine [*sic*] plates are to them!"[19]

Statements like this reflect an emerging divide between photographers and scientists by the end of the century, a division reflected in the pages of the *Photographic News,* which was increasingly devoted to topics of interest to commercial photographers. In general, the *Photographic News* over the course of the century demonstrates a decreasing focus on the wider social status of science and promotion of photography's specific value to scientists, as scientists working within institutions assumed the role of publicizing the scientific value of photographs.

A New Era in Astronomical Representation

It was partly to broaden its audience that the RAS established a Photographic Committee in April 1888. With new technical developments that made it easier to capture celestial phenomena seen through the telescope, the creation of astronomical photographs surged. The years 1851 to 1879, in particular, marked a boom in astronomical photography because wet collodion plates were in widespread use. Previously astronomers attempted to use daguerreotypes, which despite their slow exposure times, made remarkable astronomical photographs. A daguerreotype of the sun made by the French optician Noël Paymal Lerebours in 1842 is perhaps the first of its kind. In 1850, an excellent series of daguerreotypes of the moon at various phases was secured by W. C. Bond, the first director of the Harvard College Observatory in Cambridge, Massachusetts, and his assistant J. A. Whipple. These were the photographs that aroused the admiration of English scientists when they were exhibited at the Crystal Palace in 1851. As one viewer put it, Whipple's photographs represented "one of the most satisfactory attempts that has yet been made to realise, by a photographic process, the telescopic appearance of a heavenly body, and must be recognised as indicating the commencement of a new era in astronomical representation."[20] Encouraged by their success with daguerreotypes, Bond and Whipple also managed to take the first star photographs around 1850. Although the light of stars was so feeble that at first it seemed hopeless to record them by means of the daguerreotype, they eventually recorded stars on photographic plates.

The new wet collodion process, first proposed in France in 1851, was soon generally adopted by astronomers because of its greater speed and convenience for printing an unlimited number of enlarged positive copies on paper. The 1850s and 1860s witnessed rapid progress in solar photography, with systematic daily photographs of the sun supervised at Kew Observatory beginning in 1858, statistical studies made on solar activity and sunspots from these photographs beginning in 1865, the introduction of a photoheliograph at the Royal Greenwich Observatory in 1873 for making daily measurements of the sun and plotting variations in the latitudinal distribution of spots, observations of the

transit of Venus on the sun's disk in the mid-1870s, and images of the sun taken in the 1870s that showed its surface more sharply than ever. After the total eclipse of 1851, several partial eclipses were photographed around the world. Progress in lunar photography was also made, with De la Rue and other English astronomers securing good images with the wet collodion process. By 1873, Lewis Rutherfurd's famous lunar photograph from his book, *The Moon,* dazzled viewers, the picture of the moon bursting out, rotund, from the page (Fig. 5.2).

The main nuisance of the wet collodion process was that it had to be used immediately. If it was not, the excess silver nitrate crystallized in the collodion layer, and the plate lost its photographic properties. The invention in 1871 of the first positive dry emulsions for physical development, and in 1879 of the first machine for coating photographic plates with emulsion, made it easier to do astronomical photography and, significantly, to capture images with lower exposure times. With the new process, astronomers took the first successful series of photographs of nebulae and comets. David Gill's image of the Great Comet of 1882, taken at the Cape Observatory, attracted great scientific and public notice when it was announced (Fig. 5.3). Astronomers actively pursued stellar photography and made plans for a great Map of the Southern Heavens. With the aid of the spectroscope, they also applied photography to the spectral study of starlight, and they succeeded in recording the first photographic spectrum of the Orion nebula.

FIG. 5.2. Lunar photograph. From Lewis M. Rutherfurd and Richard A. Proctor, *The Moon* (Manchester: A. Brothers, 1873). Courtesy Special Collections and Archives, Wesleyan University. Photograph by John Wareham.

FIG. 5.3. David Gill, Photograph of the Great Comet of 1882, taken November 13 with a 6.3 cm. objective at the Cape Observatory. RAS Photos 2, no. C4/13. Reproduced courtesy of the Royal Astronomical Society Library.

Photographs of stellar spectra eventually led to the birth of astrophysics and quantum mechanics and were widely seen as a major application to science. William Huggins, in particular, received commendation for his star photographs. H. Baden Pritchard, author of numerous books on photography and photographers, wrote in *The Photographic Studios of Europe* (1882) that Huggins's negatives of the spectra of the stars were like "jewels" arranged in boxes. Each image was half an inch long and an eighth of an inch broad. In violet and lavender regions, the lines that were invisible to the eye could be photographed. According to Pritchard, Huggins's "little photographs" showed "at once" that there were "three distinct classes of stars."[21]

By the early 1880s, astronomical photographs were circulating among scientific friends and societies, and there was increasing pressure on scientific institutions to develop systematic methods of preserving and cataloguing them for posterity and study. The RAS began collecting and reproducing images for examination and sale around this time. Member Herbert Hall Turner declared: "This question has been raised before but no very serious practical outcome has resulted, owing chiefly to the fact that there have hitherto been so few photo-

graphs in the possession of the Society calling for reproduction."[22] After the committee formed, new questions arose about how photographs would be preserved and who would see them.

The first members of the RAS Photographic Committee were among the most prominent pioneers of astronomical photography: Andrew A. Common, William Abney, William Huggins, Edward Walter Maunder, Warren De la Rue, and Isaac Roberts.[23] Its purpose was to "undertake the charge of any astronomical photographs of value." As its members explained, the photographs presented to the society would be "duly acknowledged at the ordinary meetings of the Society from time to time." They then would become the "property" of the society, "to be used in any manner the Council think desirable." The photographs would then be made "available for examination." The committee urged that the rights to copyright should be included in the gift of the photograph, together with all data concerning the instrument, plate, exposure, and time.[24] Every care would be taken to protect the original negatives or prints from damage or loss. When possible, copies were to be made before the photographs were stored. That way, the copies rather than the original negatives or prints could be used for examination, thus minimizing damage to the originals.

The urge to build photograph collections reflected a growing sense among scientific institution builders in Britain that their disciplines were changing rapidly and that this transformation should be recorded. The RAS, which already had several photographs in its possession by the 1870s, resolved to fill gaps in its historical record by contacting individuals and societies to round out its collection. In the early 1890s, the Photographic Committee asked that "steps be taken to make known to the scientific world that the RAS is prepared to provide for the preservation of all such negatives." Members requested photographs covering all astronomical subjects, including spectra of celestial and terrestrial objects. The RAS contacted the Permanent Eclipse Committee and the Royal Society for photographs. Common, as secretary, wrote to the Royal Society in March 1890, asking for permission to photograph Sir Isaac Newton's telescope for a lecture and in January 1893 requested to copy any astronomical photographs that the society possessed. Recognizing their importance in the history of both astronomy and photography, George Tennant thought that Oxford might lend De la Rue's 1860s photographs of the solar eclipse to the RAS once "the Society is in a position to properly care for the originals." The committee also contacted the Royal Society for corona photographs taken at Novaya Zambya in 1896. The new committee hoped "that the Council shall use every endeavour to make this collection as complete as possible, especially in relation to Eclipse photography, and photographs of Comets, star clusters, and nebulae."[25]

Photographs given to the RAS were to be circulated and exchanged. Until

the society instituted a formal collection and catalogue during the 1880s, British astronomers often relied on an informal system of exchanging drawings and photographs to see what others were doing. The Royal Astronomer at Greenwich Observatory, Sir George Airy, first saw the prized star photograph made by Harvard astronomer George Bond during a visit by Maria Mitchell, America's first woman astronomer, who was touring European observatories and carried the photograph in her luggage.[26] For many years, the RAS had collected drawings made for astronomical purposes. Members of amateur organizations such as the British Astronomical Association and the Selenographical Club sent their drawings to Burlington House, site of the RAS. There, they were discussed and either incorporated in maps and charts of the planets, or discarded. Drawings of celestial objects would remain a vital part of astronomical activity, particularly among amateur planetary observers, throughout the nineteenth century and beyond.

The RAS therefore already had many excellent specimens to choose from when its members decided to build an institutional collection. David Gill and other committee members proposed that an adequate fireproof safe be provided for the preservation of new astronomical negatives. The committee requested that a cabinet, accessible to students, be provided to afford systematic storage of copies, thus making them available for discussion. The minutes stipulated that "the cabinet shall contain copies of all original negatives belonging to the Society, and, as far as possible, copies of all astronomical photographs of which the originals cannot be procured." A set of lantern slides was to be displayed in the library for inspection by the fellows. The committee recommended as complete a reference collection of astronomical and spectroscopic photographs as possible. Where practicable, they looked for original photographs, and in other cases "as accurate reproductions of the originals as may be procurable." It desired that the photographs in the reference collection "not be lent out so as to be at all times accessible there." Copies were to be loaned to any fellows who wanted them. Applications for loans of the photographs were to be made directly to the council and approved. By special permission of the council, however, copies in the form of direct prints, enlargements, or lantern slides could be supplied to fellows on the condition that they paid all expenses associated with reproduction. The copies thus supplied became the property of the fellows, the right of further reproduction being reserved by the society.[27]

Astronomer Sir W. H. Flowers complained of the "difficulty, if not impossibility, of classifying" astronomical photographs.[28] How should they be arranged? Astronomers then, as today, relied on an efficient system of registration to retrieve photographs for comparison and measurement. They also needed a reliable system for making photographs available for public circula-

tion. Committee members proposed classifying photographs in the same manner as library books. Eventually the committee adopted a systematic catalogue of all original negatives and copies belonging to the society, along with the names of their respective donors.[29]

Many in the RAS saw the sale of astronomical photographs as a means for their democratization. During this age when scientists frequently sought to distance themselves from commercial interests, it might be thought that scientists would eschew such association with the market. However, astronomers did not, at least when it came to photographs. Committee secretary Common proposed in 1892 that photographs be sold to the public "on terms that would leave the Society free from any commercial work." By April of that year, Common reported on the arrangements made with Messrs. Eyre and Spottiswoode to reproduce and sell the RAS's collection of astronomical photographs "to Fellows and the public at a fair price, in every case providing a duplicate copy for the Society free of cost."[30]

Sales of astronomical photographs increased over the next few years. Although the society received hundreds of photographs, the committee selected only a few for general reproduction. Regular articles in the *Monthly Notices* contained indices of photographs, with their subjects, makers, and dates.[31] By 1895, the list of twelve photographs available for purchase through the RAS included solar eclipse photographs by William Pickering; Nebulae in Pleiades and Great Nebula in Orion by Isaac Roberts; the Milky Way near Messier II and comets, by Edward Barnard; and a portion of the moon by Maurice Loewy and Pierre Henri Puiseux. These photographs, which through circulation became canonical images in the history of astronomy, occupied a status equivalent to that of those published in atlases, and, indeed, their very inclusion on the society's official list served as a form of publication.

By September 1892, shortly after the initial contact with Eyre and Spottiswoode, a large number of copies had already been sold. William Wesley, secretary of the RAS, reported that he had sold eighty prints and eighteen lantern slides, realizing six pounds, eighteen pence, which he considered "satisfactory" sales, taking into account the relative newness of the endeavor and a lack of publicity. In June 1898, the stock included 110 unmounted prints, 362 mounted prints, 198 slides, 24 eclipse positives, and 63 working negatives. By 1900, the number had grown to 179 unmounted and 291 mounted prints, 194 slides, 14 eclipse transparencies, and 78 working negatives. The committee wished for all mounts to be the same size to promote uniformity. When a reproduction was made for a negative instead of a positive, an intermediate positive was made for the working negative, which added one-sixth to the cost for whole plates (less for half-plates). The working negatives were made in the camera and not by contact so

that moderate alterations of scale could be made without extra cost. All prints were made from the working negatives. The cost of printing the headline "RAS" and a description averaging about four lines on the mount of each photograph was about five pounds for an edition of fifty. Mounts were estimated at twelve by ten inches. Mounted photographs could be sold to fellows at one pound, six shillings each for the whole plate; one pound, three shillings each for a half plate, and one pound each for smaller sizes. Examples of photographs that had been made by Messrs. Hinton and Co. in accordance with the above estimates were submitted to the committee. The committee resolved to spend twenty pounds to reproduce about eighteen of the photographs in the possession of the society, one dozen prints being made from each. The photographs were sold to fellows and the public, as were lantern slides, at a cost to fellows of one shilling each. By the end of 1895, 546 prints and 378 lantern slides had been made, at a total cost of roughly forty-three pounds.[32]

The commercial exchange of astronomical photographs through the RAS suggests that even the oldest and most venerable disciplines were connected with the economic market. Astronomers approved the transactions, even when it meant that they had to pay for photographs that they otherwise could rely on colleagues to show them. In a letter to the RAS from Yerkes Observatory on October 14, 1903, the American astronomer George Ellery Hale wrote: "I heartily believe in the admirable plan of rendering the photographs in the collection of the Society accessible to all through the sale of slides and prints." Although the RAS proposed to sell astronomical photographs for less than at Yerkes, Hale thought it "most undesirable" for the RAS to raise the cost—even if it meant that RAS prices "will naturally decrease our sales, which must of necessity be made at a much higher figure."[33]

The RAS took steps to circulate their photographs more widely by encouraging reproduction in astronomical journals and exhibition at public displays and world's fairs. In 1894, H. H. Turner proposed that the society publish a series of volumes of photographs, similar to those published privately by Annie S. D. Russell and Isaac Roberts. Turner suggested that the price could be based on the expense of reproduction, with fellows being charged half-price. Ultimately, the committee proposed that twenty pounds be allotted for obtaining specimens of various processes for consideration for publication.[34]

The committee also encouraged loans to public exhibitions and other scientific institutions, including the Chatham School of Engineering, the Astronomical Society of Wales, and the Royal Photographic Society. In 1893, Common arranged for a representative collection of British astronomical photographs to be sent to the Chicago World's Fair. The committee granted the re-

quest of the Imperial Institute in 1895 for photographs for a summer exhibition, and on Dec. 10, 1897, Lord Crawford secured a loan of astronomical photographs for a forthcoming international exhibition at Crystal Palace.[35]

Among the institutions that benefited from such loans was England's premier scientific organization, the Royal Society. As the study of photographic collections and archives suggests, scientists depended on commercial, visual forms of exhibition even in the 1880s and 1890s. Although one of the purposes of this study has been to show that institutions played a large role in establishing the scientific authority of photography, it is vital to recognize that this authority was challenged. To get a fuller picture of how scientific photography emerged from wider politics within the field of science, it is vital to look beyond the specific local disciplinary concerns that shaped scientific photography and venture out into the messy world of skeptics and unbelievers, the spaces of display outside the Royal Society, and the pages of the illustrated press and tabloids.

"Doubt-Killing Bullets from the Planet of War"

Within the history of science, scholars often turn to controversial episodes to better understand the process by which scientists make sense of their observations. This approach attempts to show that controversy is a normal part of the process of new discovery and is helpful in demonstrating how knowledge is negotiated.[36] This interpretive focus is useful for the study of visual representations in science for many of the same reasons that it has been useful for scholars in the history and sociology of scientific knowledge. First, it throws into relief the tacit understandings that underpinned scientific practice, which referred not only to activities related to the making of photographs but, equally, to their interpretation. Second, and more importantly, it provides a window on how scientific authority is constructed and on the spectacle of scientists in conflict with each other and with lay persons.

The making of the first successful photographs of Mars by Percival Lowell, a U.S. amateur astronomer, in 1905, offers a remarkable example of an international controversy over a photograph made for scientific purposes.[37] The controversy reveals diverging opinions about the relation of theories to photographic evidence and shows how people from different scientific and other cultural backgrounds brought outside interests or commitments to their interpretations of the historic photographs. This discussion locates the first Martian photographs in the longer historical tradition of scientific photography, including the stress on public display of techniques and images associated with science, and the tensions among amateurs and professional experts.

The British public became excited about photographic evidence of the sur-

face features of Mars because of a wider interest in the possibility of life on other planets. In 1877, Italian astronomer Giovanni Schiaparelli fueled the scientific and popular imagination after he observed a geometric system of tiny "canals" on Mars through his telescope at the Brera Observatory in Milan.[38] Soon, the question of whether or not intelligent life existed on Mars was among the most hotly debated controversies of the day.[39]

The theory of extraterrestrial life on Mars had powerful critics. Among them was Edward Walter Maunder, one of the most respected Victorian astronomers in Britain. Born in London in the same year that the Great Exhibition opened, 1851, Maunder worked briefly in a London bank before accepting the post of photographic and spectroscopic assistant in the Royal Observatory at Greenwich in 1873. This was the first post of its kind and represented a shift in the observatory's focus from positional astronomy to a commitment to astrophysical observations. Maunder worked at Greenwich for the next forty years, along with his wife, Annie S. D. Russell, earner of the highest mathematical honor then available to women at the University of Cambridge. Together, they made daily photographs of the sun for the purpose of tabulating various sunspot features, such as number, area, changes, position, and motion. From these data they drew conclusions about the position of the solar axis of rotation, the correlation between solar rotation and terrestrial magnetic disturbances, and the variation in time of the mean spotted area of the sun.[40]

As a member of an official British party to observe solar eclipses outside England, Maunder traveled to the West Indies in 1886 and to Mauritius in 1901, to photograph the corona. In India in 1898, he and Russell made separate observations. With instruments of her own devising, Russell photographed a coronal streamer extending to six solar radii, the longest ever photographed.[41] The results of their observations over several decades were communicated to the *Monthly Notices of the Royal Astronomical Society* and the *Journal of the British Astronomical Association*. Furthermore, *Nature* and *Knowledge* contained frequent articles by Maunder on popular astronomy and the history of astronomy, notably astronomy in the Bible. After his election to the RAS in 1875, Maunder took an active part in its affairs. Throughout his professional career, however, Maunder attempted to democratize the field of astronomy. Recognizing that the society did not satisfy the needs of many British astronomers, including those who could not afford to join, amateurs who found some of the papers too technical, and women (such as his wife) who were excluded from being fellows, Maunder helped found the British Astronomical Association (BAA). The purpose of the organization was "to afford a means of direction and organization in the work of observation to amateur astronomers." Founded in

1890, this organization served as a central site for the collection of empirical data from amateur astronomers throughout Europe and the British Empire, and it remains a vital organization today.

Maunder's criticism of the theory of life on Mars was especially influential because of his leadership of the British amateur astronomical community, the group most responsible for the collection of planetary data. Amateurs had the leisure, the right telescopic equipment, and the drawing skills to specialize in drawing specific planets night after night. For years, amateur observers sent their drawings of Mars to professional astronomers and other amateurs for evaluation and comparison. These comparisons were displayed and used as tools for training future individual observers. From 1890 to 1893, Maunder served as the first director of the Mars section of the BAA, and he served at various times as director of the solar section and the colored star section. Although he avoided religious arguments in public attacks, he questioned the "pluralist" position from a Christian viewpoint. Maunder was the son of a Wesleyan minister and an active member of a small Pentecostal church in London.[42] In a series of articles on Mars published in the *Sunday Magazine* in the early 1880s, Maunder professed that "it was no mere lucky chance" that had made the planet Earth so conducive to human life, while other planets possessed "no such fitness." He reluctantly used the term *canal,* stating that he employed it "in a purely technical and not in a geographical sense," and that " 'canals' in the sense of artificial productions [do not exist and it] is difficult indeed to understand how so preposterous an idea obtained currency."[43] He described the discordance between observers' drawings of Mars as their "artistic personal equation," referring to the technical term, *personal equation,* that astronomers used to denote differences in the reaction times of observers who recorded the transit of stars across a telescopic meridian.[44]

Another critic of the theory of Martian life was Nathaniel Green. Born in Bristol in 1823 and a resident of St. John's Wood in London for most of his life, Green was a noted landscape painter, art instructor, and active member of Britain's amateur astronomical community. After completing art training, Green frequently exhibited his oils and watercolors at the Royal Academy and other galleries, and he painted in Ireland and Scotland, contributing illustrations to Queen Victoria's *More Leaves from the Journal of Life in the Highlands from 1862 to 1882* (1884). However, the pressing economic and social demands of a large and growing family—he and his wife Elizabeth Goold eventually had five daughters and four sons—led him to adopt teaching as a profession. He was extremely successful and acquired a great reputation as a drawing instructor, numbering among his pupils the queen and her daughters. His many works

on art, principally drawing manuals, had a wide circulation, including *Hints of Sketching from Nature* (1871), *Foliage Exercises for the Brush* (1888), and *A Guide to Landscape Figure Drawing* (1891).

Planetary astronomers, like meteorological observers, were trained in sketching physical landscapes showing clouds and weather patterns. As a landscape painter, Green was richly qualified to contribute to Victorian astronomy, particularly planetary drawing. Around 1859, he constructed a telescope in his garden observatory and began a long series of observations and drawings. Elected to the RAS in 1875, Green was one of England's most active amateur astronomers. He contributed papers on lunar formations, accompanied by drawings, to the society's *Monthly Notices* and its *Memoirs,* as well as to the *Journal of the Selenographical Society.* His beautiful drawings of Saturn, Mars, and Jupiter survive today in the RAS. He was "the best kind of amateur observer," a peer said, possessing "great skill in drawing" and "always ready to put his experience at the disposal of other observers."[45] Contemporaries described him as an art teacher who taught students by day and worked with the telescope long into the night, often stopping only for a light meal.

After the founding of the BAA, Green served as president from 1897 to 1898. Members combined telescopic observation with the skills of amateur landscape painting. Their main difference from other amateur landscape artists was that they painted planetary, rather than terrestrial, scenery, but many of the skills of observation, trained perception, and drawing were the same. Green played a major role in teaching amateur observers how to draw planets. Green, whose own landscape paintings were characterized as "lacking in detail," cautioned the need for precise observation and cautious laying down of lines on the page. The figures show a typical format of Green's studies of Mars: pencil sketches of individual observations used in compiling synoptic observation charts (Fig. 5.4).

In 1882, Green addressed the RAS, expressing concern about a recent London *Times* article suggesting the possible significance of the Martian "canals" for the theory of extraterrestrial life. Green warned other astronomers that lending scientific credibility to such interpretations of the "canals" as irrigation works was irresponsible. "I do not wish to introduce any thing like a joke upon such a very serious matter but I am persuaded that those [canal] appearances require great caution, that is, we should not recognize them as facts until others have seen repetitions of the same phenomena." Such markings might really exist, but astronomers ought to "be very careful how we adopt them as permanent things on the planet."[46] Green's own map of Mars, made in 1877, showed softly shaded landmasses and water bodies, not hard, dark "canals." After looking at Schiaparelli's 1877 maps of Mars, Green concluded that although there

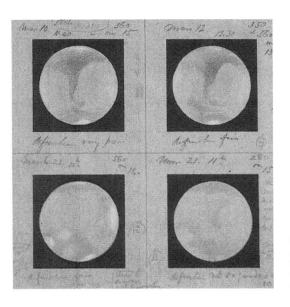

seemed to some basis for the canals, they were either features that had appeared after Green had stopped observing or, more probably, "unnatural" configurations resulting from either poor seeing conditions or drawing techniques. Where Green himself had seen and drawn "faint and diffused tones" on Mars, he stated, Schiaparelli had drawn "hard abominations." Later, he suggested that Schiaparelli's geometrical canals were an optical illusion caused by atmospheric vibrations that made a series of points in a line appear to be connected.[47] Like Symons with "thunderbolt" lightning, he thought "hard" canals had become something of a cliché that persisted through poor observational techniques and lazy drawing habits. If "any one put down on paper what he thought he saw [on Mars] and kept on putting it down," Green stated, that observer "would get a pretty fair network after a bit."[48]

The idea that intelligent life existed on Mars seemed no more remote to many people than that intelligent life flourished in other parts of the world. In an 1882 letter to the London *Times*, the astronomer and science popularizer Richard A. Proctor suggested that the canals were evidence that Martians were building "large engineering works."[49] At a time of discussion about canal building in the British Empire (for example, the Suez canal), it was no great leap for many people to conceive of a race of civilized Martians similarly advancing themselves by extensive canal networks. Many influential scientists believed that the Martian geology and climate were similar to those of southern England, strengthening suppositions that the planet could support life. As one contemporary declared, "A mind of no mean order would seem to have presided over the system we see—a mind certainly of considerably more comprehensiveness

than that which presides over the various departments of our own public works."[50] A Frenchman proposed that Martians might have been alerted to the presence of humans by the spectacular electrical illumination at the 1889 Universal Exposition, an event that organizers had conceived, after all, as a function to unify scattered nations and their populations. In 1891, Camille Flammarion further stimulated international interest in Mars when he announced that a woman had bequeathed 100,000 francs to the Institute of France to be awarded to the first person of any nation who found the means to communicate with extraterrestrial life. The following year, the London *Times* published a letter from leading scientist Francis Galton, the founder of eugenics, proposing that a combination of mirrors be constructed on earth to reflect sunlight back to Mars and thus alert Martians at their "telescopes." Roughly a week later, the *Pall Mall Gazette* recommended signaling Martians by dimming the lights of London.[51] From the 1870s through the early 1910s and beyond, artists tried to imagine what the Martians might look like (Figs. 5.5–5.6).

Percival Lowell's interest was piqued during the early 1880s after reading reports from Italy about the discovery of canals on Mars. Born in 1855 to the noted Boston family, Lowell originally pursued astronomy as a hobby. After graduating from Harvard and working in business, he served as a foreign secretary and counselor for a special Korean diplomatic mission to the United States in 1883. For the next several years, he traveled widely in the East and wrote several articles and books on Japan and Korea, including *The Soul of the Far East* (1888),

FIG. 5.5. Martians depicted as early Vikings observing Earth. The "Martian" scientific illustrator, seated behind the telescope, is shown drawing the planet Earth as he faces away from it, while the astronomer at the telescope communicates his observation telepathically. This scene expresses in pictorial terms the widespread spiritualist leanings of many Mars enthusiasts, both in England and on the continent. From Wilfred de Fonvielle, "A La Surface De Mars," *Journal des Voyages* (Feb. 17, 1901). Press clippings. Lowell Observatory Archives, Flagstaff, Arizona.

FIG. 5.6. Martians, detail from a newspaper illustration, ca. 1905. Using the familiar visual model of evolutionary development, this artist drew different "types" of Martians ascending a telescope. Note the scientists viewing the Martians through the eyepiece are older men with glasses, beards, white hair, and laboratory coats. One lies back in his chair, the standard way to view Mars through the Lowell telescope, but rendered so that it almost looks like he's on the psychiatric couch. Press Clippings Collection, Percival Lowell Collection, Lowell Observatory Archives, Flagstaff, Arizona.

Chosen: The Land of the Morning Calm. A Sketch of Korea (1885), *Noto: An Unexplored Corner of Japan* (1891), and *Occult Japan: The Way of the Gods* (1895). In *The Soul of the Far East,* Lowell expressed special interest in Eastern knowledge and religion. Reflecting the dominant view among Anglo-American scientists that Western science was superior, he stated: "To the whole Far Eastern world science is a stranger."[52]

Determined to help resolve the mystery of Mars, Lowell moved to Arizona, and in 1894, on a mountaintop above Flagstaff, he built a private observatory where Mars could be studied around the clock. Today, it remains the largest private astronomical observatory in the nation, and its library conserves the materials (press clippings, letters, photographs, and drawings) that document one of the most intriguing episodes in astronomy's history. Unlike Schiaparelli and others, however, who imagined a socialist Mars, Lowell, the aristocratic Bostonian with Social Darwinist leanings, presented Mars as a benevolent oligarchy in which "the fittest only have survived."[53]

With his move to Flagstaff, Lowell joined an international group of amateur observers who focused on the planets. Astronomy illustrates the wider ten-

sions developing among amateurs and professionals at this time. The international development of astronomical photography depended on private, amateur money. The development of science generally in England was made possible by private initiatives, from the founding of the Cavendish Laboratory at Cambridge, to the private funding of geoscience and eugenics laboratories, observatories, and universities by Lowell, Rockefeller, Carnegie, and others. Amateur observers with access to private telescopes and leisure were a dominant, active force in the field of planetary observation, as they still are today. For example, although he received only an elementary education, the English amateur astronomer Isaac Roberts achieved international recognition for his famous photographic discovery of the Great Andromeda Nebula, M31, in the late 1880s (Fig. 5.7). The Andromeda Nebula was one of the largest and brightest diffuse objects in the sky, yet its disc had a surface brightness too faint to show much visual detail. Roberts made the famous Andromeda photograph with a twenty-inch reflector, mounted on his property at Maghull, near Liverpool, on October 10, 1887. It disclosed the "true character of the Great nebula, and one of the features exhibited was that the dark bands, referred to by [George P.] Bond, formed parts of divisions between symmetrical rings of nebulous matter sur-

FIG. 5.7. Isaac Roberts, M31, Great Nebula in Andromeda. Photograph taken at Maghull, October 1888. RAS MS Roberts. Reproduced courtesy of the Royal Astronomical Society.

rounding the large diffuse center of the nebula."[54] The reference was to an 1847 drawing by Bond, made with the fifteen-inch Harvard refractor, showing two dark streaks. Roberts's photograph revealed them to be the lanes between spiral arms.

Although amateurs were valued within the astronomical community, however, they often had to work hard to earn the recognition of professionals. For ten years, Lowell and his staff turned the telescopes almost exclusively toward Mars in search of signs of the canals. Lowell thought the apparent canal network provided the best evidence that Martians were intelligent. In scientific papers that he wrote around this time, Lowell surmised that Mars was generally flat, cool, and surrounded by a thin, clear atmosphere, with at least some water on its surface arising from the seasonal melting of polar caps, which he believed were made of frozen water. Because it was dry, he believed that a system of irrigation was "an absolute necessity" for life on Mars. Unlike Schiaperelli, however, Lowell thought the markings that astronomers saw were not the actual canals, but rather, oases of fertilized land that bordered the canals.[55]

In June 1903, Maunder countered Lowell's claims with an experiment that he said proved the canals were an optical illusion. He seated a group of Greenwich schoolboys—none of whom had previously seen a map of Mars—at different distances from a chart of Mars from which all the "canals" had been expunged. They nevertheless drew a network of lines across the planet. From this experimental data, he concluded that the apparent lines on Mars were "simply the integration by the eye of minute details too small to be separately and distinctly defined."[56] Asked to debate Maunder in the *Illustrated London News,* Lowell refused, saying he would not directly enter the public debate in Britain because he had neither "the time . . . [nor] the desire to enter into any such controversy." Maunder's experiments were inconsequential, Lowell argued. He contended that they merely showed "that under certain conditions which are not those of the observations similar phenomena might be otherwise produced." Experimental physiology, he stated, bore "no relation to the 'canal' controversy" because it did not refute the possibility that some observers, at least, saw "real" canals. Besides, he argued, English astronomers would naturally be skeptical of his findings because the observations at Flagstaff were of "a much greater definiteness than is supposed in England."[57]

To reinforce his view that the canals were real, Lowell increasingly emphasized the urgency of securing photographs of them. Photographs had always seemed to Lowell a necessary form of proof of the canals' existence. "How gets on the photography . . . of Mars for the next opposition?" he wrote to his assistant, Carl Lampland, in May 1904. "We *must* secure some canals to confound the skeptics."[58]

It was difficult to obtain good photographs for several reasons. First, Mars was an especially difficult planet to observe. Because it is aligned on one side of the sun, astronomers can see it only during favorable oppositions, which take place on average every two years, with the best oppositions taking place every fifteen years. On these rare occasions, disparities of location, telescope size, magnifying powers, weather, acuity, and skill affect the quality of the observations. Second, it was harder to photograph Mars than other planets. The planet's reddish color made it necessary to give it a longer exposure than for either Venus or Jupiter. However, with longer exposures, the telescopic image traveled to amplitudes exceeding one second of arc, or about one-twentieth the diameter of Mars, and the turbulence of the earth's atmosphere kept the image in virtually constant motion.

Whereas the eye could follow this movement, the photographic plate, which required some time to make a record, could not. The photographic process integrated these images and resulted in a blurring of detail. If astronomers arranged the telescope and the camera to record an unmagnified—and therefore unblurred—image of Mars, however, the result was an image that measured only half of one-tenth of an inch in diameter, making it difficult to see physical details. While astronomers could obtain a bigger image on the plate through a different set-up, doing so reduced the optical contrast between dark and light parts of the planet. Astronomers needed this contrast in order to detect thin surface markings. Finally, when the skies were clear and Mars was in opposition to Earth, astronomers needed to be equipped and ready to photograph it. Holding equipment in readiness was difficult to manage at most observatories, where the large telescopes were occupied with different types of observations.

Until the difficulty of capturing a directly enlarged image of Mars in the telescope was overcome, the American astronomer Edward Barnard predicted, "nothing can be expected from photographs of Mars."[59] The photography of Mars initially stood out as one of the most distressing failures of nineteenth-century scientific photography. In 1879, Benjamin Gould of the Cordoba Observatory in Argentina attempted a photograph of Mars but, even with the new dry-plate process, was only able to show a few details. The Harvard astronomer William Pickering obtained a picture of Mars in 1892 that was hailed as a photographic achievement because it showed an increase in the size and brightness of a polar cap. However, it failed to keep Barnard from declaring in 1895 that "so far as Mars . . . is concerned," photography had done "essentially nothing . . . The best pictures of it are unrecognizable blotches on which none of the familiar markings so easily seen in the telescope can be made out."[60]

Indeed, the problems associated with Martian photography continued well

into the twentieth century. In light of the failures, Barnard complained, it was important to "correct misleading" statements in the American press to the effect that "'some valuable photographs of the planet Mars'" had been made at Lick Observatory. The journal had reproduced "two pictures of Mars—but not actually photographs of Mars, but photographic copies of drawings."[61]

To take the first photographs of Mars to receive global scientific and public acclaim, observers had to reach a compromise involving the aperture of their telescope, the required exposure time, and the grain of the plate. The historic Mars photographs were taken by Lampland at Lowell Observatory in May 1905 (Fig. 5.8). He first inserted a secondary lens tube inside the main tube of Lowell's twenty-four-inch refracting telescope, thus extending its normal focal length to 143 feet and gaining greater resolution.[62] Second, he made a two-way

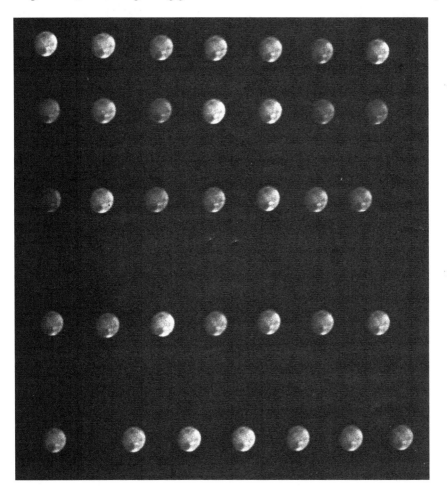

FIG. 5.8. Carl Lampland and Percival Lowell, historic photographs of Mars, 1905. Lowell Observatory Archives, Flagstaff, Arizona.

sliding plate-holder. By moving the plate at right angles up and down and from left to right, this mechanism allowed the observer to record twenty or more consecutive planetary images as fast as he could turn the ratchet and squeeze the shutter bulb. This mechanism permitted him to take advantage of moments of good seeing to record planetary images. Finally, Lampland introduced yellow orthochromatic plates to absorb the reddish light from the planet. Even with yellow-sensitive plates, however, it remained necessary to give Mars longer exposures than were necessary for photographing Venus and Jupiter. Longer exposure times, the unsteadiness of the atmosphere, and planetary rotation still introduced errors.

Photographs of Mars previously had been so poor that even Maunder described Lowell's photographs as a technical success. That Maunder described the photographs as successful does not necessarily mean that he thought they proved the existence of canals—simply that he appreciated them as technical feats at a time when Lowell's contemporary, Barnard, called photographs of Mars "unrecognizable blotches." There is no evidence that Maunder ever changed his negative opinion of canals.[63]

In Britain, Lowell received a medal from the Royal Photographic Society and recognition from the Royal Society.[64] Lowell's claim that his photographs showed thirty-eight canals, including a double canal, created an international sensation. As with the other photographs that have been discussed, public interest was not only in the epistemology of the phenomena (in this case, the "canals") but also on the issue of photographic knowledge, or what one could know with mechanically produced images.

International scientific and popular commentary on the new images expressed tensions within contemporary understandings of photographic evidence. Lowell echoed his scientific and juridical colleagues, stating that the proof was in the pictures: "The proof indeed is of the same kind and of the same strength as might convict a criminal accused of murder in cases where there had been no actual witness of the deed."[65] Lowell later wrote that "to make the canals of Mars write their own record on a photographic plate, so that astronomers might have at first hand objective proof of their reality" had long been one of the observatory's aims. Such proof might be "unnecessary" to expert observers, he stated (a bit disingenuously, in light of the great controversy over "canals") but for the "world at large," photographs of Mars offered "essential evidence."[66]

Lowell swore that the award-winning photographs of Mars were nothing less than "doubt-killing bullets from the planet of war."[67] He admitted that his theory might seem incredible to many people but professed that this strangeness arose from what he saw as the instinctive reluctance of humans to admit

the possibility of a superior race. "Quite possibly such Martian folk are possessed of inventions of which we have not yet dreamed, and with them electrophones and kinetoscopes are things of a bygone past," he declared.[68]

Lowell hoped to widen the number of witnesses to the photographs by publishing in the RAS's *Monthly Notices.* London was a world capital of science and astronomy, and Lowell needed scientists there to accredit his findings in order for his results to be incorporated into the existing maps of Mars, and for his photographs to be admired at a Royal Society *conversazione.* In 1905, Lowell sailed to London to display the original photographs of Mars at the RAS and the BAA. Many there were favorably impressed.

Because the pictures of Mars on the plate are so small and hard to see, it might be difficult to imagine how they could have proved the existence of the canals. However, many British astronomers and other natural scientists testified that the photographs indeed showed the "canals." In October 1905, A. C. D. Crommelin, BAA president, announced that having seen "the pick" of Lowell's prints, he had strong faith in the "objective reality of the canals which I had previously looked on as probable but not quite certain." Lord Rayleigh, the Hon. Robert J. Strutt, reported that Lowell had refuted E. W. Maunder's illusion theory, thanks to the compelling evidence of the photographs. "For [Lowell] gives photographs of Mars which exhibit the lines not, indeed, so well as his drawings, but still unmistakably." Norman Lockyer, then acting editor of *Nature,* opened the pages of that prestigious scientific journal to defenses of Lowell's interpretation of the photographs and other theories of organic and intelligent life on Mars. After seeing the original photographs, William Wesley, the assistant secretary of the RAS and a highly regarded figure in the field of astronomical photography, declared that Lowell was justified in his claim that the photographs showed some of the so-called canals. In fact, he declared, "these photographs go far to remove the skepticism I have always felt in regard to these features."[69]

Unfortunately, however, the images of Mars were so small and grainy that they did not reproduce well. The problems of reproducing scientific images accurately in print was, of course, a longstanding problem. Schiaparelli, for example, blamed engravers for the darkness of the canal lines that appeared in reproductions of his maps, once declaring: "I cannot find artists who reproduce them well."[70] Lowell complained of the opposite problem; the canal lines in his photographs came out too light. Magnifying enlarged prints from large-grain plates also, as Lowell said, made the plate grain "disturbingly prominent."[71]

In light of these difficulties, some British astronomers even accepted Lowell's invitation to visit him in Arizona to see the canals firsthand through the observatory telescope. Lowell's invitation appeared in a letter read to the BAA, reprinted in the *Observatory* magazine in 1904.[72] In August 1904, the Savilian

Professor of Astronomy at Oxford, Herbert Hall Turner, a member of the BAA, visited Lowell Observatory during a family trip to California. Turner, who later gave Lowell his support, agreed that "canals" existed and that they proved the habitation of Mars. "It is difficult for us in England to recognize what men will do to get water," Turner stated. In promoting his theory of Martian canals, Lowell faced some of the same rhetorical dilemmas as boosters of the southwest who turned to East coast–based papers in an effort to convince prospective settlers that intelligent life and culture could flourish in an arid environment that many thought was inhospitable to civilization.[73] Turner, having been to the arid state of Arizona, suggested that if skeptics in the wetter climate of the British Isles allowed themselves to imagine desert conditions, they might understand the "naturalness of Prof. Lowell's suggestion . . . Here in England we have plenty [of water], but when one goes to such a part of the world as that where Prof. Lowell has his Observatory, or to California, and has the experience of being without water longer than usual, it can be realized what people will do to get it."[74]

A major source of support for Lowell came from William Wesley, the secretary of the RAS and the person most responsible for producing the society's *Monthly Notices*. Wesley was an engraver rather than an astronomer, and he used his artistic skills to extract details from photographs.[75] In 1871 Wesley made a detailed composite drawing of a solar eclipse from photographs and drawings submitted by several other astronomers (Fig. 5.9). Finding that Lowell's photographs of Mars "could not be satisfactorily reproduced from the prints by any photomechanical process," Wesley therefore made an interpretation of Lowell's photograph with a drawing that showed "all the details that I can make out with certainty on *any* of the six pictures."[76] Wesley also retouched the photographs for publication in the *Monthly Notices* and included reproductions of Lowell's own drawings of Mars. Victorian scientific protocol allowed retouching under certain conditions, such as the failure to reproduce accurately, and it was a common practice for Wesley to retouch astronomical photographs before their reproduction in the *Monthly Notices*.[77] Lowell was quoted, saying "The photographs show that, within the limits imposed by the silver grain of the plates, the canals are lines, narrow and direct, following either arcs of great circles or curving (like the Djihoun) in a systematic manner."[78] Lowell explained that the general "scanner" of his photographs must bear in mind that magnification would not necessarily reveal the canals more clearly. Already the telescopic images had been magnified slightly for the benefit of "those of less penetrating sight."[79]

Even the original photographs did not convince everyone that the canals were real. Among RAS members, even those who supported Lowell's claims expressed some unease about whether or not the lines were, as he claimed, really continuous or simply "photographed imperfectly" as straight lines. "Doubt-

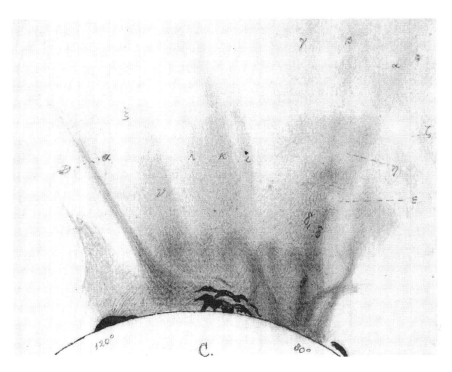

FIG. 5.9. William H. Wesley, solar eclipse, December 12, 1871. Detailed drawing from photographs and drawings by other astronomers. RAS ADD MS 203/7/C. Courtesy of the Royal Astronomical Society Library.

less a photograph has no imagination," one of Lowell's strongest apologists, Wesley, acknowledged, "but imperfect definition applies equally to photographic and visual observations."[80] Turner, who as we have seen was among a handful of British astronomers to whom Lowell had sent experimental Mars photographs (and who had visited Lowell Observatory in 1904), declared that he found it "extremely difficult to say exactly what is on these prints." Friends to whom he had shown them "differ a good deal in their interpretations."[81] One astronomer who viewed Lowell's photographs at the RAS in 1910 noted that the London reception of the Mars pictures resembled a controversy going on at the same time at the National Gallery over the exhibition and authenticity of a painting attributed to the Spanish painter Velázquez. This comparison underscored the crisis of expertise that Lowell's claims provoked among British astronomers and the uncertain representational status of his photographs of Mars.[82]

In light of the controversy, a number of scientific publications about Lowell's photographs also included drawings, many of them made by Lowell. As had been the case with bacteriology, astronomers relied on drawings to paraphrase the meaning of photographs. A 1906 article published in *Knowledge and Scientific News*, titled "Photographs of the Canals on Mars," showed how Low-

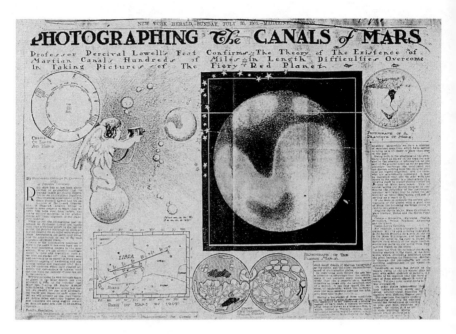

FIG. 5.10. Angel cherub as photographer. That the "photograph" is actually a drawing attracted scientific criticism. "Photographing the Canals of Mars," *New York Herald* (July 30, 1905). Press Clippings Collection, Lowell Observatory Archives, Flagstaff, Arizona.

ell used drawings to explain how he thought the surface appearances of Mars as shown on the photograph would look if it were enlarged.[83] Lowell stated that he made the drawings independently of the photographs, at "about the regions and the times at which the photographs were made."[84] Perhaps because photographs and drawings were used relationally so often, there was some confusion about what Lowell's photographs actually looked like. Several British astronomers filed complaints about newspapers that had passed off drawings of Mars as photographs (Fig. 5.10); the BAA criticized the London *Sphere* for doing this, for example.[85] That drawings of Mars could be passed off as photographs reinforces that knowledge of photographic aesthetic, or how scientific photographs looked, was not universally shared, even in an age that boasted of the mass culture of science.

Exhibiting Mars Photographs

The popularity of international industrial and science exhibitions, and new economies and techniques for reproducing scientific images in mass-circulation newspapers and magazines gave Lowell a wide stage on which to popularize his photographs and the Lowell Observatory's mission. To overcome the problems of fidelity raised by mass print reproductions, Lowell arranged to show prints

from his original negatives at public exhibits. Lowell hoped that they could be shown at places such as the Natural History Museum of New York, "where those interested can scan [the originals] for themselves."[86] In 1906, Lowell arranged for a small part of the public to inspect Lampland's photographs firsthand in Boston at the Massachusetts Institute of Technology. Over the next ten years, exhibition became a major priority. As Lowell explained in 1909: "I have concluded that it is well to have the visual representation of our work. . . more known to the world . . . [George Ellery] Hale [of Pasadena, California, who observed Mars in 1909 with the Mt. Wilson 60–inch reflector] totes his [observations] around and makes an impression."[87] Again, by taking his photographs to the public, Lowell was following a path established not just by entertainment entrepreneurs, such as P. T. Barnum and others. Well-regarded natural scientists also sought to press their claims, including popularizers of science like Robert Chambers, who in the 1840s took his case for evolution to the public. Partly for this reason, the U.S. press closely identified Lowell with the discovery, sometimes appearing more interested in him than in the canals. Readers of the December 1906 *New York Herald* article on the photographs of Mars, for example, found the first figure to be a portrait not of the canals but of Lowell (Fig. 5.11).[88]

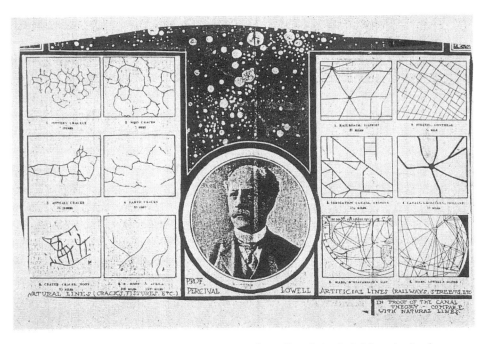

FIG. 5.11. Prof. Percival Lowell, with illustrations contrasting "natural" cracks (geological formations) and "artificial" cracks (railroad tracks and canals). "Will the New Year Solve the Riddle of Mars?" *New York Herald* (Dec. 30, 1906). Press Clippings Collection, Lowell Observatory Archives, Flagstaff, Arizona.

Lowell's appeal to the public for witnesses came at a time when it seemed that everyone had their eyes on Mars. When the editors of New York City's *Wall Street Journal* surveyed its readers in 1907 and asked them—"What has been in your opinion the most extraordinary event of the twelve months?"—they found that it was "not the financial panic which is occupying our minds" but rather "the proof afforded by astronomical observations . . . that conscious, intelligent life exists upon the planet Mars."[89] After the original photographs were made in 1905, displays in exhibitions, newspapers, and magazines constructed new viewing publics for astronomy and astronomers. In Britain, papers and journals carrying news about Lowell targeted a vast cross-section of audiences, from tabloid readers to the conservative readership of the *Standard* to middle-class enthusiasts of science who read *Knowledge* and *Nature,* to literary publics of the *Nineteenth Century* and the *Pall Mall Gazette.* Lowell corresponded with numerous London editors, including C. Watney, foreign editor of the *Daily Mail,* B. B. Powell, editor of *Knowledge,* and the science writer Hector Macpherson Jr. Lowell preserved his correspondence with these editors in bulging scrapbooks at the Lowell Observatory, reflecting his sense of the need to preserve a history of the debate that included views favorable to him.

Many in the media were eager to pay for pictures of Mars. English and American newspapers flooded Lowell with requests for "exclusive magazine publication of the photographs."[90] In 1907, *Century* paid Lowell 500 dollars for the reproduction rights to the first photographs of the "canals" on Mars made in South America.[91] As had been the case with Mumler's spirit photographs forty years before, the British press scrambled for pictures to reproduce for domestic readerships. Watney cabled Lowell to ask whether he would be willing to supply "exclusive news of what you discover in your further investigations," as well as permission to publish some of his photographs.[92] In light of the interest in his photographs, it is remarkable that many articles about Lowell published in Britain either were not illustrated at all or were illustrated with drawings based on an artist's interpretation of images. This was a combined result of the copyright fee that Lowell often demanded and the expense and poor quality of the reproductions. He loaned transparencies freely to scientific societies, but—as we will see—he used copyright law to exert control in the media over his photographs, which he regarded as his intellectual property. The anxiety over the issue of copyright points to a deeper cultural rift between knowledge and profit that has long roots in the history of scientific knowledge, as Pamela Long has shown.[93] Watney seems to have changed his mind about publishing the photographs after he discovered what Lowell charged.[94]

As mentioned earlier, many in Britain were eager to see the originals, but they were difficult to find outside the astronomical societies. One journalist

who used his personal connections with Lowell to secure drawings and photographs was Hector Macpherson Jr., a science writer for the *Scottish Review and Christian Leader*. Macpherson was a great advocate of Lowell, who thought that British astronomers were not giving him a fair hearing: "Mr. Lowell's theory has not been cordially received by men of science, particularly by some of the conservative scientists of England, who have sought every means of escape from the theory and have heaped ridicule upon it."[95] In a letter to Lowell, Macpherson asked to reproduce one of his photographs, explaining that "it is very difficult in this country to get anything new in the line of illustrations." At the same time, he appeared apologetic, saying that Lowell's was "the only theory" and hardly "needs defense nowadays."[96] In 1905, Macpherson printed a defense of Lowell in which he included a photograph of one of his drawings of Mars as well as two photographs of "canals" on Mars made by Lampland, enlarged three times (Fig. 5.12).[97] The lines on the photographs were retouched by an artist and stand out with startling clarity.

The power of drawings in an age obsessed with photographic proof is a notable feature of illustrated press coverage of science and is a crucial point to note

FIG. 5.12. "Photograph of a drawing made by Percival Lowell, May 11, 1905." In Hector Macpherson Jr., "Mars and its Canals: Is Mars Inhabited? The Question Examined in Light of Mr. Lowell's Recent Photographs of the Martian Canals," *Scottish Review and Christian Leader* (Nov. 23, 1905), 464. The caption states that the photograph by Lampland has been enlarged three times. Press clippings, Lowell Observatory Archives, Flagstaff, Arizona.

about Mars illustrations. Photographs alone were not always powerful enough to stand as convincing proof of the existence of canals, despite the powerful claim that photographs were evidentiary. Drawings often were used as auxiliary tools to supplement the truth claims made about photographs, as shown by the drawings used to interpret Lowell's photographs.

To compound the problem of their visibility, photographs of the canals were "not generally publishable," as Lowell lamented to the managing editor of the *New York Times* in November 1905.[98] To the great Boston naturalist George Russell Agassiz, Lowell complained bitterly that reproducing photographs of Mars caused a "great loss of detail."[99] Elsewhere he remarked that in publishing the photographs in magazines, it was clear "how much has inevitably been lost in these steps made in order that they might be presented to the general reader at all."[100] "The photographs are so small and the shadings on them so delicate," Garrett P. Serviss, the American science writer for the Hearst newspaper dynasty, explained to Lowell, "that it would be impossible to reproduce them in a newspaper." When Serviss inspected direct prints from some of Lampland's plates, he confirmed the "general resemblance to the drawings" made by Lowell, but he also professed to see only "mere suggestions" of canals.[101] To readers, Lowell explained, "In scrutinizing these views, one should remember two things: first, that what he sees on the printed page is three removes from the original picture." Intermediary steps included a print made from the negative, a photograph of the print (used to make the half-tone plates), and the impression on the magazine sheet. "A careful examination" would show that "discontinuities in the canals" were "due to the grain [of the photographic plate . . . not to the marking itself."[102]

Lowell again approached Wesley to retouch his photographs for publication in London's *Daily Mail*. As he explained in a July 1907 letter, "For them to do this in a manner that would bear reproduction the prints or rather the plates of the process would have to be retouched—halftone or otherwise. . . There is no one who could supervise this with so thorough a technical knowledge in this branch of astronomy as you and I write to ask if you would mind doing me the kindness," he concluded, enclosing a few prints to show what "the photographs are like." In the same connection, he also approached Agassiz: "They would have to be retouched under direction, as Wesley was kind enough to do for the Royal Society paper two years ago, and that direction cannot come from me as it would vitiate the very proof that they convey . . . It must be done by some one who is not me and yet knows. You are the best man to do it, if you will. Will you?" Agassiz consented, with the stricture that the public understood that "the results are not direct reproductions from the negatives."[103]

Ultimately, it was the associate editor of *Century*, not the secretary of the

RAS, who refused to allow retouching. The editor assured Lowell that it would "certainly spoil the autographic value of the photographs themselves." Besides, "there would always be somebody to say that the results were from the brain of the retoucher."[104] As discussed earlier, although news photography began as early as the 1840s, it was not until the halftone plate was invented in the 1880s that illustrated newspapers became feasible.[105] In the competitive world of sensational journalism, editors were motivated principally by financial pressures, therefore they wanted to produce a story before they were "scooped" by rivals. "There is no time to retouch the photographic plates," the editor wrote.[106] He listed time as his first priority; loss of "autographic" value was second.

Thus refused, Lowell sent Earl C. Slipher, the expedition's photographer, to New York with the photographs and firm instructions to supervise the work of reproducing them in mass print. "My purpose in having you go with the negatives and prints is that you may explain their fine points to them and keep a supervision over them in their workshops."[107] One of the reproductions that originally appeared in *Century* showed how Lowell mixed drawings with photographs in promoting his interpretation of the canals. The top figure shows a plate of images of Mars made in the Solis Lacus region on the right, and on the left, enlargements and a drawing by Lowell to emphasize the canals. The lower figure is of one photographic image enlarged to various diameters, rendered, as the author states, "to show successive loss of detail to the point of virtual disappearance, due to the enlargement of the emulsion grains."[108]

Lowell's recourse to the illustrated popular press to promulgate his views was completely within scientific protocols. However, many astronomers resented the public attention that he received. A British astronomer who praised Lowell's dedication to amateur observation nevertheless protested the American's "attempts to popularize Astronomy" by holding out the hope of a solution to the question of extraterrestrial life—a problem "dear to the public mind," but "not likely to be realized." Another faulted Lowell for communicating the results of "one or a few nights' observations" in "free" and "popular" language to the public press. More than one astronomer complained that by stating facts about Mars with the same certainty as explorers brought news from Central Africa, Lowell detracted from the valuable but "less sensational" labors of ordinary observers.[109]

Maunder's criticism of Lowell's use of the press might seem ironic, considering his own commitment to amateur astronomy and the popularization of science. However, Maunder and others maintained that the canal phenomena were too speculative to present to the public as convincing proof. Maunder blamed the press and its "sensational writing" for elevating a "sensational idea" to national attention.[110] It was one thing when amateurs participated in proj-

ects directed by central leaders, like Maunder, and quite another when, as with Lowell, they went public with their controversial viewpoints and evidence, seeking approval and validation from lay audiences.

Lowell's reaching out to the reading public won him many supporters, however. Among those whom he managed to convince was H. G. Wells, the influential socialist, science critic, and essayist whose "War of the Worlds" was serialized in *Pearson's* around the same time as "The Army of the Interior." In 1908, Wells contributed to the U.S. magazine *Cosmopolitan* an essay, "The Things That Live on Mars," in which he presented evidence supporting the theory of life on Mars. Wells praised the work of "my friend, Mr. Percival Lowell" to whose publications, "and especially his *Mars and Its Canals,* I am greatly indebted . . . This book contains a full statement of the case, and a very convincing case it is, not only for the belief that Mars is habitable, but that it is inhabited by creatures of sufficient energy and engineering science to make canals beside which our greatest human achievements pale into insignificance."[111]

The drawings of Martians that accompanied Wells's article in *Cosmopolitan* were made by the American magazine artist William Leigh, best known today for his later paintings of western America and native people of the southwest.[112] At the time he made these illustrations, Leigh was an artist in New York who did contract work for *Scribner's* and other magazines. As a child, Leigh avidly read illustrated natural history books and learned to draw by sketching animals around his home in rural Virginia. Leigh, who typically resisted oversight of his drawings by writers, worked closely with Wells in conceptualizing and designing the Martians. The images register current scientific descriptions of the probable appearance of Martian flora and animals, the unlikelihood of fishlike creatures on Mars, the climatic conditions, ruling inhabitants, civilization, and ways in which Martians might resemble humans.

In an earlier article published in *Nature* in 1894, Wells had enjoined science popularizers against flights of imagination. Now he urged them not to adopt "any artistic ideal that comes into our heads and call it a Martian." Wells, who had trained in biology and evolutionary ecology, was more sympathetic than many scientists to the idea of making knowledge public, yet he urged journalists to stick to scientific "facts." He thought that an artist would be unjustified, for example, in "drawing grass and wheat, oaks and elms and roses" in a Martian landscape. "Certain facts about Mars we definitely know, and we are not entitled to imagine any Martians that are not in accordance with these facts." He declared that the "probable appearance" of the Martian flora and fauna was slender, finer, and taller because the gravity was less. Because the atmosphere contained less moisture and the shape of leaves was determined by rainfall, he reasoned that the Martian tree-leaf would be spiky, more like a pine-

needle. The "typical Martian plant" would be "tall and have its bunches and clusters of spiky bluish green leaves upon uplifting reedy stalks." Still, he thought that there was "plenty of justification if an artist were to draw a sort of butterfly or moth fluttering about, or antlike creatures scampering up and down the stems of a Martian jungle." For the same reason that the fauna were tall and slender, he thought that the Martians would be tall and slender creatures. They would leap and fly to get food among the branches of the tall trees and wade to gather vegetation from the canals in spring. Because they would have to be adapted to great changes of temperature, they were likely to be covered with feathers or fur.[113]

The graphics associated with the vivid textual descriptions bolstered the connection with scientific modernity. The illustrations of Mars demonstrate the artist's sophisticated and innovative use of line and space, associated with new graphic design concepts in the early 1900s, and the nod to modern symbols big and small, from the iconography of world's fairs, monuments, and exhibitions to the fashionable dress and headband of the "flapper" Martian girl (Fig. 5.13).

Fantastical though they appear at first, illustrations like these were part of a developing visual genre of scientific realism, created to be read neither as car-

FIG. 5.13. William R. Leigh, "There are Certain Features in Which They are Likely to Resemble Us." Illustration for H. G. Wells, "The Things That Live on Mars," *Cosmopolitan* (March 1908), 335–342.

toons nor as examples of fine art but as visual summations of scientific knowledge. Wells reminded readers that Lowell had not described the form or appearance of these creatures. Lowell merely had stated that Martians should be mentally superior to humans because it seemed to be an old planet, therefore "evolution on its surface must be similarly advanced."[114] Physically, Martians were, in his view, capable of expending more energy than humans on engineering projects like canals because scientists concurred that the surface gravity of Mars was only 0.38 that of Earth. Lowell portrayed Martians as possibly three times the size of humans. "Party politics" was nowhere in evidence, for the system was "planet-wide."[115]

Wells, however, thought that Martians were "part of the natural history of Mars in just the same way that man is but a part of the natural history of the earth . . . They must have been evolved from other related types, and so we must necessarily give our attention to the general flora and fauna of this world we are invading in imagination before we can hope to deal at all reasonably with the ruling species."[116] His article makes plain how photographs and drawings reinforced each other. Photographs did not merely function in a separate visual universe, in other words, but rather worked in tandem as persuasive rhetorical graphic devices. The article drew on Lowell's theories, which, Wells noted, were in turn based on photographic interpretation.

Wells's was only one of many theories of what Mars looked like, proving that photographs sparked the production of a host of other visual images that reinforced the notion that the planet was inhabited. Significantly, through images like these, the reading public also learned that scientists disagreed. To those scientists in England who worked hard to promote an image of science as open to disagreement, fraternal, and public-minded, some of the sympathetic reactions to Lowell's discovery must have been sharply disappointing. In the novel *To Mars Via the Moon: An Astronomical Society* (1910), amateur astronomer and BAA member Mark Wicks defended Lowell, saying he was a martyr of scientists' dogmatism.[117] In his fictional account of a scientific expedition to Mars, Wicks blasted the hypocrisy of a scientific community that trumpeted the objectivity of photographs but rejected individual images that contradicted their own theories. Wicks's effort to convince the British public of the plausibility of Lowell's claims must have succeeded at least in part, for in a review that Wicks sent to Lowell, the London *Daily Graphic* remarked that "this is not the fantastical story that the story seems to indicate, but is rather a brightly and popularly written manual of instruction in elementary astronomy."[118]

In the story, the group of astronomers, which Wicks based on the BAA, highlights the professional/amateur dichotomy in British astronomy. The protagonist, an amateur named Claxton, points out

that we owe a large proportion of our knowledge of planetary detail to the work of enthusiastic amateur observers . . . In this Society, indeed, nearly all the best observational work was done by the non-professional class; and when, as the result of their systematic and painstaking work, they noted on their planetary drawings some lines or markings which had not previously been recorded, one would have thought their original work would have been commended . . . It was, however, not unusual in such cases for a professional to rise and calmly declare that the new markings were only illusions, such as he had often predicted would be claimed as discoveries . . . [Thus] the amateurs were kept in their proper places; but the professionals did not always prove to be correct in their strictures and pronouncements.

One traveler to Mars describes his reception at a meeting of the "Dedlington Astronomical Society" (a none too subtle reference to the BAA). "I showed two persons whom I thought would be open to conviction some photographic views in their natural colours, which I had brought home with me . . . One of them looked at the pictures, then handed them to his friend, with the remark: 'Clever fakes, aren't they? You can do almost anything with the camera nowadays!'"[119]

The debate over Lowell's photographs continues today, though most agree that his photographs show atmospheric clouds, not canals. Scientists in the RAS who disagreed with Lowell did not necessarily have the final word. Crucially, Lowell and his supporters' position weakened when they failed to win BAA support, especially from the leaders of the Mars section, Maunder and Eugène Michael Antoniadi. Despite his longstanding advocacy of extraterrestrial life and his many canal sightings, Antoniadi eventually emerged as one of the most important opponents of the Mars of Schiaparelli and Lowell. After moving to Paris in 1893 and becoming associated with Camille Flammarion's observatory, he was named director of the BAA Mars section, an experience that led to the publication of his classic book *La planète Mars* (1930).[120]

As director, it was his task to prepare professional reports on each of the Mars oppositions. Yet Antoniadi, who in 1894 had seen forty-two canals and at least one double canal, by 1896 was expressing doubts after noting the differences among the reports he received. As Michael Crowe points out, possibly Maunder, then editor of the BAA *Journal* and *Memoirs*, suggested to Antoniadi that the canal views were better explained as illusions.[121] In 1898, Antoniadi published in the *Journal* his theory that the perception of "geminations" involved optical illusions arising from telescope focusing errors and illusions of the eye itself, or "diplopic oscillations arising from an intermittent and uneven action of the muscles of accommodation."[122] About 1903, he asked members to report on "streaks" rather than "canals." The official chart of Mars made in 1910, after Lowell's photographic discovery, shows shaded streaks, not "canals." The map was made from observations furnished by members of the

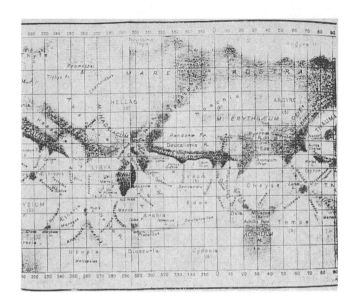

FIG. 5.14. Eugene Antoniadi, map of Mars, ca. 1910. *Memoirs of the BAA* 16–17 (1910– 1911): Appendix.

Mars section. The projection and grid are the same as in previous charts, but the canal lines are much more shaded and form a less distinct network (Fig. 5.14).

Photographs of "canals" on Mars might not appear in the gallery of great developments in astronomical photography, but they were central to public discussions of science and scientific practice, as well as to discussions about "scientific" versus "unscientific" ways of seeing and, therefore, of producing legitimate knowledge. Photographs that failed to convince scientists of the meanings their makers claimed for them can often tell us more about the dynamics of power in Victorian science and visual culture than those that received praise and scientific status. In this sense a consideration of drawings and "failed" photographs can enlarge our understanding of photographic evidence.

The discussion surrounding the reproduction and circulation of photographs of Mars illustrates important features of the visual culture of science of the time—characteristics that persist in new ways today. In her essay about family portraiture, Marianne Hirsch writes about how photographs function as memoirs that often present idealized mythologies of family life.[123] Similarly, commentary on scientific photography often presents an idealized view of the history of science and photography. As this study has suggested, photography became secure as a new form of evidence not simply because of advances in technology but as an outcome of the new hegemonies and institutions of professional science. Despite widespread acknowledgment of his and Lampland's photographs' technical excellence, for example, without support for Lowell's interpretation from leading astronomers, the images' credibility as evidence was weakened.

As in the cases we have considered, drawings frequently were designed to explain the meaning of photographs. The controversy over just what one saw when looking at a photograph of Mars recalls similar controversies over looking through microscopes. Photographs of Mars were supposed to make matters clear once and for all, but they did not—no more so than did photographs of bacteria or spirits. Nonphotographic visual devices, including diagrams and drawings, became important tools in conveying what interpreters of photographs claimed they saw.

Studying the reception of scientific photographs, not simply their production, shows how photographs were used to buttress as well as to challenge dominant images of science and scientific authority. By the end of the nineteenth century, if it was true that scientific photography had realized the widely shared dream that it would transform the sciences, it was also clear that new scientific institutions had altered photography in directions that people in its early years could hardly have imagined. Science and photography were fields of practice that were constantly tested. The history of photography's use and meaning as scientific evidence, from Talbot to photojournalism, shows how the parameters of science and visual culture were redefined in contexts of photographic viewing and display.

Epilogue: Enlarging the Concept of Photographic Evidence

It is more important than ever at this historical and political moment to consider the complex ways in which knowledge based on photographs is appropriated, resisted, and transformed by different groups. Visual arguments and evidence are central role to a range of policy and institutional activities today. More than a decade after the Rodney King trial in Southern California and in the wake of recent images of Mars and photographs from the "War on Terror," new attention is being paid in the United States and elsewhere to how visual images are used as testimony in contemporary law and society. Techniques of mechanical reproduction hold great attraction for those for whom the machine holds out the promise of images uncontaminated by interpretation. Nevertheless, as I have tried to show, despite its powerful image as a conveyor of unmediated truth, the very canon of scientific photography was the product of social efforts to establish through new theaters of persuasion what counted as objective and subjective, credible and ridiculous.

By 1914, as a result of some of the struggles described here, photography as a new visual language helped define the nineteenth century as an age of scientific discovery and invention. In Britain, the question of how to disseminate and police scientific practices and how to manufacture and interpret photographic images using scientific procedures involved deliberation on who made photographs, how, and for what purpose. As it does today, scientific photography generated great reflection on the meaning of scientific evidence and of what could count as knowledge. This fact compels us as historians to ask questions about excluded and included categories, as well as about how the practices of truth-telling in scientific photography related to other social processes, including science-in-the-making and gender-in-the-making. We must combine the study of the *idea* of mechanical objectivity in photography with studied analysis of the changing material and social processes through which people mobilized and used photographs as evidence in making claims about science and nature.

Studying the historical and disciplinary frameworks in which scientific photographs emerged as empirical proof yields a more complex understanding of the epistemologies associated with scientific photography than the "unshaking belief" theory of nineteenth-century photographic attitudes. Exposure of the historical and social roots of photographic criticism in the sciences lays bare some of the arguments for selectivity, judgment, skill, and aesthetics behind the Victorian claim that photography was a neutral mirror of reality. It then becomes possible to examine critically statements that scientific photographs are too difficult for lay people to interpret, or that their meanings are transparent and self-evident. Instead, we see that scientific photography, no less than other types of visual images, exhibited a multiplicity of meanings for different audiences in diverse viewing contexts.

Although it never achieved the scientific recognition that many Victorian scientists hoped it would, spirit photography continued well into the twentieth century. The photographs of supposedly real fairies that were taken in 1917 and 1920 by two young girls in the village of Cottingley and famously championed by Sherlock Holmes author Sir Arthur Conan Doyle, represent an ongoing cultural fascination with a veiled or secret world.[1] Interest in spirit photography in England was revived after World War I, when numerous pictures were made for mourners of war dead; there are more such photographs from this era housed today in the British Library and the collection of the Society for Psychical Research at the Cambridge University Library than for the earlier years covered by this book. There is currently a revival of interest in the history of spirit photography, propelled in part by the growing interest in the connections among photographic technology and religion, and in the role of women in photography and science.

Martyn Jolly's research on early twentieth-century spirit photography, moreover, reveals a significant social connection between W. T. Stead's work and spirit photography during the 1920s.[2] Ada Deane was a spiritualist medium whose husband left her and who brought up three children on her own by working as a servant. During the 1920s she became one of Britain's busiest photographic mediums, holding more than 2,000 sittings in North London, some of them with debunkers determined to discredit her. As Jolly points out, Deane's moment of "greatest notoriety" came in 1924 through her involvement with the eminent spiritualist Estelle Stead, W. T. Stead's daughter. After his death by drowning during the *Titanic* accident, Stead's spirit reappeared in London séances, even communicating the posthumous experiences of his fellow passengers through automatic writing to his daughter, who published them as *The Blue Island*. In 1924, the discarnate Stead was reportedly involved with the production of a spirit photograph of a crowd that gathered at the London

Cenotaph during the Two Minutes Silence on Armistice Day, in which a "river of faces" and an "aerial procession of men" appeared. The *New York Times* later described the picture: "Over the heads of the crowd in the picture floated countless heads of men with strained grim expressions . . . all that could be seen distinctly were the fixed, stern, look of men who might have been killed in battle."[3] The newspaper furor that ultimately resulted seemed to please the spirit of W. T. Stead, who communicated to his daughter, typically enough, that "We want to impress the Crowd . . . it is all important—that is what our work at the Cenotaph is for."

Meteorological photography retained its amateur field base well into the twentieth century. Some of the most remarkable photographic discoveries in meteorology since the photography of the lightning flash have been made in connection with the more specialized field of laboratory physics, reflecting a broader trend toward the artificial recreation of nature that began much earlier. They include the photographic discovery of droplets of condensation in large numbers in C. T. R. Wilson's cloud chamber at the Cavendish Laboratory in 1911; turning points in lightning spectroscopy in the 1960s that, among other things, revealed new information about the channel temperatures near peak luminosity; the first television images of the Earth's weather, a NASA photograph of Hurricane Esther, in 1960; and the first synoptic view of the world's meteorology on a single day in 1965. Today, global coverage of the world's weather now occurs on a routine basis, and synoptic images have come to be taken for granted on the nightly news.

The most spectacular innovation in the alteration of photomicrography after bacteria photography was the invention of electron microscopy in the 1930s. Viruses were to biologists as atoms were to physicists, entities that could not be seen on account of their small size until the earliest electron photomicrographs revealed their structure in the 1940s. Similarly, scientists had worked out in principle how DNA transmits genetic information in the early 1950s, but the process was not photographed until 1969 at the Oak Ridge National Laboratory in Tennessee. Electron-wave holography in the 1970s represented another extreme limit of resolving power and magnification unsurpassed in photographs from any other source.

As this book was being completed, cameras on board the latest generation of Mars orbiters beamed a continuous stream of fresh data to Earth, reviving interest in the old question of whether life exists on Mars. Astronomy, the earliest science to benefit from photography and the one that yielded the most results, remains one of the most exciting areas of scientific photography. What is especially remarkable about astronomy, along with other historical disciplines

such as geology and meteorology, is how photographs made over a hundred years ago retain their value as evidence for present-day astronomers. At the Royal Astronomical Society, for example, scientists, like historians, examine cracked Victorian lantern slides and historic photographic prints. For, as they did in Victorian England, astronomers still consult past images for the historical information they provide about the positions, classification, and formation of celestial objects, known and as yet undiscovered.

Photography continued to be used to make scientific discoveries in the twentieth century. Lowell Observatory was the site for the photographic discovery of Pluto, "Planet X," by Clyde W. Tombaugh in 1930. Ironically, images by Percival Lowell turned out to have recorded images of Pluto earlier but, repeating history, its point image was lost among the background stars, making it hard to see. At the White Sands Missile Range in New Mexico the first photograph of the sun at X-ray wavelengths was made in 1946, using V-2 rockets captured from Germany, and outstanding photographs of the sun were taken routinely by Skylab just thirteen years later. In 1959, the world glimpsed the far side of the moon, the first celestial body to reveal itself to reconnaissance space voyagers. The photographs relayed to earth from the Soviet Union's *Luna 3* mission originated on thirty-five-millimeter film exposed, developed, fixed, washed, and dried on board the satellite: a process reminiscent of early collodion photography in the field. In 1965, on *Mariner 4*, a photographic process that combined a telescope and vidicon tube with an orange filter produced images that astonished many scientific viewers, who previously had thought the surface of Mars resembled that of Earth. *Mariner*'s snapshots of Mars showed a heavily cratered surface far more like that of the moon. In 1972, *Mariner 9* and two *Viking* missions reopened the issue with the photographic discovery of channels on the Martian surface, suggesting the possibility that water once flowed freely there.

Over thirty years later, astrobiologists, geophysicists, and geologists are using an instrument imaging system on board *Odyssey* (Thermal Emission Imaging System, or THEMIS) that generates pictures of the surface of Mars in visible and infrared wavelengths. The THEMIS images are used to study the weather on Mars and to interpret signs of the presence of dirty snowpacks over a large fraction of the planet's surface. As in the earlier history of astronomical photography, a canon of images is already starting to emerge. As Phil Christensen, a geology professor at Arizona State University in Tempe who leads the team responsible for designing and building THEMIS, reported to *National Geographic* after becoming interested in a strange layer on some of the Martian slopes revealed by THEMIS pictures: "There was this one 'ah-ha' image: I

saw this pasted-on stuff with gullies in it. And that was it."[4] Subsequently his interpretation of the picture, that the "pasted-on stuff" was actually dirty snow, made it to the cover of the prestigious scientific journal *Nature.*

Scientific photographs continue to reach a variety of audiences and to mediate between scientific and popular culture. They include the first images of the mushroom cloud generated by nuclear testing in the Marshall Islands in 1952; the first endoscopic pictures of a living human embryo in 1965, later published in *Life Magazine;* and the hundreds of CAT scans and MRIs that visualize internal structures of the body and that occasionally appear in current news and popular psychology magazines in defense of arguments for biological bases for behavior. A particularly striking example from the twentieth century is NASA's 1965 color photograph of Earth, as viewed from a satellite. Interestingly, as Vicki Goldberg shows, the plan to get this famous photograph did not originate with NASA astronomers. Instead, it resulted from a campaign to get a picture of the "Whole Earth" by a man who was neither an astrophysicist nor an official of NASA.[5]

Stewart Brand, who had a vision of Earth from a low roof in San Francisco with the help of one hundred micrograms of LSD, suddenly realized that a color photograph of the planet from space would change the way everyone thought about it. The United States and the Soviet Union had been sending imaging hardware into space for ten years, but no one had ordered the cameras to look behind them. Brand made and distributed several hundred buttons and posters, including to NASA officials and congressional representatives, to generate publicity for his campaign. He later said, "I was tapping into a desire people know they had." Soon people were wearing his buttons. In 1967, *Lunar Orbiter 5* took a nearly full-disk image of Earth. Shown small and precious and relatively adrift in negative space, the planet as it appeared in the photograph appealed to the growing movement to unite people internationally and to protect the Earth's environment of interdependent parts. That November, as Goldberg shows, a writer for the *Saturday Review* suggested that the secretary-general of the United Nations deliver an annual State of Mankind address about issues confronting all nations, so that all might see "the planet as a whole, just as the astronauts see the unity of the globe when they fly around it."

Describing the impact of the photograph in the late 1960s, Fred Hoyle declared: "Has any new idea in fact been let loose? It certainly has. You will have noticed how quite suddenly everybody has become seriously concerned to protect the natural environment. Where has this idea come from? You could say from biologists, conservationists and ecologists. But they have been saying the same things as they're saying now for many years. Previously they never got on base. Something new has happened to create a worldwide awareness of our

planet as a unique and precious place."[6] That "something new," he suggested, was the first imagery of the apparent vulnerability and minuteness of Earth, a planet that people compared to a "fragile Christmas-tree ball" that had to be handled with considerable care.[7] The photograph eventually appeared in astronomy textbooks and on the front and back covers of *The Whole Earth Catalogue*.

Today, computer imaging is generating new questions about the historical underpinning of belief in photographs as neutral images of reality. It is widely commented that trust in photographs is on the decline in the wake of computer imaging, and that, in the future, photographs will seem less like facts and more like imaginative works of art.[8] Manipulations during processing, frame selection, cropping, dodging and burning, photomontage, and sandwiched negatives are used to create images that never took material form in front of the camera. Yet with digital imaging, as with Victorian scientific photography, it is vital to beg the question: *For whom* are photographs more or less truthful? For scientists? For consumers? What we are witnessing with the advent of digital imaging is analogous to photography: the cultural invention of a new medium of seeing, not simply the introduction of a new technology. We stand in an interesting moment as many people grapple with the question of photography's evidentiary forms, from archivists using digital processes to physically save photographs, to photojournalists who use digital techniques, to teenagers who use digital imaging to make movies. Perhaps, for example, a new generation of young people brought up on digital techniques of image production may think of photographs not as material objects but as images with a life independent of material culture. Here, too, perhaps there is a historical continuity, for with digital imaging, as with Victorian photography, there is a new awareness and understanding of how images are perceived.

The sophistication of modern photographic observers relative to the allegedly naïve early pioneers of Victorian photography must not be overstated, for, as this study has suggested, there was great awareness in the nineteenth century that issues of selectivity, aesthetics, and taste operated in relation even to scientific photography, which has been most strongly associated with the ideal of mechanical objectivity. My aim in this study has been to enlarge the concept of photographic evidence so that we might see the social processes and institutions involved in creating the genre of scientific photography. My approach has included the analysis of drawings as auxiliary tools for photographic interpretation; comparisons and contrasts among several local, disciplinary practices; examination of the reception of photographs by multiple viewing audiences, including those outside official scientific sectors; and consideration of the problem of photographic failures.

Enlarging the concept of photographic evidence, in turn, allows us to see

scientific photography from a fresh perspective, including how social structures allowed viewing to occur and arguments to happen, and how scientists and artists were active participants in the development of science and the exposure of nature. We see that drawings were central to the establishment of photography's authority as scientific evidence, and confront questions like those addressed in chapters 4 and 5, such as how far is it possible to paraphrase a photograph? Examining how scientists in different disciplines approached photography makes plain that scientific photography was not a monolithic category; it was a gradually evolving genre that meant different things to different people. Widening the field of vision to include the debates on scientific photography by multiple publics clarifies how many people were involved in developing the cultural meaning of photography as a new form of scientific evidence, whether or not they actually took pictures themselves. Finally, paying attention to photographic failures from the 1840s to the early 1900s reveals how a discourse of failures, perhaps even more than a discourse of photographic success, helped establish concepts of taste and science.

I have suggested that photographs of stars, lightning, bacteria, and even ghostly ancestors can reveal much about the history of science in general and the social structure of scientific authority in Victorian England in particular. To see how, we must see scientific photographs not simply as bearers of silent witness to mechanical objectivity, passive objects whose meanings are frozen in space and time, but as objects having social properties whose scientific meanings are made, as Elizabeth Edwards puts it, "through dynamic relations between photographs and culture that do not stop at the door of the archive."[9]

There are many dimensions of scientific photography. Cultural critic Walter Benjamin describes the ongoing process of calling an object into being through naming, which creates a role for objects with particular associations and preconceptions, a process akin to the creation of the categories of "women" and "men" in history.[10] Similarly, making photographs visible as works of research science required the evocation of human agency as part of the process. Whether practiced by amateurs or by commercial photographers who photographed objects in nature, or whether viewed and interpreted by scientific experts or lay spectators, the formal principles of the genre of scientific photography evolved in relation to political principles that governed the recognition of science in the first place. Who would gain control of the signifier of science through photography, however, was something that the photographic objects alone could not, and did not, settle.

Notes

Abbreviations

For full information on these repositories, please see the Essay on Sources.

BMNH British Museum of Natural History

CUL Cambridge University Library

IC Imperial College of Science, Technology, and Medicine

LOA Lowell Observatory Archives

RAS Royal Astronomical Society

RPS Royal Photographic Society

RS Royal Society

UM Ulster Museum

INTRODUCTION

1. John Tagg, *The Burden of Representation: Essays on Photographies and Histories* (Amherst: Univ. of Massachusetts Press, 1988).

2. Tagg, *Burden of Representation,* 4–5. In his response to the critic Roland Barthes, who wrote that "from a phenomenological viewpoint, in the Photograph, the power of authentication exceeds the power of representation," Tagg urges us not to look to some "magic" of the medium but "to the conscious and unconscious processes, the practices and institutions through which the photograph can incite a phantasy, take on meaning, and exercise an effect."

3. Martin Rudwick, "The Emergence of a Visual Language for Geological Science, 1760–1840," *History of Science* 14 (1976): 149–195.

4. Andy Grundberg, "Ask It No Questions: The Camera Can Lie," *New York Times* (Aug. 12, 1990), Arts and Leisure Section, 2.

5. William Ivins Jr., *Prints and Visual Communication* (1953; reprint, Cambridge: MIT Press, 1982), 94.

6. Lorraine Daston and Peter Galison, "The Image of Objectivity," *Representations* 40 (1992): 81–128; 83, 81.

7. Ian Jeffrey, who makes this point, also writes that pioneer photographers found themselves faced, from the outset, "by a serious problem—that of their medium's automatism." Ian Jeffrey, *Photography: A Concise History* (New York: Oxford Univ. Press, 1981), 10.

8. I thank Doug Nickel for pointing out this connection.

9. Elizabeth Edwards, *Raw Histories: Photographs, Anthropology and Museums* (Oxford: Berg, 2001); Deborah Poole, *Vision, Race and Modernity: A Visual Economy of the Andean Image World* (Princeton: Princeton Univ. Press, 1997); and James Ryan, *Picturing Empire: Photography and the Visualization of the British Empire* (Chicago: Univ. of Chicago Press, 1997).

10. Both astronomers had already been examining the potential of silver halides for astronomical purposes for many years. Arago recorded that earlier he had tried without success to obtain an image of the moon by projecting it onto a screen covered with a silver chloride deposit. Herschel had since 1835 been closely following Talbot's experiments in securing photocopies by direct darkening. This topic is discussed in Gérard De Vaucouleurs, *Astronomical Photography: From the Daguerreotype to the Electron Camera* (London: Faber and Faber, 1961), 14.

11. The *Photographic News* gave extensive coverage to photographic portraits that dissatisfied sitters. In 1866, English photographer Charles Knight, of Killigrew Street in Falmouth County, prosecuted a case against a sitter who failed to pay him for her portraits. However, when the sitter, Annie Trewartha, was called by the judge to testify in her defense, the young woman handed the portraits to the judge and asked, "Did your Honour ever see such frights?" After comparing the three cards with the woman's appearance, the judge eventually agreed that the photographs were neither "artistic nor flattering." In fact, he declared, they were "as rough a lot as possibly could be, surrounded with specks and stains" and a "shower of cinders." The discussion amused everyone except the photographer, and the judge determined that the sitter did not have to pay him. Photographers often responded by getting revenge on their patrons. In a German case, one photographer, stung by the attack on his reputation, put the photographs of two dissatisfied customers in his shop window, with a label identifying them as "highwaymen"—much to the chagrin of the customers and the amusement of London newspaper readers. See, e.g., Theodore Prumm, "Portraits and Likenesses," *Photographic News* (1872), 102–3. (Hereafter, citations of the *Photographic News* will be abbreviated as *PN*.)

12. Newspaper debates over science that involved photography or drawings included the Darwinian ape and other evolution arguments evoking public attention, outrage, and concern. They went as far back as the 1820s with Geoffroy St. Hilaire and Georges Cuvier and extended to the end of the nineteenth century.

13. This point is discussed in Edwards, *Raw Histories*, 131.

14. Steven Shapin and Simon Schaffer, *Leviathan and the Air-Pump: Hobbes, Boyle, and the Experimental Way of Life* (Princeton: Princeton Univ. Press, 1985), quotes on 36, 60, and 56. For more discussion, see 225–226.

15. Even astronomer Warren De la Rue's famous 1860 photographs of the solar eclipse were not as well known to the general reading public as the engravings based on his own magnificent, colorful drawings. This was perhaps partly due to the difficulty of producing multiple prints. For the claim that everybody believed photographs by the end of the nineteenth century, see Ivins, *Prints and Visual Communication*. In making the case that photography, like other arts, must be studied and collected within research settings, Ivins wrote influentially that it had revolutionized society. He acutely recognized that photographic and print technologies were part of the modernization of epistemological belief systems, but, as I have argued, this process was fraught with complicated power relations.

16. "Photography as a Civilizer," *PN* (Mar. 8, 1861), 120.

17. Douglas R. Nickel, "Is Seeing Believing?" Mellon Symposium on Photography, Huntington Library and Art Collections, San Marino, California, May 31, 2003.

18. Edwards, *Raw Histories*, 34.

19. For an excellent introduction to the history of scientific photography that nevertheless focuses on "signature" images, see Jon Darius, *Beyond Vision* (Oxford: Oxford Univ. Press, 1984).

20. "Normal science" is defined and described in Thomas S. Kuhn, *The Structure of Scientific Revolutions,* 3d ed. (Chicago: Univ. of Chicago Press, 1996).

21. Gregg Mitmann, "Cinematic Nature: Hollywood Technology, Popular Culture, and the American Museum of Natural History," *Isis* 84 (1993): 637.

22. Lisa Cartwright, "A Cultural Anatomy of the Visible Human Project," in *The Visible Woman: Imaging Technologies, Gender, and Science,* ed. Paula A. Treichler, Lisa Cartwright, and Constance Penley (New York: New York Univ. Press, 1998), 21–43; Donna Haraway, *Primate Visions: Gender, Race, and Nature in the World of Modern Science* (New York: Routledge, 1989); Ludmilla Jordanova, *Sexual Visions: Images of Gender in Science and Medicine Between the Eighteenth and Twentieth Centuries* (Madison: Univ. of Wisconsin Press, 1989); Lynda Nead, *Victorian Babylon: People, Streets and Images in Nineteenth-Century London* (New Haven: Yale Univ. Press, 2000); Katharine Park, *Body and Culture: Early Anatomy in Comparative Perspective* (New Haven: Yale Univ. School of Medicine, 1995); Rosalind P. Petchesky, "Fetal Images: The Power of Visual Culture in the Politics of Reproduction," *Feminist Studies* (Summer 1987): 263–292; Lisa Tickner, *Spectacle of Women: Imagery of the Suffrage Campaign, 1907–1914* (Chicago: Univ. of Chicago Press, 1988), among many others.

23. Genre is defined here as a category of artistic composition in science characterized by a particular style, form, or content.

24. Berenice Abbott, *New Guide to Better Photography,* rev. ed. (New York: Crown Publishers, 1953), 1.

CHAPTER 1
Constructing Science and Brotherhood in Photographic Culture

1. Discussed in David H. Davison, *Impressions of an Irish Countess: The Photographs of Mary, Countess of Rosse, 1813–1885* (Dublin: Birr Scientific Heritage Foundation, 1989), 7.

2. Discussed in Ian Jeffrey, *Photography: A Concise History* (New York: Oxford Univ. Press, 1981), 12.

3. William Henry Fox Talbot, *The Pencil of Nature* (London: Longman, Brown, Green, and Longmans, 1844), text opposite plate 3, "Articles of China."

4. Jeffrey, *Photography,* 12–13.

5. Ibid., 20.

6. Talbot's friend William Whewell coined the term *scientist* around this time, *natural philosopher* being the common designation before. See Douglas R. Nickel, "Talbot's Natural Magic," *History of Photography* 26 (2002): 132–140; 139.

7. Ibid., 133.

8. William Henry Fox Talbot, "Some account of the art of photogenic drawing" (London: R. and J. E. Taylor, 1839), reproduced in *Photography: Essays and Images,* ed. Beaumont Newhall (New York: Museum of Modern Art, 1980), 25. Discussed in Nickel, "Talbot's Natural Magic," 133.

9. Nickel makes this point in "Talbot's Natural Magic," 133.

10. As Grace Seiberling notes, "The willingness to accept whatever prints a group of people selects implies both a sense of confidence in its collective taste and a lack of direction in

collecting." *Amateurs, Photography, and the Mid-Victorian Imagination* (Chicago: Univ. of Chicago Press, 1986), 13.

11. Discussed in "Popular Science," *PN* (Feb. 22, 1861), 96.

12. Quoted in Ann Thomas, ed. *Beauty of Another Order: Photography in Science* (New Haven: Yale Univ. Press, 1997), 44.

13. Carol Armstrong, *Scenes in a Library: Reading the Photograph in the Book, 1843– 1875* (Cambridge: MIT Press, 1998), 32.

14. Katharine Martinez and Kenneth L. Ames, eds. *The Material Culture of Gender, The Gender of Material Culture* (Winterthur, DE: Univ. Press of New England, 1997), 382.

15. The images described here are reproduced in Larry Schaaf, *Out of the Shadows: Herschel, Talbot and the Invention of Photography* (New Haven: Yale Univ. Press, 1992): ribbons, p. 105; lace, 100 times magnified in surface, photogenic drawing negative, p. 84; basket, salt print from a photogenic drawing negative (May 3, 1840), 102; cherub and urn, salt print from a photogenic drawing negative (Apr. 29, 1840), 98; garden implements, salt print from a photogenic drawing negative (ca. 1840), 99; Horatia's harp, salt print from a calotype negative (Oct. 6, 1840), 109; figurines, salt print from a calotype negative (ca. 1841), 118; ladder, salt print from a calotype negative (prior to Apr. 1845, from *The Pencil of Nature*), 146.

16. See Douglas R. Nickel, "Nature's Supernaturalism: William Henry Fox Talbot and Botanical Illustration," in *Intersections: Lithography, Photography, and the Traditions of Printmaking*, ed. Kathleen Stewart Howe (Albuquerque: Univ. of New Mexico Press, 1998), 17, 19.

17. For the context, see especially work by Amy R. Meyers, including *Mark Catesby's Natural History of America: The Watercolors from the Royal Library Windsor* (Houston: Museum of Fine Arts, 1997).

18. Nickel, "Nature's Supernaturalism," 20.

19. Seiberling, *Amateurs, Photography, and the Mid-Victorian Imagination*, 10.

20. "The Calotype Society," *Athenaeum* (Dec. 18, 1847), 1304.

21. A search for photographs displayed at the Great Exhibition failed to turn up any surviving images of how these were displayed.

22. Richard Altick, *The Shows of London* (Cambridge: Harvard Univ. Press, 1978), 3, 120.

23. Michel Foucault, *Discipline and Punish: The Birth of the Prison* (1975; reprint, Harmondsworth: Penguin Books, 1991); John Tagg, *The Burden of Representation*.

24. For a parallel development in microscopy around this time, see, e.g., William B. Carpenter, *The Microscope and its Revelations* (London: Churchill, 1856). Carpenter, a leading physician and naturalist, argued that the microscope was variously an instrument of scientific research, a means of gratifying curiosity, and a healthful recreation. He provided information about how to use the microscope and what objects to look at. Although he declared that the topics in his book were determined by special interest to the amateur microscopist—"not scientific importance"—he was at pains to demonstrate scientific seeing, saying that microscopical power was "running to waste" in England on desultory observation "of no service whatever to science," iv. (Later, Carpenter urged that photography was the "next best thing" to actual specimens. See letter from Carpenter to Prof. Sharpey, Mar. 21, 1867, MS8.28, IC. I thank Helen Rozwadowski for this reference).

25. Jennifer Tucker, "Voyages of Discovery on Oceans of Air: The Image of Science in an Age of 'Balloonacy,'" *Osiris* (1996): 144–176.

26. *Reports by the Juries: Exhibition of the Works of Industry of All Nations, 1851* (London: William Clowes and Sons, 1852), 275.

27. Ibid.

28. Seiberling, *Amateurs, Photography, and the Mid-Victorian Imagination*, 102.

29. Ibid., 9.

30. "The 'Quarterly Review' on Photography," *PN* (Oct. 28, 1864), 519–520.

31. Seiberling, *Amateurs, Photography, and the Mid-Victorian Imagination*, 10.

32. "Notice to Members: Exchange of Positive Pictures," *Journal of the Photographic Society* 1 (April 1, 1853), emphasis in the original.

33. Seiberling, *Amateurs, Photography, and the Mid-Victorian Imagination*, 62.

34. Ibid., 145. Rosling, a successful timber merchant in the Hackney area of London, began making his first photographs in the 1840s. By 1846, he was selling calotypes of inanimate objects for Wheatstone's stereoscope in Soho Square. Like many of his contemporaries, even a relatively affluent man such as Rosling was prevented by the expense of daguerreotypy from pursuing it, but after 1851, when the collodion process became available, he began making photographs with gusto.

35. Diary of Hugh Diamond, D19. No. 23107, RPS.

36. Seiberling, *Amateurs, Photography, and the Mid-Victorian Imagination*, 128–129. See Carolyn Bloor, *Hugh Welch Diamond: Doctor, Antiquary, Photographer* (Twickenham: Orleans House Gallery, 1980).

37. Barbara T. Gates, *Kindred Nature: Victorian and Edwardian Women Embrace the Living World* (Chicago: Univ. of Chicago Press, 1998); and Ann B. Shteir, *Cultivating Women, Cultivating Science: Flora's Daughters and Botany in England, 1760–1860* (Baltimore: Johns Hopkins Univ. Press, 1996).

38. Clarissa Campbell Orr, Introduction to Orr, ed., *Women in the Victorian Art World* (Manchester: Manchester Univ. Press, 1995), 13.

39. Glaisher's album is on deposit at the Linnean Society, London. On Glaisher's photographs, see Caroline Marten, "'Photographed from Nature by Mrs. Glaisher': The Fern Photographs by Cecilia Larisa Glaisher" (M.A. thesis, Oxford University, 2002).

40. Seiberling, *Amateurs, Photography, and the Mid-Victorian Imagination*, 135.

41. [Lady Elizabeth Eastlake], "Photography," *Quarterly Review* 101 (April 1857): 460.

42. There is a fascinating, original discussion of how these technical and aesthetic issues were intertwined in Seiberling, *Amateurs, Photography, and the Mid-Victorian Imagination*, 29–30.

43. See Mike Weaver, ed., *British Photography in the Nineteenth Century: The Fine Art Tradition* (Cambridge: Cambridge Univ. Press, 1989), 121–131, 151–161.

44. I thank Timothy Barringer for the reference.

45. Julian Treuherz, *Victorian Painting* (London: Thames and Hudson, 1993), 75–100.

46. For more on Ruskin and the visual economy of art, see Harriet Whelchel, ed., *John Ruskin and the Victorian Eye* (New York: Abrams, 1993).

47. A well-off mahogany broker based in the city, Shadbolt stopped photographing in 1864 when the growth of his business necessitated his retirement from photography, but he remained a member of the Royal Photographic Society until his death.

48. Shadbolt quoted in R. W. Buss, "On the Use of Photography to Artists," *Journal of the Photographic Society* 1 (March 3, 1853): 11. See esp. Michael Bartram, *The Pre-Raphaelite Camera: Aspects of Victorian Photography* (Boston: Little, Brown and Co., 1985), 58–60; and Seiberling, *Amateurs, Photography, and the Mid-Victorian Imagination*, 27–28.

49. Deborah Poole, in her study of vision, race, and modernity in the Andean world, uses the term "image world" to call to mind the "simultaneously material and social nature" of photographic representation. Quoted in *Vision, Race and Modernity: A Visual Economy of the Andean Image World* (Princeton: Princeton Univ. Press, 1997), 7.

50. The 1850s was the age for the increasing professionalization of scientific activities that formerly had been the exclusive province of the cultured person. See Seiberling, *Amateurs, Photography, and the Mid-Victorian Imagination,* 108.

51. Many amateur photographers, such as Francis Frith, lamented the dissolution of the tight-knit genteel community. Frith, best known for celebrated photographs he made in Egypt and who himself profited from the commercial expansion of photography, criticized the new class of commercial practitioners as lacking "common sense and decency." See Francis Frith, "The Art of Photography," *Art-Journal* (Mar. 5, 1859), 79. Discussed in Seiberling, *Amateurs, Photography, and the Mid-Victorian Imagination,* 91.

52. Seiberling, *Amateurs, Photography, and the Mid-Victorian Imagination,* 7.

53. Quoted in Asa Briggs, *Victorian Things* (Chicago: Univ. of Chicago Press, 1988), 130.

54. "Photography: Its Social and Economic Position," *PN* (Jan. 25, 1867), 43–44.

55. "A Photographers' Relief Fund," *PN* (Dec. 11, 1863), 589.

56. "Decline of Prices in Photography," *PN* (Aug. 30, 1867), 413–414.

57. As one contemporary explained: "It may be confidently asserted that photographic portraits can only be accurate when taken with lenses of long focus and of much larger diameter than the size of the proof is supposed generally to require . . . Thus it has happened that the *cartes de visite* portraits have been a kind of revelation, not only to the public, but also to a large number of operators, and their continued popularity may be well understood when their superior accuracy of likeness is taken into consideration." In "Photographic Portraiture; On Likeness in Photographic Portraits," *PN* (Oct. 18, 1861), 492–493.

58. M. A. Belloc, "The Future of Photography," *PN* (Sept. 17, 1858), 13–14.

59. "Photography and Bad Taste," *PN* (April 10, 1863), 174–175. Originally published in the London *Review.*

60. "The 'Quarterly Review' on Photography," *PN* (Oct. 28, 1864), 519.

61. "Photographic Art a Blessing to the World—*Cartes de Visite,*" *PN* (Sept. 12, 1862), 443. Originally published in *Scientific American.*

62. Calvin Thubber, "The Mission of Photography," *PN* (July 14, 1865), 330. Originally published in *American Journal of Photography.*

63. "The Art Claims of Photography," *PN* (Nov. 11, 1864), 549–550.

64. Many nineteenth-century technologies were associated with popular taste, such as photogravure, cheap printing of dime novels, soda water, eventually the bicycle and typewriter, the revolver, new window glass, slipware pottery, silver plate, and magnetic cures. Photography posed special problems, however, because many of its supporters wanted to see it harnessed to the fine arts.

65. Lynda Nead, *Victorian Babylon: People, Streets and Images in Nineteenth-Century London* (New Haven: Yale Univ. Press, 2000), 151.

66. "The Art Claims of Photography," *PN* (Nov. 11, 1864), 549–550.

67. F. R. Window, "Remarks Upon Some of the Apparatus Employed in Photography," *PN* (July 11, 1862), 326.

68. "Prosecutions of Photographers," *PN* (Oct. 21, 1870), 493–494.

69. Henry Mayhew, *London Labour and the London Poor* (1851–1852; reprint, London: Penguin, 1985), 335, 338.

70. "The 'Quarterly Review' on Photography," *PN* (Oct. 28, 1864), 519.

71. "The Photographic Nuisance," *PN* (Aug. 16, 1861), 383, 394.

72. Wrote one exasperated photographer to the *Daily Telegraph:* "When we find photography associated with the lowest ruffianism and blackguardism, and made the medium of imposture and extortion, we are apt to grow somewhat out of patience with the proprietors

of popular cameras and the manipulators of 'portraits for the million.'" "Photographic Dens and 'Doorsmen,'" *PN* (Aug. 16, 1861), 389.

73. Ibid.

74. See Naomi Rosenblum, *A History of Women Photographers* (New York: Abbeville Press, 1994), esp. 39–72.

75. "Photography and Bad Taste," *PN* (April 10, 1863), 174–175.

76. "Questionable Subjects For Photography," *PN* (Nov. 26, 1858), 135–136.

77. Quoted in Jeffrey, *Photography*, 21.

78. "Field Meetings of Photographic Societies," *PN* (Aug. 11, 1865), 383.

79. Jabez Hughes, "Photography Considered as a Profession," *PN* (July 27, 1866), 351–352.

80. "Education for Photographers," *PN* (Feb. 1, 1878), 54.

81. "Prices and Merit, The Rank of Photographers," *PN* (April 15, 1864), 190.

82. "Echoes of the Month," *PN* (April 5, 1867), 159–160.

83. Jack Morrell and Arnold Thackray, eds. *Gentlemen of Science: Early Correspondence of the British Association for the Advancement of Science* (London: Royal Historical Society, 1984). (Hereafter, this association will be abbreviated BAAS.)

84. "Popular Literature—the Periodical Press," *Blackwoods* (Feb. 1859), 181–184.

85. See William H. Brock, "A British Career in Chemistry: Sir William Crookes (1832–1919)," in *The Making of the Chemist: The Social History of Chemistry in Europe, 1789–1914,* ed. David Knight and Helge Kragh (Cambridge: Cambridge Univ. Press, 1998), 121–129.

86. Brock, "A British Career," 122.

87. Ibid., 123.

88. A letter from Crookes to John Herschel suggests that Crookes's departure from the editorship of *PN* was motivated at least in part by photographers who praised his abilities as a chemist but criticized his photographic abilities. See Crookes to Herschel, Feb. 9, 1860, Herschel Papers, HS. 5.313, RS.

89. Quoted in "Approaching Exhibitions," *PN* (Nov. 19, 1858).

90. "To Remove the Black Varnish from Glass Positives," *PN* (Oct. 1, 1858), 45.

91. *PN* (Nov. 26, 1858), 133–134.

92. "Correspondence," *PN* (Dec. 3, 1858), 153–154.

93. *PN* (Aug. 2, 1863); *PN* (May 13, 1860); *PN* (May 4, 1860); *PN* (Feb. 24, 1860); *PN* (Oct. 1, 1858).

94. "To Our Readers," *PN* (Aug. 24, 1860), 103–104.

95. "The Cost of a Patent," *PN* (Nov. 2, 1860), 313.

96. Ibid.; "Packing Photographs for Post," *PN* (April 5, 1867), 158–159.

97. Jabez Hughes, "Photography Considered as a Profession," *PN* (July 27, 1866), 351–352.

98. "Photographic Evidence," *PN* (July 25, 1873), 359–360.

99. "Assaults in Photographic Studios," *PN* (Sept. 25, 1863), 458.

100. "Preface," *PN* (Dec. 1860), iii. "To Our Readers," *PN* (Aug. 24, 1860), 103–104.

101. "Masks and Faces," *PN* (July 16, 1869), 340–41.

102. "A Photographer's Ramble Through the Academy Exhibition," *PN* (June 7, 1867), 268–269.

103. Lake Price, "On Composition and Chiar-oscuro," *PN* (Mar. 23, 1860), 367–368.

104. "The 'Times' on Photography," *PN* (Dec. 14, 1866), 589–591.

105. "Masks and Faces," *PN* (July 16, 1869), 340–341.

106. For the context, see Mary Cowling, *The Artist as Anthropologist: The Representation of Human Types in Victorian Art* (Cambridge: Cambridge Univ. Press, 1985).

107. R. Disderi, "The Aesthetics of Portraiture," *PN* (July 10, 1863), 330–332.

108. *PN* (Dec. 9, 1864).

109. "The Ethics and Etiquette of Scientific Discussion," *PN* (Mar. 22, 1861), 133.

110. "Questionable Subjects For Photography," *PN* (Nov. 26, 1858), 135–136.

111. Angus McLaren, *Trials of Masculinity: Policing Sexual Boundaries, 1870–1930* (Chicago: Univ. of Chicago, 1997).

112. John E. Cussan, "Photographs of Photographers," *PN* (Jan. 6, 1865), 6–7.

113. See, e.g., a letter to the editor of the *Daily Telegraph,* Sept. 18, 1863, advising ladies not to go alone to a photographic studio after the writer's young relative was sexually assaulted 'by a photographer in a studio in central London (reprinted in "Photographic Rooms," *PN* [Sept. 25, 1863], 458.) Photographers also were known to attack lady customers if they complained about their portraits. See "The Photographic Nuisance," *PN* (Aug. 16, 1861), 363, 394. See also Edwards, *Raw Histories,* 154, n.28, for concerns raised about scientific photography in relation to obscenity laws. Many photography reformers criticized the circulation and display of "indecent" photographs, saying they demoralized women and deteriorated the morals of urban society. See "Immoral Photographs," *PN* (Aug. 10, 1860), 180.

114. See, e.g., "Photographic Dens and 'Doorsmen,'" *PN* (Aug.16, 1861), 389. Originally printed in the *Daily Telegraph.*

115. "Visits to Noteworthy Studios," *PN* (Sept. 10, 1869), 434.

116. Leonore Davidoff and Catherine Hall, *Family Fortunes: Men and Women of the English Middle Class, 1780–1850* (Chicago: Univ. of Chicago Press, 1987).

117. "Prices and Merit, The Rank of Photographers," *PN* (April 15, 1864), 190.

118. For the parallel case in English domestic landscape painting, see esp. Kay Dian Kriz, *The Idea of the English Landscape Painter: Genius as Alibi in the Early Nineteenth Century* (New Haven: Yale Univ. Press, 1997), 66. Kriz notes that one sphere in which gender operated to distinguish professional from amateur subjectivity was in literary satires of the picturesque.

119. Rev. S. Miller, "Photography as an Accomplishment," *PN* (Aug. 28, 1863), 414–415.

120. "Proceedings of the London Photographic Society," *PN* (May 6, 1864), 225.

121. Jeanne Moutoussamy-Ashe, *Viewfinders: Black Women Photographers* (New York: Dodd, Mead, 1986), 7. Laura Wexler notes that in the nineteenth century this freedom of expression was "limited and asymmetrical" in *Tender Violence: Domestic Visions in an Age of U.S. Imperialism* (Chapel Hill: Univ. of North Carolina Press, 2000), 1.

122. Professionalization was a common strategy for keeping women out of various domains, including science and photography. Many Victorians held that the Darwinian definition of feminine nature was essentially incommensurate with the masculine pursuit of science. See Eveleen Richards, "Redrawing the Boundaries: Darwinian Science and Victorian Women Intellectuals," in *Victorian Science in Context,* ed. Bernard Lightman (Chicago: Univ. of Chicago Press, 1997), 119–142.

123. Mary Ann Clawson, *Constructing Brotherhood: Class, Gender and Fraternalism* (Princeton: Princeton Univ. Press, 1989). Clawson discusses the fraternal model and the craftsman as hero, and scores the significance of the overlooked connection of social fraternalism and the artisanal ideal.

124. Ibid., 5. Clawson argues persuasively that Freemasonry emerged from the culture of the artisanal workshop to become a vehicle for an emerging bourgeois sociability; see chap. 5.

125. "Preface," *PN* (Jan. 3, 1862), 1–2.

126. "The Cost of a Patent," *PN* (Nov. 2, 1860), 313.

127. "Photography: Its Social and Economic Position," *PN* (Jan. 25, 1867), 43–44.

128. "Photographic Secrets," *PN* (Jan. 29, 1869), 49–50.

129. Ibid. For the early modern precedents, see esp. Pamela O. Long's fascinating discussion in

Openness, Secrecy, and Authorship: Technical Arts and the Culture of Knowledge from Antiquity to Renaissance (Baltimore: Johns Hopkins Univ. Press, 2001).

130. "Echoes of the Month," *PN* (April 5, 1867), 159–160.

131. "Another Suicide by Cyanide," *PN* (1876), 419; "Suicide of a Photographer at Lincoln," *PN* (1872), 360; "Suicide with Cyanide," *PN* (1868), 263; "Suicide by Means of Cyanide of Potassium," *PN* (1868), 504.

132. See, e.g., "Mr. England's Establishment at Notting Hill," *PN* (April 17, 1868), 184–185.

133. Cussan, "Photographs of Photographers," 6–7.

134. Professor Towler, "Specks, Flashes of Lightning, Islands, Lakes, Etc. on the Negative Film During Development," *PN* (Nov. 24, 1865), 560.

135. "Blurring, Halation, Nubation," *PN* (Dec. 2, 1864), 578–580.

136. John Stuart, "Some of the Causes of the Fading of Photographic Prints," *PN* (April 26, 1867), 198–199.

137. "Some of the Causes of the Fading of Photographs," *PN* (Aug. 9, 1867), 385–386.

138. E. A. Kusel, "Irregular Spots on the Collodion Film," *PN* (Mar. 2, 1866), 106.

139. "Blurring, Halation, Nubation," 578–80.

140. Ibid.

141. Ibid.

142. L. G. Kleffel, "On Cleaning Glass Plates for Photographic Purposes," *PN* (Mar. 25, 1869), 149.

143. "The Art Claims of Photography," *PN* (Nov. 11, 1864), 549–550.

144. "Photographic Portraiture; On Likeness in Photographic Portraits," *PN* (Oct. 18, 1861), 492–493.

145. "The Art Claims of Photography," 549–550.

146. Belloc, "The Future of Photography," *PN* (Sept. 17, 1858), 13–14.

147. A precedent came from his work as a teacher of chemistry.

148. "Answers to Minor Queries," *PN* (Oct. 29, 1858), 95. *PN* (Oct. 22, 1858). "Arrangement of the Telescope," *PN* (Sept 16, 1858).

149. "Arrangement of the Telescope for Astro-Photography," *PN* (Sept. 24, 1858), 34.

150. "How to Commence Photography," *PN* (Sept. 17, 1863), 23.

151. "Table of Necessaries for Beginners in Photography," *PN* (Sept. 9, 1859), 10.

152. "A Simple Dark Room For Work Near Home," *PN* (May 20, 1859), 122.

153. "Views for Photographers Near London," *PN* (Oct. 1, 1858), 41, 45.

154. "By What Means Can the Art of Photography Become a Science?" *PN* (Aug. 21, 1863), 403–404. Originally published in *Humphrey's Journal*.

155. "The Photographic Exchange Club," *PN* (Sept. 11, 1863), 434.

156. "A Photographic Exhibition in London," *PN* (July 19, 1867), 337–338.

157. "The Photographic Exchange Club," *PN* (Dec. 13, 1861).

158. "Amateur Photography," *PN* (April 29, 1860), 400.

159. Samuel Smiles, *Self-Help: With Illustrations of Conduct and Perseverance* (London: John Murray, 1859). Asa Briggs has argued that Smiles's list of virtues and ideas for social improvement did not spring from some peculiar source of moral smugness but from a perception that many areas of waste and inefficiency existed in society. See Asa Briggs, *Victorian People: Some Reassessments of People, Institutions, Ideas and Events, 1851–1867* (London: Odhams, 1954), 124–149.

160. Smiles, *Self-Help*, iv, 118, 132, 121, 270, 271. Also relevant here is Rev. J. G. Wood, *Common Objects of the Microscope* (London: George Routledge and Sons, 1861), 7. Wood stated that it was not the wealthiest but the acute and patient observer who made the most discover-

ies. The discussion of Smiles is from Tucker, "Voyages of Discovery on Oceans of Air," 163–164.

161. Seiberling, *Amateurs, Photography, and the Mid-Victorian Imagination*, 20.

162. Charles Babbage, *On the Economy of Machinery and Manufactures* (1832; reprint, New York: A. M. Kelley, 1963).

163. "How to Commence Photography," *PN* (Oct. 22, 1858).

164. "Photographic Failures and Accidents," *PN* (Sept. 21, 1860), 246–247.

165. "The Photographic Exchange Club," *PN* (Dec. 13, 1861).

166. "Photographic Failures and Accidents," *PN* (Sept. 21, 1860), 246–247.

167. F. F. Statham, "The Application of Photography to Scientific Pursuits," *PN* (May 18, 1860), 34–36.

168. Discussed in F. F. Statham, "The Application of Photography to Scientific Pursuits," *PN* (May 25, 1860), 45.

169. "Photography and Medical Science," *PN* (Nov. 4, 1859).

170. "Jottings for January," *PN* (Jan. 15, 1864), 28–29.

171. Lake Price, "On Composition and Chiaro-scuro," *PN* (Mar. 23, 1860), 367–368.

172. "Photography, and the International Exhibition of 1862," *PN* (May 17, 1861), 236–7.

173. Samuel Fry, "Lunar Photography," *PN* (Jan. 11, 1861), 17–18.

174. "Photographing the Moon," *PN* (Oct. 13, 1865), 486.

175. "Failure of Photographing the Eclipse in India," *PN* (Oct. 23, 1868), 507–508.

176. "Photography and Medical Science," *PN* (Nov. 4, 1859), 97.

177. Samuel Highley, "The Application of Photography to the Magic Lantern Educationally Considered," *PN* (Sept. 30, 1864), 474–475.

178. Samuel Highley, "The Application of Photography to the Magic Lantern Educationally Considered," *PN* (Mar. 6, 1863), 113–114.

179. Samuel Highley, "The Application of Photography to the Magic Lantern Educationally Considered," *PN* (Jan. 29, 1869), 54–55.

180. Highley, "The Application of Photography to the Magic Lantern Educationally Considered," *PN* (Sept. 30, 1864), 474–475.

181. Highley, "The Application of Photography to the Magic Lantern Educationally Considered," *PN* (Jan. 23, 1863), 43–44.

182. Arthur Clayden, "Photographing Meteorological Phenomena," *Quarterly Journal of the Royal Meteorological Society* 24 (1898): 169–180; 169. Hereafter, this journal will be referred to as *QJRMS*.

183. "French Correspondence," *PN* (June 23, 1876), 297–298.

184. Abney was the author of many books on photography and vision theory. See William Abney, *Researches in Colour Vision and the Trichromatic Theory* (London: Longmans, Green and Co., 1913); *A Treatise on Photography* (London: Longmans, Green and Co., 1901); and *The Art and Practice of Silver Printing*, with H. P. Robinson (New York: E. and H. T. Anthony, 1881).

185. "What Photography Does for Science," *PN* (Mar. 3, 1882), 100–101.

CHAPTER 2
Testing the Unity of Science and Fraternity

1. For praise of photographs as evidence of identity, see, e.g., "Photographic Evidence of Identity," *PN* (Nov. 29, 1867), 579; "Another Photographic Detection of a Murderer," *PN* (July 24, 1868), 359; and "Identifying by Photography," *PN* (July 9, 1875), 335. For the false im-

prisonment case, see "Photographic Identity," *PN* (July 12, 1867), 335; for the dead man in Hackney, see "Photographic Identification," *PN* (Apr. 17, 1868), 191; and for the Cockburn quote, see "See What Photographs Can Do," *PN* (Aug. 15, 1873), 396.

2. See, e.g., "Refusing to Pay for Photographs," *PN* (Sept. 9, 1864), 436; "Photography in the County Court," *PN* (Mar. 2, 1866), 193; and "Magazines and Photographers," *PN* (Sept. 19, 1879), 450–451. Many suggested that cases of mistaken identity were increasing. In a German trial that was widely reported in England, a judge agreed with two brothers that theirs were bad likenesses, whereupon the photographer put the pictures in his shop window, labeled "These are highwaymen." See Theodore Pimm, "Portraits and Likenesses," *PN* (Mar. 1, 1872), 102–103.

3. "Photographic Portraiture: On Likeness in Photographic Portraits," *PN* (Oct. 18, 1861), 492–493.

4. "Individuality and Truth in Portraiture," *PN* (Nov. 19, 1875), 558–559.

5. Discussed in Douglass Woodruff, *The Tichborne Claimant: A Victorian Mystery* (NY: Farrar, Straus, and Cudahy, 1957; and Maurice Edward Kenealy, *The Tichborne Tragedy* (London: Griffiths, 1913). See esp. Rowan McWilliam, "The Tichborne Claimant and the People: Investigations into Popular Culture, 1867–1886" (Ph.D. diss., Univ. of Sussex, 1990).

6. There was extensive coverage of the trial in the *PN*. For the case of the photographer, Mr. Wyatt of Fareham, who was accused of cheating, see "The Disputed Accuracy of the Grotto Photographs," *PN* (23 Jan. 1874), 47–48.

7. "Identification by Photography," *PN* (Sept. 26, 1874), 462–463.

8. On family photographs and identity in the U.S., see Shawn Michelle Smith, *American Archives: Gender, Race, and Class in Visual Culture* (Princeton: Princeton Univ. Press, 1999).

9. No spirit photograph appears, e.g., in Jon Darius, *Beyond Vision* (Oxford: Oxford Univ. Press, 1984), an important collection of famous firsts in the history of scientific photography.

10. Gérard De Vaucouleurs, *Astronomical Photography: From the Daguerreotype to the Electron Camera* (London: Faber and Faber, 1961), 17.

11. See Logie Barrow, *Independent Spirits: Spiritualism and English Plebeians, 1850–1910* (London: Routledge and Kegan Paul, 1986); Janet Oppenheim, *The Other World: Spiritualism and Psychical Research in England, 1850–1914* (Cambridge: Cambridge Univ. Press, 1985); Alex Owen, *The Darkened Room: Women, Power, and Spiritualism in Late Victorian England* (London: Virago, 1989); and Alison Winter, *Mesmerized: Powers of Mind in Victorian Britain* (Chicago: Univ. of Chicago Press, 1998).

12. See discussion later in this chapter of Sarah Power's plate 13, showing a "black man with a white beard," in Thomas Slaney Wilmot, *Twenty Photographs of the Risen Dead* (Birmingham: Midland Education Company, 1894).

13. "News from Mars: Alleged Communications by a Martian 'Control,'" *Borderland* 4 (1897), 406–409.

14. See Patrick Joyce, *Democratic Subjects: The Self and the Social in Nineteenth-Century England* (Cambridge: Cambridge Univ. Press, 1994).

15. "Photographs of Ghosts," *PN* (Nov. 1, 1861), 526.

16. See David Brewster, *The Stereoscope: Its History, Theory, and Construction, With Its Application to the Fine and Useful Arts and to Education* (London: J. Murray, 1856), 205.

17. "Stereoscopic Ghosts," *PN* (Sept. 10, 1858), 11. See also David Brewster, *Letters on Natural Magic* (New York: Harper, 1832).

18. "Stereoscopic Ghosts," *PN* (Sept. 10, 1858), 11.

19. Taylor, who was related to J. Traill Taylor, made this point in a lecture in 1923. Loose typescript, bottom of p. 37. J. Traill Taylor MS, Society for Psychical Research, CUL.

20. D. Davie, "Formula for Raising Ghosts," *PN* (Aug. 20, 1869), 408.

21. Ibid.

22. "Cost of Spirit Photographs," *PN* (July 9, 1869), 330.

23. London newspapers erroneously reported the date as October 5, 1862. See "Spirit Photographs," *PN* (Jan. 2, 1863), 4–5.

24. "Spirit Photographs," *PN* (Jan. 2, 1863), 4–5.

25. According to records in the Massachusetts Historical Directory in Boston, Mrs. Stuart began her career as a "Hair Jewellery" manufacturer and took up photography in 1861. There is some speculation that she herself took spirit photographs but unfortunately not much is known yet. William Henry Mumler, *The Personal Experiences of William H. Mumler in Spirit- Photography* (Boston: Colby and Rich, 1875): 3–5. See Christa Cloutier, "Mumler's Ghosts: The Trial and Tribulations of Spirit Photography" (M.A. thesis, Arizona State Univ., 1998), 16.

26. Discussed in Cloutier, "Mumler's Ghosts," 18. For an explanation of the collodion process in connection with spirit photography, see Richard A. Knapp, "Spirit and Psychic Photography: A Review of the Issues and the Evidence" (MFA diss., Univ. of New Mexico, 1974).

27. Quoted in Emma Hardings Britten, *Nineteenth-Century Miracles* (New York: W. Britten, 1884), 475.

28. Mumler, *The Personal Experiences of William H. Mumler in Spirit-Photography,* 7, 42, 41.

29. Details of the trial are given in Andrew Devine, rep., *The Testament of Mr. Elbridge T. Gerry Before Justice Dowling on the Preliminary Examination of Wm. H. Mumler, Charged with Obtaining Money By Pretended 'Spirit' Photographs, May 3, 1869* (New York: Baker, Voorhis, and Co., 1869).

30. For two nineteenth-century histories of photographic "tricks," see Albert A. Hopkins, ed., *Magic: Stage Illusions, Special Effects and Trick Photography* (1898; reprint, New York: Dover, 1976); and Walter E. Woodbury, *Photographic Amusements* (New York: Scovil and Adams, 1896).

31. "Spirit Photographs," *PN* (Jan. 9, 1863), 19–20.

32. Britain's most prominent legal experts argued to expand archives of photographs of suspected and accused criminals on the grounds that recognition even by strangers would help convict them in court. See, in addition to the cases cited above, "Photographic Portraiture: On Likeness in Photographic Portraits," *PN* (Oct. 18, 1861), 492–493.

33. Colleen McDannell and Bernhard Lang, *Heaven: A History* (New Haven: Yale Univ. Press, 1988), 183.

34. "Spirit Photographs," *PN* (Jan. 9, 1863), 19–20; "Spirit Photographs," *PN* (Feb. 13, 1863), 73–74;"Spirit Photographs," *PN* (Jan. 9, 1863), 20.

35. "Spirit Photographs," *PN* (Jan. 9, 1863), 19–20; "Spirit Photographs," *PN* (Jan. 2, 1863), 4–5; "Spirit Photographs," *PN* (Jan. 9, 1863), 19–20.

36. "Spirit Photographs, and Modes of Producing Them," *PN* (June 4, 1869), 270.

37. "Curiosities of Photography," *American Phrenological Journal* (Sept. 1863), 80–81.

38. As one explained around the time of the Mumler trial: "It was of no importance that believers in spiritualism [like Judge Edmonds] deposed that they believed in the deception . . . [but] it was startling enough when experts in photography, who had no faith whatever in spiritualism, swore that they had themselves prepared the plates and adjusted the camera

. . . [and that] nevertheless, the spectre came out of the negative." "Spirit Photographs," *PN* (May 14, 1869), 231–232.

39. Spirit Photographs," *PN* (Feb. 13, 1863), 73–74.

40. "Critics, Criticisms, and Photographers," *PN* (Nov. 26, 1869), 563.

41. From the *Christian Spiritualist* (Jan. 1875), quoted in James Coates, *Photographing the Invisible* (London: Fowler, 1911), 46.

42. "Spirit Photographs," *PN* (Feb. 13, 1863), 73–74; "Spirit Photographs," *PN* (Jan. 9, 1863), 19–20.

43. While Crookes was a committed spiritualist who became one of spirit photography's top defenders in England, Simpson's views on spiritualism are harder to decipher and he publicly criticized spirit photography.

44. "Spirit Photographs," *PN* (Feb. 13, 1863), 73–74.

45. "Questionable Subjects for Photography," *PN* (Oct. 15, 1858), 62.

46. "Spirit Photographs," *PN* (Feb. 13, 1863), 74.

47. A parallel possibly exists here between the scandal around Mumler's spirit photographs and that surrounding the Oscar Wilde trial, of which Ed Cohen writes that the newspapers produced the possibility of spectacle by establishing "an emotional relationship to the audience." They did so, he says, "by drawing upon personalized narration, vivid language, evocative detail, and most important of all, sensational subjects." *Talk on the Wilde Side: Toward a Genealogy of a Discourse on Male Sexualities* (New York: Routledge, 1993), 131.

48. John Beattie, quoted in Georgiana Houghton, *Chronicles of the Photographs of Spiritual Beings and Phenomena Invisible to the Material Eye* (London: E. W. Allen, 1882), 102–105.

49. "Spiritual Photographs," *PN* (June 11, 1869), 285.

50. See M. Carey Lea, "Spirit Photography," *British Journal of Photography* (May 31, 1872). He added: "If it be 'arrant nonsense' for investigators, whether they have or have not a knowledge of photography, to imagine there is any test condition which they can effectually apply to decide the reality of spirit photography, then, I fear, the whole spiritual phenomenon rests on an insecure foundation, and we are again left alone with the poor consolations to be derived from a dead faith, or to wander on in the comfortless regions of scepticism. Men or angels to the rescue of us poor, bewildered students of spiritualism and photography!" (Hereafter, citations to the *British Journal of Photography* will be abbreviated as *BJP*.)

51. "Spirit Forms and Photography," *PN* (Aug. 15, 1873), 395.

52. Quoted in Houghton, *Chronicles,* 143.

53. "Spirit Photographs," *PN* (Feb. 13, 1863), 74; "Spirit Photographs," *PN* (Jan. 9, 1863), 19–20; "Spirit Photographs," *PN* (Feb. 13, 1863), 73–74.

54. M. Carey Lea, a respected Philadelphia photographer, excited much indignation among London photographers after he wrote to the *News* that "the pretended spirit photographs seem to have received in your country more faith than Mr. Mumler's performances here, where, I believe, no intelligent photographer has accepted them." "Spirit Photography," *BJP* (May 31, 1872).

55. "Spirit Photographs," *PN* (Feb. 13, 1863), 74; "Spirit Photographs," *PN* (May 14, 1869), 231–232; "Spirit Photographs," *PN* (Feb. 13, 1863), 74.

56. "Spirit Photographs," *PN* (May 14, 1869), 231–232; "Spirit Photographs," *BJP* (July 17, 1874), 246.

57. See "Photographic Journals on Spirit Photography," *Spiritualist Magazine* 2 (1870), 38. For the magazine's diverse coverage of the phenomenon, see also "Sham Spirit Photographs,"

Spiritualist Magazine 2 (1870): 53; "Real and Sham Spirit Photographs," *Spiritualist Magazine* 2 (1870): 71, 75; "Photographing Spirits," *Spiritualist Magazine* 3 (1871): 200, 361, 236; "Spirit Photography in Naples," *Spiritualist Magazine* 7 (1874): 164, 265. "Spirit Photographs," *PN* (Feb. 13, 1863), 73–74.

58. "A Public Exhibition of Spirit Drawings," *Spiritualist Magazine* (1871), 263–71; and "Mrs. Houghton's Spirit-Drawings," *The Spiritualist* 1 (1869): 175. For the context of Houghton's work as a spiritualist flower painter, look for Rachel Orbeter's soon to be completed Ph.D. diss., History of Art Department, Yale University.

59. Robert Cox, "The Transportation of American Spirits: Gender, Spirit Photography, and American Culture, 1861–1880," *Ephemera Journal* 7 (1994): 94–104; 99.

60. Houghton, *Chronicles,* 1.

61. Ibid., 1–2.

62. "Alleged Spirit Photographs," *PN* (Apr. 19, 1872), 182–183.

63. Letter from William H. Harrison, *PN* (May 31, 1872).

64. See John Beattie, "In Reply to a Paragraph by Mr. Bovey on 'Spirit Photography,'" *PN* (Aug. 8, 1873), 382. Bovey was a frequent contributor to the *PN*.

65. Houghton, *Chronicles,* 92, 146, 125.

66. Ibid., 112. Houghton's writings stress the importance of clarity of likeness and link it with the character and energy of the spirit after death: "The likenesses are assuming much more definiteness from the circumstance that the veil is being gradually being withdrawn from the features, which is an evidence that we are becoming more closely united with the spirit-world." In one photograph, the "well-defined form" of Katie King appeared to be blessing with outstretched hands Mrs. Guppy and her son. See pp. 37, 10. Ibid., 52, 22, 10.

67. Ibid., 142.

68. "Individuality and Truth in Portraiture," *PN* (Nov. 19, 1875), 558–559.

69. "Likeness in Photographic Portraiture, Familiar and Occult," *PN* (Oct. 13, 1865), 481–2.

70. Houghton, *Chronicles,* 6. Spiritualists argued that they were more scientific than skeptics because they investigated phenomena that they did not always understand. They often blamed skeptics for the famous failures of spirit photography, saying that the negative mental and spiritual energies of skeptics and cynics interfered with the harmonious "amalgamations" of emanations so critical to the experiment's success. Houghton, defending Hudson at a time when he had many failures, said that his "sensitive nature is suffering much from the ungenerous attacks to which is being subjected"—his "wonderful gift" punctured by "many thorns." "Higher Angelic Intellectuals," she added, required faith; they "cannot blend with suspicion." Suspicion was an adverse external agency—much like bad weather and impure chemicals—that spoiled plates. She maintained that spirit photography could be explained if it was treated rationally rather than in the "critical, suspicious, detective-like attitude many enquirers assume." Ibid., 29, 19, 40.

71. Ibid., 118, 25, 82.

72. Mary Cowling, *The Artist as Anthropologist: The Representation of Type and Character in Victorian Art* (Cambridge: Cambridge Univ. Press, 1989).

73. See, e.g., the drawings of physiognomy and emotions in H. J. Rodgers, *Twenty-Three Years Under a Sky-Light, or Life and Experiences of a Photographer* (Hartford: American Publishing Co., 1872).

74. Houghton, *Chronicles,* 118. I thank Sally Stein for pointing out this connection.

75. Houghton, *Chronicles,* 74, 14, 38.

76. Ibid., 42.

77. Ibid., 41, 19, 31, 42.

78. Houghton, *Chronicles*, 191. Letter from John Beattie to the *BJP*, reprinted in Houghton, *Chronicles*, 152.

79. Ibid., 8, 35.

80. Shawn Michelle Smith suggests that the relation between women and the camera was seen as mesmeric. *American Archives*, 94.

81. Houghton, *Chronicles*, 54, 34, 19, 162.

82. James Glaisher, *Travels in the Air* (London: R. Bentley, 1871); John Tyndall, *The Glaciers of the Alps: Being a Narrative of Excursions and Ascents* (Boston: Ticknor and Fields, 1861); and Edward Whymper, *Scrambles Amongst the Alps* (Philadelphia: J. B. Lippincott, 1869). Houghton's narrative also fits within an emerging literature of women's adventure tales, such as Lady Blanche Murphy, *Down the Rhine* (Philadelphia: J. B. Lippincott, 1869).

83. Houghton, *Chronicles*, 73, 63, 9, 12, 112, 100, viii, 28, 191, 14, 6, 28.

84. "Dorchagraphy as a Social Rage," *Borderland* 4 (1897), 30.

85. Houghton, *Chronicles*, viii, 11, 187.

86. Ibid., 78, 25–26.

87. Ibid., 25, 36, 37.

88. Ibid., 129.

89. Ibid., 60, v, 38.

90. Ibid., 122.

91. Ibid., 52–53.

92. Coates, *Photographing the Invisible*, 27.

93. Houghton, *Chronicles*, 116.

94. Ibid., 122, 70, 29.

95. "Spirit Photographs," *PN* (Feb. 13, 1863), 73–74.

96. Houghton, *Chronicles*, 23.

97. See, e.g., Wilmot, *Twenty Photographs of the Risen Dead*, 32.

98. Ibid., 2, 10.

99. Ibid., 10.

100. Ibid., 1, 3.

101. Ibid., 26.

102. Ibid., 25, 33, 31.

103. "Spirit Photographs," *BJP* (July 17, 1874), 246.

104. "The Present State of Spirit Photography," *BJP* (1874), 324. See also "Spirit Photography Under a Cloud," *BJP* (June 11, 1875), 278–279; and "Spirit Photographs," *BJP* (July 17, 1874), 246.

105. Alex Owen, " 'Borderland Forms': Arthur Conan Doyle, Albion's Daughters, and the Politics of the Cottingley Fairies," *History Workshop Journal* 38 (1994): 48–85.

106. "The Present State of Spirit Photography," *BJP* (1874): 324.

107. Photographers complained generally that pictures were too similar and that spirit photographs in particular were "conventional" and—quite literally—"stereotyped." See, e.g., Frank Howard, "Some of the Defects in Landscape Photography," *PN* (Mar. 17, 1865), 125–126.

108. Houghton, *Chronicles*, 38.

109. The problems of naming photography are treated in Geoffrey Batchen, *Burning with Desire: The Conception of Photography* (Cambridge: MIT, 1997).

110. Glendinning, *The Veil Lifted*, vi and vii. Glendinning's was the classification that Coates reproduced in his *Photographing the Invisible*, xi.

111. Wilmot, *Twenty Photographs of the Risen Dead,* 42. For other examples of racialized spirits, see "psychic portrait of 'Hafed,'" and a psychic photograph with Elsie Reynold, a noted American materializing medium, with multiracial spirit "extras," in Coates, *Photographing the Invisible* (67, 383); and the photographs of sitters with Indian servant "extras" in W. T. Stead, "Spirit Photography: A New Series of Psychic Pictures," *Borderland* 2 (1895): 311–324.

112. John Traill Taylor, "Are Spirit-Photographs Photographs of Spirits?" *Borderland* 2 (1895): 239–241.

113. Hugh Reginald Haweis, "Ghosts and their Photographs," in *The Veil Lifted: Modern Developments of Spirit Photography,* ed. Andrew Glendinning (London: Whittaker and Co, 1894), 71–84; 72.

114. Houghton, *Chronicles,* 102–106, 48.

115. Wilmot, *Twenty Photographs of the Risen Dead,* 19–20; and reported in *British Journal of Photography,* Sept. 7, 14, 21 (1888), and Jan. 5 (1889).

116. Wilmot, *Twenty Photographs of the Risen Dead,* 47, 49–50, 6.

117. Houghton, *Chronicles,* 48.

118. See John Beattie, "Spirit Photography," *PN* (July 11, 1873), 325–326; "Experiments in Photography Controlled by Invisible Beings," *PN* (Aug. 22, 1873), 399–400; "The 'Peripatetic Photographer' on Spirit Photography," *PN* (Aug. 3, 1873), 381–2; and "On Spirit Photography," *PN* (July 11, 1873), 334–335.

119. Houghton, *Chronicles,* 151. John Beattie, "On Spirit Photography," *PN* (July 11, 1873), 334–335.

120. See Oppenheim, *The Other World,* 135. Its members included Henry Sidgwick, one of the leading British philosophers of the nineteenth century and the society's president for many years until 1892; Balfour Stewart, astronomer and professor of physics; William F. Barrett, professor of physics; and J. J. Thomson, Cavendish Professor of Experimental Physics at Cambridge; as well as members of Parliament, artists, writers, and philosophers.

121. Bishop Carpenter and Edmund Dawson Rogers, quoted in Oppenheim, *The Other World,* 137.

122. T. H. Huxley, Frederic Myers, and Francis Galton participated in a spiritualist séance on Jan. 16, 1874, but the papers are restricted until 2005. See G. H. Darwin, "Various accounts of the sitting on 16 January 1874 including those by Huxley, Myers, and Francis Galton." Society for Psychical Research Papers. Cambridge Univ. Library.

123. Hensleigh Wedgwood to T. H. Huxley, 1874. Three photographs (221–223). Huxley Papers. General Letters, Vol. XXVIII (Imperial College Archives, London), T1–WE.

124. On Huxley, see esp. Adrian Desmond, *Huxley: From Devil's Disciple to Evolution's High Priest* (Reading: Addison-Wesley, 1997).

125. Wedgwood to Huxley, 1874. (Imperial College Archives, London), T1–WE, 209–212.

126. William Crookes, *Researches in the Phenomena of Spiritualism* (London: James Burns, 1874).

127. William Crookes, "How to Clean Glass Plates," *PN* (Aug. 21, 1863), 406–407.

128. A. R. Wallace, *The Scientific Aspect of the Supernatural: Indicating the Desirableness of an Experimental Enquiry by Men of Science Into the Alleged Powers of Clairvoyants and Mediums* (London: F. Farrah, 1866).

129. The spirit photograph of Wallace's mother is reproduced in A. R. Wallace, *Miracles and Modern Spiritualism* (London: G. Redway, 1896); and is discussed in Coates, *Photographing the Invisible,* 37–38.

130. Owen, *The Darkened Room,* 139–201; Judith R. Walkowitz, *City of Dreadful Delight: Narratives of Sexual Danger in Late-Victorian London* (Chicago: Univ. of Chicago Press, 1992), 171–189.

131. *BJP* (Sept. 7, 14, 21, 1888; Jan. 5, 1889); discussed in Wilmot, *Twenty Photographs of the Risen Dead,* 20–21.

132. Wilmot, *Twenty Photographs of the Risen Dead,* 23.

133. "Spirit Photography," *BJP* (July 24, 1874); "Spirit Photographs," *PN* (Jan. 9, 1863), 19–20; "Photography as an Imposter," *PN* (June 4, 1869), 267–268; "Spirit Photographs and Modes of Producing Them," *PN* (1869), 270.

134. Houghton, *Chronicles*, 94.

135. Quoted by the Scottish spiritualist Andrew Glendinning in his defense, in *The Veil Lifted*, 104.

136. Wilmot, *Twenty Photographs of the Risen Dead*, 47.

137. Houghton, *Chronicles*, 10. Today spirit photographs that circulated as proofs are difficult to trace. Many no longer exist, having been destroyed in some cases by family members worried about the effect their inclusion in scientific papers might have on a scientific man's reputation after his death; others, such as some in the Society for Psychical Research collection at Cambridge University Library, can only be viewed in the future.

138. Wilmot, *Twenty Photographs of the Risen Dead*, 4.

139. Houghton, *Chronicles*, v, 31.

140. I am thankful to James Secord for sharing his many insights on science, media, and popular culture.

141. Mason Jackson, *The Pictorial Press: Its Origin and Progress* (London: Hurst and Blackett, 1885), 166, 205, 196.

142. Smyth made practice sketches by copying work by landscape artists such as W. J. Muller and Copley Fielding. Smyth may have engraved sketches of the war in South Africa that were sent by his friend, the artist Charles Bell, to the London office of the *Illustrated London News*. See Mary T. Brück, "The Piazzi Smyth Collection," *Vistas in Astronomy* 32 (1988): 371–408.

143. Jackson, *The Pictorial Press*, 225, 224, 233.

144. Ibid., 264–265.

145. Ibid., 286 n., 303.

146. Ibid., 281.

147. Like photography, the rationale for the illustrated press was its educational appeal to an expanding electorate. The stated aim of *Illustrations,* first issued in 1886 and edited by Francis George Heath, was to "mirror everything that interests THE PEOPLE"; "to communicate knowledge of all kinds"; "to be the cheapest illustrated review in existence"; to make a "pictorial record of the times," and to convey knowledge in "the most direct, convincing, and hence pleasant and valuable way, by means of PICTORIAL ELUCIDATION." From *Illustrations: A Pictorial Review of Knowledge Comprehending Amusement, Art, Biography, Economics, Invention, Literature, Science, Etc.* 1 (Feb. 1886).

148. Aled Jones, *Powers of the Press: Newspapers, Power, and the Public in Nineteenth-Century England* (Aldershot: Ashgate, 1996).

149. *Photography for the Press*, 2d ed. (London: Dawbarn and Ward, 1905), 6.

150. "A Day with an East End Photographer," *Strand* 1 (1891): 458–465; "Weather Watchers and their Work," *Strand* 3 (1893), 182–189; Arthur Morrison, "Instantaneous Photographs," *Strand* 3 (1893), 629–638.

151. "The Possibilities of the Roentgen Method," *Picture Magazine* 7 (Jan-June 1896): 253; "Science: Its Influence on the Future," *To-Morrow* 1 (Jan-June 1896): 51–52.

152. *Pearson's* 4 (1897); *Pearson's* 6 (1898): 306–312, 10–16, 354–357.

153. Jones, *Powers of the Press*, 92.

154. Matthew Arnold, "Up to Easter," *Nineteenth Century* (May 1887); reprinted in Matthew Arnold, *The Last Word*, ed. R. H. Super (Ann Arbor: Univ. of Michigan Press): 199–209.

155. Evelyn March Phillips, "The New Journalism," *New Review* (Aug. 1895): 182.

156. Tania Modleski, "Feminity as Mas(s)querade: A Feminist Approach to Mass Culture." In *High*

Theory/Low Culture, ed. Colin MacCabe (New York: St. Martin's Press, 1986). See also Catherine A. Lutz and Jane L. Collins, *Reading National Geographic* (Chicago: Univ. of Chicago Press, 1993), 8. William T. Stead, "Government by Journalism," *Contemporary Review* 49 (1886): 667.

157. W. T. Stead, "The Future of Journalism," *Contemporary Review* 50 (1886): 663–679; 671–674.

158. Jürgen Habermas, *The Structural Transformation of the Public Sphere: An Inquiry Into a Category of Bourgeois Society,* trans. Thomas Burger (Cambridge: MIT Press, 1985). Stead, "Government by Journalism," *Contemporary Review* 49 (1886): 654–674; 662.

159. Among other places, this is discussed in Asa Briggs, *The Nineteenth Century: The Contradictions of Progress* (New York: Bonanza Books, 1985).

160. Walkowitz, *City of Dreadful Delight,* 29, 130, 5.

161. For Stead's biography, see esp. Frederic Whyte, *The Life of W. T. Stead* (New York: Houghton Mifflin, 1925). See Neil Harris, *Humbug! The Art of P. T. Barnum* (Boston: Little, Brown, 1973).

162. "What Think Ye of the Study of BORDERLAND?" *Borderland* 1 (1894), 5.

163. Ibid.

164. "The Response to the Appeal," *Borderland* 1 (1894), 10–12.

165. Ibid.

166. "What Think Ye of the Study of BORDERLAND?" *Borderland* 1 (1894).

167. Ibid.

168. Stead, "Progress in Photographing Invisibles," *Borderland* 1 (1894): 145.

169. J. Traill Taylor, "Spirit Photography, with Remarks on Fluorescence," *BJP* (Mar. 17, 1893): 167–169; reprinted in Glendinning, *The Veil Lifted,* 24, 33.

170. The politics of "New Womanhood" are discussed in Lisa Tickner, *The Spectacle of Women: Imagery of the Suffrage Campaign, 1907–1914* (Chicago: Univ. of Chicago Press, 1988), and Walkowitz, *City of Dreadful Delight.*

171. Stead, "The 'Cyprian Priestess' Mystery," *Borderland* 2 (1895): 242.

172. Glendinning, *The Veil Lifted.* Glendinning was associated with the temperance campaign, abolition, and the so-called war against the "white-man's slavery" to scientific materialism. Additional background on Glendinning is given in Coates, *Photographing the Invisible,* 73. Information on Duguid is contained in the David Duguid papers, Medium Files, Society for Psychical Research papers, CUL. Stead, "The 'Cyprian Priestess' Mystery," *Borderland* 2 (1895): 242–243.

173. Stead, "The 'Cyprian Priestess' Mystery," 244, 243.

174. Ibid., 244–246.

175. Ibid., 243, 244.

176. Ibid., 243.

177. Victorian photographer William Harding Warner once wrote: "Looking carefully over the reports connected with such in your Journal, we find them (the spirits) chiefly female. Why not males? Are there no good male spirits? Is heaven to be composed entirely of ladies? It would appear so. Or are we males to be transmigrated into female forms after death? Who can tell?" "Spirit or Psychic-Force Photographs," *BJP* 19 (1872): 212.

178. Taylor, "Spirit Photography, with Remarks on Fluorescence," *BJP* (Mar. 17, 1893): 167–169; reprinted in Glendinning, *The Veil Lifted,* 24, 33.

179. Houghton, *Chronicles,* 27.

180. There is a parallel in the history of British art. Dian Kriz notes that one sphere in which gender operated to distinguish professional from amateur subjectivity was in literary satires of the picturesque. Kay Dian Kriz, *The Idea of the English Landscape Painter: Genius as Alibi in the Early Nineteenth Century* (New Haven: Yale Univ. Press, 1997), 66.

CHAPTER 3
Acquiring a Scientific Eye

1. Katherine Anderson, "Practical Science: Meteorology and the Forecasting Controversy in Mid-Victorian Britain" (Ph.D. diss., Northwestern Univ., 1994); Susan F. Cannon, *Science in Culture: The Early Victorian Period* (New York: Science History Publications, 1978).

2. Richard Inwards, "Weather Fallacies," *QJRMS* 21 (April 1895): 49–62; 61–62.

3. Ibid., 61–62.

4. An engraving by Robert Wallis after Turner's Stonehenge watercolor (ca. 1829) appears in Andrew Wilton, *Turner in his Time* (New York: Harry N. Abrams, 1987), fig. 257. Another image of Stonehenge by Turner (not the one I think Kidd was referring to) is paired with a view of Paestum, which shows lightning in an arc. In John Gage, *J. M. W. Turner: 'A Wonderful Range of Mind'* (New Haven: Yale Univ. Press, 1987), fig. 286.

5. Inwards, "Weather Fallacies," 56–57.

6. James Nasmyth, "On the Form of Lightning," *Report of the BAAS* (1856): 14.

7. On the classical dimensions of Victorian art, see Richard Jenkyns, *Dignity and Decadence: Victorian Art and the Classical Inheritance* (Cambridge: Harvard Univ. Press, 1992). David H. Solkin, *Richard Wilson: The Landscape of Reaction* (London: Tate Gallery, 1982): 53. The publisher received a profit of 2,000 pounds, a sum far beyond that earned by any previous engraving of a landscape by a British artist. Phillipe de Loutherbourg, "Landscape with Overturned Wagon in a Storm," Royal Academy 1809, Amherst College (Mead Art Museum). Kay Dian Kriz, *The Idea of the English Landscape Painter: Genius as Alibi in the Early Nineteenth Century* (New Haven: Yale Univ. Press, 1997), 107–108.

8. Wilfred de Fonvielle, *Thunder and Lightning* (New York: Charles Scribner and Co., 1869).

9. Richard McKim, "Nathaniel Everett Green: Artist and Astronomer," *Journal of the British Astronomical Association* 114 (2004): 13–23.

10. Joseph B. Kidd, "From New York to Jamaica" (diary), entry for August 24, 1837. The Library of Congress manuscript division has a microform copy of this and other diaries and papers by Kidd. I thank Dian Kriz for sharing this reference from her own work on Kidd.

11. Ann Bermingham, *Learning to Draw: Studies in the Cultural History of a Polite and Useful Art* (New Haven: Yale Univ. Press, 2000).

12. Bernard Smith, *Imagining the Pacific: In the Wake of the Cook Voyages* (New Haven: Yale Univ. Press, 1992): 66. Alexander von Humboldt, *Cosmos: A Sketch of a Physical Description of the Universe* (New York: Harper, 1859).

13. Susan F. Cannon, *Science in Culture: The Early Victorian Period* (New York: Dawson and Science History Publications, 1978), 105. On the cloud studies by Howard and Constable, see Charlotte Klonk, *Science and the Perception of Nature: British Landscape Art in the Late Eighteenth And Early Nineteenth Centuries* (New Haven: Yale Univ. Press, 1996), 126–127. Kurt Badt, *John Constable's Clouds* (London: Routledge and K. Paul, 1950).

14. John Ruskin, *Modern Painters* (New York: Wiley and Putnam, 1847), 201–261.

15. Gage, *J. M. W. Turner*, 1–2.

16. Théophile Thoré, quoted in W. Bürger, "L'École Anglaise," in *Histoire des peintres de toutes les écoles,* ed. Charles Blanc et al. (Paris: Librairie Renouard, 1861), 16.

17. Kriz, *Idea of English Landscape Painting*, 102–104.

18. "Monthly Retrospect of the Fine Arts," *Monthly Magazine* (July 1810): 577.

19. Discussed in Jennifer Tucker, "Voyages of Discovery on Oceans of Air: Scientific Observation and the Image of Science in an Age of 'Balloonacy,'" *Osiris* 11 (1996): 144–176; 149.

20. See George J. Symons, "The History of English Meteorological Societies, 1823–1880," *QJRMS* (1881): 65–98.

21. Symons, "The History of English Meteorological Societies, 1823 to 1880," 65–98.

22. John Ruskin exhorted individuals to participate in this venture, declaring that through their collaboration they might set the wheels of meteorology into motion:

> The Meteorological Society . . . wishes to be the central point, the moving power, of a vast machine . . . There is one point, it must now be observed, in which the science of meteorology differs from all others. A Galileo, or a Newton, by the unassisted workings of his solitary mind, may discover the secrets of the heavens . . . A Davy in his . . . solitary laboratory, might discover the most sublime mysteries of nature . . . But the meteorologist is impotent if alone; his observations are useless, for they are made upon a point, while the speculations to be derived from them must be on space . . . Let the pastor of the Alps observe the variations of his mountain winds; let the voyager send us notes of their changes on the surface of the sea; let the solitary dweller on the American Prairie observe the passages of the storms, and the variations of the climate; and each, who alone would have been powerless, will find himself a part of one mighty Mind . . . the center of a vast machine.

In conclusion, Ruskin issued an auspicious prediction. Once meteorologists "had at their command, at stated periods, perfect systems of methodical and simultaneous observations," their associates would be "astonished, individually, by the result of their labours in a body." "Remarks on the Present State of Meteorological Science," originally published in *Transactions of the Meteorological Society* 1 (1839); reprinted in *Symons' Monthly Meteorological Magazine* (1870): 36–39.

23. Kriz, *The Idea of the English Landscape Painter,* 62.

24. Ibid., 102.

25. J. H. Jones, "Photographic Rambles in Wales," *PN* (April 19, 1861), 189–190.

26. Shapin and Schaffer, *Leviathan and the Air-Pump,* 60–65, 225–226.

27. Robert Lawson, "On the Deaths Caused by Lightning in England and Wales from 1852 to 1880," *QJRMS* (1889): 141.

28. See "Notes of Damage by Rain and Thunderstorms, Extracted from the Newspaper Press," *Symons' Monthly Meteorological Magazine* 32 (1897): 124–127. The photo of the injured shepherd is in the Lockyer Lantern Slide Collection, Royal Meteorological Society, and in the Forensic Science Lantern Slide Teaching Collection, London Hospital.

29. "Electrical Manifestations," *Symons' Monthly Meteorological Magazine* 32 (1897): 127.

30. "A 'Lightning Figure' Photographed," *Symons Monthly Meteorological Magazine* (July 1883): 81. See also "Lightning Prints on Boys," Ibid., 83–84.

31. George J. Symons, "Results of an Investigation of the Phenomenon of English Thunderstorms During the Years 1857–1859," *Q JRMS* 15 (1889): 2–5.

32. Ibid., 5–6.

33. Kriz, *The Idea of the English Landscape Painter,* 62, 82. See esp. her chapter 4 for a full treatment of this issue.

34. Symons, "The Non-Existence of Thunderbolts," *Q JRMS* 14 (1888): 208. For more biographical details, see "Obituary Notice of George James Symons," typed transcript, loose materials, Royal Meteorological Society.

35. Ibid., 208, 210.

36. Ibid., 209–211.

37. Ibid., 208, 212.

38. Anon., "Meteorology and Art," *Symons's Monthly Meteorological Magazine* (May 1880): 49–51.

39. Inwards, "Weather Fallacies," 56–57.

40. "On Photographic Meteorology," *Report of the BAAS* (1899): 239.

41. Ralph Abercromby, "On the Photographs of Lightning Flashes," *Q JRMS* 14 (1888): 226–234.

42. This instrument recorded variations in the height of a barometer by passing light through the Torricellian vacuum and allowing the top of the mercury column to arrest the luminous rays on their way to the sensitized paper. For a description, see G. M. Whipple, "A Brief Notice Respecting Photography in Relation to Meteorological Work," *Q JRMS* 16 (July 1890): 141–146.

43. See Dolores Ann Kilgo, *Thomas M. Easterly and the Art of the Daguerreotype* (St. Louis: Missouri Historical Society Press, distributed by the Univ. of New Mexico Press, 1994).

44. "Photographs by Lightning," *PN* (April 23, 1869), 202.

45. Birt Acres, "Some Hints on Photographing Clouds," *Q JRMS* 21 (1895): 161.

46. Discussed in Reese V. Jenkins, *Images and Enterprise: Technology and the American Photographic Industry, 1839 to 1925* (Baltimore: Johns Hopkins Univ. Press, 1975), 112.

47. "Photographic Excursions," *PN* (Mar. 16, 1860), 342.

48. J. H. Jones, "Photographic Rambles in Wales," *PN* (April 19, 1861), 189–90.

49. "Photographic Excursions," *PN* (Mar. 16, 1860), 342.

50. "South London Photographic Society," *PN* (April 29, 1860), 400.

51. Quoted in Friese Greene, "Photography in an Age of Movement," *PN* 34 (Mar. 7, 1890), 183. Greene called photography "an extra bit of sight and an extra bit of intellect" for "all classes— high, low, rich, and poor . . . thrusting its prying eye into everything within the world and, I may say, outside of it too, for it affords the means of depicting the magnitudes and the places of stars which must otherwise have been quite unknown to us." See also "The Amateur Photographic Pest," *Punch* (Oct. 4, 1890), 166.

52. Henry Coxwell, *My Life and Balloon Experiences,* 2 vols. (London: W. H. Allen, 1887, 1889), 2:108–109.

53. Arthur Clayden, "Photographing Meteorological Phenomena," *Q JRMS* 24 (1898): 169–180; 171.

54. Frank Howard, "Some of the Defects in Landscape Photography," *PN* (Mar. 17, 1865), 125–126. For complaints about sooty skies, see, e.g., "Instantaneous Views of London," *PN* (Jan. 10, 1862), 22. Charles Piazzi Smyth, "Cloud Forms That Have Been," vol. 1, 99 (opp. No. 142), M.S. 698–700, RS. For a sense of the discussion on skies see, e.g., Valentine Blanchard, "On the production and use of cloud negatives," *PN* (Sept. 4, 1863), 424; and "To Secure Clouds in Landscapes," *PN* 7 (1863), 11, 18, 59.

55. Kenneth James, "A Hungry Lens," *The Belfast Review* 10 (1985): 19. An unpublished chronology of Welch's life has been compiled by Arthur Deane and is on deposit in Ulster Museum, Geology Department. I am grateful to Kenneth James for introducing me to Welch's work. See Welch, #1742, *Album of BAAS Geological Photographs,* Co. Donegal, UM.

56. *Report of the BAAS* (1897). Welch's *Geological Irish Views* (1894) is perhaps the first geological catalogue.

57. British Association albums of Geological Photographs (Irish Section), UM.

58. *Report of the Geological Photographs Committee,* undated, Welch's copy, UM.

59. Photograph No. 236 ("The Giants Fan"), Sept. 1887. *Album of BAAS Geological Photographs,* Co. Antrim, vol. 1, UM.

60. *Report of the Geological Photographs Committee,* undated, Welch's copy, UM.

61. *Photography for the Press,* 2d ed., by the editors of the *Photogram* (London: Dawbarn and Ward, 1905), lists the sums that photographers should expect to receive.

62. Photograph Nos. 1714–1715, *Album of BAAS Geological Photographs,* Co. Antrim, vol. 1, UM.

63. Arthur Clayden, "Photographing Meteorological Phenomena," *Q JRMS* (1898): 169–180; 171.

64. *Amateur Photographer* (Feb. 4, 1887), 50.

65. See, e.g., H. Baden Pritchard, "The Application of Photography to Military Purposes," *Journal of the Royal United Service Institution* 13 (1869).

66. Gibson, "Lightning and Lightning Photography," 610.

67. "Report of the Committee on Meteorological Phenomena" (1891), 132.

68. Frank Howard, "Some of the Defects in Landscape Photography," *PN* (Mar. 17, 1865), 125–126.

69. Acres, "Some Hints on Photographing Clouds," 162.

70. William Marriott, "Instructions for Taking Photographs of Lightning," *Q JRMS* (1889): 176. Clawson, *Constructing Brotherhood,* 213. Acres, "Some Hints on Photographing Clouds," 160–164.

71. William Marriott, "Instructions for Taking Photographs of Lightning," *Q JRMS* (1889): 176. See also William Marriott, "Application of Photography to Meteorological Phenomena," *Q JRMS* 16 (1890): 146–152.

72. Clayden, "Meteorological Photography," *Q JRMS* 17 (1891): 143.

73. Clayden, "Photographing Meteorological Phenomena," 169.

74. Clayden, "Meteorological Photography,"143.

75. The committee included the chair, George James Symons, Raphael Meldola, J. Hopkinson, and Arthur Clayden, who served as secretary. See "Report of the Committee on Photographs of Meteorological Phenomena," in *Reports of the BAAS* 60 (1891): 130–137; *Reports of the BAAS* 61 (1892): 77–92; *Reports of the BAAS* 62 (1893): 140–144; *Reports of the BAAS* 63 (1894): 143–144; *Reports of the BAAS* 64 (1895): 80–81; *Reports of the BAAS* 65 (1896): 172–179; *Reports of the BAAS* 66 (1897): 128; and *Reports of the BAAS* 68 (1899): 238–239.

76. Ralph Abercromby, "On the Photographs of Lightning Flashes," *Q JRMS* (1888): 226–234.

77. Abercromby, "On the Photographs of Lightning Flashes," 130.

78. "Report of the Committee on Photographs of Meteorological Phenomena," *Report of the BAAS* 60 (1891): 133.

79. See Francis Galton, *Memories of My Life,* 2d ed. (London: Methuen and Col, 1908), 229.

80. See Elizabeth Edwards, *Raw Histories: Photographs, Anthropology and Museums* (Oxford: Berg, 2001), 59.

81. "Report of the Committee on Photographs of Meteorological Phenomena" (1891), 134.

82. See Jeffrey, *Photography,* 23.

83. "Report of the Committee on Photographs of Meteorological Phenomena," *Report of the BAAS* 60 (1891): 131.

84. Clayden, "Photographing Meteorological Phenomena," 171.

85. Ralph Abercromby, "On the Photographs of Lightning Flashes," *Q JRMS* 14 (1888): 226–234.

86. Clayden, "Photographing Meteorological Phenomena," 174.

87. Peter Galison and Alexi Assmus, "Artificial Clouds, Real Particles," in *The Uses of Experiment: Studies in the Natural Sciences,* ed. David Gooding, Trevor Pinch, and Simon Schaffer (Cambridge: Cambridge Univ. Press, 1989), 225–274.

88. "Clouds: Their Representation and Measurement," Catalogue of the Fourteenth Exhibition of Instruments, *Q JRMS* (1894): 217–228.

CHAPTER 4
Photography of the Invisible

1. "What Photography Does for Science," *PN* (Mar. 3, 1882), 100–101.

2. G. L'E. Turner, "Microscopical Communication," in *Essays on the History of the Microscope,* ed. G. L'E. Turner (Oxford: Senecio Publishing Co, 1980), 215–232.

3. "How to Commence Photography," *PN* (Sept. 17, 1858), 23.

4. "The Influence of Photography," *PN* (June 12, 1863), 282–283.

5. Beatrice Webb, *My Apprenticeship* (London: Longmans, Green and Co., 1926), 126–127.

6. George Newman, *Bacteria, especially as they are related to the economy of nature to industrial processes and to the public health* (London: John Murray, 1899), ix.

7. Arthur H. Hassall, *A Microscopical Examination of the Water Supplied to the Inhabitants of London and the Suburban Districts, illustrated by coloured plates, exhibiting the living animal and vegetable products in Thames and other waters* (London: Samuel Highley, 1850).

8. J. D. MacDonald, *A Guide to the Microscopical Examination of Drinking Water* (London: J. and A. Churchill, 1875).

9. Christopher Hamlin, *A Science of Impurity: Water Analysis in Nineteenth-Century Britain* (Bristol: Adam Hilger, 1990), 242.

10. *Guy's Hospital Gazette* (Oct. 10, 1896), 441–442. German Sims Woodhead, "Results of Researches Carried Out at the Laboratories," *Lancet* (Dec. 12, 1891), 1321–1322. Frank James, ed., *The Development of the Laboratory: Essays on the Place of Experiment in Industrial Civilization* (Hampshire: Macmillan, 1989). William John Hatcher, *Founders of Medical Laboratory Science* (London: Institute of Medical Laboratory Sciences, 1978).

11. An early history of these developments is F. Sherwood Taylor, *The Conquest of Bacteria* (1940; reprint, London: Secker and Warburg, 1970), 21.

12. Keith Vernon, "Pus, Sewage, Beer and Milk," *History of Science* 28 (1990): 289–325.

13. Vernon, "Pus, Sewage, Beer, and Milk," 294.

14. T. Mitchell Prudden, *The Story of the Bacteria* (London: Putnam's Sons, 1889), 14–15.

15. Thomas D. Brock, *Robert Koch: A Life in Medicine and Bacteriology* (Madison: Science Technology Publications, 1988), 25–30.

16. Brock, *Robert Koch,* 54–69.

17. German Sims Woodhead, *Bacteria and Their Products* (London: Walter Scott, 1891), 8.

18. Prudden, *The Story of the Bacteria,* 15.

19. Alexander Wilson, "Micro-organisms in Disease: The Microbian Craze," *Metaphysical Magazine* 2 (June 1895): 492–505.

20. Ibid., 492.

21. Ibid.

22. Mrs. Aubrey Richardson, "Nostrums and the Microbe," *Humanitarian* 11 (Aug. 1897): 111–119.

23. Quoted in Brock, *Robert Koch,* 44.

24. Ibid.

25. Ibid., 48, 54, 53.

26. See Turner, "Microscopical Communication," 221.

27. R. L. Maddox quoted in Darius, *Beyond Vision,* 13.

28. Darius, *Beyond Vision,* 13.

29. Quoted in Ibid.

30. Brock, *Robert Koch,* 119–120.

31. Quoted in Edgar Crookshank, *Photography of Bacteria* (London: H. K. Lewis, 1887), 10.

32. Brock, *Robert Koch,* 77.

33. Robert Koch, *Investigations into the Etiology of Traumatic Diseases* (1880), quoted in Brock, *Robert Koch,* 77.

34. John Tyndall, *Fragments of Science* (New York: D. Appelton, 1897), 193.

35. W. Watson Cheyne, quoted in Robert Koch, *Investigations into the Etiology of Traumatic Infective Diseases,* trans. Cheyne (London: New Sydenham Society, 1880), "Preface."

36. Robert Koch, quoted in Ibid.

37. P. H. Gosse, *Evenings at the Microscope* (London: Society for the Promotion of Christian Knowledge, 1859), reviewed in *Quarterly Journal of the Microscopical Society* 11 (1874): 258.

38. William Henry Olley, *The Wonders of the Microscope, Photographically Revealed* (London: W. Kent, 1861).

39. Lionel Beale, *The Use of the Microscope in Clinical Medicine* (London: Churchill, 1857), "Intro."

40. Ibid., text accompanying plates 1–3, "Extraneous Matter" in urine.

41. John Hall Edwards, "Photo-Micrography," *The Photographic Quarterly* 1 (Oct. 1889–July 1890): 54–67.

42. Discussed in "Micro-Photographs and Medicine," *PN* (Dec. 22, 1876), 606.

43. "Micro-Photographs as an Aid to the Study of Pathology," *PN* (Nov. 17, 1876), 552.

44. "Use of Photography in Medical Teaching," *Lancet* (Sept. 23, 1893), 758–759.

45. Crookshank, *Photography of Bacteria,* 8, 60.

46. "The Use of Photography in Medical Teaching," *Lancet* (Sept. 23, 1893): 758–759.

47. A. A. Kanthack and T. W. Connell, "The Flagella of the Tetanus Bacillus, and Other Contributions to the Morphology of the Tetanus Bacillus," *Journal of Pathology and Bacteriology* 4 (1896–1897): 452–459, 454.

48. Crookshank, *Photography of Bacteria,* 10; "On Photo-micrography and Its Value in Biological Research," *PN* 31 (1887), 473, 506; and *An Introduction to Practical Bacteriology, Based Upon the Methods of Koch* (London: H. K. Lewis, 1886).

49. Crookshank, *Photography of Bacteria,* 66, 64.

50. Ibid., 62.

51. Timothy Richard Lewis, *The Micro-organisms Found in the Blood of Man and Animals and Their Relation to Disease* (Calcutta: Office of the Superintendent of Government Printing, 1879), 25.

52. Lorraine Daston and Peter Galison, "The Image of Objectivity," *Representations* 40 (1992): 85, 81, 84.

53. *British Medical Journal* 2 (Dec. 9, 1893): 1311.

54. Edgar Crookshank, *An Introduction to Practical Bacteriology,* 18–20.

55. "Reviews and Notices," *Lancet* 1 (Feb. 4, 1899): 309–310.

56. "Review of Andrew Pringle, Practical Photomicrography," *Lancet* (July 21, 1894): 140.

57. I. H. Jennings, *How to Photograph Microscopic Objects: or Lessons in Photomicrography for Beginners* (London: Piper and Carter, 1885), 1.

58 Jennings, *How to Photograph Microscopic Objects,* 2.

59. Charles Slater and Edmund J. Spitta, *An Atlas of Bacteriology* (London: The Scientific Press, 1898), v–vi.

60. *Lancet* (Feb. 4, 1899): 309–310.

61. *Guy's Hospital Gazette* 13 (Mar. 18, 1899), 124.

62. Ibid.

63. Edward Klein, *Micro-organisms and Disease* (London: Macmillan, 1884), 14. Lewis, *The Micro-organisms Found in the Blood,* 25, 31.

64. See, e.g., the illustrations made by Mr. E. Noble Smith in Edward Klein, *Atlas of Histology* (London: Smith, Elder, and Co., 1879).

65. Klein, "Review of Crookshank's 'Photography of Bacteria,'" *Nature* 36 (Aug. 4, 1887): 317.

66. *PN* (Aug. 3, 1888): 489.

67. Ruth Richardson, *Death, Dissection, and the Destitute* (Chicago: Univ. of Chicago Press, 2000).

68. Coral Lansbury, *The Old Brown Dog: Women, Workers, and Vivisection in Edwardian England* (Madison: Univ. of Wisconsin, 1985); and Walkowitz, *City of Dreadful Delight.*

69. See Kelly Hurley, *The Gothic Body: Sexuality, Materialism, and Degeneration at the Fin de Siècle* (Cambridge: Cambridge Univ. Press, 1996), 10–20.

70. Robert Louis Stevenson, *The Strange Case of Dr. Jekyll and Mr. Hyde* (London, 1886), 72.

71. Lansbury, *The Old Brown Dog,* 12.

72. Quoted in Mary Ann Elston, "Women and Antivivisection in Victorian England, 1870–1900," in *Vivisection in Historical Perspective,* ed. Nicholas Rupke (London: Croom, Helm, 1987), 281.

73. Ornella Moscucci, *The Science of Woman: Gynaecology and Gender in England, 1800–1929* (Cambridge: Cambridge Univ. Press, 1900), 99.

74. Frank Miller Turner, *Contesting Cultural Authority: Essays in Victorian Intellectual Life* (Cambridge: Cambridge Univ. Press, 1993). See also Richard Yeo, "Science and Intellectual Authority in Mid-Nineteenth Century Britain," in *Energy and Entropy: Science and Culture in Victorian Britain,* ed. Patrick Brantlinger (Bloomington: Indiana Univ. Press, 1989).

75. F. W. Andrews, "The Growth and Work of the Pathological Department of St. Bartholomews' Hospital," *Saint Bartholomew Hospital Reports* 34 (1898): 193–204; 196.

76. See *Lancet* 152 (July 7, 1898): 41.

77. *Lancet* 138 (Dec. 12, 1891): 1321–1322.

78. Theophil Mitchell Prudden, *The Story of Bacteria and Their Relations to Health and Disease* (London: G. P. Putnam's Sons, 1889), 32.

79. Royal Society Conversazione Programme, RS.

80. Carlo Ginzburg, *Clues, Myths, and the Historical Method* (Baltimore: Johns Hopkins Univ. Press, 1992), 103.

81. Woodhead, *Bacteria and Their Products,* 80.

82. Newman, *Bacteria,* x.

83. Percy Frankland, *Our Secret Friends and Foes,* 4th ed. (London: Society for the Promotion of Christian Knowledge, 1899), 15.

84. See, e.g., "With Professor Lister—Photographs of Bacteria," *PN* (Aug. 27, 1880), 409–410.

85. Ibid.

86. John Hall Edwards, "Photo-Micrography," *The Photographic Quarterly* 1 (Oct. 1889–July 1890): 54–67.

87. Selino Bottone, "Photo-micrographs," *PN* (May 8,1885), 298–300.

88. "The Lay Newspaper as Medical Critic," *British Medical Journal* 1 (Jan. 24, 1891): 212.

89. J. W. M. Hichberger, *Images of the Army: The Military in British Art, 1815–1914* (Manchester: Manchester Univ. Press, 1988); and Pat Hodgson, *The War Illustrators* (London: Osprey, 1977).

90. Robert J. Wilkinson-Latham, *From Our Special Correspondent: Victorian War Correspondents and Their Campaigns* (London: Hodder and Stoughton, 1979), 139.

91. Lieut.-General Sir Evelyn Wood, "One of the Bravest Deeds I Ever Saw: Captain Ronald Campbell's Heroism in the Transvaal," *Pearson's* 1 (1896): 129–133.

92. Mary Louise Pratt, *Imperial Eyes: Travel Writing and Transculturation* (London: Routledge, 1992).

93. Jan Nederveen Pieterse, *White on Black: Images of Africa and Blacks in Western Popular Culture* (New Haven: Yale Univ. Press, 1992), 78–79.

94. Robert Machray and J. Arthur Browne, "The Army of the Interior," *Pearson's* 7 (Jan-June 1899): 521–525.

95. Pieterse, *White on Black,* 78–79.

96. Robert Machray, "The Army Medical Staff and Corps, and Their Work," *Pearson's* 3 (1897): 161–166; 166. Photograph caption reads "Nigger Minstrels in the Netley Hospital Theatre."

97. Annie E. Coombes, *Reinventing Africa: Museums, Material Culture and Popular Imagination in Late Victorian and Edwardian England* (New Haven: Yale Univ. Press, 1994), 102–108.

98. Quoted in Wilkinson-Latham, *From Our Special Correspondent*, 240.

99. Cecil Eby, *The Road to Armageddon: The Martial Spirit in English Popular Literature, 1870–1914* (Durham: Duke Univ. Press, 1987).

CHAPTER 5
Photographic Evidence and Mass Culture

1. Guests were served tea and coffee from Metcalfe and Crawford, pale sherry and Sauterne, madeira cakes and ice wafers from Huntley and Palmers, and raspberry and lemon candy from Gunter and Company Confectioners in London's Berkeley Square. Soiree Committee Minutes, May 10, 1872, in Misc. Comms. 1869–84 (CMB3), RS.

2. Soiree Bills, 1861–1872, 1872, RS.

3. See Alex Soojung-Kim Pang, *Empire and the Sun: Victorian Solar Eclipse Expeditions* (Stanford: Stanford Univ. Press, 2002); Holly Rothermel, "Images of the Sun: De La Rue, Airy and Celestial Photography," *British Journal of the History of Science* 26 (1993): 137–169.

4. "Celestial Photography," *PN* (June 29, 1860), 98–99.

5. Quoted in Jon Darius, *Beyond Vision* (Oxford: Oxford Univ. Press, 1984), 40.

6. Ibid., 40.

7. "Mr. Warren De la Rue's Photographs of the Moon," *PN* (June 5, 1868), 273–274.

8. "De la Rue and Celestial Photography," *PN* (July 20, 1866), 344–345.

9. "The Eclipse of the Sun," *PN* (Aug. 10, 1860), 174–5.

10. Quoted in Gérard De Vaucouleurs, *Astronomical Photography: From the Daguerreotype to the Electron Camera* (London: Faber and Faber, 1961), 44.

11. Vaucouleurs, *Astronomical Photography*, 41.

12. Pierre Janssen quoted in Vaucouleurs, *Astronomical Photography*, 42.

13. William Wesley, RAS MSS Add 20, folio entitled "A Collection of Miscellaneous Astronomical Drawings" (ca. 1882–1888) includes several loose pencil drawings of comets, often with accompanying correspondence. See, e.g., W. H. Robinson, "Comet," May 23, 1888, Radcliffe Observatory, Oxford [RAS MSS Add 20, 2.1]; and G. H. Willis, "Great Comet," Oct., 19, 1882 [RAS MSS Add 20, 2.5].

14. Richard Drayton, *Nature's Government: Science, Imperial Britain, and the 'Improvement' of the World* (New Haven: Yale Univ. Press, 2000).

15. Royal Society Conversazione Programme (1887), RS.

16. Eric Linklater, *The Voyage of the Challenger* (Garden City: Doubleday, 1972); Helen M. Rozwadowski, "Fathoming the Ocean: Discovery and Exploration of the Deep Sea, 1840–1880" (Ph.D. diss., Univ. of Pennsylvania, 1996).

17. Alfred Carpenter, HMS *Challenger* album, PH 479; SH 349, Earth Sciences Library, BMNH.

18. Elizabeth Edwards, *Raw Histories: Photographs, Anthropology and Museums* (Oxford: Berg, 2001), 113.

19. "Royal Society Soiree," *PN* (May 3, 1872), 216; "Photography at the Royal Society," *PN* (Jan. 30, 1880), 49.

20. The Whipple daguerrotype of the moon (no. 451) was discussed as part of the jury's overview of photographs displaying scientific improvements in photography. See *Reports by the Juries:*

Exhibition of the Works of Industry of All Nations, 1851 (London: William Clowes and Sons, 1852), 275–279.

21. H. Baden Pritchard, *The Photographic Studios of Europe* (1882, reprint, New York: Arno Press, 1973), 83–92.

22. Minutes, Photographic Comm., Dec. 14, 1894, RAS.

23. Minutes, Photographic Comm., April 13 and June 8, 1888, RAS.

24. A list of the photographs presented was published in the RAS's official publication, the *Monthly Notices,* with a brief description of each. Minutes, Photographic Comm., Feb. 6, 1891, RAS.

25. Minutes, Photographic Comm., April 14, 1893, RAS; Minutes, Photographic Comm., Nov. 8, 1895, RAS; [MC.15.65] March 19, 1890 RS; [MC.16.4] Jan. 30, 1893, RS; Minutes, Photographic Comm, May 12, 1893, RAS; Minutes, Photographic Comm., June 10, 1898, RAS; Minutes, Photographic Comm., April 14, 1893, RAS.

26. Excerpt of Mitchell's letter to Bond reproduced in Henry Albers, ed. *Maria Mitchell: A Life in Journals and Letters* (New York: College Avenue Press, 2001), 93–94.

27. Minutes, Photographic Comm., April 14, 1893; Jan. 12, 1906; May 10, 1895; Feb 6, 1891, RAS.

28. W. H. Flowers, *Proceedings of the BAAS* 64 (1894). See also H. H. Turner, "What Shall We Do with Our Photographs?" *Journal of the British Astronomical Assoc.* 217 (Aug. 1894): 257–262.

29. Minutes, Photographic Comm., April 14, 1893, RAS.

30. Sub-committee meeting, Photographic Comm., June 10, 1892, RAS; Minutes, Photographic Comm., April 14, 1893, RAS.

31. See, e.g., "Reproduction of Astronomical Photographs," *Monthly Notices* (June 14, 1895), 408–409.

32. Minutes, Photographic Comm., Nov. 8, 1895; Minutes, Photographic Comm., Revenue account, Dec. 1898, Jan.–Dec. 1900; Minutes, Photographic Comm, Apr. 10, 1895; Mar. 13, 1896, RAS.

33. Minutes, Photographic Comm, Jan. 8, 1904, RAS.

34. Ibid., Dec. 14, 1894.

35. Minutes, Photographic Comm, Jan. 13, 1893; Apr. 10, 1895; Dec. 10, 1897, RAS.

36. "Doubt-killing bullets from the planet of war" is from Percival Lowell, "New Photographs of Mars," *Century Magazine* 53 (Nov. 1907–April 1908): 308. Stewart Richards, *Philosophy and Sociology of Science: An Introduction* (Oxford: Basil Blackwell, 1987), esp. 197–222. Three classic works in the study of scientific controversy are David Bloor, *Knowledge and Social Imagery* (London: Routledge and Kegan Paul, 1976); Ludwig Fleck, *Genesis and the Development of a Scientific Fact* (Chicago: Univ. of Chicago Press, 1979; first published in Germany in 1935); and Steven Shapin, "History of Science and its Sociological Reconstructions," *History of Science* 20 (1982): 157–211.

37. For the context, see David Strauss, *Percival Lowell: The Culture and Science of a Boston Brahmin* (Cambridge: Harvard Univ. Press, 2001).

38. See Giovanni Schiaparelli, "Osservazioni sulla topografia del planeta Marte," *Opere* 1: 379–388, trans. in *Popular Science Monthly* 24 (Dec. 1883): 249–253; and Schiaparelli, "Descouvertes nouvelles sur la planete Mars," *Opere* 1: 389–394.

39. See, e.g., London *Daily Graphic* (June 1905), scrapbook of press clippings, LOA.

40. Maunder's works include *The Royal Observatory, Greenwich, A Glance at its History and Work* (London, 1902); *Astronomy Without a Telescope* (London, 1903); *Astronomy of the Bible: An Elementary Commentary on the Astronomical References of Holy Scripture* (London, 1908); and, with Annie Russell, *The Heavens and Their Story* (London, 1910).

41. Deborah Jean Warner, "Edward Walter Maunder," *Dictionary of Scientific Biography*, 183–185.

42. See Edward Walter Maunder, "The 'Canals' on Mars," *Knowledge* 17 (Nov. 1, 1894): 249–250; "Some Facts That We Know About Mars," *Journal of the British Astronomical Association* 20 (Nov. 1909): 82–89; and "The 'Canals' of Mars," *Rivista di Scienza* 7 (1910): 253–269.

43. Michael J. Crowe, *The Extraterrestrial Life Debate, 1750–1900: The Idea of a Plurality of Worlds from Kant to Lowell* (Cambridge: Cambridge Univ. Press, 1986), 490, 498–99.

44. "Meeting of the Royal Astronomical Society, 12 May 1893," *Observatory* 16 (June 1893): 217–226; 219. Simon Schaffer has shown that the notion of the "personal equation" was linked to specific political and moral ideologies connected with Sir George Airy's astronomical regime at Greenwich Observatory. See Schaffer, "Astronomers Mark Time: Discipline and the Personal Equation," *Science in Context* 2 (1988): 115–145.

45. "Nathaniel Green," *Monthly Notices of the Royal Astronomical Society* 60 (1900): 320.

46. "Proceedings at Meeting of the Royal Astronomical Society," *Observatory* 5 (1882): 135–137; 135, 136. One British astronomer, Rev. Thomas William Webb, remarked that

> at first sight, there was more apparent difference in [Schiaparelli and Green's maps] than might have been expected . . . It is not surprising that in the case of minute details each should have caught something peculiarly his own; but there is a general want of resemblance not easily explained . . . Green, an accomplished master of form and colour, has given a portraiture, the resemblance of which as a whole, commends itself to every eye familiar with the original . . . The Italian professor, on the other hand, inconvenienced by colour-blindness, but of micrometric vision . . . has plotted a sharply-outlined chart, which . . . no one would at first imagine to be intended as a representation of Mars. His style is as unpleasantly conventional as that of Green indicates the pencil of an artist . . . one has produced a picture, the other a plan.

Quoted in William Sheehan, *Planets and Perception: Telescopic Views and Interpretations, 1606–1909* (Tuscon: Univ. of Arizona Press, 1988), 106–108.

47. Green's dispute with Schiaparelli is discussed in Crowe, *The Extraterrestrial Life Debate*, 488–490; and Sheehan, *Planets and Perception*, 106–109.

48. "Proceedings at Meeting of the Royal Astronomical Society," *Observatory* 5 (1882): 136.

49. Richard A. Proctor, "Canals on the Planet Mars," *Times* (13 April 1882): 12.

50. Quoted in William Graves Hoyt, *Lowell and Mars* (Tuscon: Univ. of Arizona Press, 1976), 209. For the *Times* coverage, see "Canals on the Planet Mars," and T. W. Webb, "On the Canals on the Planet Mars" (Apr. 10, 1882), 4; "Canals on the Planet Mars," and R. A. Proctor, "Canals on the Planet Mars" (Apr. 13, 1882), 12. See also "Canals in Mars" (Sept. 29, 1905), 2. See also "CANALS Our Canals" (May 16, 1894), 12; "Our Canals" (June 7, 1894), 13; Henry Taylor, "Our Canals" (Aug. 28, 1894), 3; L. B. Wells, "Our Canals" (Aug. 31, 1894), 9; and "Twenty-Fifth Anniversary of Suez Canal" (Nov. 20, 1894), 10.

51. A. Mercier, the author of *Communication avec Mars* , quoted in Crowe, *The Extraterrestrial Life Debate*, 397; see also Crowe, *The Extraterrestrial Life Debate*, 394–395. See Francis Galton, "Intelligible Signals Between Neighboring Stars," *Fortnightly Review* 60 (Nov. 1896): 657–664; Derek W. Forrest, *Francis Galton: The Life and Work of a Victorian Genius* (New York: Taplinger, 1974), 238. *Pall Mall Gazette* (Aug. 18, 1892). Quoted in Joseph Norman Lockyer, "The Opposition of Mars," *Nature* 46 (Sept. 8, 1892): 443–444.

52. Percival Lowell, *The Soul of the Far East* (1888; New York: Macmillan, 1911), 111.

53. See "The Lowell Observatory," *Observatory* 17 (Sept. 1894): 311–312. Schiaparelli's theory of

a socialist Mars is presented in Giovanni Schiaparelli, "La vie sur la planete Mars," *Société astronomique de France bulletin* 12 (1898): 423–429. Lowell quoted in Hoyt, *Lowell and Mars,* 79; and Crowe, *The Extraterrestrial Life Debate,* 515. On the political uses to which Mars was put, see also Norriss S. Hetherington, "Lowell's Theory of Life on Mars," *Astronomical Society of the Pacific Leaflet,* no. 409 (March 1971).

54. Gérard de Vaucouleurs, "Discovering M31's Spiral Shape," *Sky and Telescope* (Dec. 1987): 595–598.

55. Percival Lowell, "Mars," *Astronomy and Astro-Physics* 13 (Aug. 1894): 538–553. Percival Lowell, *Mars and its Canals* (New York and London: 1906), 162–165.

56. J. E. Evans and Edward Walter Maunder, "Experiments as to the Actuality of the 'Canals' Observed on Mars," *Monthly Notices of the RAS* 63 (1903): 488–497.

57. Percival Lowell to Editor of the *Illustrated London News* (Nov. 27, 1903); Lowell to E. W. Maunder (Nov. 28, 1903), Lowell Letters, LOA.

58. Percival Lowell to Carl Lampland (May 16, 1904), Lowell Letters, LOA.

59. Edward Barnard, "Astronomical Photography," *Photographic Times* 27 (Aug. 1895): 13.

60. Ibid.

61. Ibid.

62. Discussed in Hoyt, *Lowell and Mars,* 133, 175.

63. Crowe, *The Extraterrestrial Life Debate,* 640, n. 299.

64. Letter from RPS secretary to Lowell, Sept. 30, 1907, LOA. "I have much pleasure in informing you that the Judges of the Technical Section have awarded you a Medal for the photographs of Mars." The letter indicates there was some confusion over the attribution of this achievement: "I am not quite sure whether the inscription should be in your name only or the name of yourself and Professor [Carl] Lampland."

65. *Wall Street Journal* (Dec. 28, 1907), press clippings, LOA.

66. Hoyt, *Lowell and Mars,* 132, 134–135.

67. Lowell, "New Photographs of Mars," 308.

68. Quoted in Hoyt, *Lowell and Mars,* 209.

69. Andrew C. D. Crommelin, quoted in *Journal of the British Astronomical Association* 38 (1905): 452. Robert J. Strutt (Lord Rayleigh), "Celestial Photography and the 'Canals' of Mars," London *Tribune* (Feb. 13, 1906), press clippings, LOA. William H. Wesley, "Photographs of Mars," *Observatory* 28 (1905): 314.

70. Sheehan, *Planets and Perception,* 109.

71. Percival Lowell, "First Photographs of the Canals of Mars," *Royal Society of London Proceedings* 77A (1906): 134.

72. "Proceedings at Meeting of the RAS," *Observatory* 20 (Jan. 1904): 49.

73. On visual representations of landscapes west of the Mississippi and their use in appeals to the traveling public, see Edward Buscombe, "Inventing Monument Valley: Nineteenth-Century Landscape Photography and the Western Film," in *Fugitive Images: From Photography to Video,* ed. Patrice Petro (Bloomington: Indiana Univ. Press, 1995), 87–108.

74. "Meeting of the Royal Astronomical Society," *Observatory* 33 (May 1910): 194.

75. I thank P. D. Hingley for sharing his knowledge of Wesley and his artistry.

76. Wesley, "Photographs of Mars," 314.

77. The subject of retouching in astronomy is discussed in Barbara Becker, "Eclecticism, Opportunism, and the Evolution of a New Research Agenda: William and Margaret Huggins and the Origins of Astrophysics" (Ph.D. diss., Johns Hopkins Univ., 1993); and Alex Soojung-Kim Pang, "Victorian Observing Practices, Printing Technology and Representations of the Solar Corona," *Journal of the History of Astronomy* 25 (1994): 249–274.

78. Lowell, "First Photographs of the Canals of Mars," 134.

79. Lowell, "New Photographs of Mars," 308.

80. Wesley, "Photographs of Mars," 314.

81. Herbert H. Turner, "From an Oxford Note-Book," *Observatory* 28 (1905): 336.

82. "Meeting of the Royal Astronomical Society, 8 April 1910," *Observatory* 33 (May 1910): 191–199; 195.

83. "Photographs of the Canals on Mars," *Knowledge and Scientific News* 3 (Mar. 1906): 369. (Drawings by Percival Lowell.)

84. Lowell, "First Photographs of the Canals of Mars," 135.

85. The *Sphere* article [n.d.] is on deposit in the press clipping scrapbooks at LOA, with other examples of Mars drawings passed off as photographs.

86. "The Lowell Observatory," 308.

87. Quoted in Hoyt, *Lowell and Mars,* 186.

88. Percival Lowell, "Mars as the Abode of Life, First Paper: The Genesis of a World," *Century Magazine* 53 (Nov. 1907–Apr. 1908): 113–126.

89. *Wall Street Journal* (Dec. 28, 1907), press clippings, LOA.

90. Percival Lowell to G. Agassiz (Sept. 16, 1907), Lowell Letters, LOA.

91. Percival Lowell, "New Photographs of Mars, Taken by the Astronomical Expedition to the Andes and Now First Published," *Century Magazine* 53 (Nov. 1907–Apr. 1908): 303–311.

92. C. Watney to Lowell (July 5, 1907), Lowell Letters, LOA.

93. Pamela O. Long, "Invention, Authorship, 'Intellectual Property,' and the Origin of Patents: Notes Toward a Conceptual History" *Technology and Culture* 32, no. 4 (Oct. 1991): 846–884. On the modern intellectual property system and current law regarding property rights in images, see Vivian Weil and John W. Snapper, *Owning Science and Technical Information* (New Brunswick: Rutgers Univ. Press, 1989); and Larry Gross, John S. Katz, and Jay Ruby, eds., *Image Ethics: The Moral Rights of Subjects in Photographs, Film, and Television* (Oxford: Oxford Univ. Press, 1988).

94. C. Watney to Percival Lowell (Oct. 26, 1907), Lowell Letters, LOA.

95. Hector Macpherson Jr. "Mars and its Canals: Is Mars Inhabited? The Question Examined in Light of Mr. Lowell's Recent Photographs of the Martian Canals," *Scottish Review* (Nov. 23, 1905), 464–465. On deposit in press clippings, LOA.

96. Hector Macpherson Jr. to Percival Lowell (Sept. 30, 1909), Lowell Letters, LOA.

97. Macpherson, "Mars and Its Canals," 464–465.

98. Percival Lowell to C. V. Van Anda (ca. Nov. 1905), Lowell Letters, LOA.

99. Percival Lowell to George Agassiz (Sept. 16, 1907), Lowell Letters, LOA.

100. Lowell, "New Photographs of Mars," 308.

101. Garrett P. Serviss, "Photographs of Mars," unidentified newspaper (June 1905), LOA.

102. Lowell, "New Photographs of Mars," 308; "First Photographs of the Canals of Mars," 134–135.

103. Percival Lowell to William Wesley (July 9, 1907); Lowell to G. Agassiz (Sept. 16, 1907); G. R. Agassiz to Lowell (Sept. 27, 1907), Lowell Letters, LOA.

104. R. U. Johnson to Lowell (Oct. 7, 1907), Lowell Letters, LOA.

105. Ken Baynes, ed. *Scoop, Scandal and Strife: A Study of Photography in Newspapers* (London: Lund Humphries, 1971).

106. R. U. Johnson to Lowell (Oct. 7, 1907), Lowell Letters, LOA.

107. Lowell to E. C. Slipher (Oct. 1, 1907), Lowell Letters, LOA.

108. Lowell, "New Photographs of Mars," 308.

109. Quotes in "The Lowell Observatory," 312.

110. "Report of the Meeting of the [British Astronomical] Association," *Journal of the BAA* 20 (Dec. 29, 1909): 119.

111. H. G. Wells, "The Things That Live on Mars," *Cosmopolitan* (March 1908): 335–342; 335.

112. I thank Walter Reed, historian at the Illustration House in New York City, for providing me with biographical information about Leigh.

113. H. G. Wells, "Popularizing Science," *Nature* (July 26, 1894); "The Things that Live on Mars," 342.

114. Hoyt, *Lowell and Mars,* quote on p. 85.

115. Percival Lowell, "Mars," *Astronomy and Astro-Physics* 13 (Aug. 1894): 538–553.

116. Wells, "The Things that Live on Mars," 336.

117. Mark Wicks, *To Mars Via the Moon: An Astronomical Story* (London: Seeley and Co, 1910).

118. London *Daily Graphic* (Sept. 30, 1910). Enclosed with letter to Lowell from Wicks, Sept. 24, 1907, Lowell Letters, LOA.

119. Wicks, *To Mars via the Moon: An Astronomical Story,* 310, 312.

120. For more on Antoniadi's shifting views of Mars, see Crowe, *The Extraterrestrial Life Debate,* 519–520.

121. Crowe, *The Extraterrestrial Life Debate,* 519.

122. E. M. Antoniadi, "Further Considerations on Gemination," *Journal of the BAA* 8 (1898): 308–310; 310.

123. Marianne Hirsch, ed. *The Familial Gaze* (Hanover: Univ. Press of New England, 1999), xi–xxv.

EPILOGUE

1. Alex Owen, " 'Borderland Forms': Arthur Conan Doyle, Albion's Daughters, and the Politics of the Cottingley Fairies," *History Workshop Journal* 38 (1994): 48–85.

2. Martyn Jolly, *Faces of the Living Dead: The Spirit Photography of Mrs. Ada Deane,* 27–39. Privately published catalogue for an exhibition of spirit photography works at the Canberra Contemporary Art Space (2001).

3. *New York Times,* as quoted in "Sir Arthur Conan Doyle at Carnegie Hall," *Harbinger of Light* (July 1923).

4. Phil Christensen, quoted in Oliver Morton, "Mars Revisited," *National Geographic* (Jan. 2004), 15.

5. Vicki Goldberg, *The Power of Photography: How Photographs Changed Our Lives* (New York: Abbeville, 1991), 54–55.

6. Fred Hoyle, quoted in Jon Darius, *Beyond Vision* (Oxford: Oxford Univ. Press, 1984), 142.

7. Quoted by William Anders of *Apollo 8,* in Darius, *Beyond Vision,* 142.

8. For an insightful overview of this discussion, see Andy Grundberg, "Ask It No Questions: The Camera Can Lie," *New York Times* (Aug. 12, 1990), Arts and Leisure Sect., pp. 1, 29.

9. Elizabeth Edwards, *Raw Histories: Photographs, Anthropology and Museums* (Oxford: Berg, 2001), 12.

10. Walter Benjamin, "The Work of Art in the Age of Mechanical Production," in *Illuminations,* ed. Hannah Arendt, trans. Harry Zohn (New York: Schocken, 1969), 217–252; Judith Butler, *Gender Trouble: Feminism and the Subversion of Identity* (New York: Routledge, 1999); and Denise Riley, *Am I That Name? Feminism and the Category of "Women" in History* (Minneapolis: Univ. of Minnesota Press, 1988).

Essay on Sources

This essay reviews the photographic collections, organizational and private papers, books, newspapers, journals, and other sources used to research this book. For articles in newspapers, magazines, and scientific and medical journals, the reader is directed to specific references in the notes.

The photographic holdings of scientific organizations, private and public observatories, science museums, and teaching hospitals in Britain provide a wealth of materials and information. Scientific photographs, unlike some other types of photography, often are organized by subject rather than by the photographer's name. Therefore, the *Photographic News,* while generally not containing photographs, is a valuable preliminary guide containing historical information about the subjects that Victorian scientists and photographers thought photography should be used to investigate. It also records new technical processes, controversies, gossip, future predictions, and various reactions to photography as a new scientific tool.

The National Museum of Photography, Film, and Television in Bradford, England, and George Eastman House in Rochester, New York, are wonderful sources of early photographers' interest in scientific themes and subjects, such as the Amateur Photographic Exchange albums from the 1850s and 1860s. Concerning spirit photography, I relied on the American Society for Psychical Research; the British Library; Cambridge University Library (Society for Psychical Research Papers); George Eastman House; National Museum of Photography, Film, and Television; J. Paul Getty Museum; and the Humanities Research Center at the University of Texas, Austin. The Theatre Museum in Covent Garden, London, provided valuable sources of the history of theatrical productions involving ghosts. The Galton papers at London's Imperial College of Science, Technology, and Medicine helped to elucidate the issues at stake in the Tichborne claimant trial.

The Royal Meteorological Society and the Royal Society provided numerous photographs, lantern slides, and albums, and at the Royal Society I found albums of cloud photographs compiled by Charles Piazzi Smyth. Photographic collections at the Pitt Rivers Museum at Oxford University and the Royal Anthropological Institute in London helped to contextualize the classification tropes in Victorian scientific photographs and uncovered X-Ray images used in anthropological research. The Irish photographic albums made for the Geology Section of the British Association for the Advancement of Science and Robert Welch's glass-plate negatives of geological forms, which I viewed at the Department of Geology, Ulster Museum, Belfast, Northern Ireland, provided insights into photographic methods used in field sciences. The photographic records and publications of the Pathological Society of Great Britain, the History of Science Museum in Oxford (Royal Microscopical Society collection), and the Wellcome Institute for the History of Medicine offered a wealth of information about scientific photography far beyond the roles of these institutions.

Thousands of medical drawings, watercolors, and photographs made from 1870 to 1900 survive today in British medical archives and teaching hospitals, with St. Bartholomew's and London Hospital having particularly rich collections. The photographs, drawings, and engravings at

the Royal Astronomical Society were particularly relevant. This well-organized archive is a wonderful resource for anyone studying the visual culture of astronomy. The Lowell Observatory Archives in Flagstaff, Arizona, provided a wealth of sources of Martian photography, including original photographs and correspondence. More than 3,000 clippings from newspapers and periodicals on Lowell's research are preserved there in four large notebooks.

Readers interested in the history of photography within science should begin with two excellent overviews: Jon Darius, *Beyond Vision* (Oxford: Oxford Univ. Press, 1984), and Ann Thomas, ed., *Beauty of Another Order: Photography in Science* (New Haven: Yale Univ. Press, 1997). Much of the historical literature on scientific photography consists of chapters or short discussions in general histories of photography. These include Hubertus von Amelunxen, Stefan Iglhaut, Florian Rotzer, eds., *Fotographie nach der Fotografie* (Munich: Siemens Kulturprogram; Aktionsforum Praterinsel, 1996); Helmut Gernsheim, *The Rise of Photography, 1850–1880: The Age of Collodion,* 3d ed. (London: Thames and Hudson, 1988); Heinz K. Henisch and Bridget A. Henisch, *The Photographic Experience, 1839–1914: Images and Attitudes* (University Park: Pennsylvania State Univ. Press, 1994); Ian Jeffrey, *Photography: A Concise History* (New York: Oxford Univ. Press, 1981); and Jean-Claude Lemagny and André Rouillé, eds., *A History of Photography: Social and Cultural Perspectives* (Cambridge: Cambridge Univ. Press, 1987). A number of important works chronicle the development of photography within distinct scientific disciplines.

Astronomy, anthropology, medicine, and eugenics, in which photography rapidly was incorporated as a research method, are the sciences whose photographic histories have been best documented and analyzed. Studies of Victorian astronomical photography include Barbara Jean Becker, "Eclecticism, Opportunism, and the Evolution of a New Research Agenda: William and Margaret Huggins and the Origins of Astrophysics" (Ph.D. diss., Johns Hopkins Univ., 1994); Gérard De Vaucouleurs, *Astronomical Photography: From the Daguerreotype to the Electron Camera* (London: Faber and Faber, 1961); Holly Rothermel, "Images of the Sun: De La Rue, Airy and Celestial Photography," *British Journal of the History of Science* 26 (1993): 137–169; Simon Schaffer, "Astronomers Mark Time: Discipline and the Personal Equation," *Science in Context* 2 (1988): 115–145; Alex Soojung-Kim Pang, *Empire and the Sun: Victorian Solar Eclipse Expeditions* (Stanford: Stanford Univ. Press, 2002); and Deborah Jean Warner, "The American Photographical Society and the Early History of Astronomical Photography in America," *Photographic Science and Engineering* 11 (Sept.–Oct. 1967): 342–347.

Anthropology, like astronomy, is a historical and visual discipline that evolved alongside photography during the nineteenth century, and several works on anthropological photography are breakthroughs in photographic criticism and theory, in addition to enriching photographic history. Excellent works that theorize new ways of looking at photographs (for example, reflecting on how they acquire meaning as they travel and are viewed, and on photographic consumption) include Elizabeth Edwards, *Raw Histories: Photographs, Anthropology and Museums* (Oxford: Berg, 2001); Elizabeth Edwards, ed., *Anthropology and Photography, 1860–1920* (New Haven: Yale Univ. Press, 1992); Christopher Pinney, *Camera Indica: The Social Life of Indian Photographs* (Chicago: Univ. of Chicago Press, 1997); Deborah Poole, *Vision, Race and Modernity: A Visual Economy of the Andean Image World* (Princeton: Princeton Univ. Press, 1997); and James Ryan, *Picturing Empire: Photography and the Visualization of the British Empire* (Chicago: Univ. of Chicago Press, 1997). Although my research did not focus on anthropological photography, the interpretive framework is indebted to works like these.

For an introduction to the history of nineteenth-century medical photography, I recommend Daniel M. Fox and Christopher Lawrence, *Photographing Medicine: Images and Power in Britain and America since 1840* (New York: Greenwood, 1988); and Sander L. Gilman, *Disease*

and Representation: Images of Illness from Madness to AIDS (Ithaca: Cornell Univ. Press, 1988). Shawn Michelle Smith's excellent book *American Archives: Gender, Race, and Class in Visual Culture* (Princeton: Princeton Univ. Press, 1999) also touches on medical and scientific themes.

Since the early 1900s, a growing number of works in scientific photography studies have explored the "photography of the invisible" as a common denominator of photographs emanating from several different disciplines, from physics to spiritualism. Histories that may be considered in this category include Lorraine Daston and Peter Galison, "The Image of Objectivity," *Representations* 40 (1992): 81–128; Peter Geimer, ed., *Ordnungen der Sichtbarkeit: Fotografie in Wissenschaft, Kunst und Technologie* (Frankfurt am Main: Suhrkamp, 2002); and Alex Owen, " 'Borderland Forms': Arthur Conan Doyle, Albion's Daughters, and the Politics of the Cottingley Fairies," *History Workshop Journal* 38 (1994): 48–85.

Two subfields within the broader category of "photography of the invisible" are spirit photography and X-ray photography. There is as yet no single monograph on the history of spirit photography, but works on this topic are in progress. For general reference, I highly recommend James Coates, *Photographing the Invisible: Practical Studies in Spirit Photography, Spirit Portraiture, and Other Rare but Allied Phenomena* (London: Fowler and Co., 1911); Christa Cloutier, "Mumler's Ghosts: The Trial and Tribulations of Spirit Photography" (M.A. thesis, Arizona State Univ., 1998); Robert Cox, "The Transportation of American Spirits: Gender, Spirit Photography, and American Culture, 1861–1880," *Ephemera Journal* 7 (1994): 94–104; Fred Gettings, *Ghosts in Photography: The Extraordinary Story of Spirit Photography* (New York: Harmony Press, 1978); Tom Gunning, "Phantom Images and Modern Manifestations: Spirit Photography, Magic Theater, Trick Films, and Photography's Uncanny," in *Fugitive Images: From Photography to Video,* ed. Patrice Petro (Bloomington: Indiana Univ. Press, 1995): 42–71; Martyn Jolly, *Faces of the Living Dead: The Spirit Photography of Mrs. Ada Deane,* publication accompanying the "Faces of the Dead" exhibition (Sydney: Scott Donovan Gallery, 2001); and Cyril Permutt, *Photographing the Spirit World: Images from Beyond the Spectrum* (London: Aquarian, 1988).

For background on the contexts that spiritualism and psychical research provided for this interest in phenomena on the threshold of human vision, I found several books and articles particularly valuable: Logie Barrow, *Independent Spirits: Spiritualism and English Plebeians, 1850–1910* (London: Routledge and Kegan Paul, 1986); Diana Basham, *Trial of Woman: Feminism and the Occult Sciences in Victorian Literature and Society* (New York: New York Univ. Press, 1992); John James Cerullo, "The Secularization of the Soul: Psychical Research in Britain, 1882–1920" (Ph.D. diss., Univ. of Pennsylvania, 1980); Joy Dixon, *Divine Feminine: Theosophy and Feminism in England* (Baltimore: Johns Hopkins Univ. Press, 2001); Trevor N. Hall, *The Medium and the Scientist: The Story of Florence Cook and William Crookes* (Buffalo: Prometheus, 1984); Malcolm Kottler, "Alfred Russell Wallace, The Origin of Man, and Spiritualism," *Isis* 65 (1974): 144–192; Richard Noakes, " 'Instruments to Lay Hold of Spirits': Technologising the Bodies of Victorian Spiritualism," in *Bodies/Machines,* ed. Iwan Rhys Morus (Oxford: Berg, 2002); Janet Oppenheim, *The Other World: Spiritualism and Psychical Research in England, 1850–1914* (Cambridge: Cambridge Univ. Press, 1985); Alex Owen, *The Darkened Room: Women, Power, and Spiritualism in Late Victorian England* (London: Virago, 1989); Michael Shermer, "A Heretic-Scientist Among the Spiritualists: Alfred Russell Wallace and 19th-century Spiritualism," *Skeptic* 3 (1994): 70–83; Frank M. Turner, *Between Science and Religion: The Reaction to Scientific Naturalism in Late Victorian England* (New Haven: Yale Univ. Press, 1974); and Alison Winter, *Mesmerized: Powers of Mind in Victorian Britain* (Chicago: Univ. of Chicago Press, 1998). To interpret the symbols and icons in the spirit photographs, I consulted several works on mourning rituals and images of heaven, including Colleen McDannell and Bernhard Lang, *Heaven: A History* (New Haven: Yale

Univ. Press, 1988), and Lou Taylor, *Mourning Dress: A Costume and Social History* (London: Allen and Unwin, 1983). To contextualize discussions of "reserve" forces in spirit photography, I used Crosbie Smith and M. Norton Wise, *Energy and Empire: Biographical Studies of Lord Kelvin* (Cambridge: Cambridge Univ. Press, 1989).

General histories of X-ray photography that delve into issues of scientific controversy, evidence, practice, and professionalism include Joel Howell, "Diagnostic Technologies: X-Rays, Electrocardiograms, and CAT Scans," *Southern California Law Review* 65 (1991): 529–564; Edmund H. Burrows, *Pioneers and Early Years: A History of British Radiology* (St. Anne: Colophon, 1986); Edward Halperin, "X-Rays at the Bar, 1896–1910," *Investigative Radiology* 23 (Aug. 1988): 639–646; Nancy Knight, "'The New Light: X-Rays and Medical Futurism," in *Imagining Tomorrow: History, Technology, and the American Future,* ed. Joseph Corn (Cambridge: MIT Press, 1986), 10–34; Emanuel R. N. Grigg, *The Trail of the Invisible Light: From X-Strahlen to Radio(bio)logy* (Springfield, IL: Thomas, 1965); Nora H. Schuster, "Early Days of Roentgen Photography in Britain," *British Medical Journal* 2 (Nov. 3, 1962): 1164–1167.

Readers can glean valuable information about scientific photography from biographies of pioneers in photographic technology and scientific applications of photography, such as these excellent works: Marta Braun, *Picturing Time: The Work of Etienne-Jules Marey* (Chicago: Univ. of Chicago Press, 1992); Douglas R. Nickel, "Nature's Supernaturalism: William Henry Fox Talbot and Botanical Illustration," in *Intersections: Lithography, Photography, and the Traditions of Printmaking,* ed. Kathleen Stewart Howe (Albuquerque: Univ. of New Mexico Press, 1998), 15–23; Larry J. Schaaf, *The Photographic Art of William Henry Fox Talbot* (Princeton: Princeton Univ. Press, 2000); Larry J. Schaaf, *Out of the Shadows: Herschel, Talbot and the Invention of Photography* (New Haven: Yale Univ. Press, 1992); and Rebecca Solnit, *River of Shadows: Eadweard Muybridge and the Technological Wild West* (New York: Viking, 2003).

General histories of the development of scientific techniques and processes in photography include: M. Susan Barger and William B. White, *The Daguerreotype: Nineteenth-century Technology and Modern Science* (1991; reprint, Baltimore: Johns Hopkins Univ. Press, 2000); William Crawford, *The Keepers of the Light: A History and Working Guide to Early Photographic Processes* (Dobbs Ferry, NY: Morgan and Morgan, 1979); Reese Jenkins, *Images and Enterprise: Technology and the American Photographic Industry, 1839–1925* (Baltimore: Johns Hopkins Univ. Press, 1975); Estelle Jussim, *Visual Communication and the Graphic Arts: Photographic Technologies in the Nineteenth Century* (New York: R. R. Bowker, 1974).

For an excellent introduction to the issues raised by the history of photographic witnessing, see Vicki Goldberg, *The Power of Photography: How Photographs Changed Our Lives* (New York: Abbeville, 1991); Peter Hamilton and Roger Hargreaves, *The Beautiful and the Damned: The Creation of Identity in Nineteenth Century Photography* (London: Lund Humphries, 2001); William Ivins, *Prints and Visual Communication* (1953; Cambridge: MIT Press, 1982); Sandra S. Phillips, Mark Haworth-Booth, and Carol Squiers, *Police Pictures: The Photograph as Evidence* (San Francisco: San Francisco Museum of Modern Art, 1997); Lorraine Monk, *Photographs That Changed the World: The Camera as Witness, the Photograph as Evidence* (New York: Doubleday, 1989); Susan Sontag, *On Photography* (New York: Farrar, Straus, and Giroux, 1977); and John Tagg, *The Burden of Representation: Essays on Photographies and Histories* (London: Macmillan, 1988).

These works explore the historical meaning of observation and what it means to be a scientific observer: Jonathan Crary, *Techniques of the Observer: On Vision and Modernity in the Nineteenth Century* (Cambridge: MIT Press, 1992); Lorraine Daston, "Objectivity and the Escape from Perspective" in *Science Studies Reader,* ed. Mario Biagioli (New York: Routledge, 1999); Lud-

wig Fleck, *Genesis and the Development of a Scientific Fact* (Chicago: Univ. of Chicago Press, 1979; first published in Germany in 1935); Peter Galison, *Image and Logic: A Material Culture of Microphysics* (Chicago: Univ. of Chicago Press, 1997); Donna J. Harway, *Primate Visions: Gender, Race, and Nature in the World of Modern Science* (New York: Routledge, 1987); Joseph Rouse, *How Scientific Practices Matter: Reclaiming Philosophical Naturalism* (Chicago: Univ. of Chicago Press, 2002); Simon Schaffer, "Where Experiments End: Tabletop Trials in Victorian Astronomy" in *Scientific Practice: Theories and Stories of Doing Physics,* ed. Jed Z. Buchwald (Chicago: Univ. of Chicago Press, 1995): Steven Shapin and Simon Schaffer, *Leviathan and the Air Pump: Hobbes, Boyle, and the Experimental Way of Life* (Princeton: Princeton Univ. Press, 1985); Steven Shapin, "The Politics of Observation: Cerebral Anatomy and Social Interests in the Edinburgh Phrenology Dispute" in *On the Margins of Science: The Social Construction of Rejected Knowledge,* ed. Ron Wallis (Keele: The Univ. of Keele, 1979). Photography, as well as opening new ways of seeing, was a new way of being seen. Two outstanding works on the disciplining of observation and the body by means of photography are Suren Lalvani, *Photography, Vision and the Production of Modern Bodies* (New York: SUNY Press, 1996); and Alan Sekula, "The Body and the Archive" in *The Contest of Meaning: Critical Histories of Photography,* ed. R. Bolton (Cambridge: MIT Press, 1989).

For locating photography within the larger history of intellectual property rights in the media, see Vivian Weil and John W. Snapper, *Owning Science and Technical Information* (New Brunswick: Rutgers Univ. Press, 1989), and Larry Gross, John S. Katz, and Jay Ruby, eds., *Image Ethics: The Moral Rights of Subjects in Photographs, Film, and Television* (Oxford: Oxford Univ. Press, 1988). Related works that provide excellent discussions of digital imaging processes include Hubertus von Amelunxen, Stefan Iglhaut, Florian Rotzer, eds., *Fotographie nach der Fotographie* (Munich: Siemens Kulturprogram; Aktionsforum Praterinsel, 1996); Howard Besser and Sally Hubbard, *Introduction to Imaging* (Los Angeles: Gerry Research Institute, 2003); and Howard Besser and Jennifer Trant, *Introduction to Imaging: Issues in Constructing an Image Database* (Santa Monica: Gerry Art History Institute, 1995).

Recent scholarship on photographic exhibition and display sheds new light on how institutions in the natural and physical sciences accumulated photographs for conservation and viewing, particularly in the medical and anthropological sciences. Definitive histories include Julie K. Brown, *Making Culture Visible: The Public Display of Photographs at Fairs, Expositions, and Exhibitions in the United States, 1847–1900* (Australia: Harwood Academic Publishers, 2001), and *Contesting Images: Photography and the World's Columbian Exhibition* (Tucson: Univ. of Arizona, 1994), as well as several of the anthropological works discussed above. Neil Harris's *Humbug! The Art of P. T. Barnum* (Boston: Little, Brown, 1973) is an outstanding history that combines a history of popular epistemology with a study of how Barnum cannily manipulated elements of science and entertainment to heighten his shows' appeal.

A related, rich literature on the history of scientific collections and collecting includes Richard D. Altick, *The Shows of London* (Cambridge: Belknap, 1978); Kenneth Arnold and Susan Pearce, eds., *The Collector's Voice: Critical Readings in the Practice of Collecting* (Aldershot: Ashgate, 2000); William B. Ashworth Jr., "Natural History and the Emblematic World View," in *Reappraisals of the Scientific Revolution,* ed. David C. Lindbergh and Robert S. Westman (Cambridge: Cambridge Univ. Press, 1990); David R. Brigham, *Public Culture in the Early Republic: Peale's Museum and Its Audiences* (Washington, DC: Smithsonian, 1995); Lorraine Daston and Katharine Park, *Wonders and the Order of Nature: 1150–1750* (New York: Zone, 1998); Paula Findlen, *Possessing Nature: Museums, Collecting, and Scientific Culture in Early Modern Italy* (Berkeley: Univ. of California Press, 1994); Michael Hunter, *Establishing the New Science: The Experience*

of the Early Royal Society (Suffolk: Boydell, 1989); Joy Kenseth, ed., *The Age of the Marvelous* (Chicago: Univ. of Chicago Press, 1991); and Nicholas Thomas, *Possessions: Indigenous Art / Colonial Culture* (London: Thames and Hudson, 1999).

Newspaper histories offer a crucial interpretive framework for investigating how science constructed multiple (and often competing) audiences through photographic displays: Hannah Barker, *Newspapers, Politics, and English Society, 1695–1855* (New York: Longman, 2000); Laurel Brake, *Subjugated Knowledges: Journalism, Gender, and Literature in the Nineteenth Century* (New York: New York Univ. Press, 1994); Laurel Brake, Bill Bell, and David Finkelstein, eds., *Nineteenth-century Media and the Construction of Identities* (New York: Palgrave, 2000); Peter Broks, *Media Science Before the Great War* (New York: St. Martin's, 1996); and Peter Broks, "Science, the Press, and Empire: 'Pearsons' Publications, 1890–1914," in *Imperialism and the Natural World,* ed. John M. Mackenzie (Manchester: Manchester Univ. Press, 1990): 141–163; Cynthia Carter, *News, Gender, and Power* (New York: Routledge, 1998); Aled Jones, *Powers of the Press: Newspapers, Power, and the Public in Nineteenth-Century England* (Aldershot: Ashgate, 1996); Mary Louise Pratt, *Imperial Eyes: Travel Writing and Transculturation* (London: Routledge, 1992); John Stokes, *In the Nineties* (Chicago: Univ. of Chicago Press, 1989); and Patricia Anderson, *The Printed Image and the Transformation of Popular Culture, 1790–1860* (Oxford: Oxford Univ. Press, 1991). A key critical article that locates the history of photographic reproduction within the larger framework of art and capitalism is Walter Benjamin's classic essay, "The Work of Art in the Age of Mechanical Reproduction," in *Illuminations,* ed. Hannah Arendt (New York: Schocken, 1968), 217–251.

By showing the particularity of Victorian conceptions of photography and the variety of experiences that it made available to nineteenth-century observers, several recent works challenge the traditional model of photography as a medium with a fixed meaning or authority: Carol Armstrong, *Scenes in a Library: Reading the Photograph in the Book, 1843–1875* (Cambridge: MIT Press, 1998); Jennifer Green-Lewis, *Framing the Victorians: Photography and the Culture of Realism* (Ithaca: Cornell Univ. Press, 1996); Helen Groth, *Victorian Photography and Literary Nostalgia* (Oxford: Oxford Univ. Press, 2003); Joan M. Schwartz and James R. Ryan, *Picturing Place: Photography and the Geographical Imagination* (London: I. B. Tauris, 2003); Joel Snyder, "Picturing Vision," *Critical Inquiry* 6 (1975): 143–169), and Joel Snyder and Neil Walsh Allen, "Photography, Vision, and Representation," *Critical Inquiry* 2 (1975): 143–169; John Tagg, *The Burden of Representation: Essays on Photographies and Histories* (Minneapolis: Univ. of Minnesota Press, 1988); Jennifer Tucker, "Photography as Witness, Detective and Impostor: Visual Representation in Victorian Science," in *Victorian Science in Context,* ed. Bernard Lightman (Chicago: Univ. of Chicago Press, 1997); and Mary Warner Marien, *Photography and Its Critics: A Cultural History, 1839–1900* (Cambridge: Cambridge Univ. Press, 1997).

Since the 1970s, historians and sociologists of science have turned increasingly to the study of controversy to elucidate the tacit assumptions and practices that often go unremarked except when scientists vehemently disagree. Two classic works in the study of scientific controversy are David Bloor, *Knowledge and Social Imagery* (London: Routledge and Kegan Paul, 1976); and Steven Shapin, "History of Science and its Sociological Reconstructions," *History of Science* 20 (1982): 157–211. See also Stewart Richards, *Philosophy and Sociology of Science: An Introduction* (Oxford: Basil Blackwell, 1987), esp. 197–222. Controversies are analyzed in many histories of science, from meteorology to physics: Katherine Anderson, "Practical Science: Meteorology and the Forecasting Controversy in Mid-Victorian Britain" (Ph.D. diss., Northwestern Univ., 1994); Constance Clark, "Evolution for John Doe: Pictures, the Public, and the Scopes Trial Debate," *Journal of American History* 87 (Mar. 2001): 1275–1303; Michael J. Crowe, *The Extraterrestrial Life*

Debate, 1750–1900: The Idea of a Plurality of Worlds from Kant to Lowell (Cambridge: Cambridge Univ. Press, 1986), 514–556; Steven J. Dick, *The Biological Universe: The Twentieth-Century Extraterrestrial Life Debate and the Limits of Science* (Cambridge: Cambridge Univ. Press, 1996), 64–78; Norris S. Hetherington, "Amateur Vs. Professional: The British Astronomical Association and the Controversy over Canals on Mars," *Journal of the British Astronomical Association* 86 (1976): 302–308; John Lankford, "Amateurs Versus Professionals: The Controversy over Telescope Size in Late-Victorian Science," *Isis* 72 (1981): 11–28; and John Lankford, "Amateur Vs. Professional: The Transatlantic Debate over the Measurement of the Jovian Longitude," *Journal of the British Astronomical Association* 89 (1979): 574–582; James A. Secord, *Controversy in Victorian Geology: The Cambrian-Silurian Dispute* (Princeton: Princeton Univ. Press, 1986); William Sheehan, *Planets and Perception: Telescopic Views and Interpretations, 1606–1909* (Tucson: Univ. of Arizona Press, 1988), 62–167; and Robert Smith, "The Cambridge Network in Action: The Discovery of Neptune," *Isis* 80 (Sept. 1989): 395–422.

 Book-length histories, including many of the books and articles cited here, tend to focus on Victorian science as perceived and practiced by men of science, often without critical reflection on the intersections of gender with social factors such as class, race, sexuality, and nationalism. Recent works in the history of gender and science offer new models for exploring a wider view of how scientific meanings are generated and transformed. Feminist scholarship on gender, science, and visual culture suggests how to open the interpretive frame to considerations of the role of women in scientific imaging as well as to issues raised by the gendering of science and scientific imaging. Pathbreaking works include Lisa Cartwright, "A Cultural Anatomy of the Visible Human Project," in *The Visible Woman: Imaging Technologies, Gender, and Science,* ed. Paula A. Treichler, Lisa Cartwright, and Constance Penley (New York: New York Univ. Press, 1998), 21–43; Anne Fausto-Sterling, *Sexing the Body: Gender Politics and the Construction of Sexuality* (New York: Basic, 2000); Barbara T. Gates, *Kindred Nature: Victorian and Edwardian Women Embrace the Living World* (Chicago: Univ. of Chicago Press, 1998); and Barbara T. Gates, ed., *In Nature's Name: An Anthology of Women's Writing and Illustration, 1780–1930* (Chicago: Univ. of Chicago Press, 2002); Donna J. Haraway, *Primate Visions: Gender, Race, and Nature in the World of Modern Science* (New York: Routledge, 1989); Ludmilla Jordanova, *Sexual Visions: Images of Gender in Science and Medicine Between the Eighteenth and Twentieth Centuries* (Madison: Univ. of Wisconsin Press, 1989); Rosalind P. Petchesky, "Fetal Images: The Power of Visual Culture in the Politics of Reproduction," *Feminist Studies* 13 (Summer 1987): 263–292; Naomi Rosenblum, *A History of Women Photographers* (New York: Abbeville, 1994); Londa Schiebinger, "Skeletons in the Closet: The First Illustrations of the Female Skeleton in Eighteenth-Century Anatomy," *Representations* 14 (1986): 42–82; and Ann B. Shteir, *Cultivating Women, Cultivating Science: Flora's Daughters and Botany in England, 1760–1860* (Baltimore: Johns Hopkins Univ. Press, 1996).

 Important sources on gender, photography, and art include Lisa Tickner, *Spectacle of Women: Imagery of the Suffrage Campaign, 1907–1914* (Chicago: Univ. of Chicago Press, 1988), and Laura Wexler, *Tender Violence: Domestic Visions in an Age of U.S. Imperialism* (Chapel Hill: Univ. of North Carolina Press, 2000). Kay Dian Kriz, *The Idea of the English Landscape Painter: Genius as Alibi in the Early Nineteenth Century* (New Haven: Yale Univ. Press, 1997) provided a valuable model for exploring what counted as scientific photography and how its definition relied on categories of agency shaped by gender and class ideologies. Books that I found helpful for delineating gender and class relations in Victorian England include Leonore Davidoff and Catherine Hall, *Family Fortunes: Men and Women of the English Middle Class, 1780–1850* (Chicago: Univ. of Chicago Press, 1987); Angus McLaren, *Trials of Masculinity: Policing Sexual Bound-*

aries, 1870–1930 (Chicago: Univ. of Chicago, 1997); Joan Wallach Scott, *Gender and the Politics of History* (New York: Columbia Univ. Press, 1999) and John Tosh, *A Man's Place: Masculinity and the Middle-Class Home in Victorian England* (New Haven: Yale Univ. Press, 1999).

For the intersections of science, race, visual culture, and imperialism, see Antoinette Burton, ed., *After the Imperial Turn: Thinking With and Through the Nation* (Durham: Duke Univ. Press, 2003); Annie E. Coombes, *Reinventing Africa: Museums, Material Culture, and Popular Imagination in Late Victorian and Edwardian England* (New Haven: Yale Univ. Press, 1994); J. W. M. Hichberger, *Images of the Army: The Military in British Art, 1815–1914* (Manchester: Manchester Univ. Press, 1988); Pat Hodgson, *The War Illustrators* (London: Osprey, 1977); T. Lilly, "The Black African in Southern Africa: Images in British School Geography Books," in *The Imperial Curriculum: Racial Images and Education in the British Colonial Experience*, J. A. Mangan, ed. (London: Routledge, 1993), 40–53; Douglas A. Lorimer, *Colour, Class, and the Victorians* (New York: Holmes and Meier, 1978); John M. Mackenzie, ed., *Imperialism and the Natural World* (Manchester: Manchester Univ. Press, 1990); Nancy Stepan, *Picturing Tropical Nature* (Ithaca: Cornell Univ. Press, 2001); Nancy Stepan, *The Idea of Race in Science: Great Britain, 1800–1960* (Hamden, CT: Archon, 1982); Shearer West, ed., *The Victorians and Race* (Aldershot: Ashgate, 1996); Paul Gilroy, *The Black Atlantic: Modernity and Double Consciousness* (Cambridge: Harvard Univ. Press, 1993); Jan Nederveen Pieterse, *White on Black: Images of Africa and Blacks in Western Popular Culture* (New Haven: Yale Univ. Press, 1992); and Robert J. Wilkinson-Latham, *From Our Special Correspondent: Victorian War Correspondents and Their Campaigns* (London: Hodder and Stoughton, 1979). See also L. J. Rather, "On the Use of Military Metaphor in Western Medical Literature: The *Bellum Contra Morbum* of Thomas Campanella (1568–1639)," *Clio Medico* 3 (1972): 201–208; and Arthur Silverstein, "Cellular Versus Humoral Immunity: Determinants and Consequences of an Epic 19th Century Battle," *Cellular Immunology* 48 (1979): 208–221.

An outstanding article that lays bare the methodological issues at stake for the study of visual culture is Gregg Mitmann, "Cinematic Nature: Hollywood Technology, Popular Culture, and the American Museum of Natural History," *Isis* 84 (1993): 637–661. For the dynamic intersections of science and popular culture, see, among others, Adrian Desmond, *The Politics of Evolution: Morphology, Medicine, and Reform in Radical London* (Chicago: Univ. of Chicago Press, 1989); Desmond and James Moore, *Darwin* (New York: Warner, 1992); Sally Gregory Kohlstedt, "Parlors, Primers, and Public Schooling: Education for Science in Nineteenth-Century America," *Isis* 81 (1990): 425–445; Bernard Lightman, "The Visual Theology of Victorian Popularizers of Science: From Reverent Eye to Chemical Retina," *Isis* 91 (2000): 651–681; James Secord, *Victorian Sensation: The Extraordinary Publication, Reception, and Secret Authorship of Vestiges of the Natural History of Creation* (Chicago: Univ. of Chicago Press, 2000); James Secord, "Newton in the Nursery: Tom Telescope and the Philosophy of Tops and Balls," *History of Science* 23 (1985): 127–151; Simon Schaffer, "Natural Philosophy and Public Spectacle in the Eighteenth Century," *History of Science* 21 (1983): 1–43; Jennifer Tucker, "Voyages of Discovery on Oceans of Air: Scientific Observation and the Image of Science in an Age of 'Balloonacy,'" *Osiris* 11 (1996): 144–176; and Richard Yeo, *Science in the Public Sphere: Natural Knowledge in British Culture, 1800–1860* (Aldershot: Ashgate, 2001).

Works that examine the epistemologies associated with new scientific instruments include Jay Apt, Michael R. Helfert, Justin Wilkinson, and Roger Ressmeyer, *Orbit: NASA Astronauts Photograph the Earth* (Washington, DC: National Geographic Society, 1996); J. A. Bennet, *The Divided Circle: A History of Instruments for Astronomy, Navigation, and Surveying* (Oxford: Phaidon, 1987); J. A. Bennett and R. G. W. Anderson, *Making Instruments Count: Essays on Historical Scientific Instruments Presented to G. L'E. Turner* (Aldershot: Variorum, 1993); Reginald S.

Clay and Thomas H. Court, *The History of the Microscope* (London: Holland, 1932); Gary Lee Downey and Joseph Dumit, *Cyborgs and Citadels: Anthropological Interventions in Emerging Sciences and Technologies* (Santa Fe: School of American Research Press, 1997); Thomas L. Hankins and Robert J. Silverman, *Instruments and the Imagination* (Princeton: Princeton Univ. Press, 1995); Gerard L'E. Turner, *Essays on the History of the Microscope* (Oxford: Senecio, 1980); Gerard L'E. Turner, "Microscopical Communication," in *Essays on the History of the Microscope,* ed. G.L.'E. Turner (Oxford: Senecio, 1980), 215–232; Deborah Warner, "What is a Scientific Instrument, When Did It Become One, and Why?" *British Journal for the History of Science* 23 (1990): 83–93; and Catherine Wilson, *Invisible World: Early Modern Philosophy and the Invention of the Microscope* (Princeton: Princeton Univ. Press, 1995).

Detailed histories of scientific illustration and the visual language of science may be found in Ann Shelby Blum, *Picturing Nature: American Nineteenth-Century Zoological Illustration* (Princeton: Princeton Univ. Press, 1993); Martin Kemp, *Art and Science of the Human Body from Leonardo to Now* (Los Angeles: Univ. of California Press, 2000), and Martin Kemp, *The Science of Art: Optical Themes in Western Art from Brunelleschi to Seurat* (New Haven: Yale Univ. Press, 1990); Jane Maienschein, "From Presentation to Representation in E. B. Wilson's *The Cell,*" *Biology and Philosophy* 6 (1991): 227–254; Martin J. S. Rudwick, *Scenes from Deep Time: Early Pictorial Representations of the Prehistoric World* (Chicago: Univ. of Chicago Press, 1992); and Martin J. S. Rudwick, "The Emergence of a Visual Language for Geological Science, 1760–1840," *History of Science* 14 (1976): 149–195.

Discussions of scientific drawing in the field of the history of art provide valuable information and analysis of the culture of seeing and drawing from nature. I found especially useful Svetlana Alpers, *The Art of Describing: Dutch Art in the Seventeenth Century* (Chicago: Univ. of Chicago Press, 1983); Ann Bermingham, *Learning to Draw: Studies in the Cultural History of a Polite and Useful Art* (New Haven: Yale Univ. Press, 2000); Charlotte Klonk, *Science and the Perception of Nature: British Landscape Art in the Late Eighteenth And Early Nineteenth Centuries* (New Haven: Yale Univ. Press, 1996); and Amy R. W. Meyers, ed., *Art and Science in America: Issues of Representation* (San Marino: Huntington Library, 1998). Historians of Victorian art have focused in depth on the scientific contexts of cloud studies, and work on the scientific contexts of landscape painting is rapidly gaining. Standard sources on cloud studies include Kurt Badt, *John Constable's Clouds* (London: Routledge and Kegan Paul, 1950); L. C. W. Bonacina, "John Constable's Centenary: His Position as a Painter of Weather," *Quarterly Journal of the Meteorological Society* 63 (1937): 483–490; Louis Hawes, "Constable's Sky Sketches," *Journal of the Warburg and Courtauld Institutes* 32 (1969): 344–365; and John Thornes, "Constable's Clouds," *Burlington Magazine* 121 (1979): 697–704. On J. M. W. Turner and his interest in naturalism, see W. Bürger, "L'École Anglaise" in *Histoire des peintres de toutes les écoles,* ed. Charles Blanc et al. (Paris: Librarie Renouard, 1861); John Gage, *J. M. W. Turner: 'A Wonderful Range of Mind'* (New Haven: Yale Univ. Press, 1987); and Andrew Wilton, *Turner in His Time* (New York: Harry N. Abrams, 1987).

The following works provide an excellent introduction to Victorian culture, politics, and society, and I drew on them in locating scientific photography within a wider cultural field: Steve Attridge, *Nationalism, Imperialism, and Identity in Late Victorian Culture: Civil and Military Worlds* (New York: Palgrave Macmillan, 2003); Jeffrey A. Auerbach, *The Great Exhibition of 1851: A Nation on Display* (New Haven: Yale Univ. Press, 1999); David Cannadine, *Ornamentalism: How the British Saw Their Empire* (Oxford: Oxford Univ. Press, 2001); David Feldman and Gareth Stedman Jones, eds., *Metropolis London: Histories and Representations Since 1800* (New York: Routledge, 1989); Catherine Hall, ed., *Cultures of Empire: Colonizers in Britain and the Em-*

pire in the Nineteenth and Twentieth Centuries: A Reader (New York: Routledge, 2000); E. J. Hobsbawm, *Nations and Nationalisms Since 1780: Programme, Myth, Reality* (Cambridge: Cambridge Univ. Press, 1992); Kelly Hurley, *The Gothic Body: Sexuality, Materialism, and Degeneration at the Fin de Siècle* (Cambridge: Cambridge Univ. Press, 1996); Lynda Nead, *Victorian Babylon: People, Streets, and Images in Nineteenth-Century London* (New Haven: Yale Univ. Press, 2000); Gareth Stedman Jones, *Languages of Class: Studies in English Working-Class History, 1832–1982* (Cambridge: Cambridge Univ. Press, 1983).

Valuable photographic histories and criticism include Michael Bartram, *The Pre- Raphaelite Camera: Aspects of Victorian Photography* (Boston: Little, Brown, and Co., 1985); Geoffrey Batchen, *Burning With Desire: The Conception of Photography* (Cambridge: MIT Press, 1997); Walter Benjamin, "The Work of Art in the Age of Mechanical Production," in *Illuminations,* ed. Hannah Arendt (New York: Schocken, 1969), 217–252; and Walter Benjamin, "The Author as Producer," in *Reflections,* ed. Peter Demetz (New York: Schocken, 1968), 220–238; John Berger, *About Looking* (1980; New York: Vintage, 1991); Victor Burgin, ed., *Thinking Photography* (London: Macmillan, 1982); Anthony Hamber, *"A Higher Branch of the Art": Photographing the Fine Arts in England, 1839–1880* (Amsterdam: Gordon and Breach, 1996); Grace Seiberling, *Amateurs, Photography, and the Mid-Victorian Imagination* (Chicago: Univ. of Chicago Press, 1986); Alan Trachtenberg, *Reading American Photographs: Images as History, Mathew Brady to Walker Evans* (New York: Hill and Wang, 1989); and Mike Weaver, *British Photography in the Nineteenth Century: The Fine Art Tradition* (Cambridge: Cambridge Univ. Press, 1989).

I made much use of these works on Victorian science and culture: Gillian Beer, *Open Fields: Science in Cultural Encounter* (Oxford: Clarendon, 1996); Lucile Brockway, *Science and Colonial Expansion: The Role of the British Royal Botanic Gardens* (New York: Academic Press, 1979); Susan F. Cannon, *Science in Culture: The Early Victorian Period* (New York: Science History Publications, 1978); Roger Cooter, *The Cultural Meaning of Popular Science: Phrenology and the Organization of Consent in Nineteenth-Century Britain* (Cambridge: Cambridge Univ. Press, 1984); Richard Harry Drayton, *Nature's Government: Science, Imperial Britain, and the 'Improvement' of the World* (New Haven: Yale Univ. Press, 2000); William Graves Hoyt, *Lowell and Mars* (Tucson: Univ. of Arizona Press, 1976); Ludmilla Jordanova and Roy Porter, eds., *Images of the Earth: Essays in the History of the Environmental Sciences* (London: British Journal for the History of Science Publications, 1989); Henrika Kuklick, *The Savage Within: The Social History of British Anthropology, 1885–1945* (Cambridge: Cambridge Univ. Press, 1991); Iwan R. Morus, *Frankenstein's Children: Electricity, Exhibition, and Experiment in Early Nineteenth-century London* (Princeton: Princeton Univ. Press, 1998); David Strauss, *Percival Lowell: The Culture and Science of a Boston Brahmin* (Cambridge: Harvard Univ. Press, 2001); and Ronald M. Westrum, "Science and Social Intelligence About Anomalies: The Case of Meteorites," *Social Studies of Science* 8 (1978): 461–493.

Detailed discussions of the institutional reorganization of Victorian science can be found in T. M. W. Heyck, *The Transformation of Intellectual Life in Victorian Britain* (London: Croom Helm, 1982); O. J. R. Howarth, *The British Association for the Advancement of Science: A Retrospect, 1831–1931* (London: British Association Press, 1931); Roy MacLeod and Peter Collins, eds., *The Parliament of Science: The British Association for the Advancement of Science, 1831–1981* (London: Science Reviews, 1981); Jack Morrell and Arnold Thackray, *Gentlemen of Science: Early Years of the British Association for the Advancement of Science* (Oxford: Clarendon, 1981); William J. Reader, *Professional Men: The Rise of the Professional Class in Nineteenth-Century England* (London: Weidenfield and Nicholson, 1966); Frank Miller Turner, *Contesting Cultural Authority: Essays in Victorian Intellectual Life* (Cambridge: Cambridge Univ. Press, 1993); and Richard Yeo, "Science and Intellectual Authority in Mid-Nineteenth Century Britain," in *Energy and Entropy:*

Science and Culture in Victorian Britain, ed. Patrick Brantlinger (Bloomington: Indiana Univ. Press, 1989).

Valuable secondary sources on the laboratory method in Victorian science include Peter Baldwin, *Contagion and the State in Europe, 1830–1930* (Cambridge: Cambridge Univ. Press, 1999); J. Henry Dible, *A History of the Pathological Society of Great Britain and Ireland* (London: Oliver and Boyd, 1957); Graeme Gooday, "Precision Measurement and the Genesis of Physics Teaching Laboratories," *British Journal for the History of Science* 23 (1990): 25–51; Keith Vernon, "Pus, Sewage, Beer and Milk," *History of Science* (1990): 289–325; Andrew Warwick, *Cambridge and the Rise of Mathematical Physics* (Chicago: Univ. of Chicago Press, 2003); T. E. Woodward, "The Golden Era of Microbiology: People and Events of the 1880s," *Maryland Medical Journal* (1989): 323–328. For an excellent introduction to the controversies that laboratory methods generated, especially for reformers including many feminists, see Coral Lansbury, *The Old Brown Dog: Women, Workers, and Vivisection in Edwardian England* (Madison: Univ. of Wisconsin, 1985); Ornella Moscucci, *The Science of Woman: Gynaecology and Gender in England, 1800–1929* (Cambridge: Cambridge Univ. Press, 1900); Ruth Richardson, *Death, Dissection, and the Destitute* (Chicago: Univ. of Chicago Press, 2000); and Judith R. Walkowitz, *City of Dreadful Delight: Narratives of Sexual Danger in Late-Victorian London* (Chicago: Univ. of Chicago Press, 1992).

Index